4MSO/11

Unesco has also published the following titles of interest to the readers of this book:

THE
ORGANIZATION
OF MUSEUMS
practical advice

The Unesco Press
Paris 1974

The conclusions set out and the opinions expressed in this book are those of the authors and do not necessarily reflect the views of Unesco.

Published by the Unesco Press
7 Place de Fontenoy, 75700 Paris
1st impression January 1960
2nd impression February 1967
3rd impression December 1974
Printed by Offset Aubin, Poitiers

ISBN 92-3-100441-7

CONTENTS

Twenty-four years have passed since the publication of *Museographie,* a two-volume work compiled by the International Museums Office. It not only summarized the current status of museums, but it proved to be the basis for stimulating further progress in the development of museums throughout the world. The demand for this outstanding work was so great that it soon went out of print and it is still today one of the fundamental reference works used in museographical research.

A great deal has happened, however, since *Museographie* was published: social and political changes have occurred, a rapid advance is being made in technology, communication facilities have improved, air travel has reached a high stage of development, we are on the threshold of developing new sources of energy and the first attempts at the exploration of outer space have begun.

While the basic principles of museum work have not changed, applications and techniques cannot but be affected by contemporary needs and modern technology. Perhaps because of the current ferments, there is evident everywhere an increasing interest in the past history of mankind as well as in the phenomena of the present. Museums are bound to respond to these interests. They harbour within their walls ancient fossils, the crude stone tools of early man, works of art which express some of man's highest aspirations in his search for the meaning of existence, and models which depict and explain his latest achievements, such as the operation of atomic power plants. And throughout the world museums have reported a constant increase in attendance.[1]

The international quarterly *Museum,* published by Unesco, which reviews museum activity throughout the world, bears witness in its articles to the changes which have been taking place. The educational role of museums has become much more important than it was in the past. Exhibitions are being revised so as to be aesthetically pleasing and more informative; and temporary exhibitions dealing with a single theme have become more common. There has been a considerable development, too, of specialized educational services in museums in many countries.

Unesco has encouraged this tendency through sponsoring a series of international and regional seminars on the educational role of museums. The first was held in Brooklyn, New York, in 1952. Many of the participants were from Europe. They studied the educational programmes of museums in the United States, new trends in museum exhibitions, etc. The results were published in a report by the Director and in *Museum.*[2] A similar seminar was held in Athens, Greece, during 1954. Participants came from Europe and the Middle East, and also from the Far East and the New World. The presence of participants from less developed countries gave a different emphasis to the seminar: museum educational programmes were considered in terms of the special needs of such countries. The theoretical bases of educational programmes in countries where they are already well

1. Unesco ST/R/18, 1958, 'Preliminary Report on Museum Statistics'.
2. Unesco/CUA/54, 1954; *Museum,* Vol. VI, No. 4, 1953.

developed were evaluated, and alternative solutions were considered. As in the previous case, the results of the seminar were published in a report by the Director and in *Museum*.[1]

The expansion of museum programmes to attract visitors by means of temporary exhibitions, frequently made possible through loans, is one of the phenomena of the present. A further development is the travelling exhibition which permits people to see material most of which would otherwise be inaccessible. To encourage travelling exhibitions and furnish information designed to minimize the risks of transport, the *Manual for Travelling Exhibitions* (Volume V in this series) was published by Unesco in 1953, in English and French, and was an instant success.

The trend towards wider use of museums in all parts of the world is reflected in the requests received under the Participation Programme, through which Unesco aids the development of museums in Member States by sending experts and equipment, and providing fellowships to enable nationals to receive further training abroad. Experts have been sent to advise on aspects of museum development to Afghanistan, Ceylon, Ecuador, India, Indonesia, Pakistan, Peru, Singapore and the Sudan. Fellowships have been given to nationals of Afghanistan, Argentina, Belgium, Burma, Cuba, Denmark, Ecuador, Egypt, India, Indonesia Japan and Poland, to study museums abroad and to receive further professional training to enable them to assume the responsibilities resulting from expansion of the programmes of their musuems.

One of the most important instruments of Unesco's programme has been the co-operative effort of ICOM, the International Council of Museums, an organization of the museographical profession with national committees in 48 countries. Mr. Georges Henri Rivière, the Director of this organization since its establishment, has been particularly instrumental in working to forward the aims of Unesco. He has co-operated closely in many of its projects, including the publication of this manual, of which he helped to plan the basic outline furnished to the contributing authors, and to edit the text. On behalf of Unesco, I wish to acknowledge our indebtedness to him and our appreciation of his efforts.

This text is in no way designed to replace *Museographie*. It is, as its title indicates, designed to give practical advice to smaller museums with limited budgets, or to museums which are just beginning to enlarge the scope of their activities. I am sure that the book can be useful for this purpose. Perhaps it may also be valued by members of the profession working in museums which are already well established; and if so, this will be a testimony to the value of the texts contributed.

LUTHER H. EVANS
Director-General
Unesco, Paris, 1958

1. Unesco/CUA/64, 1955; *Museum*, Vol. VIII, No. 4, 1955.

THE AUTHORS

ADAMS, Philip R.

A.B., M.A., Litt.D. (Miami University). Lecturer, History of the Arts, Tulane University, 1931-34. Director of the Gallery of Fine Arts, Columbus, Ohio, 1934-45. Director of the Cincinnati Art Museum since 1945. Director of the College Art Association, Executive Secretary of the Art Committee, Office of the Co-ordinator of Inter-American Affairs (Rockefeller Committee), 1941. Trustee of the American Federation of Arts. Author of articles and monographs in various publications, among them *Kenyon Review, Harper's Bazaar,* and *Museum.*

ALLAN, Douglas A.

D.Sc., Ph.D. (Edinburgh). Lecturer in Geology at the Universities of Edinburgh and Durham. Director of Liverpool City Museum, 1929-44. Director, Royal Scottish Museum, since 1945. President, British Museums Association, 1942-46. Chairman, British National Committee of ICOM, 1943. Director, Unesco Seminar: Museums and Education, Brooklyn, N.Y., 1952.

COREMANS, Paul

D.Sc., university graduate in science, the history of art, archaeology. Director of the Institut Royal du Patrimoine Artistique and the Archives Centrales Iconographiques d'Art National, Brussels. Professor at the University of Ghent. Author of several articles and monographs on the scientific protection of cultural property.

DAIFUKU, Hiroshi

Ph.D. (Harvard University). Instructor, Department of Anthropology, University of Wisconsin, 1949-52. Curator of anthropological exhibitions, State Historical Society Museum, Madison, Wisconsin, 1952-54. Programme Specialist, Museums Division, Unesco, since 1954. Publications in anthropology and museography.

HARRISON, Molly

Curator, Geffrye Museum, London. Author of articles and books on museums and education, including *Museum Adventure—the Story of the Geffrye Museum;* was one of the contributing authors to *Museums and Young People,* published by ICOM in 1952. Editor of 'Museums in Education', *Education Abstracts,* Vol. 8, No. 2, Unesco, 1956.

MOLAJOLI, Bruno

B.A. Inspector, Administration of Antiquities and Fine Arts (Italy), 1933. Regional Director, Department of Antiquities and Fine Arts, Trieste, 1936-39. Director of the Art Galleries of Campania, Naples, since 1939. Member of the Council for Antiquities and Fine Arts, of the Ministry of Education.

SCHOMMER, Pierre

Graduate of the Ecole du Louvre. Attaché, National Service for the Protection of

11

Historic Monuments and Works of Art (1917-19). Assistant-Secretary of the Commission des Vestiges de Guerre; Secretary, Historic Monuments Commission (1919-26); Attaché, Direction des Musées Nationaux, 1927. Conservateur des Musées Nationaux, Assistant to the Director of the Musées de France (1945). Chief Curator, Musée de la Malmaison, since 1956.

THE MUSEUM AND ITS FUNCTIONS

by Douglas A. ALLAN

DEFINITION

A museum in its simplest form consists of a building to house collections of objects for inspection, study and enjoyment. The objects may have been brought from the ends of the earth—coral from the Great Barrier Reef of Australia, a brick from the Great Wall of China, an ostrich egg from Africa or a piece of magnetic iron ore from Greenland; they may be things of today or things of the distant past—a model of a jet-propelled aeroplane or a fossil fern from the Coal Measures; they may be of natural origin or may be man made—a cluster of quartz crystals or a woven mat from India.

A museum thus gathers for convenience under the one roof material which originally was widely distributed through both time and space. Secondly, it provides the identification and annotation of the objects as a first step towards understanding them. It makes the onlooker's thoughts travel far from things commonly known and from his immediate surroundings. Thirdly, a museum displays its collections under conditions conducive to enjoyment and study so that the visitor will be happy to enter the institution, to scrutinize the exhibits, to ponder over them and to return to see more. It is only when his curiosity and wonder have been aroused that the spectator is encouraged to stop and consider the specimens before him—to think deeply about them and to embark upon a course of study. No other institution collects and displays examples of our three-dimensional world as an aid to general understanding; museums are unique.

COLLECTING

One of the major tasks a museum can perform is to bring before our eyes that most entrancing story of all—the story of man the world over, showing how he built up his knowledge of the world he lives in, and how he developed his family life, his arts and crafts, his cultures and his civilizations. Such studies show how late in his history he developed museums, although making collections has been a characteristic of man from the very earliest times. From the very start, food, clothing and weapons were essential to him, and he learned to accumulate and store them for his future needs. Then later came the period when he collected objects as personal wealth and as a demonstration of prestige. With the rise of complicated civilizations, the opportunities to gather valuable objects, such as arms and armour, silks and tapestries, gold and jewels increased. Princely gifts decorated palaces and temples, and changed hands with alliances and marriages or with the fortunes of war. Treasures fell to aristocratic lineage or to the strong arm. Later on such wordly possessions marked the rising class of prosperous merchants and traders, for the rich and the rare have always been prized; they entertained families and friends and impressed rivals and subordinates. At a later stage still, collections were fashionable as a reflection of individual good taste, culture or wide interests. Once a man had house, wealth and family, he tended to collect books, pictures, objets d'art and natural curiosities.

Such accumulations demanded both space and maintenance, and in some cases became

a burden to their owners. In others a spirit of generosity prevailed and there was a desire to make them available to a wider public. For both these reasons gifts of whole collections were made to benefit the public, and the institutions which housed them were named art galleries or museums. In classical times the term museum denoted in general the seat of the muses and, in particular, the university building erected at Alexandria by Ptolemy Soter. Museums and art galleries sprang up in the European capitals from the mid-eighteenth century onwards, often under royal patronage, and nations vied with each other in setting up impressive institutions to house their treasures, mainly in the fields of art and archaeology. The large urban centres were not slow to follow the developments in the national capitals, whose claims to prestige they rivalled by erecting and filling museums and art galleries of their own, often relying on the benevolence of local merchants or industrialists to provide the initial funds, while the civic authorities usually undertook to staff and maintain the institutions.

The arts and crafts were not, however, the only fields to yield material worth collecting and preserving, for natural curiosities stimulated an interest in the natural sciences and the exploration of the world provided an ever increasing volume of specimens. Beginning with a single cabinet, the collector would aspire to a whole room holding a mixture of minerals, rocks, fossils, butterflies, birds and flint artifacts. Enthusiasts banded themselves into learned societies and contributed their collections to the museum of their society or presented them to the town's museum to form new sections dealing with natural history, archaeology or ethnography. Most of these early 'society' museums were centres of education, providing courses of lectures, and many of the members were actively engaged in systematic research, which they wrote up and published in their proceedings or transactions, and around which they often gathered very useful specialized libraries.

Universities built up famous reference libraries dealing with the wide variety of subjects taught, but they did not stop at that. With the rapidly expanding studies of the sciences not only were experimental laboratories required but also materials to investigate. It was essential to have extensive sets of teaching specimens, which had to be housed between lectures and made available for study in the students' own time, hence the rise of departmental museums. To them came additions from research projects conducted inside the university and also others from the overseas explorations which were such a feature of the eighteenth and nineteenth centuries. There were also gifts from the ends of the earth made by travellers and administrators, often alumni of the older universities who were anxious to give rarities, treasures and curiosities to the academies which had reared them. These in diverse ways added to the wealth of the collections inherited by the museum experts of today.

The nineteenth century was a time of educational expansion in all fields and at all levels in regions affected by the Industrial Revolution. Mechanics' institutes and technical schools sprang up to provide training for those whose days were absorbed in workshop and factory. Models were made to demonstrate in lectures the principles of the physical and applied sciences. Yet others were constructed by students as they acquired skill in precision work on wood and metals, thus providing for the growing museum collections another type of specimen greatly prized by those who came after. The universities, too, preserved apparatus and tools used in historic researches and constructed appliances employed in demonstrations. Thus in a somewhat systematic way began much of the accumulation of material for the physical science and technological museums of today. Some fortunate institutions were able to acquire special collections, such as the scale dockyard models of ships constructed for the various admiralties, or the wonderful groups of mechanical models showing the state of engineering in Sweden in the seventeenth and eighteenth centuries, which were commenced by Christopher Polhem in 1696 for the Royal Model Chamber and which are now such an important feature of the Tekniska Museet, Stockholm.

The making of collections proceeded apace, embracing all types of objects and

avidly pursued by all kinds of people, for while the accumulation of choice porcelain, glass or ivories might demand a well-filled purse, it was possible to acquire other objects such as the various types of light-making appliances, or even a range of spinning wheels, very cheaply. Sometimes the collector's urge was satisfied by the making of as complete a series as possible; sometimes he went further and conducted research into the history and development of the objects he collected; sometimes he rounded off his collecting and his studies by publishing a monograph, often accepted as an authoritative textbook on the subject. The collections, either accepted as gifts or purchased, generally found their way into some appropriate museum.

Yet another type of person was busily engaged in bringing museums into being— the lovers of furniture, fittings and domestic appliances of a certain period, associated with a particular house, or connected with the life, times and labours of a particular individual or family. These sought to save groups of objects, the furnishings of entire households, frequently in the original houses themselves. In the case of historic personages—national heroes, musicians, playwrights, artists, soldiers, explorers and scientists—documents, writings, decor-ations, clothing have been assiduously collected so as to present as complete a picture as possible of the life and times of the person concerned, thus constituting the type of museum designated a Period House or a Birthplace Museum.

A museum was thus, in the initial stages, a response to the need to house collections brought into being by the enthusiasm of collectors. There are as many kinds of museum as there are kinds of object to accumulate and to save for the enjoyment of other people now and in the years to come. Museums are not, however, as some people consider, static institutions. Human institutions like organisms tend to develop in response to changing needs, or to die a natural death from neglect. Museums began by collecting and that remains their first function. A museum may collect any-thing but it cannot collect everything. Some of the older museums did offer a welcome to all comers but with sometimes disastrous results. If some kind of order is to be maintained and some reason for a museum's existence established, there must be a well-defined objective—a master plan. To stock their show-cases and store cupboards museums may draw upon the whole field of nature and upon the long history of man and all his works, but the buildings in which such collections are to be housed are finite structures capable of only limited extension. Similarly, museum staffs are limited in number by considerations of finance and accommodation. If a museum is to do its work efficiently its staff must have expert knowledge. From this it follows that the larger the staff the wider the range of subjects which can be adequately dealt with, and the smaller the staff the narrower must be the field of their expe-rience and specialization. At rock bottom, it is finance that determines the size of a museum, its collections and its staff—that decides what a museum can be expected to do really well. There must be for every museum, then, a planned programme which will determine the pattern of the collections and the activities arising from them. This master plan should be decided after very careful consideration either at the founding of a museum or at some stage in its career when a reorganization has been decided upon. It should take due account of the site and locality, the needs of the local people and local education, the collections available and the funds that can be counted upon for expert staff and exhibition acti-vities. Thereafter all energies should be concentrated upon ensuring the complete fulfilment of the project in every respect. No material—however valuable intrinsi-cally or however attractive individually— should be purchased or accepted unless it fits unmistakably into the accepted pro-gramme of the museum. It is by the perfect performance of that programme that the museum will be judged. Yet this is not to be regarded as a strait-jacket into which the institution is to be thrust. Periodically the plan should come up for review, to see how far short of perfection it has fallen, and to see to what extent it is meeting the needs of the locality. If the need is there and the funds can be found, a new wing may be added, a new specialist recruited,

and material to illustrate a new branch of science or art introduced. In particular, the situation should be reviewed after each new curator or director is appointed and has had time to make himself familiar with both his collections and his public.

On what ideas have the plans for museums been based? A great many museums have been the practical expression of a desire to bring together objects of beauty—objects which will inspire the beholder, enrich his life and encourage him to surround himself and others with fine things, perhaps to go on to study their history and the history of the people who conceived and made them, and even to attempt to exercise his own skill and inspiration in producing something of beauty himself. Such museums contain collections of paintings and sculpture, tapestries, furniture and clothing, glass and porcelain, ivories and objects in precious metals. They display some of the highest achievements of the mind and hands of man. Yet others may house collections representing the wealth of wild nature from every corner of the earth, illustrating the sciences of geology, botany and zoology. Some may take as their aim a limited region and show its natural history and its story of human settlement in great detail, demonstrating how our forefathers won a living from the soil, fed and clothed themselves, banded themselves together for protection and co-operative endeavour, leading stage by stage to man's problems and triumphs of today. One museum may have been founded by an enthusiastic student of insects and may be devoted entirely to entomology, while another may interest itself solely in collecting arms, another musical instruments. The situation of a museum may influence its planning. A town which was an important centre in the times of the Roman civilization may, as a result of its history and the importance of local excavations, have a museum devoted largely to showing the life of the Roman period; another museum may exploit the material from a Bronze Age or an Iron Age site nearby. A seaport or a shipbuilding centre, with ships to be seen every day and stories of past seafaring exploits in ready circulation would naturally develop a Shipping Museum, enriched with models and pictures of ships, past and present, with souvenirs of famous craft and salvage from wrecks. Similarly a seaport with especially strong trading links with certain lands overseas would be likely to have in its museum extensive collections from those lands, particularly if the products, the people and the ways of life there differ notably from those at home.

In an area dependent upon mining, enthusiasts collect specimens of curious rocks, ores, crystals or fossils and examples of old tools, and make models of pits and pit machinery. Much of this may be lost with the passage of time but the best pieces are frequently saved and gathered together in a collection which may well become the nucleus of a local museum. The same is true of an area earning its livelihood by spinning and weaving. An important factor common to all these early museums is that their originators loved collecting, and it is to their enthusiasm that we owe the wonderful range of objects handed down to us today. People still display that joy in collecting and may accumulate contemporary objects with no less enthusiasm. In our own times, collections illustrating aspects of suchs subjects as health and hygiene, herbs and drugs, photography, radio communications and electronics—to name only a few—are being built up. Once private and individual collections are fused together in a building, thus forming a museum, it is the function of that museum to go on collecting material which is appropriate to it. This primary function to collect is a public duty, for it is a way of saving things which might otherwise disappear for ever. The task is relatively easy when the objects are of intrinsic value or artistic in nature with an immediate appeal to many collectors, but when they are ugly, bulky or of little or no market value the chances of anyone feeling impelled to collect them become correspondingly small. Where there is no museum, one must rely on the individual collector; where there is a museum which can institute and encourage collections of a particular nature, the private collector can still be a most important ally.

A museum is not merely a passive acceptor of proffered material, although many of the older museums throughout the world have

passed through such a stage. Limited funds for purchases, which handicap so many institutions, force them often to adopt the role of recipients from wealthy and public-spirited benefactors, but a museum which relies upon gifts from collectors, who naturally follow their own bents, must necessarily present a rather patchwork appearance—strong in one section, weak in another, with quite arbitrarily drawn boundary lines. It is the duty of any museum to present as complete and as good a picture as possible of its chosen subject, and this involves accepting appropriate specimens and adding to them so as to fill gaps, to improve the comparative series, to add to the background or to complete the historic setting. Museums must always be on the look-out for good material. They may persuade owners to present appropriate pieces, or benefactors to buy objects of particular search, or they may enter the market themselves. It is also the duty of a museum director to discover where collections and particular pieces are. Since a collector may hand down his treasures to a next of kin without transmitting his love for them, it is wise to record the institution's interest in individual objects or groups or even whole collections. One might say *especially* whole collections, for many years of experience and labour may have gone to the making of a collection. It is thus greatly to be desired that such a collection should be secured *en bloc*, before it is broken up at an auction sale, the rare pieces distributed far and wide and the commoner ones put to everyday uses or even jettisoned.

A second and equally important consideration is that museums should steadfastly refuse gifts or bequests with inappropriate conditions attached to them which, if carried out, would not be to the advantage of the collections or the institution as a whole. Museums cannot remain static; their collections must extend in size and an effort should always be made to reach higher standards as time goes on. For this reason, a gift which implies a static condition must be regarded as being against the best interests of the museum. A collection offered on condition that it is kept together and shown as the so-and-so gift or collection can only be accepted with justification if it is a complete unit of impeccably high standard. Even then, it is possible that another fine collection of the same type may come along, the two collections then obviously calling for fusion, and for the elimination of duplicate material. Again, while collections may at one time be shown on a typological basis, they may at other times demand a geographical distribution, with a resultant rearrangement of individual items. The curator should not have his hands tied in such cases by restrictive terms requiring, for example, that a gift should be permanently on exhibition, that is should be always on view in a particular place, or that it should always be associated with particular other pieces. Sometimes the bait may be extremely difficult to refuse, as one large museum in England found when it was offered a collection of largely third-rate furniture together with a sum of many thousands of pounds! Most reasonable prospective donors, seeing their possessions alongside other collections of high standard, will readily agree to allow the curator full freedom to show them as he sees fit, knowing that he is only too anxious to make the best possible use of them for his own and his public's sake. All gifts can be adequately acknowledged on individual labels if desired.

In the field of natural history there are four major methods of building up collections. Sometimes the collections are historic ones accumulated by the early zoologists and explorers. They may be rich in original material and type specimens, upon which the first official scientific description was based, and whose characteristics will determine the identification of all subsequently discovered material of that kind. Secondly, whole collections may be made by organized scientific expeditions and, after the material has been most carefully examined, written up and published, it may be presented to appropriate museums. Thirdly, museums with sufficient staff and funds may send out their own expeditions into the field in order to obtain material with which to build up their display or study collections. Lastly, there is the possibility of purchasing museum material from firms which specialize in collecting and preparing it for exhibition.

This is probably the only way in which a small museum can obtain up-to-date specimens to illustrate the typical forms of life of distant regions.

The collecting of ethnographical material presents certain problems of its own. The older collections consist of authentic specimens accumulated by early explorers, traders, soldiers and missionaries, but often inadequately annotated—partly because the need for full notes was not appreciated, partly because data on geographic setting and tribal use were difficult to obtain. The distances packages had to be carried by very primitive means of transport also militated against the making of exhaustive collections, and limitation of bulk often resulted in the spectacular, the lighter and the smaller objects being taken irrespective of their scientific value or rarity. How often is life in China shown by collections including porcelain, jade, ivories and lacquer, but excluding such essential objects as agricultural implements? It has thus fallen to later collectors to try to fill the gaps in order to obtain an accurate representation of native life and customs. The passage of time is, however, accompanied by change and development, and native habits alter with the offerings of other more industrialized civilizations, metal and enamel ware, for example, taking the place of objects of stone, shell or wood. It is thus often very difficult and sometimes quite impossible to make good the deficiencies of the past. Even the information regarding what was done and with what implements tends to disappear with the passage of time, especially as written records of the past are often non-existent.

The physical sciences and engineering came very late in the day into the field of museum collecting—for the most part only within the last hundred and fifty years, during which time the material in use was rarely considered to be suitable for museum display. The raw natural materials can still be got, of course, but the early scientific instruments and the pioneer engines and their accessories have all too often gone to the breakers' yard, the scrap heap or the melting-down furnace. Many of the early instruments and appliances were somewhat makeshift affairs, unlikely to seem worthy of saving for posterity, and in any case most of them simply wore out with use. Even instruments used by savants and engines built by now world-famed inventors no doubt seemed of little value at the time they were discarded. It was the results in the one case and the products in the other which mattered. To make sure that future museums and future museum curators do not suffer the same disabilities, it is essential that every museum should continue to collect actively.

IDENTIFYING

The second function which a museum has to perform is to identify accurately each of the specimens it acquires. Herein lies the test of the staff, for a fundamental characteristic of our museums must be their complete honesty and reliability. Once confidence is shaken it is exceedingly difficult to reinstate it. If the staff are in doubt about any specimen, it should be sent to some other institution which has the necessary specialist knowledge at its disposal. Each specimen as it is received should have noted on a tie-on label and in a numbered card index—the same number being if possible painted on the specimen itself—its provenance and when and how it was acquired.[1] This is merely a beginning, fixing the specimen in its chronological place in the collection. Then begins the laborious but enthralling job of finding out all there is to be known concerning it. It is, in fact, impossible to know too much about any specimen; the more one knows about it, the more valuable it becomes.

If it is a piece of furniture, glass or silver, the appearance of the material, its style and decoration will suggest its period and provenance. Then follows a search through the standard works of reference, comparison of the object with drawings and photographs, or, better still, with other examples. Again, it may be an autographed piece or bear a trademark, a hallmark or a pewterer's 'touch'. All this information must be added to the record, and with it should also be attached, wherever such have

1. See Chapter II, pages 37-42.

survived, accounts for the making of the object or its sale or purchase throughout its history. This is particularly valuable in tracing the story of old household furnishings and is always to be sought as providing a pedigree of the piece.

Again a careful investigation of a crystal, a butterfly or a bird will be called for to reveal diagnostic features to enable its identity to be established accurately. Unlike the types of specimen just referred to, none of these is likely to be unique: it will resemble others of the same genus and species, so that the checking-up can be accomplished with the aid of a standard textbook and some fairly simple apparatus. Also it is possible to match the object by search through a reference series kept specially for comparison. In the case of a zoological specimen, it is of great importance to know, if possible, the place, time and circumstances of its being caught or found, while details of any peculiarities may well come in useful later on. Above all, the dimensions of the object must be scrupulously noted.

Identification of the specimens coming into a museum calls in the first place for an expert staff and in the second for a good library of reference books, if the requirements of serious students are to be met. From this it follows that a museum must have a good reference library with all the standard works dealing with the subjects in the collections; such volumes are as valuable as the specimens themselves, and must be kept continually up to date. In the larger museums such works of reference are often compiled by the leading members of the staffs, who always find it pays to keep closely in touch with the experts in other museums and universities, so that the common fund of knowledge is always being added to and is ever readily available. It is, however, true that a large proportion of the visitors to a museum do not desire very detailed information about either the specimens in the collections or such curiosities or finds of their own as they may be prompted to bring to the curator. To satisfy their needs, there are in many languages simple textbooks designed to provide rapid identification of coins, pottery, rocks, minerals, fossils, butterflies,

birds and plants and so forth. With a set of such 'Name this—' handbooks and a little practice, the curator of a small, oneman museum can deal with a large proportion of the inquiries brought to him, can inspire confidence in his visitors and encourage them to continue to visit the institution and perhaps to keep a sharper look-out for interesting specimens in the future. A museum curator is most likely to have objects submitted from his own locality, so that local knowledge is always at a premium, but he will also have to deal with treasures brought back by travellers from overseas or family heirlooms handed down from earlier generations. While accurate diagnosis of unusual objects naturally adds to the reputation of the curator and his museum, it must never be forgotten that it is no disgrace to admit ignorance of some unusual thing. It is in dealing with inquiries of this kind that the network of museums can be of great value —from the single curator museum to the larger regional museum with a bigger staff of experts, and then to the immense national museum with a yet larger staff, research laboratories and reference collections and libraries. As circumstances demand, requests for information and identification can be passed down the line until an expert is found to deal adequately with them.

RECORDING

From identification we go on to records. Not all the details concerning object collection can be put on a tie-on label, nor are they needed for the show-case label. They can be kept in large, bound registers, which may show the whole collection chronologically, or in a series of volumes serving as subject registers, the contents again being arranged therein chronologically. Greater latitude and convenience can be achieved by introducing a card index, in which each specimen is allocated a card, on which is written all the information about it.[1]

The recording of knowledge about any object from our three-dimensional world

1. See Chapter II, page 39.

nearly always demands more than a description in words, no matter how technically efficient our specialized language may be, and recourse may usefully be had to carefully drawn sketches of the specimen or to photographs, which can be placed on the back of the index cards or placed in envelopes attached to the cards. The process of accumulating and recording information is thus no easy matter but it is one of the most important and interesting tasks which fall to a museum curator. Naturally, such information should be recorded in as durable a way as possible. This means that the paper, inks and paints used for tickets, identification tabs, labels and index cards must be able to stand up to the conditions of temperature and humidity prevailing in the area. To be sure of this, use should be made of comparable experience elsewhere and of systematic testing, especially with every new batch of material. Precautions must also be taken against insect pests attacking books, book bindings and cabinets. Finally the master records should be permanently stored in a strong room, proof against fire and theft, and any registers removed for work or consultation during the day should be returned to their proper safe place each evening.

PRESERVATION

Consideration of the preservation of the records leads naturally to that of the preservation of the specimens. This is so vast a subject that only an outline of the museum curator's responsibilities can be attempted here. Preservation may mean the protection of the object against natural processes of destruction by physical or chemical decay or attack by organisms such as mildew or insect pests. These vary very greatly according to the nature and composition of the specimen and local climatic conditions. Some objects such as stone axeheads are almost indestructible wherever they are—but even they are liable to shattering and flaking if they contain salt. Well-fired pottery and porcelain is subject to breakage but to little else. Wooden objects may harbour boring beetles, ants and other destructive insects and certain fungi; they may also deteriorate or break if subjected to dampness or dryness beyond a certain optimum of humidity. Leather reacts in a somewhat similar way. Ivory tends to develop cracks. Metals, with the exception of gold, are subject to the normal processes of chemical reaction with whatever other substances they happen to be in contact, processes which tend to be accelerated by the presence of humidity and a rise in temperature, and which lead to the formation of oxides, hydroxides, carbonates, sulphides, sulphates and other chemical salts. Such processes cause discoloration, flaking and blistering, and eventually destroy the shape and the fabric of the specimen. Again, specimens frequently consist of a variety of materials, so that a most complicated series of troubles may afflict them with changes of temperature and humidity. A picture may consist of wood, or wood and canvas, with a filling, then a variety of paint colours and finally a varnish to seal the surface; a wooden chair may have metal fittings and a fabric back and seat; a group of figures may be carved from wood, but have a gesso surface and moulding, surmounted by several layers of paint—and all of these materials are subject to their own particular ailments. Even the effect of strong daylight must be considered, as sunlight causes fading of colour in pictures, tapestries, fur, feathers and costumes.

EXHIBITION

It is the aim of the museum curator to present his specimens to the public in a condition as closely approximating to their original appearance as is possible. This involves varying degrees of restoration, on the one hand, and the introduction of such conditions as will prevent deterioration, on the other. This is an aspect of museum work little appreciated by those outside the museum profession, who are liable to regard the curator as endlessly engaged in accepting prepared specimens, labelling them, and laying them out on shelves or in cases. The tasks of preservation and preparation call for a high degree of skill and experience to solve the many and

intricate problems that arise from day to day—problems that may well involve priceless and unique material.

Natural history specimens offer yet another series of problems in preservation and preparation. Rocks and minerals are in most cases proof against ordinary deterioration, although some absorb water from the air and change their composition and crystal formation. Others containing sulphides are liable to decompose and give rise to acids which hasten yet further chemical changes. Fossils, which are the remains of organisms replaced by silica, calcium carbonate, or other compounds embedded in rock matrices which may have the same composition, may be weathered out of the surrounding rock by natural processes and be ready for exhibition. Others, however, may have to be cleaned out of the rock by the careful use of chemicals such as acids or by mechanical methods such as the use of dental drills. The preservation of plants may be effected by drying the plants between sheets of blotting paper —first making sure that the important parts will be well separated and displayed when the resulting dried and pressed plant is uncovered—and then mounting them on sheets of paper. Such dried specimens of plants constitute a herbarium. Yet another method consists of sealing the plant in a vessel containing a preservative fluid; some of these fluids have been found to aid the maintenance of certain of the colours of flowers almost indefinitely.

Zoological material is almost endless in its variety and its preservation presents a wide range of problems. The museum curator may collect his own specimens in the field or receive the dead bodies direct from a field naturalist. Then, in most cases, he has three types of specimen available for his museum—the soft internal parts which show how the processes of the organism work, the hard parts or skeleton supporting the organism, and the external covering (scales, fur, feathers, etc.) which when appropriately treated can be set up to give a lifelike representation of the object. The soft parts are generally of interest only to students, and can, after removal and careful cleaning, be preserved in fluids such as alcohol or a formalin solution. Provided the parts are completely submerged in the fluid and evaporation is kept to a minimum by tightly sealing the top of the container, normal processes of decay can be retarded for many years. If the skeleton is desired as a museum specimen, the bones are all carefully removed from the body and are then rigorously cleaned of any traces of soft parts which would become offensive in decay. Prolonged boiling may be necessary to remove all the flesh and chemical degreasing agents employed to extract any fatty matter distributed throughout the bones. The separate bones of the skeleton are then wired together in the proper order to display their mechanical functions and set up as an exhibit.

The skinning of mammals, birds, reptiles and fish is a skilled craft in its own right and calls for special training. The skin has to be removed with great skill, as it is liable to tear, and every part of it is essential in the building up of a lifelike exhibit. The fur or feathers or scales must be very carefully cleaned, since any fat adhering to the inner surface would be a source of decay and stains. Again, the thin skin dries readily and may crack, so that considerable experience is necessary to know how far to go in the various stages of treatment. Tanning of skins is often resorted to and can preserve them for many years. For study purposes such cleaned and dried skins are perfectly adequate; they take up much less storage room than mounted specimens and they are reasonably flexible to handle. For display, however, it is necessary to show the public an animal or a fish in readily recognizable form, and this calls for the resources of the skilled craft of taxidermy. Many years ago, the cleaned skins of mammals or birds were packed with fine sawdust, with pieces of wire to retain the shape, but modern methods demand the making of a model of the animal's body in a lifelike pose in wood, wire, plaster and papier maché, upon which the skin is carefully mounted. Fish skins, when stuffed, sometimes assumed most unnatural shapes, so that new methods of presentation had to be devised—much better results are now obtained by making a plaster mould of the dead fish and from it one or more plaster casts which can then be painted

up most realistically. Such casts are both accurate and lifelike, and last almost indefinitely. New materials are constantly being employed in making casts and include varieties of rubber latex and a wide range of modern plastics.

In the early days of museum display it was enough to reconstruct a natural history specimen in an accurate pose and mount it upon a small rectangular stand, usually of polished wood, but as time passed two new aims were adopted in taxidermy. The first was to devise an artistic setting for the bird or mammal so that the whole exhibit would be a source of interest and pleasure. The second was to incorporate as much detail as possible regarding the life and habits of the animal. Birds could be mounted perched upon twigs, sitting upon their nests, searching for food among sea and or river pebbles; mammals could be realistically set among rocks or appropriate vegetation—usually dried specimens dyed in lifelike colourings. Groups with carnivores and their prey, parents with their young, birds with their eggs, insects on their food supply, etc., all provided excellent material for educational exhibits, encouraging the most careful scrutiny of each group. To achieve such results, the taxidermists in their workrooms had to be much more than skilled craftsmen at their tasks—they had to be very good naturalists with a sound and detailed knowledge of the life cycles and habits of the living equivalents of the dead bodies they were given to mount for museum purposes. The more detail is incorporated in an exhibit the more lessons can be extracted from it by the onlooker, but it is equally true that more knowledge must be possessed by the artist who sets the group up and the more pitfalls there are for the unwary. Plumage and pelt vary with the seasons as do the colours and forms of the botanical material employed as a background. An inexperienced museum craftsman may easily mount a bird in spring plumage on vegetation in obvious autumn colouring. This most important art of museum display or presentation is the fourth major function of a museum, and the one in which the public is most interested. Taxidermists are not restricted to working with relatively small examples of birds and mammals, i.e. groups of which can be accommodated in a typical museum exhibit of, say, 4 feet by 3 feet; they have learned how to mount the largest mammals and to make most realistic backgrounds of cliffs and tree trunks, using their skill to build up immense dioramas representing stretches of appropriate countryside so that the onlooker feels he is indeed enjoying a real vista showing carnivores or ungulates in search of food, or bringing up their young. Latterly there has been something of a turning away from these large, expensive and rather static exhibits, which had become so detailed as to leave little or nothing to the imagination. The most modern groups attempt to excite more wonder and curiosity, encouraging the onlooker to note pertinent features for himself and to deduce habits from them. Much can be done by the treatment of pose—a bird leaning against the wind, with its claws clutched firmly to a branch, others huddled together for shelter with their feathers disturbed by an imaginary wind and so on. Instead of being included in displays with large backgrounds, taking up valuable space, groups of small birds can be mounted on twigs or perched on small realistic brackets of stones or gravel set against a pleasantly coloured neutral background, chosen to show up the colours of the plumage to advantage.

Display is a most important consideration for the museum curator. He may have excellent material but if he does not make good use of it in good displays, much of his work will be ignored by the public. He must so arrange his specimens that each individual one can be enjoyed on its own without the intrusion of another. Displays must also be orderly, as the specimens are shown in order to encourage people to think about them, to compare and contrast each with its neighbours, and to build up a corpus of ideas about a whole group. An exhibit must first catch the eye of the passer-by, arrest his attention and encourage closer sustained examination. This calls for some knowledge of human nature and psychology on the part of the designer and for considerable skill in setting out the various specimens. Here the nature of

the material and the aim of the display must play a large part in determining the exhibition technique to be employed. An exhibition gallery as a whole must have a pleasing appearance with an artistic colour scheme and suitable furniture and fittings. In the older museums the architecture of the building was regarded as a major exhibit and the furniture and exhibits were subordinated to its claims. Nowadays it is realized that in a museum the specimens must occupy the first place and the provision of galleries and cases, with such services as heating, lighting and ventilation, must not be allowed to interfere with the fullest enjoyment of the exhibits. Lighting, whether natural or artificial, must be adequate without being so strong as to produce fading of the exhibits or a tiring glare for the spectators. The choice of colour for walls, cases and backgrounds plays a very large part in the production of attractive and compelling exhibitions. Due consideration must be given to what is appropriate for the specimen, for the case, and for the room as a whole.

Under ideal museum conditions, museum furniture and fittings would be unnecessary or inconspicuous, the specimens attractively laid out for the public to study and the services suitably concealed. But most museums have to combat impure air and dust necessitating periodic cleaning which does damage to the specimens, and we have to go a long way yet before visitors learn not to handle fragile material or to help themselves to attractive and easily transportable items. Hence the need for protective glass cases or glazed screens, which themselves call for the expenditure of time and money in cleaning. Large, heavy and durable specimens can often be shown to advantage free-standing. Bulky pieces of furniture and machinery look odd if they are exhibited under glass cases, although thick plate glass sheets or rails must of course be used, to protect visitors from moving engines. In the case of mounted natural history specimens the aim is to have a background as near to that of the natural habitat as possible, or, failing that, to produce a pleasant neutral background which will serve to throw into relief and accentuate the shape, colour and pattern of the specimens. For geological material almost any kind of background of a pleasant colour will suffice, so long as it leaves the specimens predominant in their claim for public interest.

Art objects, if sufficiently large or important, are frequently shown individually, each with its own appropriate background, but even there it is most unwise to have too many different display methods in one room, the resulting patchwork of shapes and colours being far from appealing to the visitor on the threshold. Only experience, experiments with diverse methods and study tours of other museums will build up an adequate body of knowledge of display methods to enable museum staffs to accommodate and exhibit new and better specimens. Sometimes specimens can be enjoyed most if they are shown individually; in other cases a whole range of similar or comparable specimens may be required for study; in yet others it may be found desirable to show objects together in groups— e.g. carpets, furniture, table-ware, tapestries and pictures—which represent social or historical ensembles. A successful arrangement of such groups calls for considerable knowledge of the practices followed at different times and for much artistry in the actual grouping of the objects. Just as habitat groups can be constructed with the aid of mounted birds or mammals, rocks, grass, bushes and trees, adorned with other life types to be expected in the vicinity, so it is possible with impressive effects to reconstruct old rooms with their domestic equipment, thus giving a realistic reproduction of the conditions under which people of other times or other lands lived and worked. Similarly it is both intriguing and educative to gather together tools and work benches, raw materials and finished products illustrative of how craftsmen carried on their work in the days of individually hand-made objects and contrast these with examples of modern mass-production machinery. To the museum man there are practically no limits to what he can accomplish within the four walls of a room given equipment, imagination and artistry.

Museums have, however, moved forward from being content to collect, to identify, to preserve and to present in an attractive form. They have accepted public responsibilities to teach the truth as far as they know it and to teach new ideas to their visitors, whether they come singly or in groups, casually or of set purpose. It has become the accepted function of museum exhibits to encourage the development of ideas. The museum curator has to arouse first a feeling of wonder and then an intense curiosity about his exhibits and this curiosity once aroused has to be satisfied with the best possible answers. Curiosity may be limited to the one specimen before the beholder but, more often than not, it embraces the adjacent specimens as well, and they too must be so arranged and labelled as to answer the questions they can be expected to provoke. In the world of wild nature equipment, functions and habits may be compared and contrasted—and linked with climate, food and habitat for example. In man-made implements there is an opportunity to study man's ingenuity in meeting his needs with tools, weapons, clothing and containers, and the fascinating history of his continuing struggle to improve them both in quantity and quality. The study can be carried further to embrace that other aspect of man—the artistic expression of his thoughts and ideals.

With the aid of ranges of specimens suitably grouped and annotated, it is possible to teach museum visitors the rudiments of many of the sciences and the arts, and it is the aim of the museum man to use his wide resources to this end. In the older museum institutions of the world a great renaissance took place around the first quarter of the twentieth century, when the possibilities and the responsibilities of museums as educational factors became more widely realized. Learning had been for so long based mainly on books; now it was seen how much more could be accomplished by using three-dimensional things—the things with which people were normally surrounded. Museums were not merely a haven in which to preserve objects in danger of being lost by the passage of time or the advance of human progress; they could be dynamic institutions in which human beings could learn about the immense resources of their world and its very long history.

While museums were largely repositories, the standing of an institution tended naturally to be based upon the wealth of its collections and the intrinsic value or individual rarity of its specimens, but when it was realized that a museum had to do something with its collections a new standard of values came into being. This was a vital point in the whole museums movement, for it gave almost endless opportunities to museums of all kinds to compete in rendering public service. While wealth in money, material, buildings and staff still tend to count—and to count heavily—it is activity that earns a museum its place in public esteem. Here again it can be seen how essential it is for each institution to select its aim wisely and to use its resources to the best possible effect. Museums combine education with recreation, and both these words connote a very wide range of fields. To what major end are museum activities really directed? To the broader education of the user so that he or she may lead a fuller life and be a better member of the community. From the recreational point of view the museum fulfils a similar purpose by enlarging the emotional response of the individual to his environment, and easing him of some of the worries and restraints of such environmental handicaps as the harsh struggle of earning a living or the grim surroundings of a factory community. Eyes concentrated on day-to-day tasks are lifted to wider horizons as more and more interesting fields of exploration are opened up; a new range of emotions can be experienced as the arts and handicrafts of other people and other races are displayed and, though perhaps but little understood at first, gradually become more familiar and more deeply appreciated. The goal of any museum is service to the public and that service must be conceived of as the building up of a better, more thoughtful, and happier public. It is true that in most places the public is composed of a very varied assemblage of people of all ages, of a wide range of educational

backgrounds and of almost unlimited interests, and the wise museum curator caters for as many types as possible in his permanent displays. He does his best to reach those with more specialized interests and at the same time to bring about a broadening of general interests by staging temporary exhibitions. Whatever he does, his goal is always the enlightenment of his public.

The national museums with palatial buildings, immense collections and large, highly trained staffs can obviously attempt to educate in a far wider range of subjects than can the small ones of three or four rooms administered by one or two officers. Even the large institutions are faced with the choice of whether to deal with a few subjects in great detail, or to deal with a larger number of subjects in more simple fashion. A smaller museum has perhaps the more bewilderingly wide field to choose from, but if it selects its subjects carefully, chooses its material skilfully, arranges it artistically and annotates it with interest and inspiration, it can achieve striking success and wide renown. The museums one remembers best from a tour are not always the largest and the wealthiest, nor are the staffs of the latter always the happiest and most legitimately satisfied with their labours.

In the selection of its main objectives and in the presentation of its individual displays, a museum must keep in mind the vital need to link whatever it aims to teach with something already familiar to its visitors. One must always proceed from the known to the unknown, sometimes step by step and sometimes by imaginative and exhilarating leaps as circumstances offer. Mental processes are usually fairly slow but they are sometimes characterized by dazzling bursts of comprehension. Again it must be remembered that museum users must be attracted, persuaded and encouraged to look at things, to ponder over them and to come back and carry the search a step further. Museum visitors are in most cases there of their own free will and can leave whenever they have absorbed all they can, or as soon as they are bored. Even with well drilled groups of students or classes of school children, who may not

leave before they are permitted, there are definite saturation points beyond which it is impossible to absorb further knowledge or register more emotion.

Most small local museums take as their aim the presentation of an epitome of their locality—the rocks and scenery, the wild life, the story of man and his activities, and the rise of the little town in which they are situated. Nor is this any minor motive, for to show the people of today, be they children or adults, the story of their setting, how their forbears earned their living and how the way of life of the present is derived from the knowledge and efforts of the past leads to an appreciation of the reasons for things, of the processes of planning, development and perseverance in the face of difficulties, and to a sense of responsibility for the future.

It is the responsibility of the larger or regional museums, which probably have more funds to draw upon, to reflect a larger area with more diverse natural resources, history and human activities. Some, of course, may decide in addition to collect especially extensively in one or more fields, such as zoology, geology or archaeology, and so to build up comparative series, encouraging a more thorough study by including examples from widely dispersed areas. So the collections, the records and the studies grow, and collectors elsewhere impressed with the good work being done may in their turn present further material or even whole collections.

The national museums in the older capitals have the largest buildings with immense collections, adequate for continuous research of the highest class; they must also cater in all fields for a public which ranges from serious students to casual visitors, youth groups and young children. In addition to looking after their own clients and aiding neighbouring universities and colleges with their work, these major museums can also play a very important part in the general museums service by assisting regional and local museums with advice, with duplicate specimens, and with circulating loan exhibitions. The larger regional museums with their resources of staff and collections can in their turn help smaller local institutions.

On the other hand, it is possible for even the smallest local museum to be of important service to its larger brethren by recording finds in all fields, by supplying specialist material and by giving information it is particularly well sited or staffed to secure.

THE PUBLIC

In any country it is thus possible to build up a network of museums and museum services, collecting, identifying, preserving and presenting material for the edification of the wide public—a network in which the smallest unit has just as real a part to play as the large and wealthy ones. All sections of the public can be reached by such a network and each museum can do something in the way that experience has shown to be the most appropriate. Age is not so much a barrier to understanding exhibits as language; however, once a reasonably good vocabulary has been worked out it is possible to explain most displays in such simple terms as can be readily understood by all. Museum visitors can be divided into those who already have an introduction to the subject and those who have not. It is the essential function of every museum curator to help the beginners over this initial hurdle, to encourage them to broaden their interests and to find real and lasting enjoyment in so doing.

Many museums are finding it an advantage to arrange their exhibits in three 'intelligence' groups. First there are simple and colourful displays to appeal to children, taking perhaps the age of 12 as the upper limit. These are staged to meet the needs of a child's world—a world of wonder and discovery—beginning in terms of the child's home and surroundings and leading on to wider horizons, to associations of ideas and to some conception of causation. For the second and by far the largest group of visitors an adolescent or adult mental equipment is postulated, but with no specialized knowledge. For them an almost limitless array of exhibits can be arranged, linked with a sufficient amount of factual information adequate for them to appreciate the reasons for displaying the specimen or specimens. As many of these may be unfamiliar, it is important to attract attention by the use of arresting exhibits, artistic colouring and arrangement, and perhaps special lighting. The descriptive matter on the accompanying labels should be interesting and both specimens and labels should be arranged to lead on logically from one to another. A group of specimens or a case should build up a general idea to be carried forward to the next. If this is done sufficiently compellingly, the spectator may be intrigued to walk up and down a line of exhibits, checking up his impressions and experiencing the exhilaration of entering a new field of knowledge.

The third group of visitors comprises the specialists and experts who already have considerable practical and theoretical knowledge of a particular subject. Their prime concern is to see specimens both in great detail and in as large numbers as possible. Eagerly searching for fresh material for their studies, such users of museums need no artistic display or interestingly phrased labels to attract or hold them; they require as much material to be placed at their disposal as possible, and as much information as possible concerning its nature and origins. For them the museum provides its study collections, comparative series and research material, laid out in orderly rows or stored in cabinets and cupboards. They are experts who will seek to compare knowledge and ideas with other experts. They are in many cases, the authors of monographs on the exhibits and their knowledge and experience will help the museum officers to appreciate better the raw material of their collections. It is on the work of such experts that the identification of specimens and the texts of labels are often based. It is only in the very large museums that such immense collections can be garnered, maintained and worked over, for they call for adequate space, equipment and staff with time to conduct research upon the material in their care.

For all three groups a fully equipped museum will provide literature so that some record of the impressions gained and information learned may be taken home after the visit. There will be picture post-

cards, pictures, and picture books for the children; well written and well illustrated guide books with plans and diagrams for the general visitors; and detailed catalogues, handbooks and monographs with appropriate bibliographies for the experts. These can be consulted and re-read at leisure; they will encourage further visits and studies and will, one hopes, lead to a happy discovery of the joy of using the resources of a public library and belonging to some club or society. Thus the museum that brings collections from all over the world to its visitors, ends by sending these same visitors out into a wider world than most of them dreamt of before.

ADMINISTRATION OF MUSEUMS

by Pierre SCHOMMER

The Constitution of the International Council of Museums (ICOM) defines the term 'museum' as follows: any permanent establishment set up 'for the purpose of preserving, studying, enhancing by various means and, in particular, of exhibiting to the public for its delectation and instruction . . . artistic, historical, scientific and technological collections'.

By assimilating with museums (a) botanical and zoological gardens and other establishments where living specimens are presented, and (b) public libraries and public archival institutions maintaining permanent exhibition rooms, the ICOM Constitution specifies the widest interpretation which can be given to the term.[1]

Whatever their nature, the establishments which are now included in this definition all began in much the same way—as collections of church relics and ornaments, the accumulated treasures of royal or private collectors, etc. With the passage of time they have developed along different lines and practical necessities have dictated various rules and principles specially applicable to this or that particular case. From this accumulation of particular cases, rules of sufficient generality and of sufficiently proven worth have emerged to form the basis of a set of practical recommendations, always, of course, open to addition and improvement.

GENERAL ORGANIZATION

The definition which we have just cited emphasizes the role which all museums play in the life of the community. This role is increasing in importance. Thus, in view of the responsibilities involved, the establishment and operation of museums should no longer be dependent on mere caprice or arbitrary considerations.

THE ESTABLISHMENT AND ABOLITION OF MUSEUMS

The first duty of a museum founder is to ascertain whether his initiative meets a general need and whether the institution's future can be regarded as assured. He should therefore seek as wide a range of expert advice as possible.

Once the plan has been accepted in principle, the founder's second task is to bring it into line with the relevant laws and administrative regulations of the country. Proper observance of these laws and regulations will be a guarantee of the permanence of the new museum as a working concern and of the validity of the statutes designed to ensure its regular operation within the artistic, historical or scientific setting assigned to it. Its moral status will thereby be strengthened; and the more firmly the museum's structure is established, the easier it will be to maintain that status.

In certain countries, such as Syria,[2] all museums are owned by the State—which implies that they cannot be established by private initiative. In other countries, such as

1. See Article II, 1 and 2 of the Constitution, adopted by the General Assembly of ICOM on 9 July 1956.
2. See 'Icom Conference on museum problems in the Near East', *ICOM News/Nouvelles de l'ICOM*, Vol. 10, No. 1, February 1957.

France, the State intervenes to a greater or lesser extent, depending on the particular circumstances in the establishment of public or private museums.[1] In still other countries, such as the United States of America there is complete freedom to establish museums, provided that the legislation governing associations is respected; important fiscal advantages are granted to these institutions if it is proved that they serve the general interest [3].[2]

In any case, the importance both of the cultural objects that a museum can collect and of the role it can play in the community is such that the State, however liberal it may be, cannot afford to relinquish all control over the conditions governing the establishment of such institutions. A ministry—or at least a national co-ordinating body—should be empowered to watch over matters connected with the establishment of museums.

Just as there are principles to be observed when a museum is founded, so no museum should not be closed permanently without conformity to certain fixed rules, for the collections thus released were originally assembled in the public interest, often thanks to gifts from persons or corporations not connected with the museum, and their value remains such as to justify their being kept at the disposal of the public at large; this value will be all the greater if the collections are accompanied by documentation recording their scientific and technical characteristics. In such cases, new ways of using these collections, while still preserving their original role, should be sought.

If the museums concerned are dependent on municipal and other public organizations, the latter should ensure that a decision is taken, preferably on the basis of pre-established laws or regulations, which would permit the judicious incorporation of their collections in other public collections to which they are most akin.

In the case of private museums this problem may be more difficult to solve if, as often happens, their statutes contain no special provision for this eventuality. Thus, whenever a new museum is established, it is most important for its statutes to include a winding-up clause that is both flexible and sufficiently precise to prescribe what

should be done with its collections should closure of the museum become necessary. Moreover, public organizations should extend their generosity only to the private museums which have included such a clause in their statutes. In general, therefore, it is advisable for museums not to be established or abolished without previous notification of the competent public authorities to that effect.

The establishment or abolition of a national State museum is a governmental act which must be sanctioned by law.

The establishment or abolition of a museum depending on a local public organization should be subject to the consent of the national authority responsible for museums, whenever such authority exists.[1] This would enable the authority to ensure the judicious transfer of the collections of museums that are abolished. If no such national authority exists, the local public authorities concerned should fulfil the same function.

In the case of private museums, their establishment or abolition should not be notified merely to the authorities responsible for associations in general, but should also be brought, directly or indirectly, to the notice of the most competent public authority in the cultural field. Thus, in countries where a dissolution clause is used, its adoption could be recommended and, in the event of the museum being abolished, the clause would become operative.

STATUTES

The statutes (legal constitution) of museums vary from one country to another and often, according to circumstances, within

1. In France, in the case of art and history museums not directly dependent on the State, the 'establishment of a museum must be registered with the Direction des Musées de France at least one month before the date fixed for its opening, in the manner prescribed by an order issued on the proposal of the Minister of Education. If the registration is not effected within that time-limit, the Minister of Education may order the closure of the museum'. (See the bibliography on page 51, Les Musées, Chapter 51 Mu, Section 1, Article 7 on page 5.)

2. The figures between brackets refer to the bibliography on page 51.

the same country. The various systems are those under which:

1. All museums—or at least archaeological and historical museums—belong to the State and are administered by a single department. This is usually the case in the Near East.[1]

2. Virtually no museum belongs to the State (or Federation); some belong to other public organizations, but the majority to foundations or societies expressly established for the purpose and placed under the authority of a Board of Trustees. In such countries the State does not concern itself with museums which do not belong to it, although other public organizations frequently grant subventions to museums particularly in order to enable them to make more effective contribution to education. A typical example is provided by the United States of America (although its practice has been varied through the establishment by the National Parks Service during the past 50 years, of a considerable number of 'site' museums) [3].

3. Certain museums belong to the State. In the case of those belonging to other public bodies, foundations or private societies: (a) either the State participates, scientifically, technically and financially, in the administration of the most outstanding of these institutions, which it controls by means of inspectors (French system) [4];[2] (b) or the State shows its interest in them by providing them, regularly or occasionally, at their request, with scientific and technical advice, subventions etc. (the Netherlands).

It seems that, in countries where there are few museums, systems A and C are to be preferred as being more conducive to the development of such institutions. This contention is supported by the motions adopted at the important meeting convened by ICOM at Damascus, in 1956, with a view to studying museum problems in the Near East.[3]

PERSONNEL

Since Mr. Douglas Allan deals in detail with the whole question of the staff in Chapter III, we need make only a few brief remarks here from the purely administrative standpoint. The question of supervision is not touched on in the present section as this is also dealt with in Chapter III, in connexion with museum guards, and because we shall revert to the matter when considering the question of safety.[4]

In exchange for services rendered, museums assume certain obligations *vis-à-vis* their staff members. Those obligations are reflected in appropriate measures adopted in the different domains. These measures can take the following form with regard to health and hygiene:

In the absence of special services (which can be provided only by large museums), liaison with the local health and hygiene services; the establishment of a medical service, which can be placed in the charge of the member of the staff most qualified for that purpose; the installation of showers; the provision of overalls for staff members in charge of the maintenance of the premises;

1. See *ICOM News/Nouvelles de l'ICOM*, op. cit.
2. Particularly Chapter 56 Mu, 'Les musées de province'.
3. *ICOM News/Nouvelles de l'ICOM*, op. cit. The following is part of the first of the 13 motions adopted, entitled 'General Organizations':
 'The ICOM meeting on museum problems in the Near East . . .
 'Recommends to the interested authorities in the Near Eastern countries: (1) That when museums are attached to the General Directorate of Antiquities, they maintain this situation, on the condition that the said General Directorate takes the title of General Directorate of Antiquities and Museums and places together all the museums under a special branch of its service; (2) That when the division of direction is already established and cannot be changed, (a) there be created between the different interior administrations a commission charged to co-ordinate the programmes and activities of all the country's museums, or at least to advise on the questions, (b) when museums depend upon local authorities, there be given to the national administration concerned with their speciality the right to inspect these museums; (3) That if they wish to organize services for the co-ordination and inspection of museums, they should contact, with the aid of ICOM, the interested authorities of countries where services of this type are already in existence.'
4. See 'Security', page 45.

special equipment for the health and protection of those working in the laboratories and workshop.

In the social field, measures can be as follows: if the standard of the museum permits it, the establishment of a canteen providing nourishing meals at a modest price, or at least of a dining hall supplied with facilities for cooking and washing-up in an agreeable atmosphere, possibly with the installation of radio and television sets.

From a more strictly professional standpoint, there are various measures bearing on promotion and salary problems. Also to be included here are disciplinary measures which, in the case of a graded staff, should begin with a warning, followed by a reprimand and lastly, but in serious and exceptional cases only, by heavier penalties such as transfer to a lower step in the grade to which the staff member belongs, transfer to a lower grade, or dismissal without a pension. All these questions involve difficult moral problems for the administration; and they are not the only problems which arise on the less-known side of the life of such organizations as museums, where there is no single scientific or administrative act that does not call for administrative study and does not provide fresh experience each day.

Museum curators can belong, according to local situations, either to unions with an economic, denominational or political nature, or to professional associations. The latter often play a positive role of very great importance from the standpoint of professional advancement, and it is always useful to establish them in countries where they do not yet exist.

COLLECTIONS

The collections are the essential part of a museum. They are administered in accordance with special rules: (a) bearing on various operations (acquisitions, alienation, deposits, incoming and outgoing operations, registration, internal and external movements of the objects, management of the premises); (b) varying according to the type and level of the museum and the country concerned.

These collections are constituted by what is called, in the broad sense of the term, acquisitions. In an even wider sense, they may be regarded as including long-term deposits.[1]

ACQUISITIONS

Categories

A museum's acquisitions can be effected: (a) subject to payment (purchases), i.e. made under a contract of sale or exchange with any person or a corporate body entitled to possess and dispose of his or its property; (b) free of charge, i.e. as a result of acts of generosity: direct immediate gifts from persons or corporate bodies; bequests from persons; deferred gifts or bequests from persons who reserve the right of enjoyment for themselves or their beneficiaries during a stated period, usually the lifetime of the person in question.

Responsibility

In the proper discharge of his administrative functions, a museum curator, however competent, should not himself actually decide on an acquisition. His role is to select objects whose authenticity and inherent value seem to him such as to make them useful additions to the collections under his scientific control, i.e. objects covered by the museum's programme.[2] It is his duty to use all the available means of study and comparison, and to employ all the resources of the museum's laboratories. He must also discuss the price asked and, if it is unreasonable, secure the necessary reduction. In short, his powers are limited to the making of proposals.

The effect to be given to such proposals depends exclusively on the State, in the case of all national museums or similar establishments, whatever their title. In the

1. For collections in general see Daifuku and Bowers [1], Part 1, Chapter III, pages 27 to 30.
2. See Chapter I, pages 16-18.

case of other public institutions, the decision is a matter for these institutions themselves, unless there exists a national authority responsible for such museums,[1] in which event it alone can decide. For private museums, the decision is one for their administrators or trustees, in so far as the position of these establishments is not affected by national legislation or by private agreements.

At whatever level the decision is taken, the competent administration or organization should seek the advice of experts qualified to assess the cultural value of the curator's proposals and, in any case, should consider them with the greatest care. It should also estimate the financial and legal implications of the acquisition proposed.

De minimis non curat praetor. It is reasonable to allow the curator responsibility for the acquisition of objects of minor value, within the limits of a small annual or occasional budget.

Conditional gifts and bequests

Two problems arise with regard to gifts or bequests in respect of which it is specified: (a) that the objects donated or bequeathed must be exhibited; (b) that the series of objects donated or bequeathed must be exhibited as an indissoluble whole.

The obligation to exhibit permanently runs counter to modern museum principles, as regards both presentation—since displays must be changed and reserves are no longer considered as store-rooms but are arranged to facilitate study and reference—and preservation, in the case of objects which may deteriorate if exposed to the light for long periods.

Compulsory 'group display' of objects donated or bequeathed is usually an obstacle to the logical arrangement of exhibits. For this reason, more and more museums now endeavour to ensure that gifts and bequests are not subject to such conditions—and in certain countries offers are even systematically refused if such conditions apply— though the disadvantages of this policy must be weighed in the case of outstanding masterpieces.[2]

Insurance

The question arises whether or not to insure acquisitions. It is not the usual practice to do so in museums depending on public bodies, or at least belonging to the State.[3] Private museums do not always insure, but would be well advised to do so.

Alienation

Special precautions with regard to the alienation of museum objects are essential.

In general, steps should be taken to prevent a temporary financial difficulty, an unjustified concession to prevailing fashion, or failure to appreciate the value of collections from leading a museum, or the authorities responsible for it, to sell objects whose absence might later be bitterly regretted. Another kind of alienation which a museum must avoid or be spared from having to envisage is the untimely donation of an object, which may also be subsequently regretted.

In certain countries, where the principle of public property is jealously guarded by law, objects belonging to public bodies can be alienated 'only after the statutory procedure for relinquishment of ownership has been duly completed'.[4] This imposes special obligations on the museums concerned. Museums not subject to such obligations

1. In France, acquisitions (subject to payment or free of charge) effected by museums under the control of the Direction des Musées de France must be ratified by the Minister of Education, on the proposal of that administration, on the bibliography on page 51, *Les Musées,* Chapter 51 Mu, Section 1, Article 9, page 5.)
2. In the Netherlands, 40 years after the legator's death and at the request of the person who must fulfil the testamentary conditions, the Supreme Court may in the public interest modify or annul, so far as possible in accordance with the legator's intentions, any particular condition concerning the place or manner of display of the objects and the facilities of access offered to the public. (Law of 1 May 1925, Staatsblad No. 174.)
3. According to a French legal adage, 'the State is its own insurer'.
4. This is the position in France. (See the bibliography on page 51, *Les Musées,* Chapter 56 Mu, page 11.)

should include in their statutes a clause strictly regulating the alienation of objects. Public bodies should not grant subventions to, or deposit objects with, private museums which have not adopted such a clause.

Certain kinds of alienation, however, are not voluntary; they are due to proven theft, lengthy disappearance of objects for unknown reasons, destruction by fire, or some other accident. The procedures to be followed in these cases vary according to the country and type of institution concerned: we simply mention here the need for a full and explicit report to be made in due form and checked by the museum's highest authority.

There is one class of museum property, of course, which cannot, by its very nature, be governed by rules concerning alienation —that is living specimens, such as those kept and exhibited in botanical and zoological gardens.

However strict the control of voluntary alienation may be, there is one case which should be governed by less rigid principles: voluntary exchanges between museums belonging to the same country or to different countries, provided that such exchanges take place under a rational plan, making the fullest use of surplus collections, bearing in mind the needs of research and education and contributing where possible to international understanding. If the statutes of the museums concerned prohibit alienation for such purposes, exchanges may be effected in the form of long-term deposits.

LONG-TERM DEPOSITS

Many museums often accept objects on long-term deposit, for fixed or indefinite periods. Such a practice may be useful in so far as it results in filling gaps in collections or facilitating research. Curators should however act with care in this respect, especially in order to avoid such deposits being made for blatant advertising or commercial purposes. Incoming operations should be governed by the same rules as those applying to acquisitions,[1] provided that: (a) they give rise to an exchange of letters confirming the nature, physical condition and insurance value of the objects deposited and the duration of the deposit (this presupposes that one of the parties is obliged to insure the objects concerned); (b) the original packing is preserved and its arrangement noted as far as possible, with a view to its being used in exactly the same way when the objects are returned to the depositor.

The dispatch of objects for deposit should be governed by the same rules as those applying to loans for temporary exhibitions.[2]

Owing to their different degree of permanence, deposits should be entered in a register other than that used for acquisitions.[3]

ADMINISTRATION

Having established these principles, we must now examine the question of who should administer the collections in a museum (i.e. from the administrative standpoint, scientific administration being something quite distinct).

The question does not arise in the case of a small museum, whether or not it has the services of one or more administrative officials; it is the curator himself who is directly responsible for administration.

In museums with specialized scientific departments, the solutions adopted vary. They range from cases where the administration of collections is entrusted to each of the scientific departments concerned, to those where a special administrative organ, the Registration Department,[4] is entrusted with the task.

The existence of a Registration Department offers to scientific departments advantages comparable in importance to those afforded in other ways by a laboratory or workshop for the upkeep of collections,[5] an educational service[6] or a display service. By relieving the specialists of some routine

1. See 'Acquisitions', page 31.
2. See 'Outgoing operations', page 35.
3. See 'Inventory of deposits', page 41.
4. The basic work on this subject is Carl E. Guthe's, *So You Want a Good Museum*, see the bibliography on page 51, we shall quote extensively from it.
5. See Chapter VII.
6. See Chapter VI.

work, it enables them to devote more time to the extension and study of their respective departments' collections, and to publication of the relevant catalogues. At the same time it makes for more efficient execution of purely administrative tasks.

It should, however, be noted that because of the special nature of the specimens assembled by natural science museums, the work of registration in such museums —even in the United States of America, where registration departments are most widely adopted—is usually entrusted to the scientific departments; this solution, however, does not preclude the existence of a central service to record the information provided by those departments in one main index.

PREMISES

What premises are suitable for the administrative offices of the museum's collections? According to the type, structure and level of the museum—they may be premises which are not assigned for any other particular purpose, or preferably, they should be specially designed. The most usual case is to have special locations for unpacking, inventory or cataloguing and temporary storage [2].[1]

INCOMING AND OUTGOING OPERATIONS

The formalities and the operations themselves differ according as they concern incoming or outgoing objects (with the exception of packing and transport proper, which are dealt with further on) [2].

Incoming operations [2]

Apart from administrative and technical material, objects arriving at a museum usually fall within one of the following categories: objects submitted to the museum from outside for the purpose of scientific research, technical examination, analysis or treatment; objects loaned to the museum for its temporary exhibitions, or deposited

with it for a fixed or indefinite period for inclusion in its collections; objects offered or acquired (gifts, bequests, purchases, exchanges).

Objects arriving at a museum should be accepted only subject to the necessary precautions. Except in cases of absolute necessity, objects whose arrival the director had not notified in advance to the Registration Department or specialized department concerned should not be unpacked without his consent or that of one of his qualified assistants.

If a receipt is requested by the person delivering an object, before the presence or condition of the object in the package has been verified, the receipt should be given on a conditional basis only.

The unpacking should be entrusted to qualified staff of proved reliability; this operation calls for the greatest care and involves serious responsibilities. When necessary, the documents announcing the arrival of the objects—letters, invoices, telegrams, etc.—should be consulted prior to the unpacking; all material identifying each package—labels, numbers, directions, invoices, etc., whether inside or outside the packing—should be kept in its original place or, if that is not possible, in a working file.

When objects are found to be broken, (a) care must be taken not to mingle the fragments of different objects (if necessary the fragments should be grouped together in containers identifying them) and not to place the fragments near one another (to avoid the risk of further damage); (b) the chief of service (or in his absence, another person) should be asked to note the damage discovered after unpacking, and a report should be drawn up for signature by both parties concerned.

When objects are broken during the unpacking, the person responsible must notify the fact to his superior; an accident is not necessarily a fault, but it is a fault to conceal it.

Before the packing material is put aside, the objects unpacked should be checked with the documents announcing their dispatch in order to ensure that they have

1. For the storage of collections see Chapter VIII.

all arrived. Whatever the result of this checking, every part of the packing material should be thoroughly examined, so as to make sure that no objects or fragments of objects have been overlooked.

If any objects are found to be missing, the matter should be reported to the chief of service or, in his absence, to some other person, and a written report should be drawn up for signature by both parties concerned.

The packing used for objects which have been submitted, loaned or deposited must be preserved, so far as it is possible and useful to do so, with a view to its being used again when the objects are returned to the sender. Those parts of the packing which identify each package and are of lasting value should be kept in the object-files and the collection-files.[1]

As soon as the contents have been verified a final receipt should be sent to the consignor, together with a letter indicating, if necessary, what objects are damaged or missing.

The objects acquired should be entered in the inventory of acquisitions or accession book.[2] The objects deposited—and, by assimilation, those submitted for study—should be entered in the inventory of deposits.[3]

It is not advisable to enter, in the inventory of deposits, objects which are simply loaned to the museum for its temporary exhibitions; it is better to enter them in special inventories corresponding to each such exhibition, as the objects loaned for a temporary exhibition should constitute a complete group, not only at the preparatory stage and during the exhibition, but also in the records. In that case, the inventories used should be similar to the inventories of deposits.

Insurance may or may not be considered necessary for acquired objects, but objects submitted, loaned, offered or deposited should always be insured.[4]

Outgoing operations [2]

Apart from administrative and technical material, objects leaving a museum usually fall within one of the following categories: Objects sent out for scientific research or for examination or analysis; objects loaned by the museum for outside temporary exhibitions or deposited by it, for a fixed or indefinite period, with museums or other establishments; and objects alienated by way of sale, donation or exchange.

Sometimes it is the curator who decides on such operations, but usually it is the board of directors or the higher administration. The conditions governing alienation proper have already been defined.[5] With regard to loans and deposits, if the decision is not one for the curator, the interests of the museum and the professional standing of the curator require that he should be consulted and that his opinion be considered.

In any case, certain formalities should be observed before an outgoing operation is authorized; it is essential, in particular, (a) to make certain that the loan, removal, deposit or alienation of the object is not prohibited; (b) to ensure that its condition, in the curator's opinion, is not such as to prevent its transport; (c) to ensure, in cases when the outgoing object is to be loaned, submitted or deposited, that its physical condition is not such as to prevent its transport; (d) to obtain the consignee's preliminary agreement on the following points: the reasons for the outgoing operation, the dates of dispatch and return, the technical and financial arrangements for the packing and the outward and return transport, the amount of the insurance and the place where the policy is to be taken out, and, in the case of very valuable objects, the provision of an escort (by the sending museum) both when the objects are dispatched and when they are returned.

As soon as the outgoing operation has been authorized and the conditions have been accepted, the curator or the Registration Department (if there is one), on being notified by a memorandum or a special detailed form, should see to the packing, insurance and dispatch of the object concerned.

1. See 'Supplementary documentation', page 42.
2. See 'Inventory of acquisitions', page 39.
3. See 'Inventory of deposits', page 41.
4. See 'Insurance', page 32.
5. See 'Alienation', page 32.

The sending museum is responsible for the packing and, when necessary, should inform the consignee, in advance, of any particularly fragile objects.

The consignee should be asked for a formal receipt stating his name and address, the reasons why the object has been requested (when necessary, the title of the exhibition), the registration number, a description of the object, the amount of the insurance, the origin of the object, whether it has been transferred permanently or temporarily, and all other details specified by the sending museum.

When an object is returned, the consignee should inform the lending museum of the date of the return, at the time when he is arranging it.

On the return of objects, the unpacking must be effected with the same precautions as were taken when they were dispatched to the consignee. If any damage is noted, a report similar to that already mentioned must be drawn up and sent to the person returning the objects; if necessary, proceedings can then be instituted for compensation, by the insurance company concerned, in respect of the damage done.

A formal receipt is sent to the person returning the objects, referring, where desirable, to the receipt he originally signed when receiving them.

Packing and transport

Packing and transport methods must be carefully studied. The nature, size, weight and value of the objects must be considered in relation to the technical and financial conditions, and duration of the transport. The museum must ask the carrier companies and, if necessary, the consulates for information concerning these conditions, so as to be able to make a rational choice and avoid situations in which certain operations, not conforming to the rules applied by transport companies or to the rules in force in the countries concerned, would exonerate the carrier from all responsibility in the event of an accident or customs difficulties.

Packing. A detailed statement of the principles and methods of packing, which are constantly being improved upon would go considerably beyond our present terms of reference. We shall therefore simply reproduce the recommendations contained in *Museum Registration Methods* [2] (page 82), from which we have already largely drawn upon for the purposes of the present chapter:

'1. Pack in solid wooden boxes reinforced over-all with riding battens, never in open crates. Inside measurements of boxes must be at least $2\frac{1}{4}$ inches larger than the largest objects packed in them. (Fireboard drums or other containers meeting the requirements of both museum and carrier may sometimes be used, depending on the value and fragility of the material being shipped and the method of transportation.)

'2. Line boxes with waterproof paper stapled or glued to the box, never tacked; or pack individual pieces in sealed waterproof packages.

'3. Protect contents of box from shock with resilient material, such as excelsior wood shavings, to provide a cushion against vibration.

'4. Wrap small, fragile objects such as ceramics in tissue and then in cotton to protect the surface; then float them in excelsior in inner cardboard or wooden containers, which in turn are floated in excelsior in a large outer packing box.

'5. If possible, do not pack heavy and light objects in the same container. If they must be packed together, use cross slats to divide the box into compartments.

'6. Screw box covers in place, never nail them.

'7. Stencil or letter outside of box with caution marks such as fragile, this end up, etc.

'8. Strap or band all boxes being shipped to foreign countries.'

Transport. The decision as to whether rapid or ordinary transport is to be used will depend on particular circumstances and possibilities. The latter, although less costly, exposes the objects to travel risks during a longer period.

1. *Rail transport.* Particular attention should be paid to the category of merchandise

in which the objects are classified. Special trucks can be obtained for large-scale transport.

2. *Inland parcel post.* This is a convenient means of transport for small consignments, but should not be employed for objects of great value.
3. *Road transport.* For short distances, and subject to the exercise of great care this form of transport permits (a) the packing of small and fragile objects in baskets or cardboard boxes, (b) the use of frames, instead of packing-cases, for large objects.
4. *Air transport.* The company's responsibility is limited, unless additional charges are paid.
5. *Sea transport.* At present, passenger ships are preferable. The rates calculated on the 'maximum value' basis are high; in most cases however, rates are assessed on the object's size and weight. In the latter case, the company's financial responsibility is limited, unless additional charges are paid.

INVENTORY

Acquisitions and long-term deposits to be incorporated in collections permanently or for fairly long temporary periods, must be inventoried.[1]

Importance

The inventory is the instrument which safeguards the patrimony of a museum and the objects deposited with it. It provides the administrator with an exact picture of the objects acquired, deposited or alienated. It is an effective means of combating disorder and repletion of resources. In the event of claims on grounds of fraudulent or criminal misappropriation, or in cases of dispute at law, it provides the proof required for legal proceedings. It supplies comparative information, making it possible to determine whether new objects should or must be acquired. Pending the establishment of a scientific catalogue, it is an indispensable aid to research. As the late Edouard Michel aptly remarked, it is the 'basic' book.[2]

The inventory is essential for reasons of common sense; but the law should equally make provision for it. The need for it, which has always been fully recognized by large museums, must be constantly emphasized; and its establishment in local museums must be enjoined and secured by the responsible authorities. Museum inspectors can ask for it to be produced, and check its contents and accuracy [3, 4, 5].

Any delay in the inventory of objects may lead to disorder, as well as to confusion in identifying objects. The inventory should therefore be kept strictly up to date with acquisitions. This recommendation is particularly important for small museums.[3]

The inventory must not be confused with the catalogue. In principle, the former is administrative and the latter scientific in character.

Although the method used is rigorous, the inventory is of real scientific value for the following reasons: (a) it facilitates, in cases of emergency, the scientific interpretation of objects not yet catalogued; (b) when the catalogue is being prepared, the inventory provides data which it would not otherwise always be possible to reconstitute; (c) it ensures that the identification reference, particularly with regard to the numbers on the labels of the objects

1. It is not necessary to inventory objects which are submitted merely for study purposes (see 'Incoming operations', page 34); in such cases a formal receipt suffices; but it is advisable to insure such objects, unless there are agreements to the contrary. The registration of loans is discussed elsewhere.
2. Edouard Michel, *Musées et Conservateurs*, Brussels, Institut de Sociologie Solvay, 1948.
3. 'In a small museum the individual in charge is likely to be personally interested in each object added to the collections. He tends to postpone the chore of making a written record about it, because he is sure he will remember all the details. But, as the collections increase, his memory about certain items may become vague and incomplete, or may be lost entirely. If, for any reason, his association with the collection ceases, his information about them goes with him. It is extremely disheartening to attempt to build an adequate museum around a collection of interesting objects for which there are only fragmentary records.' (See the bibliography on page 51, Carl E. Guthe, *So You Want a Good Museum*, page 4.)

exhibited, is the same in all succeeding catalogues.

As we have just indicated, the objects to be inventoried may belong to the museum or be deposited with it on loan. Some of the methods recommended below are applicable to both cases, whereas others are applicable, according to circumstances, only to acquisitions or to deposits. They must all be adapted to the particular conditions of the various countries and their respective museums.

Types

There are three types of inventory: bound ledgers *(registres à feuillets fixes),* loose-leaf ledgers *(registres à feuillets mobiles),* and file cards *(fiches).*

The conditions particular to the country, as well as to the character and level of the museum, must be taken into account when a choice is made among these different types. The potentialities of each of them in regard to reproduction must also be considered, for the following reasons. First, a museum inventory is an instrument of inestimable value and its reconstitution is very difficult, even impossible, in the event of its loss; the existence of two copies in different places is therefore indispensable. Secondly, where there is a Registration Department, the museum's scientific departments must possess copies of those parts of the inventory which are of interest to them. Thirdly, where the museum belongs to a public body, the latter sometimes wishes to possess its own copy of the inventory.

Bound ledger. The leaves must be of pure rag paper and chemically neutral; the binding must be solid, and the pagination continuous and indelible. The objects must be entered legibly, and the ink used must be such as not to fade with the passing of time. There should be no spaces between the different entries in the register. The latter's date of opening must be indicated on the first page, together with the number of pages (which must be written in words). It should be forbidden to scratch out, rub out, or chemically obliterate anything written in the register. The only erasures or additions authorized should be those which the curator deems necessary; all such alterations should be in ink of a different colour and should be initialled by the curator. A rough draft of all entries should be made before they are written in the register so as to minimize the necessity for corrections.

The chief disadvantage of a bound register is that the entries must be written by hand; this requires time and, owing to inevitable differences in handwritings, involves a lack of uniformity. Two other drawbacks attributed to it can be remedied, at least to some extent, as follows: (a) the temptation to make corrections—by making rough drafts before the actual work of entry; (b) the difficulty of making subsequent additions—by excluding all indications not of a permanent nature, bearing on e.g. the condition of the objects, the insurance value, etc.

In countries where museums depend more directly on public bodies, this type of register provides the best safeguards and is therefore that usually adopted.

Reproduction is best done by microfilm, i.e. the microfilming of each filled-in page or group of filled-in pages. If need be, the indispensable second copy could be constituted by the 'drafts' mentioned above.

Loose-leaf ledger. The risk of leaves being lost is offset by the existence of a second copy. On the other hand, there is a risk of some leaves being fraudulently substituted for others, even when there is a spare copy. With this kind of register, entries can be typed; this ensures uniformity and makes it possible to type, at the same time, copies for the spare inventory and for circulation to the scientific departments, etc.

File cards. As in the case of the loose-leaf inventory there is a risk of entries being lost or substituted, but their loss is offset in the same way. There is less risk if the cards are perforated, affixed to rods and kept in locked drawers. The necessity of using Bristol-board cards prevents several cards from being typed simultaneously, as in the case of sheets for the unbound register, but there are various methods of

reproduction that can be used, the least costly and most practical of which are hectographing and stencilling [2]. Thus the main advantage of this system is to facilitate the preparation, not only of the spare copy, but also of the indexes for the needs of the Registration Department and specialized departments.[1] This type of register permits of additions, as well as of true and accurate substitutions. It is being increasingly used in United States museums.

Inventory of acquisitions

The essential feature of the inventory of acquisitions is that the objects entered in it cannot be struck out unless they are recognized as having been lost or alienated.

Numbering. Before an object is inventoried it should be assigned a number. The most satisfactory method, called tripartite, virtually the same as that recommended by Guthe [3], is as follows:

The *first unit* is constituted by the last two—or, if necessary, the last three—digits of the year in which the object entered the museum.

The *second unit* is the number of the collection of objects for the current year—the series of this number is renewed every year.

The *third unit* is constituted by the number of the object in the collection.

A *fourth element* may be used when the object consists of several component parts.

Thus, for instance the number 46.26.12.2 would be applied to a component part of a candlestick, twelfth object of the twenty-sixth collection entered during the year 1946.

If the object acquired is in only one piece, it should nevertheless be assigned in accordance with established practice, a collection number and an object number. This method would avoid the confusing of objects inventoried on an actual date with those inventoried on a conventional date.[2]

Headings. The question of headings raises several problems:

1. A programme problem. The headings must take into account the extreme variety of the objects which a museum can assemble; this problem arises in specialized museums, and even more in mixed museums, whose programmes may cover such widely differing fields as the arts, ethnography, the natural sciences, etc.
2. A problem relating to number. If the number of headings is too small, lack of precision may result. If it is too great the inventory involves too much work, is less handy and is liable to overlap with the catalogue.
3. A problem of permanence. If the headings cover too many unstable elements—e.g. the condition of the objects or their insurance value, which are subject to variation—the register may have to be over-corrected, and the cards redrafted too often.

The series of headings recommended below takes account of these various factors.[3] It does not apply, however, to the 'living' specimens at certain establishments, such as botanical and zoological gardens. The latter are of too special a nature to be dealt with here.

1. Number of the object.
2. Mode of acquisition: purchase, gift, bequest, exchange.
3. Purchase value of the object.
4. Surname, first name and address of the seller, donor, testator or exchange agent.
5. Date of acquisition. When necessary, mention should also be made of the nature of the authority effecting the purchase or accepting the gift or bequest.
6. Description (summary), possible title.

1. See 'Indexes', page 42.
2. See 'Retrospective inventory, page 40.
3. This series of headings is based mainly on two works already mentioned: *L'Inventaire museographique des objets culturels* and Museum Registration Methods (see the bibliography on page 51). Relatively more detailed than that recommended by the latter work, it takes account of the fact, already emphasized, that an inventory so conceived can to some extent meet the requirements of scientific preservation and consultation, pending the establishment of the catalogue—a position which is found in numerous museums of modest or average level.

7. Measurements. Height, length, width, diameter and (if necessary) weight. The dimensions of a painting will be those of the empty canvas stretcher. The number of pages or leaves of books, etc. should be mentioned.
8. Author, cultural group, species. Doubtful attributions should be indicated by question marks.
9. Origin. In the case of cultural objects, it would be useful to distinguish, by means of columns or secondary headings, between the place of production and the place of utilization (e.g. a piece of pottery produced at Faenza and received from a hospital dispensary in Lyons), the place of excavation (in the case of excavated objects) and the origin of the collection; or, in the case of natural objects, between the geographical place of origin and the actual origin of the collection.
10. Period. If possible, the exact date should be noted, otherwise the period. Rash guesses should be avoided. It is better to mention the century rather than the wrong year. If necessary, question marks should be used.
11. Collection-file and object-file. An abbreviation based on the language of the country concerned (e.g., in English CF and OF) would indicate the existence, at the museum, of one or more copies of a collection-file or of an object-file relating to the object registered in the inventories.[1]
12. Remarks. Former inventory numbers, etc.

Retrospective inventory

When a curator decides to adopt a method of registration more satisfactory than that previously used in his museum, he must begin with the recently arrived objects not yet registered. The system of numbering recommended makes this possible, owing to the annual renewal of its first unit.

The compilation of a retrospective inventory, which is a lengthy task, should be carried out gradually, as time permits.

The first duty would be to complete or reconstitute, for each object, the necessary data of administrative interest (date of entry, name of the donor or seller, original collection).

Thus a working card index would be established using information from older inventories, labels on the objects, handwritten or printed catalogues, and reports of the museum council, the press, local reviews, etc. If the cards are classified so far as possible according to the numbering system described above it will be less necessary to examine the original objects.

References to any scientific information brought to light during this work should be indicated on the index cards, as an aid to the preparation of future catalogues.

At the conclusion of this preparatory stage, four situations are possible:
1. The dates when objects entered the museum will have been ascertained. In this case, the objects should be registered in the chronological order of their entry, as in the case of an inventory of recently arrived objects.
2. The dates when objects entered the museum will not have been ascertained. In this case, a single collection should be constituted by the classification of the objects in logical order instead of the chronological order previously adopted. The classification might be by categories (chosen at the discretion of the classifier), and should be carried out as rigorously as possible.

The inventory number should be bipartite: the first unit formed by the last two digits of a 'conventional' year, i.e. the earliest year during which the presence of the object at the museum is certain. The second unit would be a serial number of one to four figures.

The objects with a bipartite number established on the basis of a conventional date would be thus easily distinguishable from those with a tripartite number based on an *actual* date.
3. The dates at which only some of the objects entered the museum will have been ascertained. In this event, methods (a) or (b) would be used, according to cases. The objects with a bipartite number would be grouped in one

1. See 'Collection-file and object-file', page 42.

(conventional) year, i.e. the earliest year during which their presence at the museum is certain.

4. A final possibility: the dates of entry of certain objects are ascertained after the establishment of the retrospective register. If, after the inventory has been established, information is obtained concerning the origin and date of entry of certain objects, these objects can be withdrawn from the series with conventional dates and renumbered in accordance with the tripartite system mentioned above.

Marking

The marking of the numbers on the objects is indispensable to completion of the inventory; information contained in the inventory might be useless if each object were not marked with the index and number under which it was classified and described. In certain cases and in order to save time, it would be useful to effect this operation by series of objects, particularly when use is made of varnishes which must be allowed to dry [3, 5].

It is useful to effect a provisional 'makeshift' marking so that the objects will not cease to be identifiable during or between the various operations.

Efforts should be made to ensure that the final marking is neither too visible (unaesthetic) nor insufficiently visible (inconvenient), and that it is not placed where it is unduly exposed to wear or obliteration (risky). Uniform practice concerning the parts of the objects on which the markings are made should be adopted.

The models to be recommended for the figures are those used in mechanical drawing.

The following techniques can be recommended for the marking of the numbers:
Stone, wooden, metal, leather ceramic or glass objects with a non-porous surface: the number should be marked with ultra-fine gouache or Indian ink according to the colour of the surface; as soon as the number has dried, it should be covered with a layer of colourless spirit varnish.[1]
Objects of the same materials but with a porous surface: the same operations, but preceded by the application of a layer of colourless spirit varnish, so as to offer a suitable surface and avoid scratching the object.
Textiles: the number should be marked with black Indian ink on a rectangular piece of parchment.
Fine basket-work, very small objects: the number should be stamped on a small rectangular brass tag.
Drawings and prints, etc.: the number should be marked with black Indian ink on the back of the object. If the paper is insufficiently sized, the number should be marked with a wax crayon, care being taken not to crumple the paper. If the object is affixed to a mount, the number should also be marked on the back of the mount; likewise with regard to the frame. In the case of prints, a very small copper stamp, inked from a special ink-pad, should be used.
Objects deposited should be marked in the same way, but prints and drawings should be numbered only with a soft lead pencil.

Inventory of deposits

The main feature of the inventory of deposits is that the objects noted in it when they enter the museum should also be noted in it when they leave the museum.

Apart from objects which are inalienable or not easily alienable and constitute the permanent collections, museums may also receive objects deposited for a fixed or indefinite period, by public bodies or even, under certain conditions, by private individuals. Such deposits must be entered, not in the inventory registers or card-indexes

1. For stone, wooden, metal, leather, ceramic or glass objects, the Directeur des objets d'art at the Louvre Museum recommends the use of a mixture of three parts of powdered vermillion to one part of turpentine and one part of super-fine varnish. Since the mixture dries rapidly it should be stirred thoroughly and frequently. Mark the number with an ordinary pen or with a fine but firm brush. (See the bibliography on page 51, L'Inventaire muséographique des objets culturels, paragraph 52.312.)

reserved for acquisitions, but in special registers or card-indexes for deposits only.

The methods for determining the inventory numbers of deposits are the same as those used for acquisitions, but it is essential that the deposit numbers be preceded by a symbol, so as to prevent confusion between acquisition numbers and deposit numbers.[1]

The register and the cards have the same headings—subjects to the differences mentioned below, the most important of these being a special column or space for the date on which the deposit comes to an end. The following are the headings suggested:

1. Deposit number.
2. External method of acquisition (i.e. how the object was acquired by the depositor).
3. Name and address of the depositor.
4. Date of the deposit.
5. Date of the withdrawal of the deposit.
6. Description.
7. Measurements, etc.
8. Author, cultural group, species.
9. Origin.
10. Period.
11. Collection-file or object-file.
12. Remarks.

The same marking methods will be used, but care must be taken to see that the deposit numbers can be effaced.

Supplementary documentation

Collection-files and object-files. Much of the information entered in the registers or on the inventory cards is taken from written documents—correspondence, invoices, bills and other private or official documents which are proof of acquisition—in the possession of the directorate or its Registration Department (if the latter exists). These documents must be so filed as to facilitate their consultation for administrative or research purposes.

One of the most effective methods is to group them in collection-files, whose folders —of standard size (e.g. 24 × 32 cm)—bear in large type the registration number of the collection and are classified in numerical order. If the collection-files become too bulky they should be subdivided into object-files, also arranged in numerical order.

Such files may also contain lists of bibliographical, archival, photographic and iconographic references, and reports concerning damage, examinations and treatment undergone by objects, etc.

These files, whose contents can be constantly increased, are always of administrative value, and are also of undeniable scientific value pending, and even after, the establishment of the scientific catalogue.

Indexes. It is often necessary to locate the inventory entry or position of an object whose number cannot be found. In such cases, the object must be identified with the help of various data (name of the donor or seller, nature and function of the object, technique and material of fabrication, its geographic origin, author, ethnic group, species, period, etc.). This necessity for indexes is felt on the administrative as well as on the scientific level, and that is why they are discussed here.

If the inventory is on cards,[2] it will suffice to reproduce as many cards as are required for the various subject headings in the index, taking account, when necessary, of the needs of both the Registration Department and the scientific departments.

In the case of the other two methods of inventory, the index cards should be specially made, preferably in the smallest international size (7.5 × 12.5 cm), and then reproduced like the others[3] by hectograph or stencil.

In the indexes themselves, the cards should be distributed according to the subject headings, using the alphabetically coded category system, the decimal system of classification or classification according to the inventory number (which would assist the departments in finding the inventory entry of objects interesting them).

The rapid consultation of the cards is being increasingly facilitated by such methods

1. For example the initial letter D (for deposit).
2. See 'File cards', page 38.
3. In the case of the inventory in the form of a loose-leaf ledger, it is also possible to use typed duplicates, if they are of average size and correspond to international standards.

as mechanical and electronic sorting; but these methods (especially the lastnamed) require a typing technique and more costly equipment, and are therefore possible only in very large museums.

LOCATION AND MOVEMENT OF OBJECTS

Every object at the museum must be given a regular location in the museum itself, either in the exhibition rooms or in the reserves. The object may be withdrawn from that location for a varying period of time: (a) within the museum, for purposes of study, examination, treatment, photography, exhibition, etc.; (b) for an outside destination, on loan, deposit, etc.

The curator, the Registration Department and the specialized departments, according to cases, must have some means of ascertaining the regular or temporary location of the objects of concern to them, and to keep check of their movements from one place to another.

The means of checking vary to a certain extent, depending on whether bound or loose-leaf inventories or registration cards are used.

When bound or loose-leaf inventories are used

Only where there is an extreme shortage of labour should the regular location of an object be noted, in an effaceable manner, on the inventory page itself. The temporary locations of objects, and the dates and purposes of their movements, should be mentioned only in a register of movements in which columns should be reserved for the inventory number, a very brief description of the object, the date on which it left its regular location, its temporary location, the date of its return to its regular location and the responsible person's initials in the margin beside each of these dates.

An even more satisfactory solution is to establish a supplementary card-index of the objects, the cards being similar to those used in the inventory indexes.[1] The regular or temporary positions of the objects can be indicated in this card-index in two ways: (i) the cards, classified in numerical order, can each have a tag, whose colour or symbol reveals, in accordance with established practice, the location of the objects; (ii) the cards can be classified according to the various locations. The first system requires less effort; the second, with its groups of positions, has the advantage of giving valuable information in more than one respect. The register of movements is none the less necessary in order to indicate temporary locations and the dates and purposes of movements.

When inventory cards are used

Several means of ascertaining positions and movements are used.

One is to provide the inventory cards with tags. Another is to reproduce the inventory cards and classify them by groups of positions. In either case it is necessary to keep a register of movements.[2]

A third system is possible: that of leaving a special space on the inventory cards for the recording of movements. This system would certainly have the advantage of obviating the need for a register of movements, but it would present two serious disadvantages: (a) it would necessitate, in the long run, the preparation of continuation cards, which would overburden the card-index; (b) it would deprive the museum of an important scientific and administrative advantage not yet mentioned, viz. the preservation, in a register of movements, of traces of former movements.

General remarks

Whatever system is adopted:
1. The responsibility for keeping inventory entries and keeping records of locations up to date would fall to the curator, the Registration Department or, within the limits of their competence, the

1. See 'Indexes', page 42.
2. See 'When bound or loose-leaf inventories are used', above.

specialized departments, depending on the organization of the museum.

2. A useful practice is to replace any object that is removed from its usual position by what librarians call a 'dummy', i.e. a card giving the number and a very brief description of the object, and the date and purpose of the removal; this is also a gesture of courtesy towards the public if the object removed is an exhibit.

3. It is also useful to have a system of topographical symbols to indicate the premises and parts of premises in which the objects have a regular location—i.e., in the present case, to the exhibition rooms.

EQUIPMENT AND SUPPLIES, PREMISES, SECURITY

EQUIPMENT AND SUPPLIES

In addition to the objects of the collections and the documentation of scientific interest —printed matter, manuscripts, tracings, photographic plates, microfilms, films, phonograph, tape recordings, etc.—which it is called upon to assemble and to offer for consultation purposes or, if necessary, to produce in order to complete its collections, a museum must have at its disposal a considerable amount of equipment and supplies, the acquisition and administration of which should also be governed by rules.

Two main categories must be distinguished: (a) Permanent equipment, which should be recorded in inventories in accordance with methods roughly similar to those used for the objects: furniture for exhibitions (show-cases, panels, etc.), furniture for the stores and workshops, scientific equipment for the laboratories, audio-visual equipment, furniture and lighting for the various services, etc.[1] (b) What is known as expendable supplies (stationery, cleaning and maintenance requirements, lumber, fuel, etc.), the supply and use of which are controlled by a system of coupons and registers.

It is not possible here to go into a detailed description of all the formalities

and rules, which vary considerably from one country to another. We shall confine ourselves to making the following recommendations:

1. According to the level of the museum, the administration of equipment and supplies should be entrusted to a separate official or specialized service.

2. Each museum service or employee should be responsible for the equipment in its or his charge, but should be supervised by the official or specialized service responsible.

3. The stocks should be concentrated in special stores, subdivided, if possible, according to categories of material and accessible to the official or specialized service responsible, subject to observance of safety rules.

4. The museum services or employees should receive expendable supplies in small quantities only.

PREMISES

The ideal situation is that in which the museum premises belong to the society or public body on which the institution depends. This reduces maintenance difficulties and facilitates the museum's transformation and expansion. In the older countries, however, museums are often housed in buildings owned by the State, and in such cases the institutions' 'beneficiary' position is equivalent to that of lessees.

One thing should be avoided as far as possible: the cohabitation, in the same building, of a museum and other institutions or services. The main disadvantages of such a situation are: (a) disagreement as to the definition and application of safety rules, owing to the fact that the situation is not the same for each occupying body, e.g. with regard to the means of preventing and fighting fires, the degree of strictness

1. The methods for identifying and marking furniture could be the same as those used for objects, provided that symbols avoiding all possible confusion are used. Separate inventories for acquisitions and deposits are also recommended. Alienations, though governed by less rigorous rules, should be controlled.

in guarding the premises, etc.; (b) difficulties of access for the staff and the public, if the museum has no direct street entrance; (c) the frequent impossibility of expanding the museum; since, all too often, a more powerful neighbour is able to 'swallow up' the museum premises.

Cohabitation, however, has less disadvantages where related organizations, such as libraries and archives, are concerned.

A museum housed in an historic building is invested with a certain prestige, beauty and attraction for tourists, but is subjected to regulations enforced by the authority in charge of public monuments.

It is advisable for the museum official or specialized service responsible for equipment and supplies to be responsible also for routine relations with the architect of the buildings. Guthe [3], pages 17 and 18, gives useful advice concerning the care which, for technical and financial reasons, should be exercised in the choice of the building.

SECURITY

The rules governing security vary, according as they relate to the prevention of theft and fire or to exceptional measures such as those imposed by armed conflict.

Theft

In premises with modern fittings, protection against theft is afforded by a number of devices, some more effective than others. Such devices should be chosen only after very careful investigation and extensive consultation with the official bodies most competent in the matter, and also with establishments, such as banks, which are more especially obliged to employ them. Special instructions concerning their use should be issued to the staff, after being officially endorsed. It would be a mistake, however, to rely exclusively on such devices; human supervision is also needed, and for this reason museum guards must be employed. In the large museums—financial and other considerations permitting—ordinary supervision should be made doubly sure by the addition of a special team of guards, wearing plain clothes and exercising discreet control over all parts of the premises accessible to the public. This human supervision, which must never be such as to constitute an affront to visitors, can be facilitated by a number of preventive measures, judiciously concerted, administratively codified and prominently displayed, imposing on the public certain obligations —such as that of leaving in the cloak-room all packages, bags, portfolios or other portable receptacles in which stolen objects might be concealed.[1]

Fire

Protection against fire involves responsibilities on the part of the proprietor, not only with regard to the museum's treasures, which are sometimes irreplaceable, but also with regard to the members of the public visiting the museum. It calls not only for material and technical but also for administrative measures, which should be particularly strict if the museum is housed in an ancient building where risks are greater.

All security measures adopted must conform to the regulations governing public safety. These regulations bear, in substance, on the maximum number of persons to be admitted to particular premises, the position and indication of the exits, the prohibition on the use of certain materials or fabrics for the decoration of the premises and on the stocking of certain volatile products (in restoration workshops) or inflammable films (in lecture-rooms), the methods of using electrical equipment, etc. A further requirement is that central museum administrations should issue explanatory recommendations concerning the regulations to the museums subordinate to them.[2] Lastly, some standing arrangements

1. See, in Chapter III, particularly pages 62 and 63, Mr. Douglas Allan's remarks concerning safety.
2. The directives concerning prevention of fire, sent to provincial museums by the Direction des Musées de France, recommend that, with a view to simplifying matters, the museum should confine itself to: (a) general instructions concerning the prevention and extinction of fire and the evacuation of persons not mobilized for fire-fighting; (b) special instructions for each individual or category of individuals normally

should be made with the local fire-fighting and police services, particularly as regards the direction of operations in the event of fire.

This will entail the establishment, by the fire-brigade services, of a plan of action in which account is taken of the lay-out of the premises and of the permanent emergency installations (pipes, pressure-hoses, tanks, fire-hydrants, fixed ladders, accesses and staircases). The plan must also state the extent of the aid required, the space to be allotted for this purpose, and what reinforcements may be necessary. The museum itself would be required to draw up two sets of instructions—the first prohibiting certain types of carelessness, recommending certain precautions (prohibition of smoking, and compulsory supervision of work of a dangerous nature) and providing for rounds of inspection, checks to be made in the event of the sounding of the fire-alarm, etc. The other set of instructions would constitute the 'fire instructions' proper. It should be brief and clear, and displayed in all parts of the premises. Periodical inspections and drill should take place to ensure that every member of the staff, particularly resident staff, is familiar with the instructions, understands them and is able to apply them without panic. The instructions should relate mainly to the emergency calls to be made in the event of fire, the parts of the premises to which staff members should proceed in order to guide and assist the firemen, and the duties of the museum staff itself with regard to the protection and, if necessary, evacuation of the collections. These details, among the various problems of practical administration, are of particular importance. A 'fire register' should be kept in order to enable the inspectors of safety measures to ascertain at any moment whether really effective preventive steps have been taken, whether there is regular and effective supervision and whether staff members are given the necessary practical training.

Armed conflict

The safety of museums during a period of armed conflict should be organized at the national level. The government should be responsible for this. It presupposes the adoption of preventive measures and complex, concerted organization, issuing from government departments to the joint administrations of national museums and from the latter to the secondary museums, which it is particularly useful, in this respect, to place under the authority or control of those administrations. In other cases (e.g. those of private museums), the matter is organized within the framework of civil security. If the measures are not to be improvised, however, they require the permanent co-operation of qualified technicians and the State authorities.[1]

Role of the supervising staff

The foregoing adequately indicates the prime role of museum supervisors; they must be regarded as members of an internal

participating in fire-fighting and certain other emergency measures, including instructions concerning the protection or evacuation of objects. The directives emphasize the need to keep the instructions up to date, particularly with regard to the telephone numbers for emergency calls.

1. See, in this respect, H. Lavachery and A. Noblecourt: *Les techniques de protection des biens culturels en cas de conflit armé* (Unesco series *Musées et monuments*, No. VIII, 1954), and more particularly the English edition, published in 1958, A. Noblecourt: *Protection of Cultural Property in the Event of Armed Conflict* (343 pages, 260 illustrations); this is in fact a new work, taking account of present conditions which prevail legally (owing to the entry into force of the International Convention adopted at The Hague in 1954) and also technically (owing to the development of modern armaments and the new means of protection). The first part of this work deals with the Hague Convention; the second contains a systematic enumeration of the various risks to which cultural property is exposed in the event of armed conflict. The third part contains general remarks on protection techniques, and a synthesis for those directly responsible for cultural property; the fourth deals with the organization of protection at the different levels (international, governmental, national, local)—while the fifth part contains technical information for the architects and engineers responsible for constructing and equipping museum buildings and shelters.

police service of whom intelligence, authority, courtesy, constant care and a knowledge of simple but essential details are required. Indeed, the smooth running of a museum depends to some extent on this group of employees who are modest helpers of the directors and curators. The museum administration must never forget that it often places its honour in their hands and that it transfers to them day and night many of its responsibilities. These employees should therefore be recruited with great care and should be remunerated in a manner appropriate to the qualities required of them and the duties imposed on them.

THE PUBLIC

The problem of public relations in museum work is a complex one. We shall deal here only with those aspects of more immediate importance to the administrative services.

PUBLICITY

It is now generally accepted that a museum may use publicity devices in order to increase the number of its visitors. A curator, however, should not forget that his task is not so much to sell an article as to use the museum's choice resources in order to disseminate knowledge about it and enable the public at large to appreciate it.

Where possible, one staff member should be appointed to maintain relations with the press, to prepare and disseminate official statements and photographs, keep files of press-cuttings and (always an important matter) send thanks to the authors of articles. He should also establish and keep up to date a card-index of journalists. Similar work should be done in the increasingly important fields of radio, film and television.

The dazzling progress of television as a communication medium does not, however, diminish the value of posters and other publicity devices. The co-operation of tourist and commercial organizations can be particularly useful in this field.

Museums can also, with advantage, publish prospectuses and pamphlets, the effectiveness of which is always heightened by elegance and good presentation.

Although little used as yet—doubtless owing to the fact that museum buildings are architecturally hardly suited to it—the system of show-cases facing the street, like those in front of large stores, can produce excellent results.

Lastly, brilliant inaugural ceremonies and receptions help to make a museum and its permanent and temporary activities better known to the public.[1]

CONDITIONS GOVERNING ADMISSION

Once the desired result has been obtained and there is a steady flow of visitors, another problem arises—that of the conditions governing their admission. This calls for a number of practical administrative decisions whose scope will be considerable, since the object in view is to provide the general public with the means of acquiring both general and specialized knowledge, ranging from the fields of history and aesthetics to those of science and technology. What conditions, then, should govern the admission of visitors to the various collections?

Museums, being destined for the general public, should in principle be accessible to everyone free of charge—as was the case in France, until relatively recently, for museums founded by the National Convention[2] and as is still the case (to mention only these examples) for most of the museums in the United States and Great Britain.

The practice of charging an admission fee has, unfortunately, become inevitable wherever museums do not receive sufficient aid from the bodies on which they depend. It may also be necessary for psychological

1. A special number of the review *Museum,* Vol. IV, No. 4, 1951, *Publicity and Public Relations,* deals with this subject in great detail; it is profusely illustrated.
2. Established between 1792 and 1794: Musée Central des Arts; Musée d'Histoire Naturelle, Musée des Arts et Métiers, Musée des Monuments Français.

reasons—the public being inclined to take more seriously a visit involving some small material sacrifice.

The proceeds from such fees may be assigned to various quarters such as: (a) the private organization to which the museum belongs, the funds being reserved exclusively for the museum itself; (b) the public authority which controls the museum, in which case they are paid either into a special account opened for the museum or into the authority's general funds; (c) a group of museums under public authority which establish an independent fund and divide the accrued amount according to the needs of each (e.g. French national museums).

Even where admission fees are charged, however, free visits should be allowed periodically on certain days and on special occasions (e.g. exhibitions). Facilities—including in certain cases free admission—should also be granted to various categories of individuals or groups: members of the museum profession,[1] scientific research-workers, students, pupils, non-commercial organizations for popular education, extra- and post-school educational foundations. All these facilities call for vigilance and understanding on the part of the museum or the higher administrative authorities.

CONTROL AND COMFORT

The presence of the public raises other problems. Firstly, without prejudice to the visitors' freedom to instruct themselves as they please, it is essential to define very precisely the controls to be observed: it is advisable that both ordinary and special visiting days and visiting hours should be governed by standard regulations in each country. These regulations involve a contract with the public, which both parties must loyally observe. It is for the museum to determine what restrictions need to be imposed on visitors' right of access to the collections. Certain museums which are housed in very small premises or in premises of historical importance cannot, without risk of disorder or damage to the exhibits, authorize visits except under the guidance of responsible staff members. The need for these restrictions is usually obvious, but they call for a spirit of understanding, which must be established, justified and maintained on both sides.

Visitors are entitled to more than this controlled freedom granted them by museums. They wish to feel at ease during their visit, and to instruct themselves without fatigue. With this end in view, museums should be provided with appointments for the visitors' comfort and, in the case of institutions of a certain level, with an information and reception service.[2]

Lastly, there arises, at least in countries whose language is little known, the problem of interpreting, if not the individual labels on the objects (possibly an unreasonable demand), at least the explanatory panels and other informative material of importance. In these cases a minimum of 'guidance' in some better-known language is extremely helpful.

SALES-COUNTERS

Visitors to museums should have the opportunity to purchase, at reasonable prices, satisfactory documentation in the form of photographs, post-cards, casts, prints and popular works. The sales-counter is usually situated at the entrance to the museum. It may be operated independently in museums of a certain level, or entrusted to those responsible for controlling admission to the museum; the latter solution has the disadvantage of rendering this control less effective when visitors enter in great numbers.

The sales-counter may be a branch of a financially independent commercial service, or it may be run by an association of 'Friends of the Museums'; the profits may

1. ICOM is inducing a growing number of museums in different countries, to grant its members free admission on presentation of their current membership cards.
2. Large museums such as the Louvre, now offer, during the tourist season, the services of several 'museum hostesses', whose duty it is to inform and guide visitors. Further, most large museums have established public relations services; in the United States of America, these services are playing an increasingly important part.

be paid to the museum concerned or to the body of museums as a whole. In other cases, the sales-counter is managed either by the organization responsible for the museum or by the museum's parent department.

PHOTOGRAPHY AND COPYING IN THE GALLERIES

With certain exceptions, the museums of many countries now recognize the right of visitors to photograph exhibits with small cameras. In certain cases, however, this right has to be restricted, and it is essential that this point be then made clearly understood. Professional photography, e.g. filming and the use of the television camera,[1] must obviously be governed by special rules, which should be periodically reviewed. It seems normal that museums should levy charges for the use of such photographic equipment. The work of artists in the rooms and galleries of museums, despite the disadvantages involved, should be encouraged. But a distinction must be made between the work of professional copyists, who sell their products, and that of students. It is normal that the latter should be exempted from all charges. It would nevertheless be idle to imagine that all these practices could ever be regulated in detail; they always give rise, in one form or another, to minor administrative problems which have to be solved as they occur.

ASSOCIATIONS OF FRIENDS OF THE MUSEUM

Although this question lies somewhat outside the limits of the present chapter, we cannot, in considering the public, omit to mention the services rendered by a type of association, still in process of development, known as 'Friends of the Museum'. These services consist, first, of the donation of objects and even of equipment and fittings which the museum cannot always obtain from the society or department on which it depends. There are other equally valuable services: support vis-à-vis the public, and innumerable forms of moral aid, all of which may have administrative implications.

FINANCIAL QUESTIONS

Financial management is undoubtedly the least spectacular, but not the least important, part of administrative work.

SOURCES OF INCOME

We must first consider the potential sources of museum income. Carl E. Guthe [3], on pages 19 to 24 of his remarkable little book, enumerates them as follows:
1. Proceeds from endowment funds, the stability of which is dependent on sound investment policy.
2. Membership fees of the museum; a graduated scale of membership fees makes it possible to attract not only the general public and certain categories of people of limited means who are particularly interested in social and cultural questions, but also the more wealthy members of society who can make considerable contributions.[2]
3. Appropriations from tax funds (city, county, State) in exchange for the cultural and social services rendered by museums, or the latter's assimilation or attachment to educational institutions.
4. Grants offered by organizations interested in social, cultural and scientific progress.

1. The problems connected with filming and television fall outside the scope of this paragraph. They have financial implications in so far as charges are to be levied (see section on 'Financial questions'). They involve the question of protection of the exhibits, in so far as co-operation has to be established between the museum, the film-producing bodies and the television organizations in order to avoid damage to the exhibits as a result of clumsy handling or over-exposure to light (see, in this respect *ICOM News/Nouvelles de l'ICOM,* Vol. XI, No. 5-6, October-December 1958, the recommendations of the ICOM meeting on 'Museums, film and television', Brussels, 1958).
2. Guthe, on page 20, distinguishes between student members, active members, family membership, contributing members, sustaining members, commercial members, life members, patrons and benefactors.

5. Fund-raising activities, e.g. annual entertainments, subscription dinners, costume balls; these activities must be in keeping with the dignity of museums.
6. Private gifts.
7. Admissions, sales and rentals, proceeds from admission fees,[1] sales-counter profits,[2] charges on photographing, filming and television activities,[3] etc.

The method of administering these resources and even the possibility of their existence depend on the museum's statutes. Guthe's list is based mainly on the essentially American type of small community museum, which is financially independent. For museums depending on a public department, income of this nature is also possible, provided that the museums really enjoy financial independence, more or less limited to certain fields,[4] or that the department transfers to them in the form of increased subventions, the sums which it receives.

Whatever the type of contribution envisaged, public generosity will not fail to be stimulated if certain legal provisions, such as those existing in the United States of America, exempt gifts to museums from income tax and estate duties.

BUDGET

Every museum must have a balanced budget; income and expenditure must be carefully estimated, and the necessary funds must be provided for acquisitions and the essential operating costs. The preparation and discussion of this budget constitute the director's most important annual task.

For practical information as to preparing the budget of a small community museum we must again consult Guthe [3], pages 24 to 26.

He first defines the budget as 'an estimating device used to determine as accurately as possible the amount of the anticipated operating income for the coming fiscal year, and the approximate portions of it which should be allocated to each of the several categories of expenses'. He remarks that it is for the Board of Trustees, (a) to determine the latitude allowed the director in transferring funds from one to another of these categories and in making adjust-

ments to the budget; (b) to develop, in advance, ways and means of increasing the income to equal the costs, if the latter are likely to be greater than the anticipated income.

He emphasizes that staff salaries constitute the most important item of expenditure and, in the light of the surveys which he himself carried out, he estimates them as representing from 60 to 70 per cent of total expenditure. The director's salary forms an important part of this; and he considers that is should be equivalent to that of the city librarian, the principal of a public school or the administrative head of a similar community service agency. He also equates the salary of a staff assistant to that of public school teacher, and the salaries of office and maintenance staff to those paid to persons holding equivalent positions in business firms.

According to the same author, the remaining one-third of the operating income is distributed among the following categories of operating costs in the budget: 'administrative expense (office supplies, telephone and telegraph charges, postage, travel and membership costs); buildings, ground and equipment maintenance (insurance, supplies, repairs); collection care (insurance and supplies); exhibits (construction supplies and insurance, rental fees and transportation charges on borrowed exhibitions); activities (lectures, movies, concerts, social events, membership programmes, catering costs); and finally a financial cushion (miscellaneous, contingency or undistributed)'.

1. See 'Conditions governing admission', page 47.
2. See 'Sales-counters', page 48.
3. See 'Photography and copying in the galleries', page 49.
4. In this respect, mention may be made of the French national museums, whose 'Réunion' constitutes a public establishment with legal status and financial independence; leaving other expenditure for the efficient operation of museums to the general budget. The 'Réunion' of French national museums collects the resources assigned by law for the extension of the collections and receives gifts and bequests (works of art, sums of money, real and personal property), whether earmarked for special purposes or not.

To this ordinary expenditure may be added such extraordinary expenditures as are required for the extension of the premises, the modernization of equipment, etc., which must be covered by special resources, such as subventions, donations, loans, etc.

Here, also, the methods of preparing the budget, and responsibilities for it, vary according to the status of the museum. Income and expenditure are strictly balanced in the case of museums supported by organizations, whereas in museums under the authority of public departments it is usually only the independently administered parts of the budget that need to be balanced.

BIBLIOGRAPHY

1. DAIFUKU, H.; BOWERS, J. *Museum techniques and fundamental education.* Paris, Unesco, 1956, 54 pp. (*Educational studies and documents*, No. 17.)
2. DUDLEY, Dorothy H.; BEZOLD, Irma, *et al. Museum registration methods.* Washington, D.C., American Association of Museums, 1958, VI + 226 pp.
3. GUTHE, Carl E. *So you want a good museum.* A guide to the management of small museums. 1957, IV + 37 pp. (*American Association of Museums publications*, new series, No. 17.)
4. *Les Musées.* Chapter 51 Mu, 'Les musées nationaux', Chapter 53 Mu, 'L'École du Louvre', Chapter 56 Mu, 'Les musées de province'. Fascicules de documentation administrative, publiés par le Bulletin officiel du Ministère de l'Éducation Nationale. Paris, Imprimerie nationale, 1955, 122 pp. (Centre national de Documentation Pédagogique, Brochure No. 23 F.D.)
5. *L'Inventaire muséographique des objets culturels.* Recommandations à l'usage des conservateurs de musées contrôlés et classés. Édition corrigée et augmentée. Paris, Musée des arts et traditions populaires, 12 November 1957, 21 pp. + tables.

CHAPTER III

THE STAFF

by DOUGLAS A. ALLAN

THE CURATORIAL STAFF

At rock bottom, the spiritual power and the active performance of every museum depend upon the curator. The late Sir Henry Miers, who probably knew more about museums than any man, said in his *Report on the Public Museums of the British Isles (other than the national museums)* published in 1928 and still a fount of sage advice: 'It will be readily understood that of all the factors which can make or mar the success of a museum, the personality of the curator is the most vital. Under a good curator a museum cannot be wholly a bad one, whatever its defects; under a bad curator a museum cannot be entirely a good one, whatever its advantages. Everything depends on the right choice of the curator, and the support given to him. Such a curator usually has the power to make his museum reflect his own ideals or theories, and the best are those in which he is fully trusted by his committee and sympathetically supported by them.' After nearly thirty years' service as director of two large museums and innumerable close contacts with many smaller ones, the author of the present chapter can only echo Sir Henry's sentiments most fervently. This is why there is so strong an element of vocation in running any museum, be it large or be it small. Some people will judge a museum by its size and equipment, by the range of its collections, and by the number and extent of its activities, but in all these things quality counts as much as size and quantity—and it is the curator who fixes the standard of quality. Moreover, museums and museum staffs change with the passage

of time and a museum may blossom out in different ways, reflecting the particular interests of the contemporary world or those of the staff at one time or another, but the one thing which can always be passed on is the standard. It is the responsibility of each succeeding curator to maintain and where possible to improve the standard of his institution; and it is a very serious thing, which can be judged in the full light of public criticism, for anyone to let the standard of a museum decline. The curator is the fountain head of power for good or ill in any museum. His staff of all ranks are his agents—agents he has selected and trained, agents whose work he directs and supervises—so that they are a part of himself and play a correspondingly important part in the running of the institution and the maintenance of its standards. It is thus of paramount importance that staff of the right type should be secured and encouraged, whether they operate a large museum and are numerous and highly specialized or whether they control a relatively small one and are few in number with many and varied responsibilities.

A survey of existing museums gives a good general indication of the types of activity involved in the efficient running of a museum. At the highest level is the director or curator, who is responsible for the smooth working of the whole machine under his charge—determining the general policy, securing material, staging exhibitions and organizing recreational and educational activities. He usually exercises his authority under a board of trustees, committee of management, council or even the

actual owner of the museum himself. Under the director is the office staff dealing with day-to-day correspondence, records, registers, book-keeping and accounts. Then there is the museum professional staff which may range from one assistant to a large team with a deputy director, keepers of departments and assistant keepers, responsible for the actual collections and the uses to which they are put. As these collections, all through their existence, need attention to preserve them from decay, a museum must have some technical assistants competent to handle such problems, and on them also often falls the responsibility of carrying out the actual work of staging exhibitions. To help the technical assistants, the larger museums employ artisans, such as joiners, cabinet-makers and painters. The collections, visited day by day by the general public, have to be protected against damage by handling or against attempted theft, and for this purpose guards or patrols or attendants are employed. Finally, since a museum must at all times present a scrupulously neat and tidy appearance, a staff of cleaners is required. In a large museum with extensive collections and adequate funds there will be groups of persons of each type to constitute the full staff, but in a small museum some persons may have to 'double' the roles—the keeper doing his own preservative and display work and the attendant both keeping the furniture and rooms clean and undertaking watching duties as well.

In a small to medium-sized museum the collections may usually be divided into two main groups—those illustrative of natural history such as geology, botany and zoology and those reflecting the work of man such as archaeology, ethnography and art. As these groups represent rather different types of bent in human interest and these bents lead their owners to follow certain well-defined courses at school, college or the university, it is common, in Western Europe and North America, to find museum curators specializing either on the natural science side or on the human development side. If, by chance, a curator has to look after both sides of his museum he tends to concentrate upon the subjects in which he is especially interested and trained and

allows the others to take second place. Such a divergence springs from a basic difference in interest and tends to be accentuated by the different types of training courses offered by colleges and universities. While good, all-round interests and knowledge are invaluable in a museum curator, it cannot be too strongly emphasized that very highly specialized knowledge in detailed fields is essential if an institution is to hold its place in the world of learning. The professional staff in their daily service to the public are presenting information and are actively engaged in education— this they can only do adequately if their own educational training has been as thorough as possible.

Qualifications

Whatever the size of the museum in his charge, the director, the curator or the keeper should be regarded as at least the equivalent of a secondary school specialist teacher. He should thus approach his chosen profession with not less than the educational qualifications of a graduate from a teacher-training college, and if he is in addition a graduate of a university, so much the better. So much of his work will be directly educational that the curator of any museum will find it a valuable asset if he has some experience of teaching at school, college or university level. He will know better how to approach his public, and he will be able to discuss common problems in a common language with the teachers who bring classes to his museum.

A curator should have a very real liking for the objects in his care; he must enjoy looking after them and feel a continuous urge to learn more about them, for only so is he likely to have that spark of inspiration necessary to display and explain them in a way that will transmit his enthusiasm to his public. There is thus a remarkably strong personal demand made upon the curator. He must have a sense of order, for he has to arrange his collections and the data concerning them in a systematic way. He must also have a strong sense of public responsibility, for he has always to remember his duty to provide as wide a

53

series of exhibitions as possible for the entertainment and education of his public, as fine examples as can be secured to interest them, and as accurate annotations and explanations as modern research can provide for their enlightenment.

It is, I think, true to say that the best curators, whether working single-handed or with a staff of keepers under them, are experts in their own right in some particular subject of their own choice, and in it enjoy a standing and a reputation quite apart from that associated with their particular institutions. This is a subject in which they are competent to do their own most detailed identifications and on which they can contribute their own monographs to scientific or artistic publications. If they also have wide and detailed knowledge and experience of other subjects that is of undoubted advantage, but in most cases other experts are called in to deal with material from other fields. The gift of enjoying passing on knowledge and enthusiasm is an invaluable one in organizing a museum—a taste for teaching and for calling forth a response in others is almost an essential prerequisite.

In the early days of museums a neat, orderly and logical arrangement of the collections on exhibition, with correspondingly neat and clear labels were all that was asked of a curator, but nowadays great stress is laid upon the undoubtedly immense appeal of artistic display. For this reason, the museum officer must be ready to experiment with and to build up a knowledge of museum furniture design, lighting, colour schemes, the compilation of interesting and succinct labels and the use of auxiliary aids such as diagrams, photographs and models. Above all, he must have good taste, for nothing is so ruinous to good display as an element of vulgarity in the layout and treatment. Some of the qualities demanded of a curator are innate, some can be acquired, but all are improved with constant practice and the constant determination to obtain better results.

Administrative duties

A successful museum director or curator must have some experience of office man-

agement, for behind his exhibition rooms or galleries there will be the office which is the brain and nerve centre of his institution and which must run smoothly in order to leave the maximum time and energy for the major museum projects of presentation and education. The office will have to handle day-to-day correspondence and the filing which follows it. There will also be accounts and finances to deal with ranging from paying wages, purchasing specimens and equipment, and meeting repairs charges to keeping account of petty cash outlays. There will be internal and external loans to keep track of and problems of insurance policies to be dealt with. The office will probably also be responsible for keeping the registers and the card-indexes up to date. To retain command of such a wide range of activities, the curator should have some practical experience of the processes involved. If his staff grows, on him will fall the duty of re-allocating jobs, of assessing fairly the responsibility of different appointments, and of seeing that the paying authority gets value for its money.

A museum curator also should have a sound knowledge of matters concerning his building and its upkeep. Any museum or art gallery is subject to deterioration as time goes on and unless it is sufficiently large to have a clerk-of-works, or is attached to an authority which employs one, the curator should be quick to notice defects and have them repaired as early as possible. Leaking roofs or pipes, for example, if not attended to immediately, may damage the fabric and decorations of a building, and even extend their ravages to furniture and collections. At least an elementary knowledge of roof structure, roof lights, and drainage systems should be acquired as soon as possible, together with an acquaintance with water and gas circuits and the plan of the electricity installation, so that water, gas and electricity can be cut off in any emergency and faults tracked down.

While a museum curator is considered by many to be essentially concerned with the maintenance and display of his collections, he is nevertheless a public servant whose duties bring him into daily contact with the public, either individually or in

groups. He must, therefore, devote himself to a study of this public in order to serve them better. This is something that cannot be learned from textbooks; it has to be acquired by actual practice. He has to deal with his board of trustees, his council or his committee, and to comport himself as a trained official qualified to carry out his job and to give, in an acceptable manner, advice on how he thinks it best to run the museum, always allowing for the fact that the trustees or committee are in the last resort responsible for the efficient performance of the institution. An appreciation of each other's point of view and a certain amount of give and take are necessary for general good will and for that cordial pooling of contributions which will ensure the best results. Again the curator has to handle a very mixed staff—from colleagues who are experts in the world of art or science, office staff, to preparers, cleaners and warders—and will have to learn by experience by what means to secure the best results, for his museum will reflect very clearly how far he has been successful in welding his mixed staff into a good working team filled with zeal for their museum and its services.

Lastly, the museum curator should have a sound knowledge of showmanship. His job is to run an institution which exists to show things to the public and he must be able to advertise his wares and his activities widely in order to bring the public within his doors. He must be conversant with the arts of advertising by means of the press, radio and television, by means of lectures and talks to the general public, to business organizations, to college and university classes and to schools of all kinds. He must ever be on the outlook to 'sell' the idea of his museum so that it can be well utilized and widely appreciated, and so that he can obtain financial support for extensions to buildings or collections or for new projects. He must also be able on occasion to persuade the owners of individual pieces or of whole collections that his institution is a suitable home for their treasures. It will thus be seen that the calls made upon a museum curator are almost endless, and the more he can answer them satisfactorily the more favourably is the museum

in his charge likely to be regarded and supported.

Academic background and training facilities

For his essential training in one or more of the natural sciences, in art, archaeology or ethnography, the potential museum curator will go to a university or an art college and after a course of three, four or five years will graduate with a degree or a diploma. Actual practice in the plastic and decorative arts can be learned in art colleges in many parts of the world, and art history and art criticism are subjects for a degree in arts in many universities. The Louvre in Paris and several of the larger museums and art galleries in the United States of America offer courses in art appreciation. Practical training in the repair and treatment of art objects is available at the Courtauld Institute in London and some colleges in North America, but on the whole it is true to say that such training is usually only to be obtained in the laboratories and workrooms of the largest museums of the major countries, with a long history of museum organization and of experimentation with methods of protection, preservation and display. In most countries, the would-be curator has to get a junior post, either paid or unpaid, and obtain tuition as part of the payment for his services. This is a somewhat unsystematic method of training but there is much to be said in its favour. The work is done under museum conditions and on actual museum specimens, so that from the start the emphasis is laid on the care necessary in dealing with unique objects. Again, the trainee is working directly under an expert or group of experts in the particular craft and is thus receiving individual tuition. There is no mass production about such methods and there is every opportunity for a mistake to be remedied without delay. In addition, such service gives the trainee access to exhibition galleries, store-rooms and laboratories, the three main divisions of the professional side of a museum.

So far it is mainly in the British Isles that systematic general training for museum

service has been worked out and put into practice as distinct from training obtained as described above or from short college courses. This general training is organized by the Museums Association and has been developing with great success ever since World War II. Its culmination is the award of the Diploma of the Museums Association as a professional qualification, the possession of which is evidence of knowledge and experience in the principles of museum service and administration and museum technique. It is awarded to museum workers who have the necessary preliminary education, who have attended three demonstration courses organized by the association, who have completed three years' full-time service in a museum—or two years in the case of university graduates—and passed the prescribed examinations. The regulations are designed to ensure that the diploma will be a reliable indication of professional competence and yet be within the reach of any intelligent and industrious person in the service of a museum, who has reached the specified standard of general education. Although the possession of a university degree or a diploma is not an essential qualification for the award of the association's diploma, great importance is attached to university training and diploma students who are non-graduates are strongly advised to study for a degree if possible. Many posts in the museum world are open only to graduates and the preference for graduates is likely to increase. The Museums Association does not undertake to train candidates in the subjects covered by museum collections—the diploma students must acquire that knowledge for themselves to enable them to pass the prescribed examinations. It is expected that the students will gain professional and technical knowledge in the course of their day-to-day work in their own museums, but demonstration courses are organized to supplement such experience and to direct their attention to advances made.

Applicants for registration as students for the Museums Association diploma must have reached the age of 19 and must produce evidence that they have passed a matriculation examination or other examination which would be accepted for admission to a full degree course in a university in the United Kingdom. They also must have been in full-time, fully-paid employment in a professional capacity in a museum for at least six months. Voluntary workers may be accepted but may not sit for any examination until in full-time and fully-paid employment in a museum. Diploma students are required to follow a curriculum of training and study extending over not less than three years, and to pass the two parts of the prescribed examinations. This curriculum comprises three sections—A, Administrative; B, Technique; and C, Specialized Work. The Administrative Course on general museum administration must be attended by all candidates. The Technical Course may be in art, or archaeology, or natural history, from which the student selects whichever subject is most appropriate to his needs. He may subsequently elect to attend one or more additional courses in order to extend his knowledge. The Specialized Course is devised especially for non-graduate students, and is designed to ensure that their studies adequately cover the field of their chosen subject. The three types of course are each of one week's duration and are in charge of recognized experts with wide experience in museum work.

The examination for the diploma is held in two parts, students sitting Part I following the completion of their work in Sections A and B, provided it is not less than two years after the date of their commencement, and Part II after passing Part I and on the completion of their work in Section C. Part I of the examination consists of papers on administrative, general and special subjects together with an essay; Part II consists of papers on administrative, general and special subjects and an essay, and also includes a second essay to be prepared in advance, an oral examination and a practical test designed to determine the knowledge of the candidate in his selected subject.

These special subjects include: fine arts, paintings, drawings, sculpture and prints; decorative arts; archaeology; folk art including local history; general natural history; botany; geology; zoology; the physical sciences and technology; and any

other academic subject which the Education Committee of the Museums Association may approve. In Section A, the administrative group, a syllabus for courses for training and study and for examination comprises the principles and practice of the control and administration of museums; building, planning, equipment and upkeep; registration and cataloguing; principles and practice of display in public galleries; relation of museums to education and research; publications; publicity; history and bibliography of museums and museum work. In Section B, the technical group, the subjects include the collection, preparation and preservation of specimens and objects; the recognition and treatment of conditions and influences leading to the deterioration or destruction of museum material; exhibition technique; storage; modelling in various media. It will thus be seen that the Museums Association of Great Britain has addressed itself seriously to the problem of providing professional training for beginners in the museums profession—training which cannot be provided in colleges or universities because so much of it must be conducted in and with the full resources of a well-equipped museum. The subjects of museum displays can be, and indeed are provided for in high-level educational institutions, but the professional side of the training is essentially to be dealt with in museums with the aid of experienced museum practitioners.

In the year 1955-56, 19 applicants were accepted as students for the diploma. The number of registered students on 31 March 1956, was 114 which included two Fulbright scholars from the United States of America and 13 students from Commonwealth countries. Six demonstration courses were arranged for diploma students—an administration course at Birmingham, a technical course in archaeology and natural history at Reading, a technical course in art at the Victoria and Albert Museum and the National Gallery, a specialized course in archaeology at Oxford, a specialized course in art at Leeds and York, and a specialized course in natural history at Cardiff—thus showing the wide range of opportunities for study and the wide variety of major institutions co-operating.

In the United States, a lead in providing professional art museum training has been taken by the authorities of the Metropolitan Museum of Art, New York. For the last four years they have had three graduate students on what are termed student fellowships, thereby receiving financial support. These people had to have completed satisfactorily two years of graduate study in the history of fine arts or its equivalent, and were selected on a basis of past performance and interview from candidates from all parts of the United States. For the first month they were given assignments so as to learn something of the other museums of New York and were also set to study the structural and administrative organization of the great Metropolitan Museum itself. Thereafter they spent two months in the departments of cataloguing, restoration, administration, publicity, education and display. For the succeeding six months they were permitted to study the subject of their choice, working intensively but informally in one department. No examinations were set, but each candidate submitted a report at the end of the year. Provided this and their work in general had been satisfactory the trainees were then given an additional grant to permit them to travel and study abroad. Now a new system of training, in close co-operation with the Institute of Fine Arts (the graduate school of the New York University), has been introduced. Under this arrangement, graduate students registered at New York University and seeking museum training will take seven one-term courses in the history of fine arts and one one-term course covering the history and philosophy of art museums at the institute. In the second year, a selected class of not more than eight will take a course given jointly by the personnel of the Metropolitan Museum and of the institute, to be held in the museum. There will be 15 three-hourly meetings at the rate of one a week, conducted on a seminar basis, and with the emphasis on connoisseurship associated with problems in working with actual specimens. The subjects covered include prints and book illustrations, drawings, paintings, classical archaeology and art, mediaeval archaeology and art, and Renaissance archaeology and art.

The students will also attend two or three additional one-term courses in the history of art at the institute, and will devote a term to the preparation of a master's thesis. In the third year, the students who survive the course will devote themselves full time to an apprenticeship in the museum where they will learn the practical side of museum administration, preservation and presentation. They will receive from New York University, upon the successful completion of their studies and the acceptance of their master's thesis, an M.A. in the history of art and from the Metropolitan Museum a certificate in museology awarded under the aegis of the New York State Board of Regents.

The United States National Parks Division maintains a series of laboratories and studios at its headquarters in Washington, D.C., in which all kinds of exhibits, from simple objects to complex dioramas, are treated and staged. Courses of training in this work have been provided, in the first place for recruits and junior members of the service, who receive full pay, travelling and subsistence allowances while in training. Outside students seeking training have been accommodated on occasion, but naturally have to find their own expenses. The museums which the National Parks Division maintains deal with natural history and topography (trailside museums) and ethnography and history (historic site museums) and so forth.

Several universities in the United States have from time to time tackled the problem of providing adequate training for prospective museum administrators and curators. For a time, courses of a general nature were offered at the University of Rochester but were subsequently discontinued. They were to be resumed in 1957. One course has been jointly organized as a team project by the Chicago Natural History Museum and the University of Chicago. In the Chicago Natural History Museum, the Department of Anthropology puts on a well-designed and broadly based course in museology for students taking anthropology as a major subject in the University of Chicago. This course, which is held as numbers demand, requires 15 hours a week for a period of nine months and covers most of the aspects of museum work—loans, gifts and purchases; accession methods; cleaning and repairing specimens; designing and staging exhibitions; planning museum buildings; organizing museum activities and the allocation of jobs among the various staff grades. From time to time, the museum accepts students from foreign countries who wish to learn museum methods. No fellowships are offered nor is any charge made for tuition. Instruction is entirely informal and the students learn mostly by doing things for themselves. In recent years there have been students from British Guiana, Egypt, Iran, Iraq and Israel, and their periods of training have ranged from a few weeks to a whole year. Further, this museum co-operates with Antioch College, at Yellow Springs, Ohio, accepting from four to six students for quarterly periods of work in the museum. Such students keep museum hours and are in actual practice museum employees, receiving a small salary and being given the opportunity to work in some chosen sphere of the natural sciences. This is most valuable in affording an opportunity to find an aptitude for a vocation. The extensive educational division in this museum recruits trainees by personal selection and each new recruit is given a highly intensified course of training for a specific job in the carefully planned and balanced set-up. The actual training is in the hands of senior members of the division's staff. A new course has been started at the University of Oklahoma, associated with the course in anthropology; originally a one-semester course, it has now been extended to two semesters. The principal object of the course is to teach the interpretation, classification, registration and presentation of specimens in different fields, and to encourage an understanding of the problems of modern museums, including education, social activities, public relations and general administration. The museum of the university, with its six sections—anthropology, botany, zoology, history, geology and classical archaeology—provides a training ground for the study of classification, accessioning and cataloguing. Field trips are organized during the week-ends to enable students to see a variety

of different types of museums, to meet their directors and to attend lectures and have discussions with their staffs on the spot. Thereafter opportunities are provided for individual students to carry out appropriate projects such as staging, writing up and publicizing an exhibit in the local museum or public library. General administrative training provided includes a study of the working out of a museum budget for different types of institutions, of the planning of museum galleries and of the organization of study groups and lecture tours. At the close of the course an examination is set to test the students' knowledge and performance.

There is a general dearth of training courses designed to produce good all-round small museum curators in America —i.e., adaptable non-specialists who can cope with a variety of subjects and who have a basic knowledge of good museum practice. Oberlin College, Yale University, and the universities of Buffalo, South Dakota and Oklahoma are leading the way in this general field, while the University of Florida is planning a course on similar lines. Art museum basic training can be had at the following seven centres (partly in the university and partly in the adjacent gallery): New Haven, Conn.; Wilmington, Del.; Boston, Mass.; Cambridge, Mass.; Brooklyn, N.Y.; New York; and Oberlin, Ohio. The duration of the courses varies from six weeks to three years. History museums basic training can be had at the following five centres: Washington, D.C.; Cambridge, Mass.; Dearborn, Mich.; Cooperstown, N.Y.; and Madison, Wis. The courses last from one week to sixteen weeks. Science may be studied at four centres: Iowa City, Iowa; Ann Arbor, Mich.; Buffalo, N.Y.; and Vermillon, S. Dak. The courses vary in length from one week to four years. The general training courses are located at Washington, D.C., Newark, N.J., Norman, Okla., and range from one month to nine months.

At the Ecole du Louvre, Paris, are trained both the future curators of art museums in France and also the guide lecturers who take visitors round the collections. Started in 1882, this school has grown in numbers and influence, and today provides seventeen organized courses catering for between two and three thousand students. A few years before World War II, a 'Section supérieure' was constituted, with special courses in museography, to provide training for art museum curators. The courses include archaeology—prehistoric European, Egyptian, Oriental and Graeco-Roman—prehistoric and historic ceramics, the arts of the Near East, the Middle East and the Far East, the history of sculpture, paintings, design and engraving, applied and decorative arts, furniture and furnishings, inscriptions and numismatics: all studied in the several departments of the Louvre. There is also a course in the general history of art based upon the collections in various museums, and lasting for three years, the first year being devoted to the art of the ancient world, the second to that of the Middle Ages and the Renaissance, and the third to that of modern times. Finally, there is a special course on museology, consisting of a study of the history and the general principles governing the organization and lay-out of museums and of special collections at home and abroad. This is followed by practical work on the management and functions of museums, and the course is concluded by technical studies and practices in specialist fields. In all these studies resident and visiting museum directors play an important part. The students attending the Ecole du Louvre are either Approved Students or Independent Students. Approved Students, of whom about twelve are accepted each year, must, during their course or at the end of their third year, take a special course of about three months' duration in a department of the Louvre chosen by them. The best of the Independent Students can likewise undergo similar specialist training. Museum guide lecturers, attached to the educational services, are selected from either type of student, but they must take a course prescribed for them and pass a competitive examination at the conclusion, thus gaining the right to style themselves 'Chargés de Conférences des Musées'. Independent Students, who have done good work, are eligible for appointment as curators in the smaller provincial museums.

There is no organized course for art museum curators or for natural history museum curators in Germany as yet. Individual young students of art history, following graduation, can embark upon a voluntary art course at one or other of the large museums, more or less on the lines of attachés or internes in American museums. In Munich they prosecute their studies for a period of two years, and in three different departments. Karlsruhe has a similar arrangement, which can sometimes be reduced to one year. Before the late war, Berlin was the principal centre for museum studies, which then lasted three years and could be carried out in any three different departments. Only now are such facilities being afforded again.

In South Africa where there is an active group of museums of various types, linked by an important Museums Association, the need for adequate training services for recruits to the museums profession is fully realized as is also the absolute necessity for a generally accepted standard to be expected of museum assistants. To this end, discussions are taking place with the object of providing training services and centres at such museums as those in Durban, East London and Pietermaritzburg. It is hoped to obtain financial support for the scheme from interested people, and to organize training courses of not less than two months' duration.

Post-academic experience

From the above remarks it will be seen how much museums rely upon universities to provide their staffs with the basic academic training necessary for the performance of their scientific duties and, on the other hand, how much of the professional training must be secured in museums and kindred institutions. Indeed it is true to say that it is impossible to train a museum officer adequately outside a museum. Nor does that training cease during the active lifetime of a curator, for he must always seek further experience and experiments both inside and outside the walls of his own institution. He must visit museums and art galleries in other towns and travel abroad

for the express purpose of studying museum techniques elsewhere. Again, he may receive new ideas from travelling exhibitions, which come with their specimens already set out for display. In particular, he should seize any opportunity to inspect new museums and to assess the value of the new ideas incorporated in them—in their exhibition galleries, store rooms, laboratories and work rooms, class rooms and ancillary public rooms, and in their methods of heating, lighting and ventilation. The rising generation of museum curators is well served by the Unesco quarterly publication *Museum,* which issues accounts of novel exhibitions, new museum buildings and current activities, all handsomely illustrated by excellent photographs.

Museum curators cannot be too strongly encouraged to travel abroad on study tours and to inspect museums in other countries so as to see what is being attempted and accomplished elsewhere, and to meet other museum curators and discuss problems with them. Such tours provide invaluable opportunities to air one's own difficulties in a sympathetic atmosphere, to see other solutions to similar difficulties, and to revive one's sense of vital public service. The intending traveller should first seek the approval and support of his own employing board, committee or government, to whom he must look for the special long leave to carry out his scheme. Secondly he ought to seek financial aid for his project, which may well be a fairly expensive one. Sources of financial aid fall into two main groups—international bodies and national ones. International bodies which may be approached for travel grants, scholarships or fellowships are Unesco and one or two of the big foundations in the United States of America. The Unesco handbook *Study Abroad* contains particulars of fellowships and scholarships tenable in various parts of the world. It can be consulted at most ministries of education throughout the world or purchased at Unesco House, Place de Fontenoy, Paris-7e, France. The national bodies to be approached are the ministries of education, culture and finance in the candidate's own country, the secretaries of which will be able to give details of

the persons to whom application should be made. Certain universities hold travel funds to aid specific cultural projects; consultation of their yearbooks or applications to their secretaries may provide the candidate with the opportunity he seeks. The British Council in London, publishes a small handbook entitled *Scholarships Abroad offered to British Students by Foreign Governments;* a similar publication should be sought in the country of the intending traveller.

Where the museum has only one professional curator, he must concentrate in great detail upon the subject he has made his special study, be it the natural sciences or an aspect of human history, and make his exhibition series in that field pre-eminently attractive, interesting and reliable. He must also however devote some considerable time, perhaps with the aid of temporary or honorary assistants, to making the other departments of his museum redound to his credit as well. Temporary expert assistance in other fields may be obtained from university or college lecturers or retired members of staffs, or from laymen who have made a hobby of studies in the fields desired. When circumstances and finances permit, a second or assistant curator should be appointed, care being taken to see that his main field is complementary to that of the senior, so that together they will be able to deal authoritatively with the variety of material likely to be afforded to them for showing and with the search for information concerning it. If the curator is an archaeologist, then his assistant should be a natural scientist, and vice versa. Further increases in staff will naturally widen the range of subjects that can be dealt with in detail.

THE OFFICE STAFF

The curator of a small museum may have to be his own secretary, attend to his own correspondence, and keep his own records and registers, but he should do his best to get some trained clerical assistance as soon as possible. An active museum will have a growing volume of correspondence, and more and more work to be done in registering accessions and collecting information about its specimens. There will always be work for an office staff—keeping accounts, working out the pay sheets, etc. Help and advice regarding the organization of a museum office may be sought from other bodies with experience in keeping archives and records, such as libraries, banks and insurance companies. Maximum use should be made of labour-saving and space-saving office furniture and equipment.

THE TECHNICAL STAFF

Also behind the scenes but of vital importance for the efficient running of any museum are the work rooms and their staffs. These fall into two main groups—those dealing with museum specimens and those dealing with museum fabric and furniture. As was mentioned earlier, museum specimens call for continuous attention from the time they arrive or are made until they are finally disposed of. For cleaning and repair work the museum must have an assistant who is thoroughly interested in the objects, whether they are natural history specimens or human artifacts. Here again the work falls into two groups and it will ultimately be necessary to have one assistant to clean and mount birds and butterflies and another to learn the various techniques of treating wood to protect it against parasites, cleaning paint surfaces buried under the grime of ages, reconstructing broken vases etc., and repairing old costumes and tapestries. While wood carving, metal work, modelling and painting may be learned at school or art college, many of the skills necessary in a museum work room can only be learned by practical experience on the job. It may be possible to find a likely young recruit, already keen on this type of work, and to send him for a few months' training to a large museum with the staff and equipment to teach him the rudiments of his craft, in which, by steady application, he will in time become expert. He should have an inquiring mind and be ready to experiment, using expendable material until he becomes skilful and reliable. Good work can be aided by good working conditions. The

room devoted to museum specimen repairs must be well lit and well ventilated. It should be fitted with several good working benches and large sinks, and have a plentiful supply of hot and cold water and some form of heating equipment. Adequate cupboards and storage racks for chemical reagents and paints should also be provided.

As regards artisans or skilled workmen, the first essential for a museum is undoubtedly a good handyman, preferably a joiner or a cabinet maker. Such a craftsman can effect repairs to old furniture, frame and glaze pictures, build display cases and construct brackets, shelves and screens upon which to arrange objects. He can be most useful in dealing with locks and keys and doors and windows, he can erect platforms for lectures or opening ceremonies, make packing crates, help with unpacking and packing, and fix advertising and notice boards. The second workman to appoint, in these days when colour counts so much, should be a painter. He, like the joiner, can clean and touch up specimens of old furniture, can paint display cases, do small internal decoration jobs and, if he has had some training in sign writing, he can paint direction signs above cases and doorways and even design notices for the outside of the building. Moreover, a good cabinet maker and a good painter working together can be of inestimable use in a museum in designing and fabricating models for exhibition. For example they could illustrate the history of domestic architecture by making a series of scale models of types of houses down the ages, with sectional models to show the structures of roofs, doors and windows. As it may be necessary to make do in smaller museums with one or two assistants who combine several skills, the Museums Association of Great Britain has introduced a Technical Certificate as a warrant of proficiency confering adequate standing on those workers who pass the requisite examination.

If a third workman is employed, the appointment will depend upon the character and volume of work for which he is required. It might be advisable in some cases to employ a second joiner or cabinet maker; another museum, however, may find it advantageous to have a printer on its staff. A museum owes much of the good impression it makes on the visitor to well phrased and neatly printed labels. The first labels used may often be handwritten or typewritten. The former are laborious to produce and the latter suffer from being rather small in type for convenient reading, and both have a tendency to fade. While the modern electric typewriter produces excellent labels, it is a very expensive machine to buy. No label is as neat and lasting as a printed label, and the wide range of type sizes available makes it possible to have bold headlines where necessary or small, succinct texts to accompany smaller and more delicate objects. Once installed, a hand printing set lasts for many years and can be used to produce labels, notices, programmes of meetings and lectures and so on. As the staff grows, other skilled workers may be employed, such as a metal worker, a French polisher or an electrician, the demands for whose services naturally vary considerably from one museum to another. An art gallery, on the other hand, would require a competent picture framer and a print mounter.

THE GUARDS

With regard to the maintenance of order in a museum or an art gallery and the security of its collections, two considerations arise. The first is that there must be adequate patrolling and supervision throughout the galleries during the hours when the public is admitted to the building. The number of guards or attendants required depends on the size and type of the institution—a large building naturally requires more supervision than a small one, one with several floors calls for more staff than one on a single level, and one with many small rooms more than one with a few large halls with uninterrupted vistas. The more blind areas there are—such as those produced by screens, high cases and an intermingling of high and low or large and small objects—the more supervision is necessary. To be efficient, supervision must be continuous—and allowance must be made

for periods of absence such as meal times and holidays. This, however, is offset by the fact that the duties of supervisory staff can often be combined with assisting in case moving and in loading or unloading, packing or unpacking. Guards and attendants must all be chosen with the greatest care and must be thoroughly reliable in every way. Many museum attendants are ex-non-commissioned officers of the armed forces or retired policemen, accustomed to discipline, neat personal appearance and to the general requirements of guard duties. They should be men of good manners, trained to deal firmly yet politely with the public and able to answer the general questions put to them. Since the visitor's impression of a museum or an art gallery depends to a large extent upon them, great care should be exercised in selecting men for such posts. While they may never be called upon to act as firemen, these men should be trained in the use of fire-fighting apparatus—chemical fire extinguishers, hoses, etc.—and they should know the lay-out of the water, gas and electricity services and the positions of the various control valves and switches.

WATCHMEN

In a large institution or one housing very valuable specimens, it is necessary to ensure efficient warding of the building and its collections during the hours when the public are not admitted. This involves warders or watchmen being on duty, in rotation, twenty-four hours a day. If the museum is open for eight hours a day, there will be over sixteen hours to be covered by the watchmen; this can be done by having at least two men, each of whom is on duty for a watching shift of eight hours. To ensure efficient patrolling of the building, time clocks can be fitted at strategic points, so that the watchman must pass through the various galleries so many times each shift, the visits to the clocking points being recorded on paper dials which can be inspected subsequently by the curator or another officer. Additional security can be achieved by arranging for telephone calls to be made from time to time between the museum and the local police headquarters.

CLEANING SERVICES

After security, the next important consideration in the administration of any museum is cleanliness. Nothing is more likely to appeal to the visitor when he first arrives than a museum presenting a bright and shining appearance—well dusted and polished woodwork and furniture, shining glass cases, well swept and tended floors and steps, and well polished door handles, hand-rails and other metal fittings. In a small museum the cleaning may be performed by the warder staff before the public enter the building and is often continued during the forenoon. If this is the case, the heavy work such as sweeping, washing and polishing floors and stairs should be completed before the public are admitted; the lighter work, such as polishing the furniture, polishing the glazed cases or dusting heavy and large, free-standing specimens and cleaning windows, should be left till later, when supervision has to be maintained. In a large museum, it will be necessary to employ special cleaning staff, either male or female. Here again, the heavy cleaning work should always be completed before the public enters the building, only the light cleaning and polishing being done while visitors are moving about the halls and inspecting the exhibitions. The bigger the building, the larger must be the cleaning staff and the greater the amount of cleaning materials required; once the staff reaches a certain size someone is needed in a supervisory capacity to take charge of bulk stores of cleaning materials and ration their distribution according to the amount of work to be done, and to allocate and check the various tasks. The quantity of cleaning materials required will vary according to the number of visitors and the state of the weather. The cost of cleaning a museum or an art gallery is a considerable item in the annual expenditure. In at least two ways economies can be effected. The first is at the planning stage of the building, when care should be exercised to eliminate unnecessary decorative

devices, ledges where the dust accumulates or places difficult of access for cleaning purposes. Horizontal bars in railings or stair balustrading, for example, demand much time and care in cleaning, since feather dusters merely flick the dust from one place to another. Radiators are also traps for dirt. The second way of saving time and labour is to employ, wherever possible, modern mechanical devices, generally electrically operated, such as vacuum cleaners and floor polishers. While polished wood, cork and rubber floors present a most attractive appearance, care must be taken to employ non-slip polishes, to avoid the danger of accidents to the public.

OTHER SPECIALIZED STAFF

The foregoing remarks apply to any museum with a staff of between five and fifty in number. The bigger the institution the larger the staff, the greater the field of specialization and the more numerous the services that can be offered to the public. It is curious to note that it is in both smallest and the largest museums that the curator has the least time to devote to his own particular branch of study. In a small institution he has to be a Jack-of-all-trades, ready to turn his hand to almost any kind of work; in a very large one his work is very largely that of a general manager and administrator. But at all levels his major concern is service to the public, which finds the money to run the museum or gallery. Greater funds do however make it possible to employ a larger number of persons to do specialized jobs. A museum may, for example, be able to appoint a registrar to deal with accessions, loans, and the never-ending task of bringing identifications up to date and adding fresh notes on the history, provenance and peculiarities of the specimens. A museum may also in time institute its own central library—in addition to the individual reference libraries of the keepers —to serve all its staff, and the supervision of this library naturally calls for the appointment of a full-time librarian. Again, the keeping of detailed records of specimens may demand the employment of a photographer and the construction of a dark

room and photographic laboratory. This expert can be employed, not only in preparing photographs to go with accession cards and card-index records, but also lantern slides for public lectures and prints for general sale to the public.

EDUCATIONAL SERVICE

One of the functions of museums is to provide direct educational services to the public. In a small museum, lectures, talks and guided lecture tours are mainly carried out by the curator himself or the assistant curator. School classes visiting the museum may be taken round the collections and given special lessons either by the curator and his assistant or by the individual class teacher after some preliminary briefing by the museum staff. Again, duplicate specimens may be made up in small carrying cases with printed or typewritten notes for loan to schools for classroom use. As the educational services of the museum grow, special provision will have to be made to meet the demands for both staff and material.

In some centres, school teachers are seconded by the local education authority to serve as guide lecturers and specialist teachers for classes visiting museums and art galleries; in others special additions are made to the staff of the museum for this purpose. The latter are usually young university graduates with a special bent for this kind of work and often with some actual experience in class teaching. At first they will have much to learn about the museum collections and how to use exhibits and specimens in lessons; and they will also have to acquire experience in the techniques of holding the attention of a group of children in the public galleries of a museum. But the task is undoubtedly a most rewarding one, and one which will both open the door of a new world to the children and inculcate the valuable habit of resorting to museums and art galleries in later years. Guide lecturers have also to learn how to handle adult parties, to stimulate their interest and to satisfy their curiosity, in the hope of encouraging at least some of their hearers to take a new interest in natural history, archaeology or some art

or craft. While the main emphasis in this work is naturally laid upon the inspection of the museum's three-dimensional exhibits, use should also be made of lectures and of such auxiliary aids as lantern slides, films and demonstrations. In addition, a good guide lecturer can give recommendations regarding books to consult and appropriate societies to join, so as to encourage a continuation and an extension of the interest aroused. Not only does this legitimate extension of museum activities demand extra staff, it also requires special equipment in the form of folding stools, drawing boards, storage cupboards and cloakroom accommodation.

The second aspect of museum aid to education, the provision of loan services, requires suitable specimens, information sheets, containers, adequate storage accommodation, transport and staff. The staff required fall into three categories—first, those employed in making models, mounting birds, framing pictures and textiles and setting specimens on suitable backboards; secondly, those who are responsible for the organizing and clerical duties, such as circularizing schools regarding the loan exhibits available, booking and allocating the requests, despatching the loans and recovering them at the end of the agreed period; and thirdly, those directly concerned with inward and outward transportation.

The first group belong to the normal museum grade of technical assistants or preparers, their duties being the preparation of the same type of exhibit, the only difference being that all the exhibits must be small enough to be readily transportable and strong enough to stand transport and handling in the class room. These workers must also devote a considerable amount of time to the renovation of exhibits showing signs of wear and tear as a result of continued handling. The second group will probably be recruited straight from art or other colleges and must combine a real interest in three-dimensional objects with an interest in the use of such objects to educate children. They must have some knowledge of the elements of teaching and of the contents of standard school curricula. Especially they should have the imagination to understand the world of the child and the enthu-

siasm to broaden his horizons. The third group will handle the transport between the museum depot and the schools, packing and unpacking the cases and delivering them by motor van. Such school loan services usually begin in a very small way with a staff of two or three, but as the demand increases so also must the number of individuals employed increase. Where this service is part of a normal museum, care should be taken to see that the demands it makes are not to the detriment of the maintenance and utilization of the standard museum exhibits.

SUMMARY AND SUGGESTIONS
FOR STAFF TABLES

After this description in some detail of the types of employees to be found on the staffs of museums and art galleries and the duties they have to perform, it will be of advantage to consider the administrative set-up of three museums of different sizes. For the first, a local museum of, say, four large rooms or galleries, six small rooms serving as offices and work rooms and four store rooms, the staff required would be a curator and an assistant curator, a typist-clerk, a technical assistant, two guards and two cleaners. In such an organization the curator and the assistant curator would be responsible for the collecting, the identification and the arrangement of the museum material, while the technical assistant would clean, repair and mount specimens, and probably undertake the interior decoration of the cases as well. The two cleaners would be responsible for the general cleaning of the building, while the two warders would clean furniture and glass cases before opening hours and patrol the building once the public was admitted. As the number of visitors in the forenoons of weekdays from Mondays to Fridays is likely to be small, cleaning operations could be carried out by the guards up to the lunch break.

In a larger regional museum of, say, twenty halls or galleries, containing exhibits classified in four major departments, a senior staff of a director and four keepers would be required, each of the keepers

having a separate department under his control. The office in that case, considering the volume of correspondence, inquiries and registration to be dealt with, would need at least two clerical assistants. To clean, mount, work through material and look after the extensive reserve and study collections in each department, each keeper would require one technical assistant. The patrolling of the building would call for a minimum of twelve guards one of whom could act as the senior, to see that the instructions of the director were carried out in an orderly way. At least eight women cleaners would be needed to keep such a building—with its exhibition rooms, store rooms, work rooms and offices—in good order, and one of these cleaners could serve as supervisor. Two tradesmen—a joiner and a painter—could be kept in constant employment. In the administration of such a building and staff, the director would exercise over-all supervision. He would preside directly over his office and control the activities of the four departments through their keepers, under whom the technical assistants would serve. To correlate the work of the guards and cleaners and take charge of the bulk stores for cleaning and packing, a foreman would be necessary, through whom orders and instructions could be transmitted from the director. The foreman could also allocate and supervise jobs for the two tradesmen. The appointment of a senior guard and a supervisor of cleaners would ensure the proper carrying out of the work entrusted to these two relatively large groups of twelve and eight respectively, among whom disputes might well occur as to which job was to be done by whom, in what way and in what order. For the efficient administration of any staff and the proper carrying out of respective duties, especially where they involve team work, there must be a clearly established order of seniority and system of control to ensure that detailed instructions reach each individual concerned, are clearly understood, and are properly carried out. In this particular case, the director's immediate contacts would be (a) the four keepers (b) the senior of the two clerks, and (c) the foreman. Through them and with their aid work in all the departments could be allocated and reports received regarding its completion. It would fall to the director to make periodic tours of inspection to satisfy himself that his orders had been carried out to his satisfaction. Such tours of inspection serve the additional purpose of encouraging the good worker, who works all the better for an appreciative notice, and of stimulating any, who may be slack or slow, to put forth greater efforts to avoid adverse comment. It may be added, as a result of considerable experience, that it is advisable to be reasonably economical with both praise and blame.

Having considered the staff set-up in a small local museum employing eight, and a larger regional museum employing thirty-four, we shall take as the final example a central or national museum of forty or fifty galleries with a staff of nearly a hundred. Assuming that there are again four major departments, the director would have under him a senior staff of four keepers, each of whom would require two assistant keepers to enable the field of each department to be sub-divided into three, each officer undertaking to make himself expert in certain branches of the studies involved. Each keeper would be responsible for the staff, the collections, and the registration in his department. The collections would be in part on exhibition, in part in store, with perhaps a small number of exhibits on loan elsewhere. To look after these collections, each keeper would need a staff of two kinds—museum assistants responsible for registration, location noting, dusting, and orderly arrangement of the specimens in the exhibition galleries and in store cupboards and cabinets behind the scenes; and technical assistants, equipped with research apparatus in laboratories and work rooms, to deal with the cleaning, repair, preservation and scientific investigation of individual specimens. Each department would need a task force of a senior museum assistant and three museum assistants and, in the laboratories, two technical assistants. The office staff for such a museum would call for a secretary, an accountant and two clerks at least, together with a telephone exchange operator and a messenger. The artisans required by a national museum

would be about ten joiners, painters, French polishers, metal-workers and electricians, plus one or two engineers to look after the heating plant. Under a museum superintendent would be placed the security and cleaning staffs which, in such a museum, would number at least fifteen guards, eighteen male cleaners and twelve women cleaners. This yields a total of ninety-seven. In this case the director gives his instructions direct to the four keepers, the secretary, the accountant and the museum superintendent, a closely-knit organization of seven people, to each of whom is left the task of allocating particular duties and special projects. Nor is the line too long to the furthest members in the staff pattern —an equally important consideration in an institution where everyone must know and understand the details of all that is to be done, must appreciate what other members of the staff are doing and must share in the spirit that lies behind the whole undertaking. The bigger the museum the greater the need for a combination of individual responsibility and genuine team spirit. There are few forms of public service that offer a more rewarding sense of vocation than work in the field of museums and art galleries.

CHAPTER IV

MUSEUMS AND RESEARCH[1]

by Hiroshi DAIFUKU

INTRODUCTION

Research is defined as 'critical and exhaustive investigation or experimentation, having for its aim the discovery of new facts, their correct interpretation, the revision of accepted conclusions, theories or laws. . . .'

In the light of this definition, it must be admitted that the most vigorous research programmes are to be found among the larger museums and those affiliated with or belonging to educational institutions. There is, however, a growing tendency among smaller museums to acquire scientific staff—particularly younger people—qualified to undertake serious research as part of their curatorial duties.

As in the universities and colleges, the work undertaken by museums has been in academic rather than in applied research.[2] The series of scientific and scholarly monographs which have been published by various museums are similar to those published by universities on the same type of work. The principal difference between the two types of institutions is that the museum also publicizes the results of its research through public exhibitions and displays. There are, of course, exceptions to this rule, for some highly specialized museums (e.g., medical museums) are not open to the general public and are intended for very restricted audiences.

It is impossible to list here in detail all the notable contributions made by museums and their staffs through research programmes. A brief outline of some of the principal fields of research must suffice. There are no clear-cut lines of division between the kinds of research work undertaken by the different types of museums. For example, art and anthropological (in the American use of the word) museums may undertake archaeological research, the former as the inheritors of the tradition of collecting Greek and Roman art which began during the Renaissance, and the latter, as the study of the origins of man, which took over pre-historic archaeology. Today, however, anthropological museums also study civilizations in the New World which are comparable in development to those of Classical Antiquity studied by archaeologists in fine art museums. As in other areas of scientific work, the growing tendency towards interdisciplinary studies in which several institutions in different fields may co-operate in major programmes of research has further broken down the traditional dividing lines between the areas of specialization.

For purposes of review, we may nevertheless describe in summary form some of the principal forms of research undertaken by different classes of museums,

MUSEUMS IN THE HUMANITIES

The primary emphasis of research has been in the field of art history. Studies have

1. I wish to acknowledge the aid of Dr. Hans van de Waal, Professor of Art History, University of Leyden, for his kind suggestions about this manuscript.
2. 'Applied' research in museography is becoming more important, as the idea that museum work is a profession has gradually become widespread. Projects such as the study of effects of exhibitions, of analyses of the behaviour of visitors, the effects of publicity to attract visitors, have taken place in several countries . . . see Chapter V, page 73.

been made of the work of a given artist, of 'schools' of art, etc. In recent years the scope of such research has been broadened to include studies not only of the works of individual artists or even of 'schools', but of major cultural trends which have found expression in the works of artists.

A great deal of what is known of the evolution of human society from the simple 'city state' to the large political agglomeration has been the result of research undertaken by archaeologists on the staff of art museums. The collections in such museums as the Metropolitan of New York or the Louvre in Paris are a striking testimony to the importance of this type of research.

Folk art and decorative art museums also conduct a great deal of historic research. Research on the art of primitive peoples would also include ethnological studies.

Applied research, especially in the technical analysis of works of art (drawing upon chemistry and physics), constitutes an important part of the research studies undertaken by the major art museums and their laboratories.[1]

The specialized interests of many other types of art museums are reflected in their research programmes. Each museum has also the further responsibility of interpreting the results of its research to its lay public. The late Francis Henry Taylor, who had not only conducted a great deal of research but also instituted popular programmes which increased the attendance in the museums in which he worked, made the following comments concerning the problems of the relationship between the artist and the public [6].[2] 'If the artist is obligated to communicate his meaning, the public in return should bear in mind that they are no less obligated to make an effort to understand what the artist is saying to them. The message of art is not necessarily a simple message or an easy one; and it is quite legitimate that a painting or a statue be meaningless to persons at one level of education and yet be clear and explicit to those of another level, who are particularly trained to understand it. The same layman who takes offence at an abstract picture in an exhibition, into which the artist has put years of self-discipline in logical and orderly abstract or theoretical ideas, will accept without question the right of a university or a research foundation to publish abstruse mathematical conclusions and equations which, as an untrained person, he can never hope to comprehend.'

The schoolboys of today accept the principles underlying flight and use them in constructing model aeroplanes which are far more sophisticated in design than the early pioneering attempts of not so long ago. The lay public in Western countries accepts too with appreciation the works of the Impressionists which were once greeted with scorn and dismay. Is it not part of the task of the science museum to interpret principles which underlie modern scientific development in terms which visitors can understand? Should not the art museum perform the same service for contemporary art? Is 'cultural lag' necessary? The curator in an art museum, working with current trends, is or ought to be aware of the factors influencing contemporary artistic creation. One of his tasks surely is to use his knowledge and training in interpreting the art of the present day in terms which the public can understand.

SCIENCE MUSEUMS

There are two main categories of science museums—those for the natural and those for the physical sciences. These two categories may in turn be subdivided according to specializations, but such divisions are never hard and fast and overlapping frequently occurs.

In general, natural science museums assign a larger proportion of their budget to research than do other museums. During the latter half of the nineteenth century and the early twentieth century they sent collecting expeditions throughout the world and accumulated specimens from the depths of the seas to the upper reaches of high mountain ranges.

Expeditions were sent to collect contemporary species and also to search ancient geological beds for fossils demonstrating

1. See Chapter VII.
2. The figures between brackets refer to the bibliography on page 72.

the sequence of evolution which have formed the basis for new theories about biological evolution and the creation of 'laws', making it possible to explain for example, the changes in size of different species throughout spans of millions of years. Certain studies undertaken by museum staffs have also had direct economic value (e.g. the study of invertebrate palaeontology is important to the petroleum industry), although such commercial applications were not the purpose of the research. Natural science museums have also conducted studies of local ecology and, in addition to their studies of zoology and botany, many include anthropology, the study of man from the point of view of his biological evolution and his cultural history up to the early stages of urban civilization (including the urban cultures of pre-Columbian America).

The physical science museums also cover technology and industry. For the most part their research is devoted to historical studies of the development of the physical sciences and of industry. Many of their displays are didactic exhibits giving an explanation of principles underlying modern science and industry. A great deal of study must go into the preparation of such exhibitions for they must be historically accurate and at the same time help the visitor to understand the operation of the mechanism which is being demonstrated. They can be and frequently are an excellent means of illustrating the transition from primitive industry to modern technology.

Other types of museums reflect man's interest in and curiosity about the world and the universe. Regional museums undertake studies of their areas including archaeology, folk art, local industry, etc., and produce publications and exhibitions of real scientific worth. Historical society museums, ancient buildings and the homes of famous men have also become the foci of research leading to new knowledge of the past.

PUBLICATIONS

Museum publications give perhaps the best indication of the amount of research undertaken by them. The wide range of scholarly research carried on by certain museums is evidenced by their 'papers', 'series', 'quarterlies' and other types of scholarly monographs and journals. These publications have a wide circulation among libraries, universities, museums and professional people whose interests they serve. They are, of course, too numerous to list here. Museum staff members also publish articles in professional journals or have books published by commercial printers.

Reports on research work, or the results of a museum expedition often appear too, in the popular press—usually prepared by those responsible. Some museums, a notable example is the American Museum of Natural History in New York, publish in their monthly magazines 'popular' scientific articles [4], summarizing the work being done by their staff or by other allied institutions. Thus the contributions of museums to research are publicized not only in the professional journals but are made available to the general public.

STAFF[1]

Whether or not a museum has an active programme of research depends on the curatorial staff. Most large museums have such programmes, and there are many small or local museums whose staff also engage in research. Their curators may conduct research independently or in co-operation with members of larger museums, universities, learned societies, etc. Such co-operative work is also advantageous to larger museums as a means of obtaining local co-operation and the use of local facilities.

In rare cases, persons without university training and lacking any advanced degrees have still made major contributions to knowledge. Nevertheless, they are the exceptions to the rule and it is generally agreed that curatorial staff should have academic training to give them the necessary background for the execution of their duties, and particularly for research work. Academic training is, in fact, the minimal requirement, for successful research projects depend in

1. See also Chapter III.

the final analysis upon the initiative and interest of the researcher; the human element is the most important.

The share of responsibility taken by the scientific staff for general museum programmes is increasing steadily in most institutions. In some museums which have active programmes in the traditional areas of academic studies there is, however, a sharp dichotomy between the curators carrying on research and the staff members engaged in such museographical problems as display and programmes for the general public. This creates, in effect, two separate organizations whose only common interest lies in sharing the same building and the same over-all organization. This cannot fail to be demoralizing, with consequent detriment to the progress of the museum.

To the specialist in research falls the responsibility of working out the selection of objects to be shown and planning the background of the exhibition so that the confidence in its authenticity, on the part of the public as well as of the visiting scholars, in justified. Some of the most interesting exhibitions have resulted from close co-operation between the specialist, the curator in charge of the educational programme and the curator in charge of the exhibition. At its best such work produces exhibitions of considerable educational value and aesthetic appeal.

In small museums or those having limited budgets and unable to afford curators who have been trained as designers, the specialist in research should also be familiar with the basic principles of design for presentation. He should know the techniques worked out by Bayer for the use of the principle of the 'field of vision' in setting up displays placing objects in the correct relation to the height and the angle of the average visitor's field of vision. The curator should know the basic principles governing the use of colour, the use of space to accentuate objects, and of lighting. He should be familiar with the work of outstanding designers at international fairs, exhibitions, and of the work being done among the leading museums in exhibition techniques [5].

At the same time this should not mean a sacrifice of his original function. Recently Colbert [1] stated: 'Whether the curator does exhibition work of necessity or through choice, it is important that he participates in this phase of the museum's activity if the museum is to have authoritative exhibits. This is where the curator's research pays off so far as the museum administration and the public are concerned. . . .'

He adds that: 'The sad part of this aspect of the curator's work is that exhibition work can overwhelm him. Exhibits may take a very large fraction of his time . . . but after that, for compensation he should for a considerable period of time be entirely free from exhibition problems in order that he may catch up with his neglected research.'

The foregoing represents the dangers of one extreme, but in some countries curators still have very little to do with projects designed for the public.

FACILITIES FOR RESEARCH

These facilities may be at a minimum, but if a museum believes that its staff should engage in original and creative work, it should encourage research by providing the necessary time, and should assist the curator by providing working space, equipment and funds. An indication of the importance attached to research is given by the amount of space which is usually allotted for it by museums. According to Coleman [3], the 'rule of thumb' is to devote at least as much space for curatorial, administrative and service purposes as is allotted for exhibitions. Space for curatorial work (i.e. laboratories, study collections, study facilities) should amount to a third, and in some museums may take over one-half, of the total available space.

Most curators possess personal libraries, but the museum also should have an adequate library for the use of its staff and for visitors who wish to undertake serious study. It is estimated by Coleman [3] that well-known museums of intermediate size in the United States have libraries of about 25,000 volumes, and it is not uncommon for museums to have libraries of over 100,000 volumes.

Many museums provide in their budgets for travel for their professional staff and

for their administrative officers. Conferences of fellow professionals encourage the informal exchange of ideas, and make it possible to keep up with current research (the results of which may not be published for several years). In general, they act as a stimulant to the individual and encourage further work in research.

THE FUTURE

Work in the traditional areas of research will undoubtedly continue, with a gradual shift in emphasis from the collection of material towards analytical studies. Cooperative projects involving several institutions which combine their resources and talents are becoming more and more common. These projects also contribute to the development of interdisciplinary research through which individual specialists can pool their efforts and arrive at a more comprehensive analysis than it is possible to accomplish alone.

One of the important problems facing the underdeveloped countries today is how to improve their standards of living through the incorporation of technological advance, and yet maintain the continuity of their traditions and culture. This problem presents a challenge to all the institutions in such societies and especially to museums which can play such an important part. Several of these countries already have physical science or technological museums under way or in the planning stage. Their staffs must prepare exhibitions for largely illiterate audiences to whom the new tech-

niques are entirely alien. The interpretation of these techniques which have arisen in a foreign tradition will demand a great deal of careful experimentation and analysis.

Natural science museums carrying out regional ecological studies should analyse and interpret prevailing practices in land usage and demonstrate through exhibitions modified methods based upon scientific analyses.

Under the present stress of acculturation which has resulted from the introduction of new techniques at an ever-increasing pace, knowledge of traditional arts and cultures must be recorded and collections made before these arts become irretrievably lost. Analytical studies of these societies, of their changing cultural values, should also be undertaken by museums, but they can only be satisfactory if they are scientifically accurate.

To sum up the importance of research in museum development Coleman [2], in 1939 made the following statement which is still valid today: 'Like institutions of higher education, museums are likely to be as deep or as shallow in their teaching as they are strong or weak in research. When there is no spirit of enquiry there can be but limited learning since the scholar is the product of investigation. Where teaching goes on unrefreshed by learning, it soon becomes uninformed or even dull. Museum material demands that whoever will interpret it be well prepared. . . . Research and teaching, though often questioned as to their need and even their right to belong together, are jointly helpful to the workings of a museum.'

BIBLIOGRAPHY

1. COLBERT, E. H. 'On being a curator', *Curator,* a quarterly publication of the American Museum of Natural History, New York, Vol. I, No. 1, 1958.
2. COLEMAN, Laurence Vail. *The museum in America.* 3 volumes. Washington, D.C., American Association of Museums, 1939. (See Volume II, page 370.)
3. ——. *Museum buildings.* Washington, D.C.,

American Association of Museums, 1950. (Volume I.)
4. *Natural History.* New York, N.Y., American Museum of Natural History.
5. NELSON, George. *Display.* New York, N.Y., Whitney Publications, 1953.
6. TAYLOR, F. H. 'Art and human dignity', *Saturday Evening Post,* 17 May 1958. ('Adventures of the mind'.)

THE MUSEUM AND THE VISITOR

by Hiroshi Daifuku

INTRODUCTION

During the nineteenth century many museums were sanctuaries rarely invaded by the public and, in fact, frequently inaccessible except through special appointment. Today, however, it is generally agreed that one of the functions of the museum is to show its collections to the public. There are still certain types of museums, such as those attached to medical schools, where entrance is restricted to a particular group, but they are exceptions to the general rule. The great majority of museums are open to everyone, although their success in attracting visitors varies considerably and depends upon a number of factors including the nature of the collections, the periods of time when the museum is open, the programmes conceived for the visitors, and so forth.

To a certain extent the origin of museums still tends to colour the relationship between the museum and the visiting public. Museums began as collections accumulated by connoisseurs, or scholars, which were shown to friends or to societies. Those who took the pains to visit the museum were more frequently than not already aware of the nature and the value of the collections. Today, a covert assumption undoubtedly exists among some museum workers that visitors, whatever their background, have or ought to have the same interests as the curator. If it becomes evident that few visitors seem interested in the material on display, it is all too common to blame the visitor for his lack of taste or education, thus disclaiming responsibility for the success or failure of the museum's programme for the public.

However, as long ago as 1870 the Metropolitan Museum of Art in New York stated in its charter that it was formed: 'for the purpose of establishing and maintaining in said city a museum and library of art, of encouraging and developing the study of fine arts, and the application of arts to manufacture and practical life, of advancing general knowledge of kindred subjects, and, to that end, of furnishing popular instruction and . . . it shall be classified as an educational institution'.

If it is conceded that other museums share this goal, then the assumption that the curator knows what is best for the public and correctly anticipates its interests, should be put to the test.

REACTION OF VISITORS TO EXHIBITIONS

Among the first studies of this question were those made by G. T. Fechner in Germany in which he used questionnaires to judge the effects on visitors of works of art [5].[1] Similar projects have since been undertaken in many museums, in which an attempt is made to gauge the response of visitors to a particular exhibition or display. However, rigorous scientific studies using the techniques developed by psychologists and sociologists for the evaluation of the reactions of a wide range of visitors have been rare.

1. The figures between brackets refer to the bibliography on page 80.

In 1924, at an annual meeting of the American Association of Museums, Clark Wissler challenged the assumption that museum exhibitions and programmes which were prepared for the average visitor were satisfactory, inasmuch as controlled data were lacking. Nor did he believe that curators had the qualifications to carry on scientific studies of the visitor. The Association decided to undertake a series of studies and interested a psychologist, Edward S. Robinson, in this project [3]. After preliminary investigation, Robinson proposed a programme of observational studies based upon techniques used in psychology, which were carried out in several co-operating institutions in Chicago, Buffalo, New York and Philadelphia. Similar studies were also carried out in one or two other museums in other cities. Observers were equipped with stop-watches and stationed unobtrusively in various halls. An accurate record was kept of the amount of time visitors spent in a given hall before a particular object or series of objects, and of the visitors' routes. The data were analysed to determine whether any patterns could be discerned, and if exhibitions were altered, how far such modifications altered the behaviour of subsequent visitors [9].

An intensive study was also made at the Pennsylvania Museum of Art by Melton (one of Robinson's associates), in which several *a priori* assumptions followed by museum curators were found to be erroneous [6]. In general most museums had been arranging their exhibitions so that visitors were supposed to circulate in a clock-wise (i.e. in a left to right) order. It was supposed that visitors would look at the exhibitions in the way books are read in the West. However, observation of several thousand visitors revealed that over 82 per cent of the visitors turned towards the right rather than the left . . . and objects located to the left of the entrance received less attention than those immediately to the right. It was also found that for the most part objects on exhibition received only casual inspection and few visitors bothered to read lengthy labels. Another factor which affected traffic flow was the location of exits. If, for example,

an exit was located along the right wall most visitors (over 60 per cent) went out without bothering to complete the circuit of the hall, giving the rest of the material a cursory glance before using the exit.

Somewhat similar results were found in an analysis of the behaviour of visitors to natural science museums [8]. The Peabody Museum of Yale University was planned to show the evolutionary sequence of the development of animal life. Visitors were supposed to enter the hall directly in front of the entrance which showed the development of the Invertebrates. After making a circuit in the shape of an inverted 'U' visitors were supposed to turn left into a hall demonstrating the sequence of the development of Primitive Vertebrates. The visitors then had to turn at the end of that hall-way, into the hall of Mammals, finally into the hall of Primates and end the visit at the main entrance. Instead, the average visitor turned to his right at the main entrance and saw the exhibition in reverse sequence.

Of course these patterns occurred in the United States of America where motor traffic also goes on the right. It is probable that differing patterns would be found in other cultures.

These studies of the behaviour of visitors have provided important data for the preparation of exhibitions. Planning and layout of displays have been modified by many museums, and the habits of visitors is now an important consideration in the location of choice items. The studies have also shown that the time spent by the average visitor in front of a given item is short and on the average does not exceed a minute or two. Long labels usually go unread (exceptions to this rule are exhibitions designed for students) and many museums today tend to use captions instead of labels. Below the 'headlines' there may be longer explanations which some of the visitors whose curiosity is aroused take the pain to read. Some success has resulted from the provision of 'take-away' reading material—mimeographed sheets to supplement the data given by captions—which can be picked up by visitors and read at leisure later.

ATTEMPTS TO ATTRACT A WIDER PUBLIC

The General Conference of Unesco, during its ninth session (New Delhi, 1956) expressed a wish that attention should be given to ways and means of enabling museums to attract a wider public, particularly workers. It pointed out that 'even in those countries that are most richly endowed with museums, where entrance to those institutions is often free, hardly one person visits them for every 200 who pay for admission to a cinema' [10].

Many museums have profited by the lessons learned in studies of the behaviour of visitors and vigorous efforts have been made to improve exhibitions and make them more intelligible. In some countries, entry fees have been abolished by many museums, or have been sharply reduced, and some fix certain days on which entry is free to the public. Guided visits, special exhibition rooms for young people, special programmes for school visits have all been means of broadening the educational work of museums and have resulted in steadily increasing attendance figures in museums throughout the world [11]. Undoubtedly, another very effective means of inducing repeated visits is the growing use of temporary exhibitions.

An instructive study of the use of publicity in attracting visitors was made recently in the United States of America. In January 1953, the Japan Society (U.S.A.) co-operated with the Government of Japan in sponsoring an exhibition of Japanese art. It included objects loaned from some of the principal museums of Japan as well as from private collections which had never before been shown to the public. The exhibition lasted for about a month in each city—Washington, New York, Seattle, Chicago and Boston and a sociological analysis was made of visitors in the last three [2].

A card register was made of all adult visitors (i.e. 18 years or over) to the exhibition in the three cities during a sample time period and recording name, address, age, sex and occupation. A selected sample was then taken covering the duration of the exhibition and representing proportionately the volume of visitors during the hours the exhibition was open to the public. The selected sample was then interviewed at home.

A major publicity campaign to publicize the exhibition was undertaken in Seattle where it was considered to be an important social and cultural event. Constant mention was made of the exhibition in newspaper articles and radio programmes. Billboards, mounted posters publicizing the exhibition and in addition a letter from the director of the art museum was reproduced and given to schoolchildren to take home to their parents. The Parents and Teachers Association (PTA) also contributed to publicizing the exhibition. In addition, a constant round of receptions and teas were held for the same purpose which were reported in the social columns of the newspapers. As a result, of a total population of 500,000, there were 73,000 visitors to the exhibition, of whom 2,500 were registered and 290 interviewed.

Less publicity was given to the exhibition in Chicago, although it was treated as a major art event and received a good deal of attention from the press and the radio. However, the campaign was not extended to the schools and it did not carry the connotation of an 'obligation' to attend which characterized the Seattle effort. Metropolitan Chicago has a population of a million but proportionately fewer attended (total of approximately 60,000) of whom 2,500 were registered and 280 interviewed.

The situation in Boston differed very much from those of the other two cities. Publicity efforts were limited to the opening period and the exhibition was treated as an ordinary travelling exhibition. Of a total population of 1,600,000 only 20,000 visitors attended the exhibition, of whom 1,600 were registered and 217 interviewed. The difference in emphasis was in part owing to the fact that one of the finest collections of Japanese art in the Western world is at the Boston Fine Arts Museum.

The success of the Seattle publicity campaign is evident from the fact that a large proportion of the population visited the exhibition, among whom many did not habitually visit museums. In Chicago and Boston 63 per cent of the visitors

interviewed had gone to art museums four or more times during the preceding year compared to 34 per cent in Seattle. Moreover, 45 per cent of the visitors in Chicago and 43 per cent in Boston stated that they attended the exhibition because of prior interest in Japanese art compared to only 12 per cent in Seattle.

The success of the publicity campaign in Seattle as compared to Chicago and Boston can also be measured in terms of the difference in educational backgrounds of the adult visitors as compared with the whole adult population, shown in the following table:

not art enthusiasts and lacked knowledge of the traditions and background of Japanese art. Bigman pointed out that in all three cities the interviewees who expressed dissatisfaction 'included some who complained that their knowledge of Japanese art—whether great or little—was insufficiently supplemented by explanatory material at the exhibit'. Obviously the danger is great that having once come to see an exhibition as a result of publicity efforts, visitors may leave disappointed. On the other hand, only 34 per cent of the visitors from Seattle had visited art museums more than four times during the preceding year,

Highest education received	Seattle		Chicago		Boston	
	Interviewees	Population	Interviewees	Population	Interviewees	Population
	%	%	%	%	%	%
Less than high school graduate. . .	10	45	5	57	2	49
High school graduate	33	30	21	25	26	34
Some college	20	13	23	9	16	10
College graduate.	25 }	9	28 }	6	34 }	4
Post-graduate degree.	11 }		21 }		21 }	
No answer.	1	3	2	3	1	3

It is clear that in all three cities the visitors to the exhibition were not representative of the population. However, the visitors in Seattle were much more heterogenous and more nearly approximated the composition of the general population than did those attracted in Chicago or Boston.

The next question is to consider how satisfactory the experience of seeing the exhibition was to the visitors from these three cities. Their reactions are summarized in the following table:

Reaction	Seattle	Chicago	Boston
	%	%	%
Liked it very much. . .	39	47	66
Liked it fairly well . . .	39	40	26
Very little, disappointed. .	19	9	8
Not reported	3	4	0

Proportionately, the visitors from Seattle did not like the exhibition as much as the visitors in Chicago and Boston. Many were

and 39 per cent reported that 'they liked it very much' and another 39 per cent reported that 'they liked it fairly well'. This suggested to some American museographers that such campaigns were justified and that many among the 39 per cent who 'liked it fairly well' would enjoy a second show much more, having gained acquaintance with the first.

COMPOSITION OF VISITORS TO A MEXICAN AND A DUTCH MUSEUM

An analysis of visitors to the Museo Nacional de Antropologia in Mexico City was conducted recently [7]. The visitors could be divided into two major groups, Mexicans and foreigners (of the latter 80 per cent came from the United States of America, 14 per cent from Cuba and the rest primarily from other Latin American countries). For most of the foreigners the period under survey was their first visit

and presumably relatively few of them made more than one visit to the museum. Many of the Mexican visitors however were 'repeaters' who lived in the immediate vicinity, only 40 per cent of them stated that they had visited the museum for the first time.

The interests of the two groups of visitors also varied. The foreigners tended to concentrate their visits on such well-known objects as the Aztec 'calendar stone' which receives considerable publicity in tourist folders, moreover replicas of it are sold as souvenirs throughout Mexico City which also calls attention to the original. The Mexican visitors tended to spend a higher proportion of their time visiting the halls in which their traditional arts and crafts were shown and spent less time on the prehistoric or Conquest material. However, the noteworthy result of the survey was that both groups were alike in that a high proportion of visitors from both groups were from professional backgrounds and were correspondingly better educated than the average individual in Mexico or the country of origin.

It is instructive to compare the results of a survey of visitors conducted by the Gemeentemuseum in The Hague in the Modern Art Department of the Museum. The survey was limited to visitors who came to the museum on Saturdays when admission was free [13]. It was hoped that the free admission would attract many individuals who had not been in the habit of visiting the museum, and particularly members of the working classes. However, it was found that the highest proportion came from the professional classes of the neighbouring area. Most were 'repeaters' who were particularly attracted by the temporary exhibitions, and spent little time looking over the permanent exhibitions.

The most popular exhibitions were those which featured the 'early' moderns, i.e. painters between 1850-1900, whereas contemporary paintings—particularly non-objective art—were not appreciated. It was thought however that the visitors would have been interested had they had sufficient explanation of the goals of the artists. Guided tours were available (70 per cent of the visitors made use of them),

but were apparently not satisfactory and visitors often remained puzzled about works of contemporary artists. The author suggests that in addition to guided tours an orientation room be set up where an analysis of the works of the artists would be shown accompanied by a tape recorded explanation for visitors before entering the exhibition. Another recommendation was to work with small, homogenous groups from different social classes and thus create a cultural 'elite' who in turn would spread their influence to attract visitors of more diversified background.

The survey made at the Gemeentemuseum showed that the elimination of entrance fees for Saturday did attract more visitors than came during the rest of the week. The principal reason for the larger numbers registered was apparently the attraction of new temporary exhibitions. It was concluded that the elimination of entry fees was in itself insufficient to attract a more diversified group of visitors.

FACILITIES TO ENCOURAGE VISITORS

Many museums have developed special facilities to make visitors feel welcome. Nevertheless, a survey conducted by the International Council of Museums (ICOM) for Unesco revealed that 'museums are still being neglected and the number of visitors is much lower than it should be'. However it is encouraging to note from the report that museums are trying, through various means, to become much more accessible to the public. One of these is by offering such facilities as restaurants, pleasant courts, proper seating which in a purely practical way contribute a good deal to the creation of a pleasant atmosphere. Of the museums polled by ICOM (excluding American museums) '79 had taken the trouble to install a restaurant or at least a bar, a cafeteria or lounges with magazines or books to read. The countries which had done most in this respect are: Norway (10 out of 15), the Netherlands (9 out of 16), the United Kingdom (6 out of 15), Sweden (4 out of 6), Denmark (4 out of 5), and Austria, Egypt, France, Germany (Bavaria), Italy and the Soviet Union' [12].

Keeping museums open during lunch hours, after working hours, and during the evenings once or twice a week and on Sundays greatly facilitates visits. These measures, of course, entail hiring additional staff and for evening openings adequate lighting facilities must be provided.

One of the most effective means of attracting visitors would seem to be the development of educational services.[1] Museums in many countries have established close relationships with schools. Organized visits are frequently conducted either by the museum staff or by the teachers and instructors of the students who receive orientation lectures before class visits. However, the results of the questionnaire prepared by ICOM show that no professional relations have been established between organized labour and museums, except among Austrian provincial museums and those of the U.S.S.R. The answers received do indicate, however, that on the whole museums are ready to undertake such work. The report goes on to state: 'Yet apart from guided visits and individual initiative, no such work has been organized. It could only be done systematically by museum educational services in collaboration with popular or trade union committees on artistic matters. Such committees are extremely rare (Sweden); however, they are extremely necessary, even indispensable, if the future of the labouring classes is not to be confined to their daily work and poor or even degrading use of their leisure time.'

THE PUBLIC IN NON-INDUSTRIALIZED CULTURES

Since the end of World War II there has been a rapid diffusion of industrial techniques among peoples who did not previously possess them and who had not developed the social patterns for living in an urban civilization based on industrial economy. The changes which are now taking place among such populations are revolutionary; they bring with them the grave danger of breaking the continuity between the traditional cultures and the new ones which are in the process of formation.

Museums can take an important part in acculturation. By including in their collections and exhibitions elements of the old, they can enable visitors to see in concrete form the transition between the old and the new; they can also help to introduce new concepts and ideas [4].

In the United States of America, for example, several American Indian tribes have museums which preserve examples of their old culture, and are studied and used as inspiration by their contemporary craftsmen. The museum thus serves to maintain the continuity of a distinct tradition and to preserve in present-day craftwork some of the unique qualities of the work of the past. Annual displays of the best work can encourage high standards, and lend status and prestige to the craftsmen. Continuity of museum collections can be maintained by purchase of the prize-winning objects.

Applied museography, the use of museums and exhibitions to help people to assimilate new values, has not yet been fully developed. For example, cause and effect correlations based upon scientific and pragmatic observation are a product of a particular culture and must be explained to people having entirely different modes of thought. Among many folk societies the failure of crops, desiccation of pasture lands, poverty, sickness and other serious difficulties are often ascribed to the effects of witchcraft, failure to observe proper rituals, the malignant attention of some deity, etc.

A people may have a non-utilitarian system of values according to which large numbers of cattle bring status, or the shape of a horn is more important than the amount of dressed meat one can obtain from a cow. They are unaware that large herds cause over-grazing with resultant loss of plant cover, erosion, gullying and a drop in the water table. They consider these as separate rather than correlated phenomena, and explain them as the effects of witchcraft, etc. A reduction of herds imposed by government authority may cause considerable ill-will and resistance. In such situations an educational programme

1. See Chapter VI.

has proved to be the best solution—demonstrating the interrelationships of these various phenomena. Exhibitions presenting in summary form a sequence showing the land with adequate cover, the changes which resulted from overgrazing, and explaining a programme for the reduction of herds with possibly the introduction of new breeds, and the resulting restoration of plant cover would help people to understand the problem and the suggested cure. At the same time it would introduce them to one of the methods of evaluating phenomena which has been essential to the development of contemporary science.

While the basic principles of museum exhibition remain constant, it is not advisable to transfer in exactly the same form exhibitions designed for the needs of one society to another. To do so would be to risk complete misunderstanding. For example, the experimental fundamental education museum in Mysore, India [4], had constructed a large-scale model (half-size) of a hand-lift irrigation system for one of their exhibitions. However, as the use of scale is not common among many people, its function was completely misunderstood and most visitors thought it was a child's toy. An analogous experience was reported in a project to encourage the revival of weaving among the Navaho (United States of America Indians). They were furnished with photographs of traditional old rugs with an enlarged detail showing the colours. The weavers copied the detail without reference to the photographs, and their rugs reproduced one quarter only of the design [1].

Some interesting results were obtained by the Mysore experimental museum. An exhibition was prepared in the rural district of Yelwal in which there were over seventy villages. A high degree of illiteracy, heavy density of population, deforestation, erosion and widespread poverty characterized this area. The exhibition was set up to demonstrate to the villagers of the area the relationship between progressive deforestation complicated by overgrazing, and erosion. The exhibition showed what had happened to the land in the past fifty years through careless use of forest land, and the solution to the problem through re-

forestation. It was not possible to evaluate in detail the effects of the exhibition on the villagers, but it was the consensus of opinion of those who had worked there (fundamental education, production, topic and social science specialists) that, if similar exhibitions were an element of continuous campaigns, they would have considerable impact upon the minds of their audiences.

SUMMARY AND CONCLUSIONS

The general public's interest in museums is constantly increasing, and in most countries, museums now rely on public funds for their support; this is becoming true of many United States museums also. In a sense this places them under the obligation of satisfying the interests of the general public and, in recent years, has lead them to seek to interest the larger sector of the public which has not been in the habit of visiting museums.

Museum exhibitions have changed, no longer are their halls filled with material which would require previous knowledge on the part of the visitor. The tendency has been rather to reduce the number of items on exhibition and to present them so as to give the average visitor a general synopsis of the subject in a short period of time. Frequently, this has been done rather by trial and error, but in recent years a body of scientific data has been gradually accumulated as a guide to the planning of exhibitions in order to cater for the needs and interests of visitors. Observational studies have been made of the behaviour of visitors and analyses of their social and economic background and their reactions to exhibitions. These studies have pointed out several shortcomings and have stimulated further development.

Museums are not educational institutions in the formal sense of the word, but rather a source of intellectual stimulation and entertainment. They can be a means of communicating ideas about cultural achievements of other peoples, about modern science, about one's own traditions. This should not mean, however, that in striving towards the worthwhile goal of introducing

new concepts or of widening the intellectual horizons of people, they should lose sight of their traditional purposes. On the whole, the movement towards a broader function for museums has been beneficial to museums and has shaken them out of a state of lethargy and intellectual isolation. Nevertheless, it might be well here to quote from the ICOM report [12] previously referred to: 'Prudence should, however, be recommended to museums tempted to become involved in the social, business or industrial life of their city or region; a museum must not push such activities so far as to lose sight of its essential role . . . (which is) . . . its scientific activity or its function as a place to preserve objects. These are its primary purposes, and it is obvious that a museum can carry out a social mission only if it has enough staff and can entrust the task to officers specializing in such matters.'

BIBLIOGRAPHY

1. AMSDEN, C. A. *Navaho weaving, its technic and history*. Santa Ana, Calif., Fine Arts Press, 1934.

2. BIGMAN, S. K. 'Art exhibit audiences', *The Museologist*, no. 59-60, June and September 1956. Rochester, N.Y.

3. COLEMAN, L. V. *The museum in America*. 3 volumes. Washington, D.C., American Association of Museums, 1939. (Volume II.)

4. DAIFUKU, H.; BOWERS, J. *Museum techniques in fundamental education*. Paris, Unesco, 1956, 54 pp. (*Educational studies and documents*, no. 17.)

5. FECHNER, G. T. *Vorschule der Aesthetik*. Leipzig, Breitkopf und Hartel, 1897.

6. MELTON, A. W. *Problems on installation in museums of art*. 1935. (*Publications of the American Association of Museums*, new series, no. 14.)

7. MONZON, A. 'Bases para incrementar el publico que visita el Museo Nacional de Antropologia', *Anales de Instituto Nacional de Antropologia e Historia*, tomo VI, 2a parte, no. 35, 1952.

8. PORTER, M. C. *Behaviour of the average visitor in the Peabody Museum of National History, Yale University*. 1938. (*Publications of the American Association of Museums*, new series, no. 16.)

9. ROBINSON, E. S. *The behaviour of museum visitors*. 1928. (*Publications of the American Association of Museums*, new series, no. 5.)

10. UNESCO. *Records of the general conference, ninth session, New Delhi, 1956*, Annex A, 4.6 'Culture and community development'. Paris, Unesco, 1957.

11. ——. 'Preliminary report on museum statistics', Unesco/ST/R/18, 1958.

12. ——. 'Preliminary study on the technical and legal aspects of the preparation of international regulations on the most effective means of rendering museums accessible to everyone', Unesco/CUA/87, 30 April 1958.

13. VAN DER HOEK, G. J. 'Bezoekers bekeken', *Mededilingen, Gemeentemuseum van den Haag*, vol. 2, no. 2, 1956. (English summary.)

EDUCATION IN MUSEUMS

by Molly HARRISON

INTRODUCTION

Years ago the responsibility of museum officials was limited to acquisition, con-servation, research and some display, but in the modern world their successors have a far wider responsibility. They have to consider how to translate the meaning of their exhibits, and how to communicate their values to the lay public.

The change has taken place gradually but unmistakably. The broadening concept of the museum's responsibility first came to include people who, if not initially interested, were potentially so and were equipped by background and training to understand. They were a passive audience, but one easily captured and not actively hostile. But it is only comparatively recently that the idea has taken root that the museum has an obligation to the whole community, regardless of age, or type, or intellectual capacity. There is a missionary spirit afoot in museums and it is more and more realized that an unenthusiastic public has to be won over if the collection, conserv-ation, study and display of worth-while objects are to have any real influence in our modern communities. We surely cannot doubt their potential influence; museum exhibits have much to communicate, but they are sterile unless they are made to speak to human beings. The communic-ation of interest, of information, of values is the essence of education; thus, for good or ill, museums cannot avoid education.

To some people education means merely instruction. They see it as the means by which factual information is passed on from person to person and from generation to generation. To them, museums are merely another kind of reference book, presenting factual information in vivid and pleasing form.

To others, education means a training in the use of one's mental powers. In this sense, learning how to learn and acquiring the habit of logical thought are the aims of education. Here, too, museums can help, for their displays do not merely state facts; they can show the relationships between things which are not always brought clearly into focus by textbook or verbal lesson. Exhibits can stimulate thought and encou-rage clear observation and logical deduc-tion.

Education is, however, more than either of these, and many people today are fearful of an over-development of the human intellect at the expense of the emotions. They see the purpose of education as being not mainly the memorizing of facts or a training in logic, but as aiming primarily at the development of imagination and sensitivity. The influence of museums on this aspect of human development can be immense; they are, by definition, custodians of quality and merely looking at things of beauty and interest can stimulate and foster an awareness of both truth and beauty.

In its full sense, of course, 'education' implies all these purposes, and more. Its goal is the fullest development of the whole human being and among its many means it must neglect neither the factual evidence of real, tangible objects nor the evocative, imaginative impact of things of beauty and worth. Education cannot afford to neglect museums.

There are probably few people, at this

mid-century, who would deny this close interrelation: museums, if they are to continue to have any real function, cannot avoid serving education; and education, if it is to be effective, dare not neglect the museum. That much agreed, there remain a great many practical problems confronting the museum official who plans to organize an education service, whether for adults or for children. This chapter gives an analysis of these practical problems under the headings which are thought most likely to meet the needs of the practising museum official: Who shall 'do' the educating? Where can it be done? When can it be done? How can we do it? A final section attempts to answer the fundamental question of why?

WHO WILL UNDERTAKE EDUCATIONAL PROGRAMMES?

Without exception everything that a museum does is educational, even when this is not the intention. The standard of display of the exhibits, the quality of thought that goes into their arrangement, the friendliness and sincerity of the personnel who serve the public, the design of fitments and equipment, the typography as well as the text of the publications issued—all these are a potential influence for good and are as much a part of education as are the services aimed directly at enlightening the public. Some aspects of museum work are, nevertheless, specifically educational and can best be carried out by special staff recruited for the purpose.

The curatorial staff, in most museums, take care of the selection and display of objects, public lectures and the compiling of labels. They can often deal well with the educated and informed adult visitor, but they rarely have time to devote to the uninformed adult or to children, nor do they usually possess the necessary combination of abilities. Popular interpretation is very difficult work, for which a specialized knowledge of some particular branch of academic study may be poor preparation and may, indeed, be a handicap.

Knowledge and understanding of the subjects covered by the museum are, of course, necessary for anyone who proposes to interpret them to the lay public, but of equal importance is a knowledge of people. Anyone who is to be successful in helping people to see and enjoy museum material needs to know as much about human nature as he does about the exhibits. This means that there should be, in all museums, staff who have been trained as teachers. Only a pedagogical training of some kind can teach a man or woman to know the needs, interests, limitations and potentialities of children, and also how to handle groups of older people skilfully, so that the interests of all shall be catered for and both the brightest and the dullest given the help and encouragement they need.

Museum instructors need, therefore, to be alive to new trends of thought and practice in the educational world. They will be the more successful in their work, the more fully they realize that it is not necessarily, nor even usually, when a teacher 'teaches' that a person learns. Their function is not to lecture, or to tell all they know about a subject, but to stimulate thought, to arouse questioning, to strike a spark in even the most unpromising mind, to kindle an interest and to open windows which may have been firmly closed before.

People capable of doing this are not easy to find. A university training is not enough, nor is a normal teacher-training course sufficient preparation. A combination of the two can produce the ideal type of person and, in countries in which a postgraduate course in pedagogy can be followed by University graduates, there is likely to be a ready source of suitable people. Such twofold training is good, but there is danger in taking students into the museums before they have had a period of classroom teaching in a school or college. It is only by personal responsibility and experience that a man or woman can learn group management and understand the essential need of immature or underdeveloped minds for really simple presentation.

It is important, too, that whoever undertakes this work shall be suited, by temperament and manner, to popular exposition —a talent no training can give. It is largely

a matter of contact, of friendliness combined with ease of manner, and an ability to use simple words clearly. Most people are immediately alienated by a stiff, academic manner and the display of much erudition may appear to be patronizing and present difficulties to anyone having little or no cultural background.

If the dual training referred to is not available, there appear to be two possible ways of replacing it with some degree of success. Museum specialists who wish to work with the public in the museum can be given a period of practical experience in a school or college, or practising teachers of good educational background can be given training and experience at the museum. Both methods are less satisfactory than the one previously recommended, but both aim at the necessary combination of two very different skills.

Some people advocate that when children are taken to museums, the class teacher who goes with them should deal with the material, but this view is not shared by the writer. The attitude and interest of the teacher they know is, of course, very important in helping the children to enjoy and understand what they see, but a fresh viewpoint and a new voice have a stimulus and an interest all their own. Moreover very few teachers, immersed in the daily business of school life, can have sufficient time to give to thorough study of the collection in a museum and few, perhaps, have the inclination to do so. Museum material is for the most part specialist material and it is no solution to pretend that all that is required in order to deal with it is personal interest and a systematic reading of the labels. Anyone who is truly aiming to 'light a spark', whether for a child or an adult, needs to know and feel far more about the material being considered than can be gained by a cursory visit or two.

The highly qualified specialist teacher could, of course, handle the situation, and frequently does so, for no sensible museum official would discourage a school teacher who obviously had the necessary knowledge and flair from dealing with his group himself. One of the assumptions that museum educationists have to live down, however, is that anyone who can read and

can speak to a group of listeners is, *ipso facto,* able to convey the significance of museum material to that group. It is a far more subtle and difficult matter than that and, as a general rule, only specially trained staff can hope to do it well.

In some areas the problem is thought to be solved by arranging for teachers who are interested in taking their children to museums, to be given lectures on the exhibits beforehand. The basic assumption behind this arrangement is, of course, totally wrong. The stimulation of the imagination and development of sensory awareness which are among the prime purposes of museum education cannot possibly be fostered by persons who have been given bare facts but have not had the experience of daily contact with the tangible objects from which the facts are derived, or with which they are related. Only through living and working in a museum can one acquire a real knowledge of the material, of the differing specialist points of view about every exhibit, and of its background as represented by the work of the curator, administrator, research scholar, archaeologist, display specialist and collector. As a member of an integrated and enthusiastic team one may hope to impart enthusiasm and to convey something of both the permanent and the transient values implicit in the museum collection. Lectures for teachers are, of course, good if they are good lectures; but although they can give interest and knowledge to those who seek, they provide no real substitute for a museum education service, however small that service may have to be.

It is sometimes objected that smaller and poorly endowed museums cannot hope to pay the salary demanded by qualified educational staff, and indeed cost may be a strong deterrent to plans to set up an educational service. People may occasionally be found who are so devoted to the aims of museum teaching that they are willing to undertake the work for a very small salary, but only rarely does such a solution work well. In principle we should not expect museum education to fulfil its function properly or to win public support if the staff are not properly paid.

The present trend is towards solving

this financial problem by co-operation between museums and public education authorities. If the authorities in charge of the administration of the public education service can be persuaded that the museum can have a valuable influence in general education, they will often be willing to make a financial contribution. Where common interests are served, shared financial responsibility is, of course, reasonable.

Such co-operation may be worked out in various ways in different national and local circumstances:

1. The education authority makes a financial grant to the museum, in proportion to the number of school parties and adult education groups received annually.
2. The education authority provides suitable members of its teaching staff, to work in the museum education department. In some cases they remain as employees of the local education authority, in others they are either appointed permanently to the museum staff, lent for a stated period, or given an intermediate position as a liaison between the two parties.
3. The education authority sets up a committee of teachers, administrators, and perhaps others, to advise the museum upon its educational work. This is usually done only when the museum lacks a functioning education department, but it could serve as a useful interim measure.
4. Some education authorities appoint one teacher whose time is divided among a number of museums in the area.
5. In addition, in some countries the education authorities also pay staff to organize in museums educational work with adults. This practice meets with good response and might well be extended.

Each of these measures has its merits and each its disadvantages and dangers. Each local situation calls for a different solution and there could be no value in recommending, in a general handbook such as this, any particular method of co-operation between museums and education authorities. So long as the interests of the visitors are never lost sight of, and the general aims and requirements of museum education are kept in mind, a workable system will

develop. Each museum must find the arrangement which will best meet its particular need.

WHERE CAN IT BE DONE?

Accommodation is frequently a problem and many curators who would like to establish and encourage specifically educational work do not do so because they believe they have not enough room.

This belief is founded upon an assumption that education is something apart, separable in a museum from its other work. If this were so, then separate and virtually insulated accommodation would be essential and care would have to be taken that 'education' work did not affect the other programmes. It is clear, however, that 'education' can be experienced anywhere and at any moment. In a museum the most likely moment is when a worthwhile exhibit comes to life for a receptive visitor, and the most likely place in which that can happen is the museum gallery, where the exhibit is displayed to its best advantage, surrounded by other things related to it, its meaning and appearance enhanced in all possible ways.

Therefore, initially and for as long as possible, talks, discussions and classes should take place in the public galleries. A stage will be reached, however, when numbers present a problem or when the group needs to undertake noisy or—in the case of children—messy activities. Then some additional accommodation will be required, but it should not be provided while it is still possible to use the galleries.

Museums which consider that a reduction of exhibition or storage space is justified set aside a demonstration room, workroom, or lecture room for the use of various groups in different ways according to the principles upon which the work of the museum is based. Exhibits from the galleries, or duplicates from the storerooms may be shown and handled in informal lessons; lectures and slide or film programmes may be given, after which the audience goes into the public galleries to relate the background information they have been given to specific exhibits. Sometimes this room

is used as a private study for those who, having seen the exhibits, wish to read or write or browse, and in this case, of course, books and periodicals and some exhibit material are available for reference. The room may also have a reverse function: rather than providing a quiet retreat for visitors it may be a noisy room. Here children—and adults, too, if they wish—may go when they need to discuss more freely than is suitable in the museum itself. They can also be allowed greater freedom here, and paint, clay, cardboard and wood are among the materials available to them.

The advantages of separate accommodation are obvious, for it permits certain activities which cannot be allowed in the museum galleries. Various dangers need to be guarded against, however, if the use of separate accommodation is not to detract, in the long run, from the true educational function of the museum.

First, there is the danger of excessive use. A workroom of the type referred to is usually a more convenient place in which to assemble a group than a public gallery. There will probably be chairs and tables laid out ready, so that the noisy problem of portable stools is avoided; there is little to distract attention from the matter in hand and no irrelevant material towards which curious eyes can wander. Even the most sensitive teacher is liable at times to forget that such a room is merely an organizational convenience and but a poor substitute for the museum gallery. The real purpose of the visit is to look at the exhibits in their setting and if too much time is spent in the museum classroom the group will be given too little opportunity to see the galleries. Museums which make a practice of using a separate workroom for group programmes usually arrange for the groups to walk through the public galleries after a lesson or discussion—the purpose being that they may see what they have been discussing. However, the reverse would seem to be infinitely preferable: the group needs to see first and will then want to discuss what they have seen. The real contact with the objects should come first, and the abstraction—the words, theories and explanations—follow.

There is a great temptation, too, to lapse into formal instructional teaching if visitors are conveniently seated as a group, ready to listen without interruption. When dealing with a group in the public galleries, however, it soon becomes obvious, that formal group teaching is often ineffective; all cannot see what is being discussed, those at the back are easily distracted by other visitors, not all the group want to look at the same objects. Individual teaching and more practical techniques are the alternative: museum teaching does much to underline the truth and relevance of many of the new educational theories.

There is greater likelihood, too, that verbal facts about the exhibits will be stressed and the objects themselves neglected if people are separated from them for longer than is strictly necessary. Whether factual information is given verbally or through films and filmstrips, there is, in the museum classroom, a great temptation to forget that the main purpose of a visit to a museum is not the mere acquisition of facts but the broadening of awareness and the stimulation of imagination and sensitivity. Real objects seen in their best setting can accomplish this far more effectively than can second-hand experience, and a well-arranged museum gallery offers wider opportunities for mental and visual exploration than even the best-appointed classroom. (See Illustration 1.)

The influence of a good museum can cover a wide area, particularly in relation to schools. There may be many reasons preventing a particular class of children from being taken often to visit a museum —they may be too far away, or physically handicapped, there may be an acute staff shortage, lack of means, or inadequate transport arrangements. In such cases, members of the museum staff can go to talk to the children in school and show them some of the exhibits, or the museum can lend suitable material to the schools for a period.

There is little to say about sending museum staff into the school or college. Those sent must obviously be good speakers, able to meet the young people on their own level; they must be experienced in handling groups and more concerned to arouse curiosity and interest than to give

a formal lecture. The museum will inevitably be judged by these unofficial ambassadors, and if the group have enjoyed their visitor they will want to go to the museum itself and will probably find means of doing so. Talks about museum material will also be much more lively and interesting if exhibits are included for demonstration to whet the young people's appetites.

The loan of exhibits to schools, colleges and adult education centres has a much deeper influence than visiting speakers can have, because the material stays at the site long enough for the local group to become thoroughly familiar with it. A good loan scheme is an educational venture which many museums carry out with conspicuous success.

Highly valuable objects, and material necessary for the maintenance of a good study collection should not, in general, be lent by a museum. However, duplicate material which is not required for display can be of considerable interest and value to people who are unable to visit the collection.

Perhaps the most important criterion in choosing material for loan is interest; and certainly the most important points to be considered in presentation are truth, simplicity and vividness. These four make up the quality of a loan, irrespective of the rarity or individual value of the object. An everyday piece of craftsmanship, a pleasant piece of pottery or textile are neither rare nor of great financial value, but they may be of great educational value.

In planning a loans scheme close consultation with schools and other potential users is extremely important. Museum officials may easily hold a view of what people ought to want to see and know, which is at variance with what, in fact, they do want and are able to grasp. Nor, of course, should the requirements of the museum be forgotten. Objects must be well packed, properly transported, well housed at the receiving end and care must be taken to avoid damage. It is usually found, in fact, that groups take very great care of museum material lent to them.

In such a scheme careful recording of loans distributed is essential and catalogues and information relating to material lent should be published. This information may take the form of notes for teachers, but it must not be implied that these are lecture notes (lectures about the material borrowed will obviously be inappropriate). Rather, suggestions should be given for thought, discussion, further reading and subsequent visits. The actual use of the material in the classroom will not usually lie within the province of the museum staff, although they can give a good deal of help by making suitable comments and suggestions and by taking care to provide vivid and interesting material and sensible captions and notes. Frequent friendly contact between the museum educational staff and those at the receiving end is the key to the provision of a good loans service.

Travelling exhibitions can be a further important means of helping people to understand and appreciate ways of living and forms of artistic expression other than their own. Lessons in health, sanitation, and technology can also be taught by clear and simple exhibitions, attractively mounted, sent out from museums to remote areas.

In discussing where museums can best serve education the question of special museums for children merits consideration. In some countries such institutions are an accepted and very active element in the museum sphere; elsewhere they are not favoured. A brief consideration of the pros and cons would seem to be worth while here.

The points in favour of children's museums are perhaps obvious—immediate appeal, ready public interest and support, their freedom from the trammels of specialist departments, and so on. At first glance there is much to be said for the establishment of special exhibit material for young people, in buildings specially equipped for the purpose and with staff devoted to the interests of the young.

In the opinion of the writer, however, the disadvantages of children's museums are considerable for, in a world already too prone to specialization, they divide still further, and artificially. They separate children from the rest of the community, as if a clear line could be drawn between those matters which interest young people and those which appeal to older people. They separate those in the museum pro-

fession who have a particular concern for popular presentation and simple statement from their more specialized colleagues—to the detriment of both. They tend, too, to separate young people—the future adults —from early contact with first rate objects of great worth, for these inevitably can be displayed only in the larger public museums.

Although in special circumstances and in particular national or local conditions children's museums are certainly valuable and important institutions, it can be argued that the future lies rather with attempts to carry out popular education, at both the juvenile and the adult levels, in the context of the public museum.

WHEN SHOULD EDUCATIONAL PROGRAMMES BE GIVEN?

Ideally, of course, education in a museum should be planned for the right moment, when the person is ripe for it, but that moment cannot be accurately foreseen. No one can be sure exactly when a spark will be struck, either for child or for adult, when imagination and feelings will be touched, or when eyes will see and mind will truly understand. These things happen when atmosphere, circumstances and personalities function in harmony—something that no amount of organization can bring about. However, museums can anticipate and take advantage of special occasions or events which will attract visitors to come, to see, to learn. A Bach centennial, the two-thousandth anniversary of Buddha, a special nation-wide programme such as 'Asia Month' (November 1957) in the United States, may be the occasion for special exhibitions. A film recently made in England which had scenes of the Science Museum in London attracted numerous visitors. Television programmes made by museums or in co-operation with museums such as *What in the World* by the University Museum, University of Pennsylvania, or *Animal, Vegetable and Mineral* in England, have encouraged visitors to see the original material featured in the programme and to see other items in the collections of the museum.

An individual visitor can go to a museum when, for him, the moment is ripe. Group visits are, however, a different problem; to conduct 'visits for groups of any age needs planning and preparation, and inevitably the moment which is right for some will be wrong for others. It is for the group teacher, therefore, to decide when the interest of the majority is best served, to say when they are ready for the interest and stimulation which a museum can give, how many will be in the group, how long they want to stay, how frequent their visits shall be.

In all probability the museum education department will not be able to meet all these requirements and adjustements will have to be made. Here friendliness and co-operation on both sides are vitally important. If the possibilities and limitations are frankly discussed and both the group teacher and the museum official realize that the other has true educational influence at heart, serious difficulty can usually be avoided.

There is great variation in the amount of time schools are willing or able to devote to outside visits. Many are ill-placed for visiting, others are handicapped financially or by the pressure of examination work and visits to museums may seem to them at first to be a luxury. Museum staff can do much, by their enthusiasm and by the thought and effort they give to the needs of each visiting group, to change this point of view and to ensure that the organization of visits is practical.

A first essential is that there shall not be too many children in a group; the exact number which can be received is a matter for the museum staff to decide. Limitations are inevitably set by the nature of the exhibits, the size of the galleries and so on; it is no kindness, and certainly no contribution to education, to accept more children than can be properly dealt with. In spite of pressure from teachers wishing to bring large groups, the museum must set a reasonable standard in such matters, or visits will often be a waste of time and opportunity.

How many schools can visit at one time depends upon museum staffing and accommodation and is not a matter on

which the individual schools need to be consulted. Care must always be taken that numbers do not prevent good work from being done; two school groups received, well catered for and sent away enriched and enthusiastic, are far more worth while than ten groups who return to school feeling they have been merely herded through a crowded, muddled visit, with no clear idea of what they have seen, or why.

How often any group should visit the museum depends, of course, upon the age of the children, the distance they have to travel and the requirements of the theme they are studying. Usually a series of visits is of very much greater value to the children than a single visit. All boys and girls are at first a little awed by an unfamiliar environment, often they are over-excited and need time to settle down. A first visit can do little more than catch their interest and whet their appetite; it is on the second and subsequent visits that real observation and thought can best develop. So long as interest is maintained, it is doubtful whether a group of children could ever visit too frequently, for most museums contain material which has infinite educational possibilities if rightly treated.

They should not stay too long, however, nor visit more than two museums at most in one day. Looking at static things is tiring, new impressions are always slightly confusing and museum floors are notoriously uncomfortable to walk on. A short lively visit, designed to maintain alert interest, will be enjoyed by all; a visit that is even two minutes too long will make the children disinclined to return and may prejudice them against museums for a long time to come. These principles apply equally to non-specialist visitors of any age.

If boys and girls have enjoyed their school visits to museums they will want to return in their leisure time and, indeed, this is a fair test of the success of any group visit. More and more museums are finding that they are able to undertake a great deal of educational work with young people during school holidays, on Saturdays, and sometimes in the evenings. This is probably by far the most important education work which museums can undertake

for children and it presents a considerable challenge.

When we do a thing because we want to, we do it in a subtly different spirit from that which surrounds things we 'must' do. This is very true of children and lends particular importance to all hobbies and voluntary activities. A museum in which boys and girls choose to spend regularly a proportion of their leisure time has a particular contribution to make to the solution of present-day educational and social problems. Education must not be segregated in the schools, it is a force that could and should inform all human activity.

The voluntary attendance of children is a great stimulus to the museum staff for it becomes essential to provide children with a variety of things to do, or their interest will quickly wane. The organizational problems are different from those involved in group visits, for the children themselves will decide how often they visit, how frequently and for how long. There may well be a danger of over-tiredness as a result of too much enthusiasm, and problems will arise regarding differing tempos for when children are allowed to work at their own pace it is found that their pace is in many cases surprisingly quick. Discipline will not normally present any difficulty, for when young people are actively engaged upon an activity they enjoy and have chosen to undertake they are not tempted to misbehave. If the atmosphere is willing and friendly and the environment pleasing, and if there are interesting things to do, very many boys and girls will make good use of what a museum offers them, and the poorer their background, the greater their need for stimulation and help.

HOW SHOULD THEY BE GIVEN?

How can we interpret museum material and arouse the interest of visitors so that they want to find out for themselves? Surely it should be our long-term aim that we, as intermediaries between people and objects, may gradually become superfluous and that the men and women, the boys and girls who enter our doors shall

form the habit of looking at things with discrimination and affectionate understanding. How can we, therefore, give enough information but not too much, guide but not too firmly and focus attention without seeming to insist? Much depends, of course, upon local circumstances and there is great diversity in the type of help that museums can give to uninformed visitors, both young and old.

Clear, coherent display is a first essential and those concerned with the interpretation of museum material must use their influence to ensure that the exhibits are shown logically, simply and pleasingly. The layman needs more than this, however, if he is to find real interest in the museum. He needs, for example, something more than a bare date to help him place the exhibit in its time and sequence; he will be helped by a technical note about construction and preservation, perhaps by a map or a sketch showing where the object was used or found, or the costume and way of life of those who made it. If such additional information is provided with discretion, skill and taste, it need not detract in any way from the importance of the exhibit itself and many visitors will find help and encouragement from it. (See Illustration 2.)

But merely to show things is not enough and however well exhibits are displayed they usually need some kind of interpretation if visitors are not to wander aimlessly about.

Interpretation usually takes the form of talk, but words can as often obscure an impression as illuminate it. A 'guided tour' can be stimulating but it can also be among the dullest of experiences and there is always a risk of denying the existence of human differences and individuality. People vary greatly in what they know and what they want to know, in their understanding of words and in the pace at which they can think. It is quite impossible to satisfy the needs of everyone in a group and the less informed, the less academic the listener, the more difficult it is for him to listen and to connect verbal statement with things seen. Nevertheless, of course, talk there must be. . . .

In some cases a brief introductory talk is all that is required for a group of adult visitors and if lines of interest and inquiry are suggested they can then disperse, each following his own interest and asking the lecturer the questions which occur to him. In any case it is important that what talk there is shall not be one-sided. The successful museum teacher, as does the successful teacher anywhere, needs to realize that it is often more valuable to raise a question in the visitor's mind than to give the answers, and that a discussion about things is, for the non-specialist, far more rewarding than merely hearing about them.

Children, in particular, do not take easily to the set lecture, however well it is done. Education today, in many countries, recognizes the importance of active methods of learning; and modern boys and girls are accustomed to pursuing their own interests at their own pace and to working because they want to and because they see some sense and purpose in what they are learning. Some children can, of course, learn by verbal instruction, but they are a minority; they present few problems to their teachers and will probably in any case make good use of museums. But it is not so easy to interest the 'ordinary' child (no child is, in fact, 'ordinary') and help him to use museum resources and to pursue his studies there for his own, understood ends.

Looking at things and learning about them intellectually is not sufficient. Something further is needed, some way of encouraging the visitor to use more of himself, to participate, to experience through his hands as well as through his eyes, ears and brain. Some museum material can be handled without risk of damage and, if this is permitted under supervision, understanding and appreciation will burgeon and the visit will take on a reality which it might otherwise lack. If the original material cannot be handled with safety, often duplicates can be handled and many museums set aside part of their reserve collections for this purpose. Some museums, indeed, allow some of their material to be actively used: boys and girls may, for instance, dress up in costumes and armour, use primitive tools, and play upon instruments which, when silent, have no life and little meaning.

The use of reproductions should not be scorned in this connexion, so long as it is made perfectly clear which things are originals and which are not. Many a valuable object lying in its case, neither appreciated nor fully understood, will spring to life if a less precious version can be actually used. For example, a girl who walks among eighteenth-century furniture dressed in a good reproduction of the costume of the period feels something of what life was like two hundred years ago, more deeply than could result from merely seeing, or even handling the furniture. Her class-mates, too, will notice that she walks differently in the long dress and that her gestures and the tilt of her head alter; they will sense the past more vividly for seeing her walk, even though the costume she wears was made but yesterday.

This reproduction material is used in much the same way as stage properties are used by actors. Museums could well make more use of dramatic technique and 'props' in the interpretation of their exhibits. Two-dimensional material is also useful. While prints, models, charts, diagrams and photographs cannot replace the real object, if properly used they can have great educational value: models and prints lent for outside use can stimulate interest and engender the desire to see for oneself; charts and diagrams show the relation of a series of facts which may otherwise seem disparate. colour prints and photographs add enormously to the liveliness and interest of publications. Their deep concern for the preservation and integrity of original material should not blind museum workers to the importance of good reproductions. Nothing need be lost by their use, much is to be gained.

There is a world of difference between 'looking around' a museum and 'looking for' something in it. The first can soon become a passive stare, the second entails a keen, alert, sustained seeking after specific things of interest and an informed discussion of them. However, while the suggestion—'let's see if we can find a so and so'—will sustain and stimulate an individual child or a small group for a considerable length of time, something specific, tangible and definite is needed if the attention and interest of large numbers of youngsters are not to evaporate. 'Things to do' follow as the logical solution. The idea is fast dying that we can continue to gain anything from looking at things for any length of time without some opportunity of 'doing'. Seeing and doing are complementary activities.

But doing what? It is impossible to generalize, for the activity which strikes home with one person will probably bore another, what is interesting and significant to one museum teacher will not appeal to others, what one museum has to offer may be entirely outside the sphere of another. In some cases the best approach may be a mere list of questions to answer; in others, sketching paper, pencils and crayons may be provided. The emphasis may be upon educational apparatus, similar in essentials to what is used in Montessori classes but adapted to museum material; or upon some form of pictorial summary of the story of the objects seen and enjoyed. A great variety of materials can be brought into use, children can make delightful series of pictures from pieces of textile, coloured and patterned paper and card, leather, veneer, feathers, buttons, pipe cleaners and so on. Once they feel at home they can work in a perfectly orderly manner in front of the exhibits while their inspiration is still fresh. They will be really looking and working, usually far too absorbed to cause any embarrassment to other visitors.

Such activities lead the visitor to the exhibit and focus attention upon it, they slow him down so that he is less inclined to rush excitedly from object to object; they give rise to questions and stimulate conversation about the exhibits and their implications; they provide something for him to take home to show his family and friends, a permanent reminder of what he has seen and enjoyed. Moreover they are fun and, surely, if museums are to have any appeal for the non-academic majority of people, they must offer an opportunity of worthwhile fun.

Two main points should be kept in mind in planning educational activities. First, such activities are not an end in themselves but a means of developing in the child a closer understanding and appreciation of

the museum material. They do not replace the teacher, their purpose is to induce an alert and receptive state of mind and feeling, in which the child is able to respond to what the teacher shows him. Activities are a waste of time unless they lead to that all-important moment when an enthusiastic and questioning child looks at a worth-while object in the company of a sympa-thetic, enthusiastic and knowledgeable adult. Then a spark is lit, feelings are touched and mind leaps ahead.

Secondly, the further they depart from the 'questionnaire' style, the greater the educational value of such activities and equipment. The museum's domain is primarily a visual one and the most appro-priate techniques of interpretation and explanations are, obviously, also visual. Museums are not primarily reference books, although facts play an important part in their work. The visitor who has successfully answered a number of factual questions may have done little more than read the labels; he may go out of the museum no richer than he came in. If, however, his imagination has been aroused and his sense of values touched, he achieves a synthesis, and the facts will fall into place as a part of his interest.

In some museums, usually under the influence of a curator or a teacher who realizes the importance of sensory training, opportunities are given for visitors to take part in creative art activities. Formal and informal sessions are arranged for people of all ages in various branches of the arts and crafts. What is produced may not necessarily have any obvious connexion with the museum material, but this is an excellent means of developing imagination and sensitivity and is likely, in the long run, to improve the standard of appreciation of those who take part. People using a museum should nevertheless not long neglect the significant material shown there. Art and craft groups, for instance, which merely meet there without basing their work sometimes upon the exhibits are not really an integral part of museum education. However valuable they may be to their members, they are, as it were, tenants in a building used for several purposes.

In some countries museums are being increasingly used as community centres and thus have a far wider function than that of merely showing their collections. Popular lectures are given there for adults, concerts and recitals (often of period music on instruments exhibited), demonstrations and meetings of public societies of various kinds are held. Such use of museums in no way harms their collections, rather the reverse: the public thus encouraged to come into the building tends to become interested in the exhibits and in the ideas which they illustrate. As the building is used by more people, public appreciation is bound to grow.

Museums in many countries make good use of mechanical visual aids which can be a great asset. There is value in occasionally supplementing interest in tangible, three-dimensional material with opportunities of seeing films, filmstrips and lantern slides. It is, however, vitally important to remember that such techniques are merely aids. They are justified in the museum context because they can bring exhibits to life and provide links between them. Well used, they can be a means of helping people to see the exhibits, to enjoy them and to think about them; poorly used they are a waste of time which would be much better spent looking at the exhibits.

Publications are another important means of increasing interest in museum exhibits and of interpreting their meaning. Most museums issue them but very few museum publications are sufficiently simple, attrac-tive and inexpensive to appeal widely to the non-academic visitor of low reading capacity. Attractive picture books are issued by many museums, but the captions to the pictures are often in specialist language and there is rarely a simple introduction, explaining the theme in terms that the layman can understand. There is a lack, too, of inexpensive publications planned to be read before and after museum visits rather than during them. Most people find it extremely difficult to look at exhibits and read a text at the same time; yet many try to do so and thus achieve neither concen-trated reading nor real, appreciative looking. Inexpensive publications which include pages for note-taking and for sketching would perhaps encourage the visitor to

make a contribution himself, and he would therefore be more likely to return.

To sum up, it needs to be stressed that there are no 'blue prints' or textbooks which can tell museum workers how to make the fullest educational use of their material; every museum must have its own emphasis. The methods must be flexible, the equipment devised must be varied and of high standard of appearance and must function well, and in interpreting museum material at the popular level one must continually think in terms of people, their needs and interests. Although we are working with things we must remember that we are working for people.

WHY SHOULD EDUCATIONAL PROGRAMMES BE CONSIDERED?

Why do we do it, why indeed *must* we do it?

Not merely because we believe that our museum objects are important, but because we believe that people are more important.

In many ways modern man is most deprived when he is most privileged. Industrialism is spreading fast but the astonishing technical advancement of the past hundred years has not, on the whole, been matched by comparable spiritual or aesthetic developments. There are many dangers to human nature inherent in the present speed and mechanization of life; museums are among those institutions which have permanent values to impart, if they can make their voice heard.

We live among miracles but tend to accept them without wonder or delight; museums can help us to recapture a sense of magic and of awe at the complexity and beauty of the natural world and at the genius and skill of men. We live our lives increasingly at second-hand, divorced too often from reality, thinking and feeling through words and pictures rather than in real situations; museums, showing real things, can help us to understand the importance of evidence and to comprehend things through what our senses tell us about them. We are faced with a future of greatly increased leisure but many of us do not know what to do with time and are bored, unseeing and unaware. Museums can open windows to those who lack interests and can help to develop sensitivity and discrimination in those who are visually illiterate.

Many influences today are actively at work to undermine man's human qualities, and if love of knowledge and contact with the good, the true, and the beautiful are ever to grow and develop in those who seem often to despise them, the museum is perhaps one of the few instruments which can be effective. Museums are marginal institutions which can have an integrating influence in a world suffering from division: they make an appeal to both intellect and emotions and encourage that kind of delighted observation where a storing of the mind is accompanied by a rapture of the senses. They have an urgent task in our modern world.

THE MUSEUM LABORATORY

by Paul Coremans

INTRODUCTION[1]

'Man is the worst enemy of works of art.' These hard words from an old conservation expert may be an exaggeration, but they have a kernel of truth in them. In the work of restoration, man wants to show off his knowledge and skill and often does so at the expense of the originality and life of the work he is restoring; he builds museums that are much better 'conditioned' for visitors than for the treasures housed there; proud of his possessions, he ships them off to international exhibitions, where, as he well knows, different climatic conditions will damage the artistic heritage of which he is but the trustee.

The last two world wars, with their resultant destruction of cultural property, have drawn general attention to the safeguarding and active protection of relics of the past, historical monuments and museum specimens. Unesco, its Museums and Monuments Division, ICOM (International Council of Museums), IIC (International Institute for the Conservation of Museum Objects) and many other bodies have entered into direct relations with the ever-increasing number of laboratories and workshops in every part of the world which now devote scientific study to works of art, their deterioration and their preservation.

It seems natural to lay first stress on scientific study as pursued in museum laboratories. It will help us to become familiar with ancient materials and with the way in which they deteriorate, and to understand better the problem of their preservation, which is the ultimate aim of all laboratory technicians. But alas, there is an inexorable law which spares no works, past or present: all living matter is subject to decay and must one day perish; like doctors, we can only do our best to delay that deadly process.

Archaeologists, art historians and, in some degree, aestheticians study an ancient object in the light of comparable documents of the past, place it in its historical and stylistic setting, determine, in fact, the characteristics by which it may be situated in time and space.

Unlike these specialists of the form of objects, a laboratory deals with the substance of which they are made, probes into their composition, structure, state of decay, in fact, into the possibilities of conserving or restoring them. The laboratory research worker must forget that he has before him a prehistoric axe; what he seeks to determine is the metal or alloy it is made of, the peculiarities of its casting, the later mechanical or thermic treatment it has undergone, the harmful effects of air and soil upon the whole object. So he weighs all the characteristics which will enable him to recommend a method of treatment—in order that this axe may survive for a long time to come, as a subject of learned archaeological study and of growing curiosity on the part of museum visitors.

An investigation carried out by the author a few years ago in three countries of Western Europe revealed that less than one ten-thousandth part of the public funds available for the purchase and installation of museum objects and the repair of historical monuments was devoted to museum

1. Received in 1957.

laboratories. That is surely a very small proportion and argues scant concern for the future of a cultural inheritance whose irreplaceable character is so frequently proclaimed.

SCIENTIFIC EXAMINATION

Less than two hundred years ago, medicine was an art which endeavoured to cure all ills by purging and bleeding. Until a few decades ago, the medical treatment of works of art existed only in name, and restorers, shut away in their ivory towers, applied a few standard remedies. A painting received its ration of alcohol or was saturated with glue through innumerable little canals pierced by a needle. As a last resort, the specialist would assert his mastery of 'transposition'. Times have happily changed, and there is now wise collaborations between museum heads, restorers and the laboratory, which last puts more and more numerous and varied methods of investigation at the service of cultural property.

Whenever an ancient object is brought into the laboratory the same problems normally present themselves. What is its nature, its composition, its structure. How far has it deteriorated; and what are the natural or accidental causes of that deterioration. The technicians are then asked to find a suitable way of conserving it for the future. Admittedly, their answers will often betray some doubt, some degree of ignorance, since the field is a vast one; but in every case they will point the way to a rational solution which others may develop and perfect. Nor must these limitations cause us to forget that the essential need has been met. The study of ancient materials has come into being and taken the place of empirical knowledge and individual know-how. The laboratory research worker who handles physical matter knows that, in becoming a work of art it has reached its highest form. For the same reason he also knows that artistic expression must dominate matter, and when a work is entrusted to him he will endeavour to preserve it in such a way that its inherent beauty will in no wise suffer.

With this understanding of the laboratory's task, we must now review the methods which it has at its disposal. A distinction is generally made between physical (optical) methods—often called 'nondestructive methods' because most of them do not require the taking of samples—and microchemical techniques, for which a few minute portions are indispensible as specimens. To avoid the taking of samples, the examination of a piece must always begin by the use of physical methods, and it is in this domain that the most profitable innovations may be expected.

Laboratories therefore start by exhausting the whole range of physical methods, including the fields of both visible and invisible radiation.

Radiation	Wavelength (in Å) [1]
γ	0.001 - 0.01
X	0.01 - 10
Ultra-violet	10 - 4000
Visible	4000 - 7000
Infra-red	7000 - 10^6 (0.1 mm.)

1. The unit for measuring wavelengths, the Ångstroem (Å), corresponds to one ten-millionth of a millimetre.

It will be seen at once that the visible range is an infinitesimal part of the whole. The vast field of invisible radiations has therefore to be investigated, with the help of photographic recording, which makes up for the imperfections of the eye and furnishes a lasting document available for a whole variety of subsequent comparisons.

Among the short wavelengths, most use is made of X-rays (radiography) and in particular, of their power to penetrate materials. This is an easy and rapid way of ascertaining the object's condition throughout its depth and obtaining data on, for example, the mineralization of metal, the repairs to a piece of pottery, damage to and restoration of a painting. In recent years, the technique of gamma radiography has developed. The effect of gamma rays is comparable to that of X-rays; they will find abundant applications when atomic energy comes to be used for the preservation rather than the destruction of the cultural heritage

of man. X-ray diffraction and electronic diffraction, so useful for studying intimate physical structures or very detailed surface characteristics, have a great future before them. For the moment, however, the cost of equipment and the difficulties of interpretation remain serious obstacles.

In contrast to these short-wave radiations, the ultra-violet, visible and infra-red rays reveal the characteristics of the material at its surface or in the neighbouring zone of superficial 'patina'.

We are all familiar with the selective effect of light, which varies especially with the colour, texture and characteristic absorption power of the object. Within the range of the *visible* rays, a glaze of red paint should be examined with the help of a source rich in red rays; the chances will be increased of detecting a concealed design and exposing a portion which does not belong to the original work, especially if the naked eye is supplemented by the use of a binocular microscope of low magnification (enlarging 5 to 50 times) and if the direction of the light is varied.

Generally speaking, the same principle —namely, the capacity of a radiation to be absorbed, transmitted or reflected selectively by a specific material—applies to *ultra-violet and infra-red rays*. Although individual results are not easily predictable, in general ultra-violet rays have a better chance of success with cold-tinted objects; warm colours give better results with infra-red rays. Fluorescence—an ultra-violet radiation transformed into visible light—has been used in a great variety of ways in the history of art and in archaeology; it helps to determine the relative age of the varnish in a painting, the presence of restoration, false patina of an organic character on many museum objects, repairs to textiles, the differentiation of colouring matters, and so forth. The field of investigation is becoming larger every day, thanks to the variation of wavelengths in the invisible range and to the use of simple apparatus for transforming infra-red into visible rays.

In addition to the non-destructive methods, there are others which, though likewise based on physics, require the taking of samples. Foremost among them is the *spectrography* of emission and absorption.

The first of these two techniques makes it possible to determine the composition of inorganic substances; the second helps mainly, in the visible and invisible ranges, to characterize the chemical structure of organic compounds, which are identified only with great difficulty by other operational techniques.

Microchemistry, as its name implies, is chemistry applied to extremely small quantities. It remains a favourite tool of museum research workers, who are usually provided with only a few milligrammes of material and have to be content with a restricted series of crystallization and colouration reactions in determining the nature of ancient organic substances with transformed characteristics. In this field (for example, the binding medium of a painting) progress is slow, in contrast to that in the identification of inorganic compounds (e.g. pigments), which is usually reliable.

Microscopy, or examination by means of powerful magnification combined with microphotography (in the visible and invisible ranges) and the preparation of transversal and longitudinal sections of old material, is everywhere in use. Microchemistry determines the presence of certain compounds; microscopy and sections make it possible to localize these compounds and to give a semi-quantitative appraisal of them. It has thus become possible to identify structures, with excellent results, especially for old metals and paintings.

Museums have begun to apply the C^{14} method in determining the age of ancient objects. The British Museum Research Laboratory has been working with this technique for several years and is now gathering the first fruits of its research. The work is continuing and many new applications will develop.

Considered separately, all these methods have relative value; their sensitivity and precision are often faulty, and, even more often, valid interpretation is lacking. But when they are used together, their results confirm and supplement one another and lead to profound and more objective knowledge. Moreover, photography, the importance of which does not need emphasis serves to record these results. Photography makes up for the imperfections of the eye,

to which the vast field of invisible radiation remains inaccessible and of memory which is unable to register for long the characteristics of deterioration and the sometimes radical transformations undergone by a work during restoration. Black-and-white and colour photography remain the only objective means of recording the various stages of examination and treatment and of transmitting them to future generations. The men of the future, more fortunate than we, will no longer have to 'innovate', but will enjoy a maximum of guarantees in continuing the work of their predecessors, to the greater benefit of cultural property.

DETERIORATION
OF OLD MATERIALS

When we glance casually at a museum object in its showcase, we tend to think that the object is inert and that the matter, composing it is no longer subject to change. Nothing could be more untrue. Those responsible for cultural property are well aware that a short period of inattention or any hasty or ill-directed action is all that such matter requires in order to remind us that it is still very much 'alive' and particularly sensitive to any variation or shock inflicted upon it.

By 'deterioration' is meant the natural and accidental 'ageing' of a material, and its inevitable effect upon the appearance and structure of museum objects. These transformations are obviously in proportion to the specific power of resistance of various materials and to the nature, violence and duration of the factors of deterioration.

To emphasize the importance of 'air-conditioning' in museums, we shall discuss at some length the question of climate, before proceeding to another factor in deterioration, 'light'. We shall then pass from the general to the particular and briefly establish a broad classification, valid for most types of museum, of the varying degree of resistance to deterioration offered by objects in collections.

Climate

Fortunately matter, and therefore 'fashioned' matter as seen in antiquities and works of art, possesses an extraordinary capacity to adapt itself to the climate in which it has to live. Thus a swamp can adequately preserve bronze or wood; a painting can resist the persistent dampness of certain churches. After a long preliminary period of deterioration, equilibrium is achieved between the material and its surroundings. However, this balance is disturbed, and the process of deterioration resumed *in toto* when the object is moved and has to breathe a new environment. This is why so many objects found in excavations are deformed or crumble into dust as soon as they leave the soil. It is for the same reason that an object of ethnographic interest causes so much trouble to the distant museum which receives it, while organizers of expeditions wonder why a work of art, so much less well treated in its country of origin, reacts so unfavourably to a perfectly air-conditioned gallery.

A first general rule may be deduced from this: a museum object must not be subjected to variations, especially to sharp variations, in its physical climate.

In defining this climate, we must consider four primary factors: the purity and homogeneity of the air, its temperature and especially its humidity.

Humidity is largely responsible for the decay of material, in which it provokes mechanical, chemical (or physico-chemical) and biological reactions.

Mechanical effect. Organic materials (papyrus, parchment, paper, textiles, wood, bone, ivory, leather, as well as glue, adhesives and impregnating substances) have an essentially cellular structure. As a result, they are extremely hygroscopic: the cells are swollen by increased humidity, with consequent expansion of the material (except canvas, which shrinks); dryness empties them of their liquid content and contracts them. Moreover, water dissolves the salts contained in objects (e.g. soft stone) or crystallizes them (with a resulting increase in volume) with any increase in dryness.

Chemical effects. Practically no form of chemical deterioration can take place without water. There will be no oxidation of old metal, no migration of soluble salts, no

discoloration of tissue. Water almost always contains carbonic acid gas, which considerably increases its dissolving power. An example of direct chemical deterioration is provided, in industrial regions, by limestone monuments, to which 'sulphating' causes considerable damage.

Biological effects. The 'mould formation point' (more accurately called 'fungi') is generally agreed to be a relative humidity of 70 per cent (see below) when the temperature is between 20° and 25° C. The relative humidity in a museum must therefore be kept below this point; proper ventilation must prevent air from stagnating (as it would in a corner too sheltered or in the drawers of a cabinet containing drawings). During the last war, many organic objects, temporarily sheltered in unheated cellars, became ideal media for the development of micro-organisms; at the same time, insects attacked the material, which had already become less resistant. Obviously biological destruction is most to be feared in tropical countries (for example, the plains of Indonesia), where the relative humidity may be above 80 per cent throughout the year.

Control of humidity. In the analysis of atmosphere in museums and of air-conditioning in the galleries, the concept of humidity is generally replaced by that of relative humidity (rH), which indicates the close relationship of humidity with surrounding temperature (t). That is, relative humidity expresses the relation between the quantity of water present in a given volume of air at a given temperature and the maximum quantity of water which that same given volume may contain at the same temperature.

Temperature (t) in °C	Grammes of water vapour per kilogramme of dry air		
	rH $= 20\%$	rH $= 60\%$	rH $= 100\%$
0	0.38	2.28	3.82
20	1.43	8.69	14.61
40	4.55	28.30	48.67
60	12.50	83.35	152.45

A glance at these figures shows that, at a given rH, the quantity of water present in the air increases considerably with t, or in other words, that rH can be reduced if t is raised; likewise, at a given rH, it suffices to lower t sufficiently to reach the saturation point of the air (rH $= 100$ per cent). Part of the water vapour will then condense, and moisture will be deposited on the object; this phenomenon is particularly dangerous to the well-being of all ancient materials. The influence of t on rH is still better seen by reference to the 'psychrometric curve' (see diagram on page 100).

In recent years, the optimum rH of museum galleries has been a matter of general concern. It has come to be realized that with a complete stabilization of the atmosphere in museums, most forms of deterioration would theoretically cease. This complete 'conditioning'—i.e. purity and homogeneity of the air in regard to both rH and t—is the ideal to be aimed at; but installation and maintenance costs are high and very few institutions (several museums in the United States, the Kunst museum in Basle, several rooms of the National Gallery in London, etc.) have attained this result. It is therefore more usual to try to obtain an optimum rH, which specialists consider to be between 60 per cent and 65 per cent. That figure, applying to all climates, is determined by the 'mould formation point', fixed at 70 per cent, and by the need of not reducing rH to 50 per cent or below, where conditions are unfavourable to hygroscopic materials.

The 60-65 per cent rH optimum is, very often, impossible to obtain. Care must then be taken that variations in rH shall not be sudden or excessive; rH must remain somewhere in the zone between about 50 and 65 per cent. In most climates where museums are built of solid materials, the screen provided by the thick walls prevents rH in the galleries from oscillating more than between 50 and 70 per cent, even when the figures for outside vary between 30 and 90 per cent. The fluctuation is even slighter when the museum contains regularizing materials, such as tapestries, which absorb water, or when objects are kept in water-tight cases. In this last eventuality, fluctuation hardly exceeds 10 per cent. The

97

measures adopted 20 years ago at the Brussels Musées Royaux d'Art et d'Histoire resulted in a rH which rarely went beyond the limits of 50-70 per cent, and in certain cases (tapestries) 55-65 per cent; the same was true for the more tightly closed showcases.

It is thus usually possible—in the case of buildings or museums with a limited budget—to accept without risk a rH varying between 50 and 65 per cent.

In countries with a temperate climate (in the Northern hemisphere), it is not often necessary (except in July-August) to reduce the humidity of the atmosphere; to increase the relative humidity (in December-January or February) is much more important. Every year, in mid-winter, it becomes necessary for us to vaporize water in the restoration workshop of the Institut Royal du Patrimoine Artistique[1]; otherwise, furniture would crack, sculptured wood would split and paintings would warp. Dozens of organic objects require urgent and careful attention a few weeks after the end of every cold period (and of the extreme dryness produced by central heating). In tropical regions the problem is quite different: even during a so-called dry period (in Indonesia, for instance) the atmospheric humidity must be reduced at all costs, for the high temperature favours the growth of mould and 'mosses'.

For lowering rH, inexpensive apparatus is now available based on the refrigeration principle or the use of silica gel. The first type of apparatus consists in the main of a finned refrigerator with ventilator, the water being collected in a container placed beneath the apparatus. The second method uses a ventilator with a reservoir containing a large quantity of humidity-absorbing silica. Silica gel is an artificial product having the same composition as natural silica (sand, or rather quartz), but containing, like a sponge, innumerable fine pores. Thus it can 'adsorb' large quantities of water (several dozen times its own volume); another and a remarkable property is that it can be used again after saturation, if it is heated to above 100° C. Silica gel, as a completely neutral substance, is much superior to the products formerly employed: sulphuric acid, quicklime, soda-lime, etc. When finances permit, a very useful accessory to these two types of apparatus is a humidostat, which can be set at the desired minimum rH.

Humidification of the atmosphere is most easily obtained, at little expense, with one of the many kinds of vaporizing apparatus. The air is sprayed with water from a reservoir. All types are acceptable, provided that true water vapour is sprayed from the apparatus and not a fine rain, for small drops deposited on objects would constitute ideal centres of decomposition. Here again the use of the humidostat gives an additional guarantee. Where money is lacking, rH can be raised 5 to 15 per cent if vats of water are placed, preferably above the radiators, or if a kind of flowing lattice is installed, holding a long cloth with one end in a reservoir of water. In this case, evaporation will be accelerated by a ventilator.

Hygrometric conditions in the building, the conditioning of which is to be improved must, of course, be known at the start. A hygrometer with a dial is generally employed; rH is registered by a substance (quite often a small tuft of hair) which is sensitive to humidity variations. The method is a good one provided it is realized that such apparatus soon gets out of order and must be checked every week. This is also true, though to a lesser extent, of thermo-hydrographic recording instruments. One good checking instrument, which is also an excellent means of measuring temperature and humidity, is the dry- and wet-bulb thermometer. The dry-bulb thermometer gives the temperature, and relative humidity is obtained by noting the difference between this temperature and the one recorded on the wet-bulb thermometer. The latter's reservoir of mercury is lined with a saturated absorbent tissue; by rotating the apparatus for a certain length of time (120 to 150 revolutions, as the experimenter may think necessary), the difference between the temperature of the wet-bulb thermometer (heat of evaporation) and that of the dry-bulb is found to be greatest when rH is lowest; climatic values may then be determined with the help of a slide rule and a table giving rH to t relationships.

1. Formerly known as the Laboratoire Central des Musées de Belgique.

Another climatic factor which must be considered is *temperature,* although, by itself, it hardly influences the deterioration of museum objects. Its importance lies in its relationship with rH, which will be modified by any considerable variation in t; thus (see diagram on page 100), when the air out of doors (see annexes pages 113 to 118) has a t of 10º C and a rH of 80 per cent, the rH in a building heated to 20º will be only 40 per cent. Such conditions may easily prevail in winter and explain most of the damage done by central heating.

The *purity of the air,* the third factor in the problem of conditioning, deserves some attention.

Air in inhabited places contains substantial quantities of dust. This dust is deposited on museum objects and wears them gradually, with the help of well-meaning but over-zealous attendants who lightly brush the objects entrusted to them once a day with their feather dusters; the dust flies up and then settles anew in the same quantity on the same objects; and this operation is repeated every 24 hours until it is finally understood that there exist such things as suction machines, called vacuum cleaners, which are infinitely more practical, if less elegant. Dust slowly wears down soft materials; everywhere it creates centres of deterioration in which water vapour is most apt to condense and catalyse chemical and biological reactions.

The residual products of combustion, fumes and sulphurous gases, which are characteristic of large industrial and urban centres, are far more dangerous than dust. Sulphur compounds (hydrogen sulphide and especially sulphur dioxide) attack metallic constructions and historical monuments, especially those built of limestone; they also attack these materials, though to a much lesser extent, even when they are protected by museum walls or by glass. Cities like New Delhi or Stockholm, which have little or no heavy industries and are surrounded by a screen of water or a green belt, are in a much more favourable position than Brussels or Paris, for example, or such 'smoke-producing' centres as Pittsburgh or London. Throughout Western Europe, where limestone has always been a favourite building material, stone decay has to be given constant attention; however, museum laboratories experience sulphurous deterioration in only a few cities, notably in London.

Ancient buildings situated close to the seashore (e.g. the ruins of the ancient Abbaye des Dunes at Coxyde, Belgium; the vast Roman shipyard at Salona, Yugoslavia; many religious monuments in India) are special examples of air vitiated by marine salt, a hygroscopic and particularly corrosive substance; however sodium chloride crystals rarely find their way as far as the museum showcases.

The *homogeneity of the air* calls for less discussion.

In a gallery of simple design which is suitably ventilated by doors and windows, t and rH of the air will be practically the same everywhere. But if the room has a more complicated structure or is filled with screens (partitions, showcases) or if objects are enclosed in receptacles, the figures will vary. These differences may, in themselves, be negligible, but there are cases where they catalyse deterioration, especially if the surrounding rH is high. In cellars and storerooms, some particularly sheltered corners may have a rH 10 to 20 per cent higher, permitting mould formation. In Belgium during the last world war, two famous Rubens paintings were sheltered from bombs in an unventilated cellar. Two months later their painted surfaces were completely covered with mould, and several varieties of voracious insects had also begun their work.

The remedy is simple, perhaps too simple for general use. All that is needed is ventilation, to keep air circulating. The same principle holds for hot and damp climates, where t and rH conditions are ideal for the hatching and growth of micro-organisms and insects; good ventilation does much to slow down biological decay.

To sum up this important problem of air-conditioning in museums:

1. The ideal is to come as near as possible to complete conditioning, with pure, homogeneous air, a low temperature of about 18º C and a rH of about 60 per cent.
2. If this is impracticable, rH should be kept within the 50 to 65 per cent range;

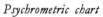
Psychrometric chart

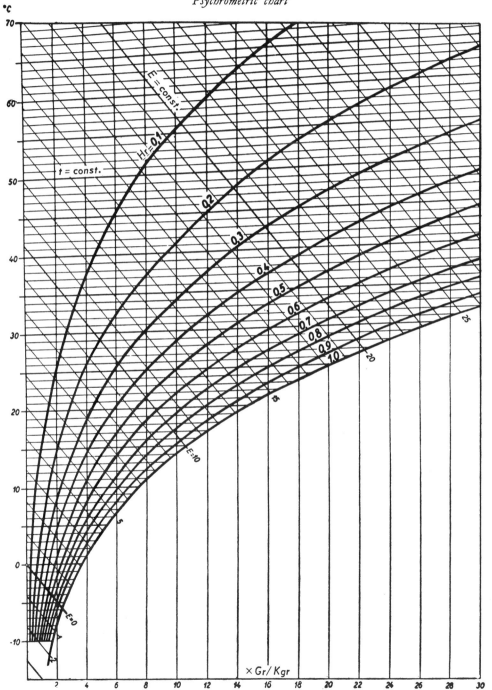

°C

70

60

50

40

30

20

10

0

-10

E = const.

Hr = 0,1

t = const.

0,2

0,3

0,4

0,5

0,6

0,7

0,8

0,9

1,0

25

20

15

10

E = 10

5

E = 0

× Gr / Kgr

2 4 6 8 10 12 14 16 18 20 22 24 26 28 30

a low rH is more to be feared than a high one.

3. Sudden changes in rH, which rapidly 'fatigue' ancient materials, must be avoided; so must a very high rH, moulds and the condensation of water.
4. Temperature is practically of no importance except in regard to rH; a rise in temperature considerably diminishes rH and vice versa.
5. If the air is not really pure, the accumulation and scattering of dust must be prevented.
6. The building must be ventilated so as to avoid stagnation of the air.
7. In whatever climate the museum is located, its characteristics must be known; simple, inexpensive apparatus for measuring rH and t is obtainable.

Light

The choice of a light source depends upon two important factors: it must be capable of showing up exactly the colour and relief of exhibits; it must not constitute a major cause of deterioration.

When the relative merits of artificial sources, for the most part incandescent lamps and fluorescent tubes, are compared with those of sunlight, it is sometimes forgotten that the former are unchanging, while the latter is infinitely varied in quality and quantity according to the country, the atmospheric conditions, the season and the time of day. Thus, if it became necessary to light a Chartres window artificially, the technician would feel that he had succeeded fairly well if he faithfully reproduced the values of the two main colours, the red and the blue; but he would be quite unable to imitate, at the same time, the impression produced by morning sun—a real symphony of blues—or the crimson glow of the window when flooded by late afternoon sun. The monotonous rendering of colour is probably the physiological and psychological cause of 'museum fatigue'; the visitor prefers the infinitely varied resources of sunlight to artificial illumination.

However, except when, by chance, it falls in exactly the right way, natural light gives a very imperfect rendering of the volume of bas-reliefs, sculptures, and all works whose plastic values require to be brought out. Here, fluorescent tubes are little to be recommended, unless their rays are combined with those of incandescent lamps, which, as pin-point sources, are easy to adjust and throw clearly localized shadows.

We all know that light is a sure cause of deterioration in materials; in the home no wallpaper or carpet can in the long run resist its destructive action. In museums, its effects are of course, mainly felt by organic materials (paper, textiles, leather, water-colours—more than any other kind of painting), especially if they are coated with colouring matter which is sensitive to light. The members of ICOM's International Committee on Museums Techniques will long remember the striking evidence offered them in 1950 by their Stockholm colleagues when the latter exhibited two eighteenth-century French tapestries (belonging to the same series, from cartoons by Boucher), one of them as luminous as a tapestry of today, the second dull and faded ('patinated' is the wrong word) like other old tapestries we daily admire in museum galleries.

The mechanism of deterioration by light is still a little-known subject. Certain major causes—enumerated below—may be recognized; but other obscurer factors also play their part, especially in tropical countries, where higher temperature and humidity catalyse this decay.

It can be postulated that all light, whether visible or invisible, natural or artificial, is a cause of deterioration. Sooner or later, the illuminated matter, which is sensitive to light, must deteriorate and finally disappear. The process may continue over several years or centuries, according to the duration and intensity of the exposure, the type of radiation and the kind of object illuminated.

Intensity and duration of exposure to light. At the end of the last war, many museums were rebuilt and their collections reinstalled. At that time—thanks also to the introduction of a new light source, fluorescence—a pronounced move was made towards increasing luminous intensity. One effect of this otherwise praiseworthy initiative was to stimulate deterioration by light.

Incidentally, the intensity of direct sunlight is much stronger—tens or even hundreds of times, according to circumstances—than that of the usual forms of artificial lighting. Even diffused sunlight is much more intense than spotlighting.

Little need be said about the factor of duration of exposure. There is hardly a museum whose staff does not turn off the lights at once at closing time or fails to lower blinds in order to prevent the infiltration of daylight.

Type of light source. In addition to visible and therefore directly serviceable light, the sun and artificial sources emit a certain quantity of invisible (ultra-violet and infra-red) radiation. Ultra-violet light (which has a shorter wavelength) is mainly to be feared for its spectro-chemical effects; infra-red light (with a longer wavelength) has a calorific action.

When the fluorescent tube ('cold source') and the incandescent lamp ('warm source') are compared, it will be seen that the tube gives out more ultra-violet light than the lamp, while sunlight has the deleterious qualities of both artificial sources, and, it must be repeated, to a higher degree.

ICOM and Unesco have concerned themselves with the potential danger—which by the way, has been much exaggerated—of the use of the fluorescent tube. A large-scale survey instituted by ICOM led to the publication, in 1953, of a pamphlet[1] which has given general extension to the use of fluorescent light in museums; it also drew the attention of manufacturers to a few rare types of tube which were less to be recommended for the illumination of museum exhibits. Some institutions are still conservative enough to forbid the use of fluorescent light. The same thing happened when the first oil lamps made their appearance, and later, a half-century ago, when the first incandescent lamps were introduced. But the large majority of visitors seem to have become used to fluorescent light. At first they had to accustom themselves to the change from the yellow light of incandescent lamps to the 'colder' tints of some fluorescent tubes; they still feel, perhaps, without being able to explain it, that there is some essential physiological

difference between the discontinuous fluorescent source (radiant emission) and the continuous source of the old yellow lamp and of the sun.

Nature of object illuminated. Attention has already been drawn to certain materials which are more sensitive to light than others. This experimental result is the fruit of observation and has not yet been satisfactorily explained. The physical and chemical composition of the substratum of objects most certainly plays its part, as does the composition of the colouring matter. But it will be many years before the direct cause and effect relationship can be determined, especially the relationship between 'selective absorption' and deterioration by light.

This report has attempted to outline a few theoretical and practical aspects of the deterioration of museum objects by the effect of light. To the general recommendations already advanced, the following suggestions may be added regarding the use of screens.

1. Opaque screens (of aluminium, sheet-iron, etc.) direct the luminous flux selectively and make it possible to use less harmful indirect lighting.
2. Translucent screens (opaline and frosted glass filter and diffuse the light and dilute its intensity).
3. Transparent screens (natural and artificial glass) also filter the light. A good artificial substitute which keeps back ultra-violet rays without distorting colours in the visible range has still to be found.

Specific liability to deterioration

Museum materials are generally classified in four categories: organic materials (hides, leather, parchment, paper, bone, ivory, textiles and tissues, wood); metals and alloys (gold, silver, lead, tin, copper and its alloys, iron and steel); siliceous and equivalent materials (natural stone, bricks, pottery, ceramics, glass) and, lastly, easel and mural paintings.

It is not easy to determine the relative liability to deteriorate of these four groups;

1. See bibliography, pp. 108-12.

very different factors of deterioration can exert more or less action according to the group; secondly, within the same group, and by the play of the same factor, some materials may resist perfectly well, while others go completely to pieces. With due regard to these qualifications, it is, however, possible to draft a table of specific liability of materials to deteriorate; the relative stability of the structure and composition of each material is compared with the nature and intensity of the factors of deterioration in the environment (air and ground) which attack the mechanical, physico-chemical and biological integrity of these substances.

Organic materials. The first category includes organic materials, viz. those of animal or vegetable origin, the three other categories include all the inorganic compounds from the mineral kingdom. Easel paintings however (in the fourth group) include a few organic substances: certain colouring matters, almost all the binding mediums and adhesives, and certain supports, such as canvas and wood.

In the study of liability to deterioration, a clear distinction must be made between inorganic materials, with their infinitely variable structure and composition, and the so-called organic materials, with their carbon-based composition and cellular structure. Organic substances are of course the least stable. They offer little resistance to light, to variations in humidity and temperature, to dryness (collapse of the cells) and to excessive humidity (biological reaction). Hence the small number of organic antiquities which have reached us and hence their brittleness, especially after a prolonged period under ground.

Metals and their alloys. Metals and their alloys are much more stable. Light does not affect them, variations in temperature are of little importance, and they are safe from biological action. On the other hand, variations in humidity, impurities in the air and especially in the ground (sulphur vapours, carbonic acid gas, soluble salts) exert an extremely variable influence according to whether the metal is 'precious' (gold and, to a lesser extent, silver) or non-precious (in ascending order of liability to deterio-

ration: lead and tin, copper, iron). This deterioration, commonly called 'corrosion', is reflected in a transformation of the metal into its salts (patina, incrustation) and ultimately into the corresponding minerals ('mineralization') found in nature. In this way nature reasserts her rights and begins to reverse the cycle of the metallurgical process (from ore to pure metal). The most eminently precious of the metals, gold, remains intact even in unfavourable surroundings. Silver oxidizes on exposure to the air, its surface becoming tarnished. A long stay under ground may produce a patina with an oxide, chloride or sulphide basis. At the other end of the scale, copper and iron are easily oxidized metals even when exposed to the air, still more so, when they are under ground. In fact, satisfactory conservation is possible only under particularly favourable conditions; lacking these, the metals—iron even more than copper— become completely 'mineralized', iron being transformed into 'rust' (oxide) and copper into complex salts the beautiful brown, blue or green colour of which cannot conceal the instability of the metal. Examples are the sulphurous green patina of the copper-containing roofs of buildings in industrial centres, Egyptian antiquities devoured by chlorides in the valley of the Nile, the many copper and bronze objects which have become distorted in soil full of water and carbonic acid. Among these various factors of corrosion, the chlorides are probably the most destructive, and the best known to museum curators: a fine, pale-green powder is sometimes to be observed in showcases; this is almost always evidence of chloride action and is a sure sign that treatment is urgently called for.

Siliceous and equivalent materials. A number of different materials, are grouped under the heading 'siliceous and equivalent materials'. This is a convenient, but not quite accurate grouping for, although most of these materials have a basis of silica or silicates, some —certain varieties of natural stone, limestone and marble, for instance—do not contain those substances. However, as far as liability to deterioration is concerned, the phenomenon is everywhere comparable.

In this second group, natural stones must

be considered separately. They differ greatly in composition, density and hardness; their susceptibility to factors of deterioration varies infinitely from granite and basalt, which are highly resistant, to limestone and sandstone, which are particularly friable. The granite of historical monuments in Spain and Indonesia resists much better than the soft stone of Western Europe, Egypt or India. We can, however, cite a few major causes of deterioration that are common to them all: industrial sulphur fumes, temperature and humidity variations, saline efflorescences and the cryptogamic invasion that accompanies them. The factory's chimneys and house fires of the London area, for example, fill the air with vast quantities of dust, soot and sulphur fumes, which attach themselves to limestone, modify its chemical composition at the surface (sulphatation) as well as its structure (increase of volume). The stone flakes off, crumbles away, and bit by bit sculptures disappear. The process is not observed in cities like Stockholm or New Delhi, where these causes of deterioration are absent. A striking example of the effect of temperature variation is provided by the site of Persepolis, where recent excavation has uncovered an historical collection of the greatest importance: daily temperature variations of about 40 per cent are ruining the sculptures one by one. To a lesser extent, such deterioration affects stone in all countries with considerable and sudden changes of temperature (as from day to night). The surface of crystalline stone is especially vulnerable to heat: the minerals expand and cleavages occur. Humidity variations are even more to be feared: their concomitants are the migration of soluble salts ('efflorescences') in all climates, the effects of freezing in cold countries, abundant washing of the material and cryptogamic growths in the rainy season of tropical regions. For soft and therefore porous stone, saline efflorescences are probably the worst of these perils. All stone contains water, often heavily charged with salts. These salts dissolve in the rainy season, and crystallize again (increasing in volume) during the dry season; repeated *ad infinitum,* this cycle draws the salts, towards the surface, where they form 'efflorescences' which flake or rupture the ma-

terial. The one-tenth increase in volume which accompanies the conversion into ice of the water in the stones is also responsible for extensive damage to old buildings in countries with hard winters. In tropical countries the alternation of wet and dry seasons accounts for most of the trouble. In Indonesia, the rainfall exceeds 2,000 mm. in about three months; on the same day after heavy rain—and for months during the dry season—the sun rapidly vaporizes the water at the surface of the stone and exerts strong pressure on the pores of the material; such violent and repeated shocks disrupt the mechanical equilibrium of the stone, especially if it is hard and does not absorb or give up humidity like a sponge. Conditions in tropical countries are ideal for the appearance and development of moulds and 'mosses': high temperatures, very high relative humidity (80 per cent or more throughout the year) favour the rapid growth of all cryptogamic vegetation. Micellae find their way into the smallest cracks, attach themselves firmly and rupture the stony envelope surrounding them. All too often, purely mechanical means (brushes made of wood fibres) are still employed to remove such vegetation; the envelope of stone, already very brittle, crumbles at the lightest touch.

Construction bricks and pottery baked at a high enough temperature may be put into the same class; they are of similar composition (clay). Their liability to deteriorate may be compared with that of natural stone of average resistance. Pottery baked at low temperatures or merely dried is, of course, more fragile, and its sensitivity to external agents is at least as great as that of soft natural stone. Genuine ceramics are highly resistant to these various factors of deterioration. Their principal enemy—as in the case of bricks and pottery—is water with salt in solution, which can provoke efflorescences.

Glass, the last sub-group among the siliceous materials, is relatively stable. Yet museum laboratories regularly have to deal with old glass which an excess of alkali has rendered less resistant; on contact with water, part of the alkali is spread along the vitreous mass. Humidity also sometimes sets up a disease in glass; the material becomes

dull and loses some of its transparency. Chemists then find that the physical equilibrium has been upset; the glass is becoming devitrified and contains an infinite number of small cracks.

Easel painting and mural painting. The fourth category includes easel painting and mural painting. This rather arbitrary classification may be justified by the highly variable nature of the organic and inorganic ingredients composing the various layers: the varnish (or protective layer), the layer of paint, the 'ground' and the support. Varnish is purely organic; the layer of paint, sometimes with several secondary layers, is composed of organic and inorganic colouring matter bound by an organic medium (exception-frescos); the ground (easel painting) or coating (wall painting) is of similar composition. The support varies greatly: sometimes it is organic (wood, canvas) and sometimes inorganic (copper, the substance of a wall). In addition, a film of organic composition is often applied between these various layers to help them adhere to one another. Such variety in chemical composition and such complexity of structure obviously presents many possible causes of deterioration; the layers may cease to adhere to one another, or decay may occur within each of the various layers.

No ordinary varnish (made of natural resin) conserves its original properties for longer than 20 to 50 years. Affected mainly by damp, it loses its elasticity, cracks and ceases to protect the layer of paint; indeed it becomes a danger and, in falling, carries the paint away with it. This loss of elasticity is accompanied by a physico-chemical transformation seen in the yellowing of the varnish, a new characteristic which some consider the finest expression of 'patina'. Others reject it as a veil held between the spectator and the original work, a veil which denatures the colours and even obscures the composition.

In the layer of paint, there are few pigments which do not resist time's action. However, certain organic colours and a few inorganic pigments are of doubtful stability, especially when atmospheric agents (humidity, notably) are violent in their action. The main source of deterioration is the instability of the mediums (siccative oils, distempers of egg, gum, glue, etc.); these are liquid when applied, but are rapidly transformed into a film which is at first elastic, but later becomes brittle and therefore permeable to damp, its principal enemy. This natural 'ageing' is, of course, hastened and intensified when conditions of conservation are unfavourable. The results of deterioration soon become visible : cracks in the paint layer, protrusion of little islands of colour formed in this way, flaking, loss of the original colour. Over-frequent cleaning and clumsy repair work often diversify and augment the damage.

The ground or foundation (white lead, chalk, gypsum, marble powder, kaolin, mortar, oil, glue, etc.) is better protected on the paint layer side (especially in easel painting) than on the reverse surface. Here, too, damp is the most important factor in deterioration. It is revealed by a powdery deposit on the ground, or even by cryptogamic invasion. In easel painting, soft wood supports (pine, for example) are less resistant to water and insects than those of hard wood (oak is the best). All of them, however —and canvases still more—are affected by damp. That is why many old Flemish panels (Van Eycks, for example) were originally covered at the back by a protective layer of chalk and glue. Damp, with its accompanying saline efflorescences and moulds, is the principal cause of the destruction of mural paintings—not only of paintings in caves and other underground places but also of those in quite different and better ventilated sites such as churches and large houses. The trouble almost always comes from the wall; water, sometimes containing salts, either seeps out of it continuously or rises from the floor, by capillary action, to the level of the painting. This movement may be horizontal or vertical and soon affects the paint layer, both in fresco and in distemper work. The painting (which alternates between dry and moist) disintegrates, the phenomenon being catalysed by temperature variations and by the effect of light and micro-organisms. On the whole, it is well that most mural paintings have been laid bare only recently. Even so, they are not yet safe, for damp in walls—and

their condition determines that of the paint layer—often defeats us still.

Of course, various factors of decay operate not only inside the layers of the painting, but cause still greater damage between these layers. When organic substances (oils, glue, etc.) no longer fulfil their role as adhesives, then unsticking, blisters and all the other ills which go with insufficient adherence are bound to follow.

CONSERVATION AND RESTORATION

It is not possible here even to sketch the principal methods of conservation and restoration : there are far too many of them, museum materials are too diverse, and their state of conservation too variable. We therefore refer the reader to the selected bibliography at the end of this chapter and especially to an excellent work by H. J. Plenderleith, *The Conservation of Antiquities and Works of Art*, published in 1956. It is hoped that this will soon be translated into other languages. The present document will be limited, then, to general considerations, illustrated by concrete examples from data available in Brussels.

In 1950, during the treating of Van Eyck's *Agnus Dei*, the *Institut Royal du Patrimoine Artistique* defined this treatment as 'a technical operation aimed at maximum prolongation of the life of the work—conservation —with a minimum of surgery—restoration'![1] This definition is valid for the treatment of all museum objects and historical monuments; the versatility of the restorer and the fashion of the day must yield to the need to preserve these works for future generations. It is probably for this reason that in Germany and in the United States, the technicians who undertake this work are termed 'conservators' rather than 'restorers' as they are still called in other countries.

The treatment of a museum object is primarily a 'technical operation'. That is obvious, since what is being treated and subjected to reagents in the laboratory is the material. Yet the aestheticians rightly maintain that a work of art is 'a thing of beauty' and that treatment, of whatever kind, must be satisfactory from the aesthetic point of view. Laboratory workers cannot just steep a fine wooden statue in paraffin in order to preserve it, and send it back to the gallery darker and greasier. They must also find a way of restoring its pristine appearance; the work will then be preserved without giving the impression of having been to the laboratory.

As regards both easel painting and mural painting, the apparent opposition between technique (aesthetics) and conservation (restoration) has led to controversies, notably around the thorny problem of the 'reconstitution of the original'. Some specialists, especially museum curators, are tempted to reconstitute the work as completely as possible. Their first concern is to present the public with an entire exhibit in which the inexperienced eye can no longer easily distinguish the original from later additions. Others—the educators—are opposed to this intentional deformation of the work. The degree of deformation varies according to the individual responsible for it, but is always dangerous; the visitor believes he is admiring the creation of a revered genius, and what he sees may be only the result of the successive interventions of various restorers in the course of centuries. This purist controversy will recur periodically until it is admitted that every treatment presents a special case, that in restoration respect for the master's work is the first concern, and that, lastly, good documentation (reports, photographs) can do much to allay anxiety. The removal of varnish (totally or partially) is also much disputed. The contending parties are not the less agitated for being divided merely by 'an infinitesimal layer of varnish'. And how are we to differentiate between varnish, patina and 'dirt'? Where are we to find the solvent that will remove the varnish without destroying the original glaze ? How can we possibly leave an unhealthy varnish, when everybody knows that before long it will damage the paint layer ? The discussion is often academic, for whatever we may recommend in theory, the varnish will in practice have to be removed if the paint

1. P. Coremans, 'L'agneau mystique au laboratoire. Examen et traitement', in : *Les primitifs flamands*, Vol. III, No. 2. See bibliography on page p. 108.

itself is in bad condition. In other less common cases, we must trust the operator's respect for the work, and its condition would be far better safeguarded if more attention were paid to the condition of the support which largely determines that of the painting itself. Reasonable reinforcement and barriers against damp, made possible by techniques of impregnation, can obviate the necessity of a good deal of cradling and transposition, the final results of which are hard to foresee, with the exception of their increasing the cost of restoration.

As regards historical monuments, restoration is always the main objective. In every country, churches, cathedrals and civic buildings are constantly marred by scaffolding; new stones inserted one by one contrast crudely with the patina of those which still resist the hand of time. The conservation of stones and bricks by laboratory methods has made scant progress; there are very few products which can prevent or reduce the action of weather by washing or impregnation. The fact that a small country like Belgium devotes tens of millions of francs (10 million francs represents $200,000) annually to the restoration of its ancient monuments, gives some idea of the enormous sums spent on this task throughout the world. It must be hoped that a laboratory will soon be established which will be exclusively concerned with this world-wide problem. Such a workshop would serve to clear up many points and to compare the different forms of deterioration with the protection offered by products on the market. Within a few years, concrete results should be reached which would greatly reduce the sums allocated to the restoration of ancient monuments.

In archaeology, there is much less opposition between restoration and conservation; conservation is almost invariably the first consideration. Antiquity is regarded rather as a venerable document than as a manifestation of beauty, and archaeologists, much more than art historians, seek truth through the labyrinthine channels of a remote and almost always anonymous past. As a rule, they prefer that a ferruginous mass shall be freed from its coating of rust, and are content if the technician gives them back an axe whose main features have been preserved; they will ask the laboratory to respect the fine patina of a bronze statuette, unless it is a threat to the figure's very survival or conceals ornament or inscriptions which are indispensable to its study. Whatever the laboratory's difficulties—and they are many—it can go about its work with a quiet mind; and it produces successful results more often than in the field of easel painting, where the ethics of treatment have not yet been defined with sufficient clarity.

The increased number of laboratory tools, the diverse methods of conservation and restoration and a steadily growing interest in this useful and interesting activity have brought new laboratories and workshops into being. The search is everywhere keen for museum chemists and physicists, keener still for qualified 'restorers'. And although our leading laboratories have opened their doors to a few favoured 'trainees', all too little progress has been made. The time has come when we should consider the establishment of research and conservation schools in a field which so closely affects the preservation of the cultural heritage of all nations.

CONCRETE EXAMPLES OF
EXAMINATION AND TREATMENT

The reader is referred to the illustrations (Plates 3-33) which have been chosen with due regard for the various methods of examination and different kinds of conservation and restoration treatment.

By including so many, we wish to emphasize the importance of the photographic data[1] which should accompany all laboratory operations.

1. See the appendix to this chapter entitled 'Photographic Technique' on pages 117-18.

These few pages on the mission of the museum laboratory present a bare outline of the many problems created by the study of the deterioration, conservation and restoration of cultural property. The following bibliography may serve as a guide to readers who wish to study the question more closely; the publications listed will point the way towards other references which it was not possible to include.

'Art et science', *Alumni*, vol. XIX, pp. 247-387 + ill. Brussels, 1950.

AUGUSTI, S. *Il contributo della chimica e della fisica all'esame dei dipinti*. Florence, 1942, 8 pp. + ill.

——. *Tecnica e restauro*. Naples, 1949, 7 pp.

BARROW, W. J. *Procedures and equipment used in the Barrow method of restoring manuscripts and documents*. Richmond, Va., W. J. Barrow, 1946, 11 pp. + ill. (Commercial circular.)

BATTA, G.; FIRKET, J.; LECLERC, E. *Les problèmes de la pollution de l'atmosphère*. Liège, 1933, 462 pp. + ill.

BELGIUM. Ministère de l'intérieur, Sécurité civile. *Guide pratique pour la protection des biens culturels*. Antwerp, 1953, 60 pp. + ill.

BOURCART, J.; NOETZLIN, J.; Dr. POCHON; BERTHELIER, S. *Étude des détériorations des pierres des monuments historiques*. Paris, December 1949, 16 pp. + ill. (*Annales de l'Institut technique du bâtiment et des travaux publics*, special number, no. 108.)

BRADLEY, M. C. *The treatment of pictures*. Cambridge, 1950, 127 pp. + ill.

BRANDI, C. 'Il restauro dell'opera d'arte secondo l'istanza estetica o dell'artisticita', *Bollettino dell'Istituto Centrale del Restauro*, vol. XIII, pp. 3-8. Rome, 1953.

——. 'Restauri a Piero della Francesca', *Bollettino d'Arte*, vol. XXXIX, pp. 241-58 + ill. Rome, 1954.

BRAVI, L. 'Disinfezione dei libri e igiene bibliotecaria', *Bollettino del Istituto di Patologia del Libro*, vol. II, pp. 97-110, 145-56; vol. III, pp. 1-10, 49-61. Rome, 1940 and 1941.

BUCK, R. D. 'A note on the effect of age on the hygroscopic behaviour of wood', in: *Studies in conservation*, vol. I, pp. 39-44. London, 1953.

CALEY, E. R. 'Coatings and incrustations on lead objects from the Agora and the method used for their removal', in: *Studies in conservation*, vol. II, pp. 49-54. London, 1955.

CAMERAMAN, C. *Les pierres de taille calcaires. Leur comportement sous l'action des fumées*. Brussels, 1952, 186 pp. + ill.

CARITA, R. 'Considerazioni sui telai per affreschi transportati su tela', *Bollettino dell'Istituto Centrale del Restauro*, vol. XIX-XX, pp. 131-54 + ill. Rome, 1955.

CHRISTENSEN, B. Brorson. 'Om Konservering af Mosefundne Traegenstande', *Aarbøger for Nordisk Oldkyndighed og Historie*, pp. 22-62 and ill. Copenhagen, 1951. (English summary: 'On the preservation of wooden objects found in peatbogs', pp. 55-62.)

CLARK, W. *Photography by infra-red*. 2nd edition. London, 1946, 397 pp. + ill.

COOPER, B. S. 'Fluorescent lighting in museums', *The Museums Journal*, vol. LIII, pp. 279-90 + ill. London, 1954.

COREMANS, P. *La protection scientifique des œuvres d'art en temps de guerre. L'expérience européenne pendant les années 1939 à 1945*. Brussels, 1946, 32 pp. + ill.

——. *Van Meegeren's faked Vermeers and De Hooghs. A scientific examination*. Amsterdam, 1949, 40 pp. + ill.

—— (under the direction of). 'L'agneau mystique au laboratoire. Examen et traitement', in: *Les primitifs flamands*, series III, no. 2. Antwerp, 1953, 130 pp. + ill.

COUTO, J. *Aspectos actuais do problema do tratamento das pinturas*. Lisbon, 1952, 31 pp. + ill.

CURSITER, S.; DE WILD, A. 'Picture relining', *Technical studies*, vol. V, pp. 157-78 + ill. Cambridge, Mass., 1937.

DE LAET, S. J. *L'archéologie et ses problèmes*. Vol. XVI. Brussels, Latomus, 1954, 156 pp. + ill.

DERIBERE, M. *Les applications pratiques des rayons infra-rouges*. Paris, 1943, 222 pp. + ill.

——. *Les applications pratiques des rayons ultra-violets*. Paris, 1947, 247 pp. + ill.

——; PORCHEZ, J.; TENDRON, G. *La photographie scientifique. Expertise, identification, étude des documents et œuvres d'art*. Paris, 1951, 128 pp. + ill.

DE WILD, A. M. *The scientific examination of pictures*. London, 1929, 105 pp. + ill.

DINET, E. *Les fléaux de la peinture*. Paris, 1926, 136 pp. + ill.

DOERNER, M. *The materials of the artists. Their use in painting*. London, 1949, 435 pp. + ill.

EIBNER, Dr. A. *Materialenkunde als Grundlage der Maltechnik*. Berlin, 1909, 480 pp.

——. *Entwicklung und Werkstoffe der Wandmalerei.* Munich, 1926, 618 pp.

——. *Entwicklung und Werkstoffe der Tapefmalerei.* Munich, 1928, 195 pp. + ill.

EVANS, U. R. *Metallic corrosion passivity and protection.* London, 1948, 863 pp. + ill.

FEDERICI, V. *Conservazione e ricostituzione delle opere d'arte lignee.* Rome, 1938, 63 pp. + ill.

FEDOROVSKY, A. *La conservation et la restauration des objets ethnographiques.* Paris, 1933, 63 pp. + ill.

FELLER, R. L. 'The conservation of paintings', *Carnegie Magazine,* January 1952, 4 pp. + ill. Pittsburgh, Pa.

——. Color change in oil-paintings', *Carnegie Magazine,* October 1954, 6 pp. + ill. Pittsburgh, Pa.

FEYTAUD, J. 'Una malattia degli edifici. La termitosi. Cause-sintomi-prevenzione-cura', *Bollettino dell'Istituto di Patologia del Libro,* vol. XIV, no. I-II, pp. 17-61; no. III-IV, pp. 5-44; vol. XV, no. I-II, pp. 5-35 + ill. Rome, 1955 and 1956.

FINK, C. G.; ELDRIDGE, C. H. *The restoration of ancient bronzes and other alloys.* New York, 1925, 53 pp. + ill.

FORBES, R. J. *Metallurgy in Antiquity. A notebook for archaeologists and technologists.* Leiden, 489 pp. + ill.

——. *Studies in ancient technology* 2 vols. Vol. I, 194 pp. + ill.; vol. II, 215 pp. + ill. Leiden, 1955.

FRANCHET, L. *Céramique primitive. Introduction à l'étude de la technologie.* Paris, 1911, 160 pp. + ill.

GALLO, A. 'Patologia del Libro', *Bollettino dell'Istituto di Patologia del Libro,* vol. VIII, pp. 1-55 + ill. Rome, 1949.

——. 'La lotta antitermitica in Italia', *Bollettino dell'Istituto di Patologia del Libro,* vol. XI, pp. 1-34. Rome, 1952.

GENARD, J. 'L'émission ultraviolette extrême des lampes fluorescentes tubulaires et son incidence sur l'éclairage des musées', *Museum,* vol. V, no. 1, pp. 53-8 + ill. Paris, 1952.

GETTENS, R. J. 'Polymerized vinyl acetate and related compounds in the restoration of objects of art', *Technical studies,* vol. IV, pp. 15-27 + ill. Cambridge, Mass., 1935.

——; PEASE, M.; STOUT, G. L. 'The problem of mold growth in paintings', *Technical studies,* vol. IX, pp. 127-43 + ill. Cambridge, Mass., 1941

——; STOUT, G. L. *Painting materials—a short encyclopaedia.* New York, 1942, 333 pp. + ill.

GILARD, P.; DUBRUL, L. *Les bases physico-chimiques de l'industrie du verre.* Paris, 1937, 221 pp. + ill.

GREENE, F. S. 'The cleaning and mounting of a large wool tapestry', in: *Studies in conservation,* vol. II, pp. 1-16 + ill. London, 1955.

HAN, V. 'Le problème du traitement des peintures. Aperçu sur l'état de la question', in: *Recueil des travaux sur la protection des monuments historiques,* vol. II, pp. 51-6. Belgrade, 1951.

HAUGE, D. T. 'Konservering av tre' (Conservation of wood), *Universitets Oldsaksamlings Arbok,* pp. 5-33. Oslo, 1949-50.

HETTERICH, H. *Zum Stand und zur Künstigen Entwicklung der mikrochemischen Bilduntersuchung.* Munich, 1931, 83 pp. + ill.

HOURS-MIEDAN, M. *A la découverte de la peinture par les méthodes physiques.* Paris, 1957, 145 pp. + ill.

INTERNATIONAL COUNCIL OF MUSEUMS. Commission de l'éclairage des objets de musées. *Utilisation des lampes fluorescentes dans les musées. Considérations générales et conseils pratiques à l'usage des directeurs et des conservateurs de musées.* Paris, Conseils international des musées, 1953, 14 pp. + ill.

——. *The care of wood panels / Le traitement des supports en bois.* Paris, *Museum,* vol. VIII, no. 3, 56 pp. + ill., 1955.

INTERNATIONAL MUSEUMS OFFICE. 'La technique des feuilles archéologiques', *Monseion,* vol. XLIII-XLIV, pp. 125-284. Paris, 1938.

——. *Manual on the conservation of paintings.* Paris, International Museums Office, 1940, 296 pp. + ill.

KALLSTROM, O.; OLSON, G. 'Lighting methods for showcases. Exhibition and research work at the Statens Historiska Museum, Stockholm', *Museum,* vol. IV, no. 3, pp. 205-11 + ill. Paris, 1957.

KECK, C. K. *How to take care of your pictures.* New York, 1954, 54 pp. + ill.

KUDRJAWZEW, E. W. *Die Technik des Gemälde-Restaurierens.* Leipzig, 1954, 164 pp. + ill.

LAMING, A. (under the direction of). *La découverte du passé. Progrès récents et techniques nouvelles en préhistoire et en archéologie.* Paris, 1952, 363 pp. + ill.

LAURIE, A. P. *The pigments and mediums of the old masters.* London, 1914, 192 pp. + ill.

——. 'The identification of pigments used in painting at different periods', *The Analyst,* vol. LV, pp. 162-79. London, 1930.

——. *The technique of the great painters.* London, 1949, 192 pp. + ill.

LAVACHERY, H.; NOBLECOURT, A. *Les techniques de protection des biens culturels en cas de conflit armé.* Paris, Unesco, 1954, 222 pp. + ill. (*Musées et monuments,* no. VIII.)

LEE, H. N. 'Methods for the examination of paper', *Technical studies,* vol. IV, pp. 3-14 + ill.; pp. 93-106 + ill.

LEFEVE, R.; SNEYERS, R. 'La microchimie des peintures anciennes. Une nouvelle méthode de préparation des coupes', *Mededelingen van de Vlaamse Chemische Vereniging*, vol. XII, pp. 99-101 + ill. Brussels, 1950.

LEPESME, P. *La protection des bibliothèques et des musées contre les insectes et les moisissures.* Paris, Centre de Perfectionnement Technique, May 1943, 16 pp.

LIBBY, W. F. *Radiocarbon dating.* Chicago, 1952, 124 pp.

LIBERTI, S. 'Nuovi ritrovati nella disinpestazione delle opere d'arte', *Bollettino dell'Istituto Centrale del Restauro,* vol. XIX-XX, pp. 155-76 + ill. Rome, 1955.

——. 'Consolidamento dei materiali da costruzione di monumenti antichi', *Bollettino dell'Istituto Centrale del Restauro,* vol. XXI-XXII, pp. 43-70. Rome, 1955.

LUCAS, A. *Antiques. Their restoration and preservation.* 2nd rev. ed. London, 1932, 240 pp.

——. *Ancient Egyptian materials and industries.* 3rd rev. ed. London, 1948, 570 pp.

MAGER, F. X.; MACHATA, G. 'Spectrographic series studies of prehistoric metal discoveries', *Österr. Chem. Ztg,* vol. LIV, pp. 178-9. Vienna, 1953.

MAŃKOWSKY, T. 'Prakownie konserwatorskie państwowych zbiorów sztuki na wawelu' (Conservation workshops in Wawel), *Ochrona Zabytków,* vol. II, pp. 160-7 + ill. Warsaw-Cracow, 1949.

MARCONI, B. 'Rentgenografia obrazów. Nowe polskie urzadzenia i metody' (Radiography of paintings. New Polish installations and methods), *Ochrona Zabytków,* vol. II, pp. 25-30 + ill. Warsaw-Cracow, 1949.

——. 'Zwalczanie owadow-szkodników drewna za pomoca promieni rentgena, ultrakrótkich fal radiowych i ultradźieków' (The struggle against harmful wood insects with X-rays, ultra-short waves and ultrasonics), *Ochrona Zabytków,* vol. VI, pp. 218-23 + ill. Warsaw, 1953.

MARYON, H. 'Metal working in the ancient world', *American Journal of Archaeology,* vol. LIII, pp. 93-125 + ill. Boston, 1949.

MOLISZ, R. 'La conservation des monuments par les méthodes électrocinétiques', *Ochrona Zabytków,* vol. IX, no. 3 (34), pp. 113-50. Warsaw, 1956.

MOSS, A. A. 'The application of X-rays, gamma rays, ultra-violet and infra-red rays to the study of antiquities', in: *Handbook for museum curators,* part 8, section 4. London, 1954, 6 pp. + ill.

MOURA, A. *Os raios infra-vermelhos e ultra-violetas aplicados no exame das pinturas.* Lisbon, Instituto para a alta Cultura, 1946, 9 pp. + ill.

NICHOLS, H. W. *Restoration of ancient bronzes and cure of malignant patina.* Chicago, Ill., 1930, 51 pp. + ill.

OHTSUKI, T.; IWASAKI, T.; EMOTO, Y.; SAITOH, H. 'Studies on dust particles scattering in the air of the museum', *Scientific papers on Japanese antiques and art crafts,* no. 1, pp. 21-4 + ill.; no. 2, pp. 16-23 + ill. Tokyo, Association of Scientific Research of Antiques, January 1951 and October 1951.

ORGAN, R. W. 'The washing of treated bronzes', *The Museums Journal,* vol. LV, pp. 112-19. London, 1955.

OTTO, H.; WITTER, W. *Handbuch der ältesten vorgeschichtlichen Metallurgie in Mitteleuropa.* Leipzig, 1952, 222 pp. + ill.

PARTINGTON, J. R. *Origins and development of applied chemistry.* London, 1935, 597 pp.

PLENDERLEITH, H. J. *The conservation of prints, drawings and manuscripts.* London, 1937, 66 pp. + ill.

——. *The preservation of leather bookbindings.* London, 1946, 24 pp. + ill.

——. *The conservation of antiquities and works of art. Treatment, repair and restoration.* London, 1956, 373 pp. + ill.

——; CURSITER, S. 'The problem of lining adhesives for paintings—wax adhesives', *Technical Studies,* vol. III, pp. 90-113 + ill. Cambridge, Mass., 1934.

——; ORGAN, R. M. 'The decay and conservation of museum objects of tin', in: *Studies in conservation,* vol. I, pp. 63-72 + ill. London, 1953.

PLESTERS, J. 'Cross-sections and chemical analysis of paint samples', in: *Studies in conservation,* vol. II, pp. 110-57 + ill. London, 1956.

PRATT, L. S. *The chemistry and physics of organic pigments.* New York, 1947, 359 pp.

RADLEY, J. A.; GRANT, J. *Fluorescence analysis in ultra-violet light.* 2nd ed. London, 1935, 326 pp. + ill.

RATHGEN, F. *Die Konservierung von Altertumsfunden mit Berücksichtigung ethnographischer und kunstgewerblicher Sammlungsgegenstände.* 2 vols. Berlin; Leipzig, 1924, 1926, 170 + 174 pp + ill.

RAWLINS, F. I. G. *From the National Gallery laboratory.* London, 1940, 50 pp. + ill.

——. 'The control of temperature and humidity in relation to works of art', *The Museums Journal,* vol. XLI, pp. 279-83 + ill. London, 1942.

——. 'Some physical aspects of the storage of works of art', *Journal of the Institution of Heatin*

and Ventilating Engineers, vol. XI, pp. 175-85. London, 1943.

——. 'Soft X-rays in the examination of paintings', in: *Studies in conservation,* vol. I, pp. 135-8 + ill. London, 1953.

——; WERNER, A. 'Scientific method and the art gallery', *Science Progress,* vol. XL, pp. 585-603 + ill. London, 1952.

REES-JONES, S. 'The Coronation chair', in: *Studies in conservation,* vol. I, pp. 103-14 + ill. London, 1954.

RIETH, A. *Die Eisentechnik der Hallstattzeit.* Leipzig, Mannus-Bücherei, 70, 1942, 178 pp. + ill.

ROSEN, D. 'The preservation of wood sculpture; the wax immersion method', *Journal of the Walters Art Gallery,* vol. XIII-XIV, pp. 45-71. Baltimore, Md., 1950-51.

RUHEMANN, H. 'The impregnation and lining of paintings on a hot table', in: *Studies in conservation,* vol. I, pp. 73-6 + ill. London, 1953.

SAITOH, H. 'On architecture and moisture; especially on the moisture of the storehouses of national treasures', *Scientific papers on Japanese antiques and art crafts,* vol. I, pp. 49-54 + ill. Tokyo, Association of Scientific Research of Antiques, January 1951.

SALIN, E.; FRANCE-LANORD, A. *Rhin et Orient. Le fer à l'époque mérovingienne.* Paris, 1943, 292 pp. + ill.

SALMANG, H. *La céramique du point de vue physique et chimique.* Paris, 1935, 361 pp. + ill.

SANTUCCI, L. 'Metodi per la rigenerazione di documenti carbonizzati', *Bollettino dell'Istituto di Patologia del Libro,* vol. XII, pp. 95-102. Rome, 1953.

——. 'Il contributo della chimica alla lotta anti-termitca', *Bollettino dell'Istituto di Patologia del Libro,* vol. XIII, pp. 15-77. Rome, 1954.

SCHAFFER, R. J. *The weathering of natural building stone.* London, 1932, 149 pp. + ill.

SCHWEIDLER, M. *Die Instandsetzung von Kupferstichen, Zeichnungen, Büchern, usw. Alte Fehler und neue Methoden bei der Beseitigung von Alterschäden an graphischen Kulturgut.* Stuttgart, 1949, 186 pp. + ill.

SHEPARD, A. O. *Ceramics for the archaeologist.* Washington, 1956, 414 pp. + ill.

SHIBATA, Y. 'Outline of the association of scientific research of antiques in Japan', *Scientific papers on Japanese antiques and art crafts,* vol. I, pp. 1-3 + ill.; vol. II, p. 32. Tokyo, Association of Scientific Research of Antiques, January 1951 and October 1951.

SIEDERS, R.; UYTENBOGAART, J. W. H.; LEENE, J. E.

'The restoration and preservation of old fabrics', in: *Studies in conservation,* vol. II, pp. 161-9 + ill. London, 1956.

STOUT, G. L. *The care of pictures.* New York, 1948, 125 pp. + ill.

——; GETTENS, R. J. 'The problem of lining adhesives for paintings', *Technical studies,* vol. II, pp. 81-106 + ill. Cambridge, Mass., 1933.

STRAUB, R. E.; REES-JONES, S. 'Mikroskopische Querschnitte von Gemälden', *Maltechnik,* vol. LXI, pp. 119-25 + ill. Munich, 1955.

——; ——. 'Marouflage, relining and the treatment of cupping with atmospheric pressure', in: *Studies in conservation,* vol. II, pp. 55-61 + ill. London, 1955.

Studies on old art objects through optical methods. Tokyo, 1955. (By several Japanese authors.)

SWINGS, P. *La spectroscopie appliquée.* Liège, 1935, 188 pp. + ill.

TEXTILE INSTITUTE, MANCHESTER. *Identification of textile materials.* 3rd ed. Manchester, 1951, 96 pp. + ill.

TOISHI, K. 'Radiography of small bronze Buddha images by means of X-ray from Co60', *Scientific papers on Japanese antiques and art crafts,* vol. VII, pp. 18-25 + ill. Tokyo, Association of Japanese Research of Antiques, March 1954.

——. 'Recent arguments about effects of artificial lighting on art crafts', *Scientific papers on Japanese antiques and art crafts,* vol. X, pp. 19-22. Tokyo, Association of Japanese Research of Antiques, March 1955.

UNESCO. *The care of paintings | Le traitement des peintures.* Paris, Unesco, no date, 163 pp. + ill. (Articles published in *Museum,* vol. III, nos. 2-3, 1950; vol. IV, no. 1, 1951.

UNITED KINGDOM. Department of Scientific and Industrial Research. *The cleaning and restoration of museum exhibits.* Reports upon investigations conducted at the British Museum. London, 1921, 12 pp. + ill.; 1923, 11 pp. + ill.; 1926, 70 pp + ill.

VALADARES, M. 'Laboratorio para exame das obras arte', *Boletim dos Museos Nacionais de Arte Antiga,* vol. I, p. 32. Lisbon, 1939.

VEZZANI, R. 'Difesa degli edifici e del legno delle termiti', *Bollettino dell'Istituto di Patologia del Libro,* vol. XI, no. III-IV, pp. 23-74 + ill. Rome, 1952.

WEHLTE, G. 'Gemäldeuntersuchung im Infrarot', *Maltechnik,* vol. LVI, pp. 52-8 + ill. Munich, 1955.

WEHLTE, K. *Wandmalerei. Praktische Einführung in Werkstoffe und Malweisen.* Ravensburg, 1938, 200 pp. + ill.

——. *Temperamalerei. Einführung in Werkstoffe und Malweisen.* Ravensburg, 1940, 200 pp. + ill.

WERNER, Dr. A. 'Plastics aid in conservation of old paintings', London, *British Plastics,* 1952, 363-6 pp.

WOLTERS, C. *Die Bedeutung der Gemäldedurchleuchtung mit Röntgenstrahlen für die Kunstgeschichte.* Frankfurt am Main, 1938, 72 pp. + ill.

YAMASAKI, K. 'Technical studies on the pigments used in the ancient paintings of Japan', *Proceedings of the Japan Academy,* vol. XXX, pp. 781-5 + ill. Tokyo, 1954.

I. TABLE OF CONCORDANCE
DEGREES CENTIGRADE (CELSIUS) AND DEGREES FAHRENHEIT

°C	—10	—9	—8	—7	—6	—5	—4	—3	—2	—1	0	1	2	3
°F	14.0	15.8	17.6	19.4	21.2	23.0	24.8	26.6	28.4	30.2	32.0	33.8	35.6	37.4
°C	4	5	6	7	8	9	10	11	12	13	14	15	16	17
°F	39.2	41.0	42.8	44.6	46.4	48.2	50.0	51.8	53.6	55.4	57.2	59.0	60.8	62.6
°C	18	19	20	21	22	23	24	25	26	27	28	29	30	35
°F	64.4	66.2	68.0	69.8	71.6	73.4	75.2	77.0	78.8	80.6	82.4	84.2	86.0	95.0
°C	40	45	50	55	60	65	70	75	80	85	90	95	100	
°F	104.0	113.0	122.0	131.0	140.0	149.0	158.0	167.0	176.0	185.0	194.0	203.0	212.0	

II. MONTHLY AVERAGES OF MEAN TEMPERATURES (t) (IN °C) AND RELATIVE HUMIDITY (rH) (IN PERCENTAGES)[1]

Average mean temperature and relative humidity

Station	Jan.	Feb.	Mar.	April	May	June	July	Aug.	Sept.	Oct.	Nov.	Dec.
Ankara (Turkey)	0.3	0.9	4.9	11.1	16.2	20.0	23.2	23.3	18.6	13.1	7.4	2.1
	79	75	65	57	56	50	42	40	46	56	71	80
Athens (Greece)	9.1	9.5	11.5	15.0	19.4	23.8	26.9	26.8	23.3	18.9	14.4	11.2
	71	70	66	60	55	51	43	44	51	63	70	73
Berlin (Germany)	0.2	0.6	4.1	8.2	13.7	16.5	18.4	17.1	13.6	8.9	3.7	1.1
	85	81	76	70	65	66	68	73	76	82	86	87
Bombay (India)	23.9	24.0	26.3	28.1	29.7	28.8	27.4	27.1	27.1	28.1	27.3	25.4
Brussels (Belgium)	2.7	3.1	5.5	8.2	12.8	14.9	16.8	16.4	14.0	10.0	5.2	3.3
	90	87	82	78	77	78	79	80	83	87	90	91
Budapest (Hungary)	-0.4	1.0	6.3	11.0	16.6	19.7	21.6	20.8	16.3	11.1	5.0	1.5
	81	77	71	66	66	65	63	65	71	77	81	83
Buenos Aires (Argentina)	23.3	22.7	20.6	17.0	13.0	9.9	9.6	10.5	13.0	15.4	18.9	21.7
	68	72	76	80	83	84	84	79	78	76	74	69
Chicago (U.S.A.)	-4.0	-3.0	3.2	8.4	14.3	19.6	23.1	22.2	18.8	12.5	5.6	-1.7
	89	84	75	70	66	68	66	68	71	71	74	85
Copenhagen (Denmark)	0.5	0.0	2.1	6.0	11.3	14.8	17.1	16.0	12.7	8.5	4.1	1.7
	89	88	85	77	71	71	75	79	83	87	88	89
Jakarta (Indonesia)	25.9	25.8	26.2	26.7	26.7	26.5	26.3	26.5	26.8	26.8	26.5	26.1
	85	88	84	82	84	82	81	77	77	80	82	84
Helsinki (Finland)	-5.5	-5.8	-2.7	2.2	8.2	13.0	16.8	15.0	10.6	5.3	0.5	-3.4
	88	87	83	78	74	72	73	80	83	86	88	89
Hong Kong	15.6	15.2	17.6	21.3	25.1	27.3	27.9	27.7	27.0	24.6	20.8	17.2
	75	77	82	84	84	83	83	83	79	72	69	70
Karachi (Pakistan)	18.9	20.1	23.4	26.3	28.6	29.8	29.0	27.5	27.2	26.5	24.2	20.2
	56	63	68	76	81	79	82	83	80	72	69	57
Khartum (Sudan)	22.4	23.5	27.2	30.7	32.5	32.6	30.7	29.4	30.8	31.2	27.2	23.4
	33	23	16	16	19	27	43	54	41	30	29	34
Leopoldville (Belgian Congo)	25.7	26.1	26.6	26.6	26.0	23.8	22.3	23.2	24.8	25.8	25.6	25.7
	80	79	80	79	83	81	81	75	74	78	81	82
Lisbon (Portugal)	10.6	11.3	12.6	14.2	16.7	19.4	21.3	22.0	20.5	17.4	12.6	11.5

Statistics table — for each town, two figures are given per month (temperature in bold, relative humidity below). Values are transcribed as printed (columns read left-to-right as they appear in the source).

Town												
Madras (India) — temp	24.7	26.1	28.2	29.8	30.4	31.1	32.6	33.1	30.6	27.7	25.9	24.7
— humidity	87	86	85	87	88	88	88	86	84	85	86	87
Madrid (Spain) — temp	5.3	8.2	13.6	18.8	23.5	23.2	19.7	15.6	11.6	8.8	6.2	4.8
— humidity	82	78	68	56	43	43	51	57	58	64	72	77
Manilla (Philippines) — temp	24.9	25.7	26.3	26.7	26.9	26.8	27.7	28.3	28.0	26.5	25.3	24.6
— humidity	81	83	84	85	85	85	81	76	70	70	74	77
Melbourne (Australia) — temp	18.5	16.4	14.6	12.6	10.7	9.7	10.3	12.5	15.3	18.4	20.2	19.2
— humidity	60	62	63	67	72	72	76	70	69	62	60	57
New York (U.S.A.) — temp	1.3	7.1	13.5	19.3	22.3	23.4	20.3	15.6	9.7	4.4	-0.7	-0.4
— humidity	73	70	70	72	70	67	67	62	63	68	71	74
Oslo (Norway) — temp	-3.6	-0.5	4.8	10.6	15.0	17.0	14.1	9.9	3.9	-1.0	-3.9	-4.7
— humidity	73	70	70	72	70	67	67	62	63	68	71	74
Paris (France) — temp	4.0	5.7	10.5	14.7	17.5	17.9	15.9	13.6	9.0	6.5	3.7	3.4
— humidity	86	86	83	77	72	70	71	71	70	74	81	85
Peshawar (Pakistan) — temp	10.2	15.3	22.4	28.1	31.3	33.2	33.4	28.9	22.6	17.3	11.8	9.4
— humidity	56	52	49	55	62	49	34	38	51	54	59	62
Rome (Italy) — temp	8.5	11.6	16.5	21.6	24.6	24.7	22.1	18.1	13.9	10.7	7.9	6.9
— humidity	73	70	69	61	54	52	55	58	62	64	67	69
San Francisco (U.S.A.) — temp	10.6	13.8	16.2	16.6	15.1	14.8	14.7	13.7	13.3	12.4	11.7	9.8
— humidity	73	68	66	70	77	78	72	70	68	69	72	76
Santiago (Chile) — temp	18.8	16.5	13.8	11.3	9.5	8.0	8.2	10.8	14.1	17.2	19.1	19.9
— humidity	56	61	70	76	78	80	82	78	71	65	61	56
Stockholm (Sweden) — temp	-1.3	1.6	6.4	11.2	15.2	16.8	13.7	9.2	3.6	-0.4	-2.6	-2.5
— humidity	91	89	87	81	76	71	68	67	75	78	87	90
Utrecht (Netherlands) — temp	2.9	5.0	9.6	13.6	16.0	16.6	14.8	12.4	7.8	4.9	2.5	2.3
— humidity	90	89	87	83	81	80	78	77	78	83	86	88
Vancouver (Canada) — temp	3.4	6.0	9.9	13.8	17.1	17.6	15.2	12.4	8.8	5.9	3.8	2.0
— humidity	90	89	87	83	77	80	80	81	83	87	86	88
Vienna (Austria) — temp	-0.4	0.4	5.0	9.1	14.2	17.1	19.0	18.2	14.4	9.4	4.1	1.1
— humidity	79	77	72	67	68	67	67	70	75	79	80	82
Washington, D.C. (U.S.A.) — temp	2.4	7.8	14.1	20.4	23.5	24.8	22.2	17.8	12.2	7.2	1.7	1.3
— humidity	70	72	72	74	72	69	69	65	61	65	68	70
Zürich (Switzerland) — temp	1.1	3.7	8.8	13.8	17.0	17.6	15.9	13.2	8.2	4.7	0.8	-0.2
— humidity	85	84	83	80	75	72	71	70	71	75	79	84

1. Statistics supplied by the Institut Royal Météorologique at Brussels. For each town, the first figure shows the temperature and the second the relative humidity.

III. ANNUAL AND MONTHLY MEAN TEMPERATURES (t) (IN °C)[1]

Station	Latitude	Altitude (in m.)	Annual mean	Jan.	Feb.	Mar.	April	May	June	July	Aug.	Sept.	Oct.	Nov.	Dec.
Athens (Greece).	37°58'N	107	17.6	8.6	9.4	11.9	15.3	20.0	24.4	27.3	26.9	23.5	19.4	14.1	10.5
Berlin (Germany)	52°30'N	50	8.5	-0.4	0.3	2.8	7.7	12.7	16.7	18.1	17.4	13.9	9.0	3.4	0.4
Bogota (Colombia)	4°36'N	2600	14.4				14.8[2]			13.9[2]					
Bombay (India).	18°55'N	10	26.3	23.6[2]				29.2[2]							
Boston (U.S.A.)	42°42'N	9	9.3	-2.8	-2.2	1.6	7.4	13.7	18.8	21.8	20.5	17.1	11.2	5.1	-0.2
Buenos Aires (Argentina).	34°37'S	20	16.2	23.1[2]						10.1[2]					
Cairo (Egypt).	30°50'N	23	21.2	12.3	13.8	16.9	21.2	24.9	27.7	28.6	28.1	25.6	21.9	18.4	14.4
Caracas (Venezuela).	10°30'N	900	21.8					23.3[2]	20.3[2]						
Chicago (U.S.A.)	41°46'N	35	9.9	-3.9	-2.8	2.3	8.4	14.2	19.9	23.1	22.2	18.1	12.3	5.1	-1.5
Denver (U.S.A.).	39°46'N	1612	10.1	-0.9	0.5	3.9	8.7	13.5	19.2	22.4	21.8	17.2	10.9	4.5	0.4
Detroit (U.S.A.).	42°24'N	189	9.2	-3.5	-3.6	1.2	7.9	14.2	19.8	22.6	21.4	17.8	11.4	4.3	-1.8
Jakarta (Indonesia).	6°11'S	10	26.0						26.5[2]	25.8[2]					
Hong Kong.	22°18'N	15	22.0		14.3[2]					27.6[2]					
Leopoldville (Belgian Congo).	4°17'S	300	25.3			26.8[2]				22.4[2]					
Lisbon (Portugal).	38°42'N	20	15.3	9.6	11.1	12.3	13.6	16.0	19.1	21.1	21.2	20.0	16.4	13.4	10.4
Madrid (Spain).	40°24'N	655	13.3	4.3	6.6	8.6	11.3	15.2	20.3	24.3	23.8	19.1	12.7	8.4	4.5
Melbourne (Australia).	37°50'S	30	14.7	19.7	19.6	18.1	15.4	12.2	10.3	9.3	10.6	12.2	14.2	16.2	18.1
Mexico, D.F. (Mexico).	19°27'N	2300	15.5					18.3[2]							11.9[2]
Milan (Italy).	45°28'N	50	12.5	0.2	3.4	7.8	12.9	17.0	21.1	23.8	22.8	18.9	13.1	6.7	2.0
Montreal (Canada).	45°30'N	57	5.6	-10.9	-9.1	-4.3	4.8	12.6	18.3	20.5	19.3	14.7	7.8	-0.2	-7.1
Moscow (U.S.S.R.).	55°30'N	170	3.9	-11.0	-9.6	-4.8	3.5	11.7	16.4	18.9	17.1	11.2	4.3	-2.4	-8.2
Nagpur (India).	21°9'N	300	26.4					34.7[2]							19.5[2]
New Orleans (U.S.A.)	29°58'N	20	20.6	11.7[2]						27.4[2]					
New York (U.S.A.).	40°42'N	3	11.5	-0.1	-0.1	4.0	9.4	15.7	20.8	23.6	22.8	19.6	13.7	7.4	1.7
Paris (France)	48°50'N	50	10.0	2.1	3.7	5.9	10.0	13.1	16.6	18.0	17.7	14.7	9.0	5.8	2.7
Peking (China).	39°57'N	116	11.7	-4.7	-1.7	5.0	13.7	19.9	24.5	26.0	24.7	19.8	12.5	3.6	-2.6
Rio de Janeiro (Brazil)	22°54'S	20	23.2		26.1[2]					20.4[2]					
San Francisco (U.S.A.)	37°47'N	16	13.4	9.9	11.4	12.3	13.0	13.7	14.7	14.7	15.0	16.3	16.0	13.6	10.7
Shanghai (China).	31°12'N	10	15.0	3.1[2]						26.9[2]					
St. Louis (U.S.A.).	38°37'N	146	13.2	-0.6	0.8	6.4	13.4	19.1	23.9	26.2	25.2	21.1	14.7	6.3	1.9
Sydney (Australia).	33°51'S	50	17.2	21.9[2]						11.3[2]					
Teheran (Iran).	35°41'N	1160	16.5	0.9	5.7	8.9	16.3	21.8	26.7	29.4	28.4	25.4	18.8	10.7	5.4
Tokyo (Japan).	35°41'N	21	13.8	2.9	3.5	6.7	12.4	16.4	20.5	23.9	25.4	22.0	15.9	10.2	5.2
Trondheim (Norway)	63°26'N	10	4.7	-2.6	-2.9	-1.1	3.3	7.7	11.9	14.0	13.5	10.0	5.1	0.4	-2.5
Warsaw (Poland).	52°13'N	121	7.4	-3.5	-2.5	1.0	6.8	13.4	16.3	18.2	17.2	13.2	8.0	2.1	-1.7
Washington, D.C. (U.S.A.).	38°51'N	4	13.3	1.8	2.3	6.8	12.3	18.1	22.8	25.2	24.0	20.6	14.3	8.0	2.9

1. From E. de Martonne, *Traité de géographie physique*, 6th edition, 1940—except for Chicago, Denver, Detroit, New York, San Francisco and Washington, D.C.; figures for these stations were taken from *Climatological Data*, U.S. Department of Commerce, Weather Bureau, 1953-54.
2. Average of hottest or coldest month.

(First line: Annual and monthly mean temperature. Second line: Highest and lowest recorded temperature. Third line: Annual and monthly mean relative humidity, recorded early in the morning. Fourth line: Annual and monthly mean relative humidity, recorded towards noon.)

Station	Latitude	Altitude (in m.)	Annual mean	Jan.	Feb.	Mar.	April	May	June	July	Aug.	Sept.	Oct.	Nov.	Dec.
Chicago, Ill.	41°46'N	185	11.7	-2.3	3.1	1.7	11.8	14.0	24.4	24.8	23.0	20.8	13.0	5.8	0.0
				(-21.7)					(37.7)						
			75	73	73	69	71	67	72	73	83	77	81	81	77
			55	64	58	53	54	43	50	50	57	48	57	61	69
Denver, Col.	39°46'N	1612	11.0	4.2	0.3	6.6	6.0	11.9	21.0	23.3	21.8	18.9	12.4	6.2	-0.3
				(-19.0)					(37.7)						
			59	50	57	56	70	68	61	65	68	46	53	56	58
			34	34	37	30	43	34	29	38	33	21	29	35	43
New York, N.Y.	40°42'N	3	12.4	-0.3	4.6	5.1	11.7	15.1	21.2	24.0	22.0	19.3	16.0	7.7	2.1
				(-18.9)					(35.5)						
			73	72	68	65	75	71	74	73	75	79	77	80	69
			61	63	59	53	62	61	56	54	62	68	62	66	61
San Francisco, Calif.	37°47'N	16	13.7	12.4	12.2	11.8	11.5	13.7	14.3	14.0	15.3	17.0	16.5	13.7	12.8
							(4.5)					(31.5)			
			88	92	77	88	88	87	89	91	90	86	86	90	88
			67	80	65	59	69	62	66	73	75	69	56	75	58
Washington, D.C.	38°51'N	4	14.6	2.3	6.7	7.1	15.7	17.3	23.9	26.2	24.3	23.0	16.7	7.7	3.3
				(-11.1)						(40)					
			74	76	69	68	76	70	69	68	77	79	82	83	74
			49	60	43	47	49	48	46	40	53	48	49	56	54

1. According to *Climatological Data*, U.S. Department of Commerce, Weather Bureau, 1953-54.

V. PHOTOGRAPHIC TECHNIQUE

Museums are calling more and more upon photography in the preparation of inventories, for the reproducing of objects for study or dissemination, and to provide documentation on works undergoing treatment.

A few principles governing the photography of cultural property should therefore be recalled.

Apparatus

The choice of the camera and its size depend on a great variety of factors, including, of course, the amount of money available and the proposed use.

Large cameras. Generally the 13 × 18 or 18 × 24 cm.

sizes correspond respectively to the 5×7 and 10×12 inch sizes.

Advantages: interchangeable lenses (normal focus lenses, long-focus lenses, wide-angle lenses); possibility of attaining a true perspective by having horizontal and vertical adjustments, use of adapters for smaller sizes; possibility of making macrophotographic prints; adaptability to techniques of photography using ordinary light, infra-red and ultra-violet photography; use of plates or cut films; use of contact prints.

Disadvantages: cost (especially of sensitive material); slow operation.

Middle-size cameras. Generally the 6×9 and 9×12 cm. or $2\frac{1}{4} \times 3\frac{1}{4}$ and 4×5 inch sizes (plates or rigid films).

Advantages: the same as for the large sizes, except that the document must usually be enlarged; in addition, use of roll film.

Small cameras. Generally the 6×6 or 6×9 cm. (roll film) and 24×36 mm. (perforated film) sizes.

Advantages (especially for the 24×36 mm. size): existence of many different types with a built-in range finder or 'reflex' optical system; wide choice of lenses; accessories for close-range photography and macrography; possibility of photographs using both visible light and infra-red and ultra-violet light; ideal size for microfilming; rapid execution.

Disadvantages: no adjustment of the image is possible; enlargements are almost always necessary; preservation difficulties and fragility of negatives.

Sensitive material

For black-and-white photography there are the orthochromatic emulsion (maximum sensitivity from ultra-violet to green), panchromatic emulsion (sensitivity extending to red) and infra-red emulsion (sensitivity up to the nearer side of the infra-red range). Radiography requires special film.

Colour photography is coming more and more to replace black-and-white techniques. Several types of emulsions (negative, positive, reversible, for daylight and artificial light) are available.

Special photographic techniques

Radiography. The choice of apparatus for radiography depends upon the type of material to be examined. For textiles, paper and wood fibres and for examination by diffraction and micro-radiography, apparatus with a low kilovoltage—5 to 15 kV (soft rays)—is needed. Paintings (with dense pigments) and thick wood (sculptures) are traversed by harder rays of 20 to 60 kV (medical apparatus). Work on metals must be done at between 100 and 300 kV. Thick blocks of metal such as bronze statues can be photographed by means of the gamma rays (gamma radiography) emitted by radioactive substances.

Ultra-violet and fluorescent photography. These two techniques require illumination by mercury-vapour or arc lamps, which are sources of UV (maximum of about 3650 Å) and visible light. In UV photography, the visible rays are absorbed by a wood screen placed in front of the lens, whilst in fluorescent lighting, the wood screen absorbing visible rays is placed in front of the source, and a screen to absorb the UV rays is placed in front of the lens.

Ortho- or panchromatic emulsions are to be employed as sensitive material.

Infra-red photography. Lighting is the same as for ordinary photography: daylight or incandescent lamps. A screen which absorbs visible rays and so makes the emulsion sensitive to the corresponding IR rays (generally about 8000 Å) is to be placed in front of the lens.

Special emulsions sensitized to IR rays are to be used as sensitive material.

Micrography. Microphotography comprises photographs taken through a microscope, starting, approximately, from a tenfold enlargement. The sizes used are 9×12 cm., 6×9 cm. and 35 mm. film. A special photographic chamber adaptable to the microscope must be procured.

There are also microscopes specially designed for metallography.

Various accessories (luminous source, screens, emulsions, lenses and finders) makes it possible to use all black-and-white, UV, fluorescent and colour techniques.

COLLECTIONS:
THEIR CARE AND STORAGE

by H. Daifuku

INTRODUCTION

At the turn of the century it was the custom of many museums to place their entire collections on exhibition, a practice which is still to be found among some museums today. This results in a series of more or less identical objects being crowded together in what seems to be, and sometimes is, meaningless confusion. These museums may not be without interest and they have a fascination similar to that of a visit to a cluttered antiquarian's shop where an unusual or valuable thing may sometimes be discovered. And, of course, certain specialists who visit museums to study the collections consider that the manner of presentation is not too important.

It is interesting, however, that during the 1920s and 1930s a number of studies made to gauge the duration of time spent by the average visitor in a museum showed that a functional relationship existed between the number of items on exhibition and the amount of time given to the study of an individual object. The total amount of average time spent in an exhibition hall remained constant after an optimum number of objects were placed on exhibition and thereafter increases in the number of objects shown resulted in less time being given to individual items on diplay [6].[1]

In addition to the factor of 'fatigue', contemporary trends in exhibition (in which a smaller number of objects are placed on display for aesthetic as well as educational reasons), place considerable emphasis upon storage facilities. This tendency toward the display of selected items does not do away with the importance of having a series of objects for comparative purposes. Objects placed in storage are important not only for scientific reasons, but also for changing exhibitions, for loans, travelling exhibitions and other museographical activities. These functions cannot be fulfilled efficiently if objects which are not currently on exhibition or in use elsewhere are put haphazardly in any 'convenient' space. Efficient use of the collections, which justifies the time and expense involved in their accumulation, calls for careful maintenance to prevent deterioration, careful storage and accurate records.

The amount of space given to storage by modern museums today is indicative of this attitude. It is generally considered that only one half of the space of a museum should be devoted to exhibitions, the other half being for curatorial functions including storage. In some types of museums, particularly natural history museums, more than one half of the available space may be devoted to storing study collections [2].

'New' objects are continually being added to the collections and they arrive in various states of disrepair. When an item is acquired it should be registered[2] and, if necessary, examined for insect or mould contamination before it is added to the collections.

Chapter VII, on the museum laboratory, covers several aspects of the work involved in preserving or restoring material. The following discussion on the care of collections is a brief summary of some of the

1. The figures between brackets refer to the bibliography on page 125.
2. See Chapter II and the book by Dorothy H. Dudley, Irma Bezold, *et al.* [3].

practices followed. An extensive technical literature exists, particularly for the care of works of art [9, 10, 11, 12].

INORGANIC MATERIAL

In general material which is inorganic is relatively stable and does not need as much protection as objects which are organic in origin. However, nearly all objects, whatever their origin, can be affected by adverse conditions, and some things which are inorganic can deteriorate very rapidly under improper care.

Minerals

In all museums minerals in many common forms are found—ranging from crystalline formations in a geological museum to carved objects of stone in an art museum. They differ widely in hardness, usually expressed in terms of a scale introduced by Mohs in which the minerals are numbered from 1 to 10 by order of hardness (those having the higher numbers are hard enough to scratch those having lower numbers). This is the list : 1, talc; 2, gypsum; 3, calcite; 4, fluorite; 5, apatite; 6, orthocalse (felspar); 7, quartz; 8, topaz; 9, sapphire (corundum); 10, diamond. For example, an alabaster vase which has a hardness of about 2 or 3 on the Mohs scale can be scratched by one's fingernail and needs corresponding care in handling.

Sedimentary rocks, such as sandstone or limestone, may be subject to deterioration as they are comparatively porous and may be impregnated with salts. Hygroscopic action (absorption of moisture) would lead to flaking of the surface. They should be leached or kept in a dry place in storage. Marble, a metamorphosed limestone, used particularly in sculpture may need considerable care. Marble statuary in storage should not be in direct contact with excelsior batting (wood shavings) as this may lead to staining, nor for the same reason should the marble be in contact with iron or steel nails or screws. Dust covers of cloth (suitably fireproofed) or paper should be used to cover statuary in storage and marble

objects on exhibition should be periodically cleaned.

Quartzite, chert and flint were commonly used in the manufacture of implements by peoples lacking metals or where metals were rare and expensive. They are relatively inert and not easily affected whether on display or in storage. Most damage is caused by careless handling which may be aggravated by overcrowding in storage.

Objets of unbaked clay raise difficulties in preservation. If they are valuable and it doesn't matter whether physical changes take place, it is best to have them fired before they are stored. Other methods include impregnation with a liquid plastic such as polyvinylacetate.

Pottery and other objects of clay which have been well baked are relatively stable. For example (under some conditions), specimens have been recovered which may exceed 5,000 years in age. The surface, however, may not be durable, for example some pottery may have 'fugitive' decorations, in which the potter used a water paint in the design. Care must therefore be used in cleaning them. Dry brushes may be used, sometimes supplemented by toothpicks.

Modern glass is generally very stable. But ancient glass may have a much higher percentage of alkalis and thus would be subject to 'disease'. Glass which is subject to disease should be treated in a laboratory and kept in air-tight cases on display or in storage. A package of silica gel is usually added to the container to prevent moisture from affecting the specimen.

The storage of gold objects is usually a question of security rather than preservation. Some museums have gold specimens kept in bank vaults for storage if they lack sufficient 'secure' storage in the museum.

Objects of silver should be cleaned before being placed in storage. Silver tarnishes rapidly, particularly in the presence of sulphur compounds, which are frequently present in the atmosphere of industrial centres. Silver objects can be wrapped in anti-tarnish cloth or placed in containers with an anti-tarnish paper which would lessen the possibility of reaction with sulphur compounds.

New objects made of copper and its alloys should be cleaned and buffed before being

placed in storage. Polyvinyl or cellulose acetate may be sprayed or brushed on the object to retard tarnishing. It is usually considered desirable to preserve the 'patina' on older objects, particularly of bronze, but a given specimen may have areas which are subject to corrosion, in which case they should be treated before being placed in storage. If there is danger of further corrosion, the object should be placed in an air-tight case or some form of container with a dessicant like silica gel.

Objects of iron or its alloys are frequently found in historic as well as art museums. Objects which are in good condition should be carefully cleaned and rust spots removed. Some sort of preservative which would keep air from coming into contact with the metal should be applied. There are many commercial preparations based upon petroleum derivatives which are used to keep iron or steel from rusting. Objects which are corroded should be treated or stabilized before they are placed on exhibition or in storage.

ORGANIC MATERIAL

Objects of organic origin are much more sensitive to surrounding conditions than inorganic material. High humidity encourages the growth of various moulds. Certain insects, such as termites, some beetles, larvae of moths, etc., are constant dangers. Excessive heat, humidity or dryness may cause warping, splitting, etc.

All objects of organic origin should be checked for insect or mould infestation before they are added to the collections, as they may introduce pests which can be difficult to eradicate, and which would attack other objects in the collection. Optimum temperatures are between 68 and 80° F. with approximately 50 per cent relative humidity. Some types of objects would need higher humidity and others less. Many museums located where temperatures and humidity conditions range beyond the optimum have installed air conditioning for storage areas as well as for exhibition halls, curatorial offices and laboratories.

Fine art museums have devoted a great deal of study to the storage of oil or easel paintings, which deteriorate rapidly under extremes of temperature and humidity. Many museums ensure their preservation by storing them in air-conditioned rooms where a relative humidity between 50 and 55 per cent can be maintained. Paintings on wood need similar care where there is a danger of the wood support warping with wide changes in humidity. Many museums store their oil paintings on movable racks which are suspended from the ceiling and which can be slid out for easy access (see Plate 34).

Bone, ivory and antler, while they appear to be durable, can be attacked by rodents, moulds or insects. Old ivory is particularly sensitive to changes in temperature and humidity. It is generally agreed that ivory keeps best at about 55 per cent relative humidity. If the objects are in poor condition they should be stabilized in the laboratory before being placed on exhibition or in storage.

Objects made of wood should be carefully checked for insect infestation before being placed in storage. If necessary they should be fumigated in the laboratory or by a commercial organization before being added to the collections. Wooden objects should not be subjected to temperature and humidity extremes. Painted wooden objects (particularly panel paintings) may need particular care [4]. Lacquered objects should be kept at fairly high relative humidity of about 55 per cent. Fine furniture should be waxed periodically.

Hides and leather are found in many ethnographic museums as well as natural history museums. Skins which have been 'tanned' with such primitive methods as smoking, or rubbed with animal brains, or urine are not very stable, and become dry and brittle if there is insufficient moisture. Rawhide and skins which have been 'tanned' by greasing should have an application of vaseline before being placed in storage. Paradichlorobenzene crystals are usually placed in the containers with the material. Relative humidity should be between 50 and 55 per cent. If 70 per cent relative humidity is reached, there is danger of mould growth.

Hair and fur are subject to attack by insects, particularly if there is any trace of

animal grease or other organic waste. They should be cleaned before being added to the collections. Some museums place furs in long-term commercial storage where they can be kept in refrigerated rooms, although some museums may have such facilities on their own premises. Gas-tight rooms are also used in which the furs are preserved by the use of fumigants. Individual pieces may be kept in plastic bags filled with paradichlorobenzene crystals. Furs in exhibition cases should be protected by paradichlorobenzene crystals or some other repellant.

Textiles (cloth, clothing, mats, nets, etc.) should not be placed on exhibition or stored in such a way as to form creases. This eventually weakens the fibre along the line of the crease with ensuing tearing or breakage. For storage, large textiles are usually rolled on a wooden cylinder which may be suspended from wall brackets or from the ceiling. Clothing can be padded with tissue paper to prevent creasing or hung from padded forms and covered with plastic bags (see Plate 35). Textiles of animal origin (wool, silk, etc) are subject to attacks by insects and should be cleaned and moth-proofed (see Plate 36). Smaller objects can be placed in plastic bags with paradichlorobenzene crystals. They should be shielded from light to prevent fading. It is best to maintain a rather low relative humidity—between 40 and 50 per cent.

Mats, nets and basketry may become brittle if too dry. They may be brushed with a solution of beeswax and turpentine or sprayed with polyethylene plastic before being placed in storage or on exhibition. Generally they are kept in more humid conditions ranging between 50 and 55 per cent relative humidity.

Paper is very hygroscopic and may also be subject to attacks by insects and moulds. Standard library practices should be followed for books [13]. Rare manuscripts need special care [10]. Prints are usually mounted on mats (rag stock—as sulphite pulp eventually stains) held in place with Japanese or Chinese rice paper, with a covering 'window' mat. A clear cellulose acetate or plastic sheet may be used to protect the surface of the print. If they are placed on exhibition from time to time,

they may be mounted between air-tight lucite or plexiglass sheets [8] (see Plate 37).

Historical museums frequently keep old newspapers or issues commemorating an important historic event in their collections. Newspapers before 1860 were usually printed on rag paper, but following this date wood pulp and sulphite stock became common. The latter types become brittle with age and change colour more quickly than paper made from rags. Many libraries bind newspapers between hard covers or mount them so that they can be stored flat.

Plant and animal specimens are kept particularly by natural science and site museums. Plant specimens are usually dried and mounted on rag paper known as herbarium sheets. In turn these sheets are kept in suitably identified envelopes. Standard manufactured cases can be purchased to hold the envelopes and sheets. Specimens should be thoroughly dried and treated before being placed in storage to discourage the development of moulds.

Animal specimens vary from collections of insects to large animals. The smaller specimens and skins of the larger are subject to attacks by rodents, insects and moulds. Insect specimens are usually kept in glass-covered trays which help to retain naptha-lene or paradichlorobenzene. The U.S. National Museum in Washington, D.C. has standardized cases built for their storage [1]. Specimens which are kept in bottles with alcohol or other preservatives are usually placed on wooden shelves, the larger ones just off the floor.

STORAGE CONDITIONS

Many museums use the basement floor for storage which avoids certain problems of load stress but imposes others, among these is the greater danger of humidity in the basement. There are, moreover, many other functions which can be best carried out in the basement; the furnace and air-conditioning equipment should be installed there; the basement is the best place for: storage of large stocks such as cases and other hardware; accepting deliveries and for crating and uncrating material; the

carpenter shop; the photography dark-room, etc.

Many museums may have a central storage system for all departments, particularly the smaller museums. However, the general tendency in the design of new museum buildings is to treat the curatorial space as an integral unit with the office and the laboratories of the curator attached to the storage areas. Thus the curator undertaking research or preparing an exhibition can check the collections and still be near his office. In addition, if there are students working with him or visiting specialists, he can keep an eye on what is going on and be on call if needed to help look up material.

In designing the building, the architect must provide floors strong enough to support the weight of the material. Storage areas should meet fireproof standards and should also be proof against rodent or insect invasion. Facilities such as extinguishers and buckets of sand to put out small fires which may damage specimens should be located in strategic areas.

Air conditioning is becoming increasingly important in planning the construction of museums.[1] The wide variations in humidity and temperature found in many parts of the world have led many museums to include their storage areas in the air-conditioned sections of the museum. In the absence of air conditioning other means have been used; in air-tight cases humidity can be maintained within limits (using desiccants such as silica gel) suitable for the objects stored. Other solutions include the use of either electric or gas-operated driers or humidifiers in rooms and individual items may be placed in sealed plastic bags.

ACCESSIBILITY

The accessibility of a given object is an important factor not only for the keeping of accurate records, but it should also be an element in the efficient design of exhibition and storage facilities. Adequate lighting, work tables and other necessary facilities should be provided in the storage area for the use of staff or visiting scholars.

If the curatorial space and storage facilities are several storeys high, a goods elevator should be installed. The architect should plan its location so that it can be readily loaded and unloaded in the basement and on all other floors. It is an advantage to place it so that it is accessible to delivery vans and can be raised to the height of the floor of the van to facilitate loading and unloading.

Standard warehouse mobile hydraulic jacks are useful to manœuvre heavy loads which can be placed upon wooden platforms. If a museum plans to acquire such equipment, the central aisles, at least, should be wide enough for it to pass. Two models of trolley have been found useful. A light type for standard museum trays and a heavier one for larger objects. These trolleys have ball-bearing, rubber-tyred, castor-type wheels, they are silent in use, easily moved and swivelled and do not mark floors.

Shelving for storage. Some museums use standard steel shelves which are manufactured commercially for warehouses (see Plate 39). They have certain advantages in that they can be dismounted without too much difficulty and are termite proof and fire resistant. Other museums prefer wooden shelves as they reduce the risk of breakages, and danger from condensation. An adaptation of these is the use of wooden shelves placed upon vertical supports made from standard plumber's pipes and joints. This kind of shelving can be easily assembled by the museum staff without the assistance of a carpenter. Rapidly assembled and dismantled steel shelving using specially patented nuts and bolts, such as those manufactured by Unistrut (U.S.A.) and other similar commercial units have been proved exceptionally flexible. But they are more expensive than ordinary shelving and may not be available in all countries.

Racked sliding trays are widely used to store smaller objects and can usually be made by the museum carpenter or ordered from a timber merchant. A common model is about 24 to 30 inches long and about 18 to 20 inches wide and 4 to 5 inches high. The bottom can be made of quarter-inch plywood or masonite (tempered fibre board) (see Plate 40). Various sizes of pasteboard boxes: $4 \times 2 \times 4$ inches;

1. See Chapter VII and article by Logan L. Lewis [5].

$4 \times 4 \times 4$ inches; $6 \times 4 \times 4$ inches; and $6 \times 6 \times 4$ inches are convenient for storing small specimens. Cotton batting may be placed in the boxes to nest more fragile items. These boxes can be stored in the wooden trays mentioned above.

Sliding screen panels for the storage of easel paintings are commonly used by art and historical museums. The frame of the panels is made of 2×2-inch stock, in which expanded metal screens or heavy mesh screens are set. The screens may be of standard 4-foot widths and about 8 feet high. Each panel is made up of two 4-foot width screens, so that the total width of the panel including the 2×2-inch frames would be 8 feet 4 inches.

Several methods are used to make the screens movable:

1. Suspension from the ceiling.
 (a) Single track. Relatively inexpensive hardware (rollers and tracks) of the kind designed for sliding garage doors can be obtained. The disadvantage of a single track is that paintings (if they are heavy) must be of the same weight on both sides of the panel otherwise the panel does not stand perfectly upright.

 A solution to this problem is, instead of suspending the panel about 6 inches above the floor, to continue it so that the bottom slides along grooves or guides set in the floor.
 (b) Double track. A T-bar suspension is used (see Plate 34). Balance is not important as the double track stabilizes the panel. The clearance permits easier cleaning of the floor.
2. Floor support.
 (a) The panels are set on wheels and tracks on the floor with ceiling grooves to hold the panel in place. Cleaning becomes a problem in this case.
 (b) A combination of floor and ceiling tracks to assure great rigidity has been used.

Most museums today seem to prefer the ceiling support as it facilitates keeping the floors clean. The panels are usually about 18 inches to 2 feet apart. The hallway should be at least 8 feet wide to permit pulling the panel out to its full width.

STORAGE RECORDS

Records of the objects kept in storage is usually the responsibility of the registrar, if there is a central storage system, or the curator if storage is by departments. Once an object has been sent to storage, it should be recorded in a file noting the room, bay, cabinet or shelf in which it was stored. If this object was stored in the department, the registrar should be given the information for the central files as well. It is advisable to have a standard form printed on file cards for this purpose. In addition, each series of shelves, trays, or other storage unit, should also have a card mounted on it to record the objects placed in it or taken away, and by whom. Nothing is more exasperating and time consuming than trying to trace down a missing item from the collections.

The keeping of records of individual items placed in charge of a curator or the registrar is an irksome task. However, it is an essential part of the work and takes less time than trying to find items which may have been moved about from time to time by five or six different people and for as many different reasons.

SUMMARY

Museums are responsible for objects entrusted to them whether it is a choice specimen for exhibition or whether it is primarily for study and comparison. 'Live' as against 'dead' storage is one of the keys to the well being of a museum. There is little sense in having collections which cannot be used owing to lack of records, or to inability to locate them, or in keeping them under conditions which lead to their deterioration.

All these problems are faced by museums which have an active programme of collecting, research, and education. An efficient programme of conservation and a policy of accessibility to the collections for exhibitions (loan or temporary) and for research, will maintain the interest of the staff in their work and encourage others to make use of the institution.

BIBLIOGRAPHY

1. BURNS, N. J. *Field manual for museums.* Washington, D.C., U.S. Government Printing Office, 1941.
2. COLEMAN, L. *Museum buildings.* Washington, D.C., American Association of Museums, Smithsonian Institution, 1950.
3. DUDLEY, D. H.; BEZOLD, I, *et al. Museum registration methods.* Washington, D.C., American Association of Museums, Smithsonian Institution, 1958.
4. INTERNATIONAL COUNCIL OF MUSEUMS. *The care of wood panels | Le traitement des supports en bois.* Paris, *Museum,* vol. VIII, no. 3, 1955.
5. LEWIS, Logan L. 'La climatisation des musées / Air conditioning for museums' *Museum,* vol. X, no. 2, pp. 132-47. Paris, 1957.
6. MELTON, W. A. *Problems of installation in museums of art.* Washington, D.C., American Association of Museums, Smithsonian Institute, 1935. (*Publications of the American Association of Museums,* new series, no. 14.)
7. NOBLECOURT, A. *Protection of cultural property in the event of armed conflict.* Paris, Unesco, 1958. (*Museums and monuments* series, no. VIII.)
8. OSBORN, E. C. *Manual of travelling exhibitions.* Paris, Unesco, 1953. (*Museums and monuments* series, no. V.)
9. PLENDERLEITH, H. J. *The conservation of prints, drawings and manuscripts.* London, Oxford University Press, 1937.
10. ——. *The conservation of antiquities and works of art.* London, Oxford University Press, 1956.
11. STOUT, G. L. *The care of pictures.* New York, Columbia University Press, 1948.
12. SUGDEN, R. P. *Care and handling of art objects.* New York, The Metropolitan Museum of Art, 1946.
13. WHEELER, J. L.; GITHENS, A. M. *The American public library building.* Chicago, Ill., The American Library Association, 1941.

CHAPTER IX

THE EXHIBITION

by P. R. ADAMS

INTRODUCTION

After a museum has collected, preserved and studied the objects of its special interest it must exhibit them. The ends of instruction and edification could possibly be better served by other means such as books or films, and at less cost, but the unique concern of the museum is with things and the exhibiting of things. Now to exhibit is to show, to display, to make visible; but in most languages the word exhibition implies the meaningful showing of things, display with a purpose.

The purpose will vary with the nature of the museum or of its departments. The purpose of London's National Portrait Gallery, for example, is obviously to exhibit portraits of historic British personages. The visitor settles comfortably into this assumption until he is startled by an unquestioned work of art, Goya's *Duke of Wellington,* whose high historic importance is secondary to its aesthetic value, even in such a setting. Should the National Portrait Gallery transfer its Goya to the neighbouring National Gallery, securing instead a mere Wellington, history undisturbed by art? Or should the National Gallery in exchange send over the Wilton Diptych with its portrait of Richard II, since a contemporary likeness of a fourteenth-century English king is so rare that its historic value must outweigh almost any artistic consideration? Probably neither of these distinguished museums is agitated by the question, but many historical and ethnological collections do raise such problems. A science museum for example is not well advised to ignore completely the often great intrinsic beauty of the specimens it uses to develop an ecological or evolutionary argument. Neither should an art museum neglect the human and historical implications of its objects. Assuredly not all artifacts are works of art but all works of art are artifacts, and many of them below the level of the masterpiece might be better so handled. Portraits are a case in point, as are many of the so-called decorative arts, which frequently have more to say of man's general cultural background than of his capacity for artistic excellence. On the other hand many a canoe paddle or jungle fetish has rejected the anonymity of the anthropological shelf and insisted on its artistic rights.

Another question of purpose is whether the object is to take its place in a long-term or permanent setting or answer to the more immediate demands of a temporary exhibition. The difference between a temporary and a permanent exhibition is something like that between a poster and a painting. Temporary exhibitions, like posters, need to make their thematic points quickly, and this must be accomplished in the course of a single visit, the object being required to play a supporting role to the theme. In permanent displays such subordination of the object, especially art objects, can be disastrous.

PLANNING THE EXHIBITION

But before these and many other important problems arise, the object itself asks basic questions. For whatever purpose it is displayed the showing of the object cannot

be effective unless its own particular personality is brought out and enhanced; a fresh look at the object is the beginning of all exhibition procedures. Is it big or little, big or little in character as well as actual measurement? This is the problem of scale. Indifference to this property of size can shrink big objects into insignificance or inflate little objects out of reasonable proportion. The usual museum visitor may not be conscious of these factors, but by an unconscious process of empathy (or physical identification with the object), he may feel cramped or otherwise uneasy if the scale adjustments are not right. And at the first stirrings of mental discomfort the object begins to lose its native power of communion with its observer.

What is the specific gravity of the object, and did it move or was it still? Did it float or fly like a fish or bird? Is it massive like a boulder or a column? Was it worn like a sword, a cloak or a brooch, or held like a crosier? Did it move swiftly like a deer or a locomotive? Was it held and caressed by hands like a violin, a book or a scroll painting? Did it sit like a chair or lie like a rug? And how many of these original qualities can be respected in the static framework of exhibition? To be sure all objects in a museum must be fixed, even though some turn by clockwork to show their profiles or demonstrate a scientific principle, but the air of deadly repose hanging over some museum halls breathes from a violation of the object's physical nature.

What is the colour of the object, what is its texture? A background of complementary colour is a safe formula for decorative effect, but may work against whatever subtle colour variations the object may have. Eighteenth-century porcelains, for example, are often shown against a complementary ground as a contrast to their predominantly white colour range. The variations of these delicate whites, however, are important to a collector's eye and hence important to the untaught eye which must be educated. They can be best brought out by an off-white background, and the same is true of the Turkish pottery, once called Rhodian, where the quality of the white determines the value of the plate or tankard.

Silver will gleam against a background of almost any colour, but different shades of greys can play up particular variations from piece to piece. Gold raises similar questions; the blues, reds, blacks and warm browns against which it is frequently exhibited proclaim its richness at a glance, but the exquisite tonalities of ancient metal are sometimes thereby sacrificed to the drama of the moment, whereas beige and soft greys can cherish them. These are weighty considerations in the choice of immediate backgrounds such as case linings and panel mounts, but all-over schemes of primarily decorative effect need nevertheless not be abandoned altogether. Tomato-reds, purple-blues and greens have been used for walls and ceilings where Turkish pottery is shown, powder blue for walls holding the off-white cases of French ceramics, even lacquer reds and blacks for silver galleries.

The same principle holds as regards the texture of the object, although contrast here is more often desirable—a smooth-textured setting for a rough object (perhaps not so often should a coarse texture, like the currently popular burlaps and grass-cloths, be used as a background for a fine-surfaced object). Smoothest of all, glass shows equally well against knobby raw silk or antique satin and velvet. Common use will sometimes suggest appropriately textured backgrounds—the suede and satin linings of jewellery boxes, the velvet lining of violin cases, the baize or felt linings of knife cases when arms are to be shown.

In what light was the object seen? The dark unfathomed caves of ocean may have borne many a museum gem, but in spite of the monumental gloom dear to many traditional museum buildings enough light for adequate visibility is needed for the exhibition of all objects. The question of light immediately raises the complicated question of original setting and of how far it is desirable to reproduce the object's natural context without undoing the basic purpose of exhibition, which is to single the object out for special attention. By approximating original conditions of light the American Museum of Natural History gives additional conviction to its showing of the *Men of the Montaña*, a culture which lives in the jungle shade of upland Peru. An

unlighted awning stretches a forest roof over the exhibition area; from above it come the sounds of tropical rain, the cries of jungle fauna. With simpler means, primarily by control of light, New York's Museum of Modern Art, in a notable exhibition of the *Art of the South Seas,* emphasized the artistic differences between objects of many kinds made by dwellers in the Melanesian forest's half-light and those made in the blaze of the sun by coastal peoples. Both exhibitions, one permanent the other temporary, considered the circumstances of the objects' original settings and judiciously exploited them to achieve a maximum of aesthetic and educative effect.

In their 'habitat groups' museums of natural history have developed extraordinary skills in reproducing natural settings not only of plants and animals but of man as well, although not always as successfully in their anthropological departments. Art and history museums have profitably followed this lead in recreating the lived-with atmosphere of given periods and places. Archaeological museums are able to house object and actual setting both, whole architectural units such as tombs and small shrines with their contents.

While the buildings of art museums usually attempt to reproduce the formal settings for which much painting and sculpture of the past was designed, they have to decide carefully how far they should include the historically appropriate, but possibly distracting decorative details of furniture, textiles and bibelots that originally accompanied the paintings. Some art museums, following the early lead of palace collections, in throne room as well as *Wunderkammer,* and the pioneer museum practice of the Kaiser Friedrich, choose to stress the aesthetic whole of a period, running the calculated risk of subordinating art to history. Others of late insist, as a matter of pure artistic emphasis, that paintings should be shown unframed unless the frames are chronologically consistent. Prints of all kinds, miniatures and book illustrations, scroll paintings that were meant to be looked at singly and in the privacy of a study, obviously cannot be shown in any context that remotely resembles the original. Similarly, the arts of use, the so-called decorative arts, so often seem ill at ease in the frozen air of museums.

THE SETTING FOR THE EXHIBITION

All problems of setting begin with the placing of the exhibition in the museum building itself. Almost all buildings have to be adapted to the needs of the exhibition in one way or another, since no architect could conceivably design all the kinds of space required by the varied and changing exhibition programmes of even the smallest museums. If this is true of new, specially designed museum buildings, it is still more true of the many museums that must fit themselves into former post offices, libraries and government buildings. It is painfully true too of museums housed in inherited 'white elephants' which so often, with costly materials and unusable space, memorialize an older period's 'idea' of a museum. As Laurence Vail Coleman aptly says, the monumental stairways in the grand halls of nineteenth and early twentieth-century museums are about as convenient as 'an open step-ladder in a closet'. It may not be strictly accurate to assert that a museum official should be ready 'to fight an architect at the drop of a hat' as one veteran New Englander remarked, but he does need to be fairly bold if he is to bend the cumbersome architecture of most buildings to his plans, which though they may bear traces of the changing tastes of passing generations are the result of his deep thought and careful consideration of the problems to be solved.

In defence of architects however, it should be said that walls and roofs have to be weather-proof and reasonably permanent, and hence are fixed quantities not subject to manipulation. But apart from these stable elements everything, ideally, including outside approaches, lighting, interior walls, ceilings and floors should be as adaptable as possible. Structural building alterations are costly, but adjustments inside the building's shell need not be excessively so. Translucent awnings can be stretched to lower ceilings and diffuse light, and perhaps to conceal an earlier era's love of elaborate cornices and other distracting ornamentation. Slight

screen walls of a construction which is not beyond the abilities of the average carpenter or carpenter-janitor, who constitutes the maintenance staff of many small museums, can be put up with inexpensive materials, moved on occasion, pierced with openings of simple design, and placed in front of old cases. Temporary lighting arrangements are available to anyone who can plug in an extension cord.

Most museum officials, unless they work for very rich foundations, should be able to use their hands, at least on a drawing-board, or have enough practical sense of tools to be able to design and oversee the inevitable adaptation of fixed space to changing needs. This ability is not often mentioned in training courses, but it is a rude necessity for all but the most fortunate. After all, effective exhibition must depend upon the person originally responsible for the object and its museum use, whether he is curator, director or educator. He must, as a scholar and critic, be able to conceive the proper showing of the object, and also be practical enough to devise ways to achieve it. No one else can quite do it for him !

TEMPORARY EXHIBITIONS

Experiments in modification of building space, control of circulation of visitors and arrangement of material can be tried out in temporary exhibitions. It is, in fact, one of their chief virtues that they invite, almost require, fresh exhibition effects, many of which can be adapted to permanent, or at least more lasting, use. Some of these effects will need judicious toning down of colour or of dramatic lighting accent—since the pace of temporary exhibition is swift. It tries to communicate quickly by legitimately theatrical means rather than to develop the leisurely and quiet contemplation which comes from the frequent return to familiar things in familiar settings.

In order to make its point quickly the temporary exhibition must guide the visitor's attention and movement as firmly as possible; movement of the eye or the body from object to object is an element in any kind of museum showing. First comes the general effect, the equivalent of raising the curtain in the theatre. This introduction invites the visitor and announces the harmonic theme which should unify the exhibition. Consistent colour schemes are most useful in maintaining this unity and help set the special exhibition off from the rest of the museum. If the first impression, which must be striking to do its job, is over emphatic or too prolonged, the visitor may be disinclined to concentrate adequately on the details that follow—it is probably a poor opera that is remembered only for its overture. Then comes the orderly development of the theme which may be anything from a categorical arrangement by material, medium, geographical place or historic period to the illustration of an explicit idea.

Of course temporary exhibitions have many other uses. A new or small museum can plan a series of changing shows, over several seasons perhaps, which will outline its ideal programme and define its aspirations for the benefit of its public and patrons. Large and long-established museums can call attention to aspects of their collections by special showing, and temporarily fill gaps in their permanent collections. Sometimes a new acquisition suggests a temporary exhibition to introduce it. No museum lacks occasion for special exhibitions, the problem is to determine how many can be adequately presented in view of the cost, and of the months or years of preparatory study a good exhibition demands. Temporary exhibitions impose a discipline of order and arrangement for calculated effect which many museums could well apply to the display of their permanent collections. They require forethought, planning and above all a clear conception of the end in view. No museum, big or little, can easily excuse itself for a carelessly prepared special exhibition as it often excuses its permanent showings by citing the poor quality or other shortcomings of its collection.

LABELS

Temporary exhibitions call for catalogues, informative material of many kinds and, above all, for labels. Museums which may

be casual to the point of neglect in labelling their permanent collections will often rise to the challenge of a temporary showing. Perhaps this is because only one or a few aspects of the object have to be treated in the label of a temporary showing, whereas the permanent label must treat it fully. Only the person who has tried to write a museum label can understand how thorny a problem it is. The purpose of a label is to impart information in a compact, comprehensible form. But how compact? There is no end to the educational chain-reaction set up by museum objects. Comprehensible to whom? The casual, possibly illiterate, visitor, or to the travelling specialist? He at least is certain to read a colleague's labels and not always with fraternal sympathy. When all the requirements are considered it becomes evident that only a master of the short essay should be allowed to write a museum label; unfortunately not many of these work for museums. And whereas Montaigne and Bacon presumably had definite audiences in mind, as has a popular journalist today, a museum's reading public is of the most general kind. One possible solution is to give two kinds of information on the same label: a bold heading easily read at a distance to identify the object, carrying essential vital statistics, followed in smaller type by as extended a discussion as the museum cares, or is able, to make. If a visitor is content with dates and scientific Latin he may glance and move on; if he wants more he is entitled to it, but not at the cost of that prior attention which is the object's right.

Ideally both the bold identification and the extended discussion should be close to rather than on the object. Even where the object must be identified quickly the explanatory material will command its own attention and should be placed nearby rather than in direct competition. This may not be so in the theme exhibition which is itself an enlarged label with objects used by way of illustration. However, for most exhibitions, temporary or permanent, labels should be visible but not intrusive. Extended information may also be provided by 'room labels' in pamphlet form to be read by the studious visitor. Experiments have recently been made too with controlled radio transcriptions—a complicated and expensive but promising device.

The content of a label is an educational matter, but its visual presentation is an organic part of the whole exhibition; it should conform in colour, scale and location with the all-over scheme. Throughout the exhibition the typographical style of the labels should be consistent. Consistent styling of announcements, invitations and posters is also desirable. The labels should preferably be processed in some way, if possible printed, or if not, photostated from typed or hand-lettered texts. Photostating permits easy enlargement of a typewritten text as well as decorative tone graduations from negative to positive. Permanent labels should be mounted or framed, for reasons of both appearance and maintenance.

Maps are a graphic way of imparting information and useful for many kinds of exhibitions. They may range in size from a sketch map on the label, small enough not to compete with the object, to large rural maps designed as part of a fairly large area and helping to unify it. Maps have endless decorative possibilities and the further advantages of being readily available and authentic. Mural maps should take their colours, however, from the colour scheme of the gallery or exhibition area and not risk the confusion of introducing new elements of design. Their lettering again should be consistent with the style of the exhibition. Such small factors can add up to a powerful influence on the visitor without his being consciously aware of it. A sovereign rule of all exhibition procedures and one that is common to most creative activities is the rule that art should conceal art; the method of exhibition should not be more noticeable than the things shown.

EXAMPLES OF EXHIBITIONS

Since these general principles apply to the exhibition problems of all types of museums and are infinitely varied in their application, it may be valuable here to discuss some concrete examples, beginning with the queen of museums, the Louvre (Plate 41). Not all museums are housed in great palaces and few, unfortunately, have things of such

supreme worth as a fragment of the Parthenon's frieze to exhibit. But most museums have to adapt their permanent architecture to the scale and space requirements of their collections and every museum has some objects it particularly prizes and wants to show in a way that will induce respect and affection, or at least serious attention, in its visitors. It is an old saying that no museum can show an object without commenting on it, even if only by their manner of showing it. If the presentation is casual or indifferent, pompous or confused, the public's sensibilities will react accordingly. And these sensibilities can be marvellously acute, even if not often articulate; a museum should never overestimate its visitors' knowledge, or underestimate their intelligence.

The Louvre's problem, in this case, was to simplify the palatial architecture without abandoning or concealing it and to relate it to the modest scale and the inherent character of the Parthenon fragment. Beneath huge vaults and against a large blind arch of richly coloured and patterned marble a simple stone slab rises from a stepped platform to hold the frieze. Everything is measured to the grave stateliness of classic style. Without the stone, the frieze in its simplicity might have been overwhelmed by the rich marble which however does comment on the artistic value of the sculpture by striking a luxurious note. But the stone background slab is plainer than the Attic carving of the frieze, which is set close to the marble wall although not immediately against it and placed so that natural side light from a window picks up and emphasizes the relief. The platform suggests the stylobate of a Greek temple and defines a volume of uninterrupted space, a kind of unwalled room inside the large hall, where the visitor feels he can enter and see the sculpture by itself. The platform appears to invite close inspection of the sculpture but in practice it keeps the visitor at a respectful distance and protects the ancient stone from the damaging touch of hands. Platforms also reduce the sheer acreage of gallery floors which is a cause of museum fatigue and boredom.

In the very different modern setting of New York's Museum of Modern Art (see Plate 42), one of the key objects in an exhibition of American Indian art had to be shown so that its truly monumental scale could be brought out in spite of its miniature size. The 'Adena pipe' is a scant eight inches high, yet it has a sculptural grandeur which the visitor with average intelligence but without special experience in such artistic matters might not sense. It was shown in a small free-standing case against a huge photographic enlargement. This photo-mural announced the scale of the whole group of small but monumental objects from the same culture and unified the exhibition area by its decorative power. The cut-out letters of the master label are also larger than many of the objects but do not compete with them or diminish them. This results from their relation to the colossal size of the photo-mural, which runs from floor to ceiling of the gallery and is as much larger than the original as the room will permit. In fact both the mural, and the label become part of the room rather than of the exhibition. Had they been smaller they might easily have been a source of confusion, neither decorating the gallery nor asserting the character and importance of the objects. This dramatic effect is perhaps more suitable to a temporary exhibition but the principle could be modified for permanent use. Textures and colours are studiedly neutral, so as to let the modest soapstone, steatite and obsidian of the objects speak for themselves.

Enlarged photographs are often used to bring out the latent monumentality of small objects such as coins, carved gems, medals and seals, or simply to make them more visible regardless of their scale properties; the chief problem is to find the right size for the enlargement. Actual magnifying glasses are sometimes set over small objects but this method permits only one visitor at a time to see the object, whereas photographic enlargements can be read by many, and at a distance.

The Palazzo Bianco in Genoa (see Plate 43) deliberately contrasts the dramatic austerity of modern decoration and modern materials with an early Renaissance sculpture of medium size. A machined metal support can be raised, lowered and turned showing the infinite profiles of an object in the round;

the visitor can thus relax and does not need to move. The spirit of the materials used for the mounting is in direct contrast with the hand-carved stone of the sculpture. Surrounding walls and furniture define the volume which the sculpture's self-contained movements reach out and demand. Any hint of period setting is consciously avoided so that the Giovanni Pisano is presented in an atmosphere of almost surgical purity. This is a bold and effective way of concentrating every power of observation on the object itself. Perhaps only a masterpiece can survive such concentration but studied simplicity is a useful focus for most museum objects.

Natural light, often the most desirable and inexpensive, is always appropriate for the great majority of natural objects and those originally meant to be seen in natural light. But it is sometimes difficult to control, especially for objects in the round. The diffused overhead light of traditional galleries is excell nt for paintings but can be too bland for sculpture and other three-dimensional objects. Fixed artificial lighting has its virtues but can never capture the variable play of natural light which, even in a short period of observation, can model and animate. Plate 44 shows an effort to throw a sharp raking light on two shallow reliefs in order to accentuate the fine detail of their carving. One bay of a large gallery was partially walled to exclude a general and warm yellow south light. Two tall, narrow windows to the north were inexpensively closed with paperboard on wooden frames to concentrate cool bluish light, falling from above and to the side (see Fig. 1). The reliefs were then set in walls at slight angles determined by moving the reliefs until they seemed to find the best illumination. The Assyrian fragment of a winged genius is mounted at the height it would have reached if it were intact and the plywood wall is covered with coarse sand mixed with wet paint to contrast with the fine-textured alabaster. The Persian relief came from the parapet of a stairway leading to the palace platform of Persepolis. Though small it has considerable power which was lost when it was shown flat on too large a wall. Set in an approximation of its original parapet location its curved

upper edge functions naturally and it feels generally more 'comfortable', hence more accessible to the observer. Its wall is unpainted rough plaster without the finish coat. The space of this area, enclosed primarily to provide adequate light, may suggest the proportions of a Mesopotamian palace corridor without too urgently insisting on the resemblance.

Reconstructions of original settings run the risk of seeming artificial and contrived. They are, in any case, complicated, possibly costly undertakings, and the desired effect can often be simply achieved by suggestion. The Niederöstereichisches Landesmuseum (see Plate 45) gives two Schleinbach graves their proper subterranean character by raising a stone platform above floor level to house them. The rough masonry is appropriate to the prehistoric theme and incorporates a case of small objects. A large map of the site gives both information and decorative unity and a stylized mural of skeletons in burial position symbolically announces the theme. Graphic symbols of this type can be highly effective but, where more sophisticated objects are shown, can also be competitive.

Plate 46 shows the quieter environment of a permanent gallery in a small museum adapted for the showing of Greek and Roman art. Large museums often have to select their exhibitions from an embarrassing profusion of objects; smaller museums sometimes need to expand a few to give the effect of many. This gallery in Honolulu's Academy of Arts is architecturally unobjectionable but was obviously designed to exhibit paintings. The potteries are small and need enclosure and the small sculptures ask for sympathetic emphasis. Walls of light construction divide the larger area and provide niches for sculpture and also incorporate conventional cases. Cases are a constant museum problem, since there is no such thing as an all-duty case. Ideally, every single object and type of object requires a space of its own. Shelves can be instruments of boredom and the case itself is often a bulky object, adding its own physical presence to the scene. As a general principle of design three elements, whether of colour, value or shape are the maximum that can be successfully combined without

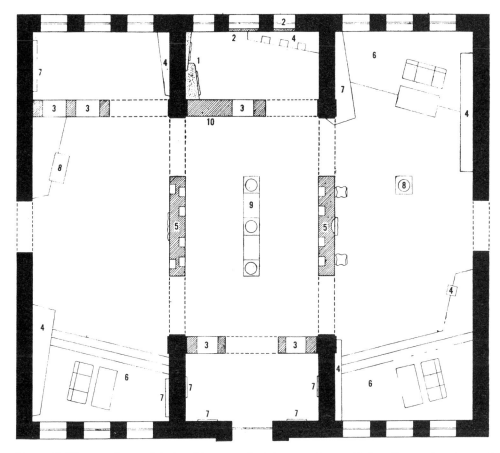

Fig. 1. Solid areas show original architecture—shaded areas show added walls. 1—Assyrian and Persian sculpture (see Plate 44). 2—Window closed with paperboard on wood framework. 3—Two-way or window cases. 4—Suspended wall cases for pottery and bronzes. 5—Inset wall cases. 6—Raised platforms with couches and sloping-topped tables that show miniatures. 7—Angled wall mountings that show miniatures. 8—Free-standing cases for pottery and bronzes with self-contained lights. 9—Free-standing cases connected by a soffit that holds light. 10—Mural map.

causing confusion. It is difficult enough to handle the object, the element of space-colour-and-texture immediately surrounding it, and the larger room in which it is located, without the fourth element of the case intruding itself. If cases then can be incorporated with walls or their structure minimized, the problem is simplified. One inexpensive way of accomplishing this is to build walls around the cases a museum happens to have, as was done here. The projection of the centre case is a pleasing

variation and works against the threatened monotony of too many objects of the same size on the same levels. The mosaic from Antioch is quite logically shown as a floor pavement and being a large rectangular area on a different plane helps to tie the room together.

Large wall spaces and room areas can be adjusted to the showing of small objects in a variety of ways. The Pinacoteca di Brera in Milan (see Plate 47) lowers the vaulted ceiling of a disconcertingly long, high

gallery by a suspended ceiling, half the corridor's width, set at a congenial height with cove-lighting above it, to show early Lombard and Venetian paintings which are characteristically small panels. Vistas are dramatic in themselves but can shrink the objects set along them and sometimes tire the visitor with the threat of too much lying ahead. Yet cutting the long hall into cubicles could be monotonous and would sacrifice the monumental scale of the old gallery which does suggest the original church setting of the paintings. The Brera reduces the corridor's sweep with screens at right angles to the wall, set on legs for an effect of lightness, and stayed to the wall with a rod. The hanging space is considerably increased, the scale is brought down for the benefit of small paintings while the overall architectural unity is not violated. Natural light from high windows on the opposite wall is gently broken and diffused by the screens.

The Stedelijk Museum in Amsterdam (see Plate 48) softens the light from side windows by setting them with panes of translucent glass, and lowers a beamed ceiling with an awning. Benches have been built along the window-wall to cover unsightly radiators and a horizontal exhibition plane has been introduced with low platforms on which paintings are shown. The platforms play an important part in the decorative scheme of the room, breaking up a large floor area and offering a fresh way of looking at paintings. The Stedelijk has changed the surface of many walls in its old building by nailing up a gridwork of wooden battens over which fabric can be stretched, sized and tinted in the fashion of stage scenery. The battens hold nails for picture hanging at all the usable levels and are much less costly than the floor to ceiling planking customarily used in painting galleries.

The Museo Nacional de Historia in Mexico (see Plate 49) had to adapt the massive scale of the Castle of Chapultepec to suit the display of coins which demands a more intimate setting. This was most successfully done by a permanent alteration which lowered and simplified the ceiling over a long hall—electrical fixtures being provided where needed—and lowered it still further with a wide flat dropped ceiling above

which cove-lighting gives a diffused general illumination to the gallery. A master label runs from the floor to the dropped ceiling, subdividing the exhibition space and carrying information on the history of silver coinage in Mexico. Strip cases are built into one wall, and a fin wall with a two-way case bounds the exhibition area. Walls of this type allow the visitor to see something of the neighbouring galleries, inviting him to go further without distracting him or too rigidly confining him to the subject at hand. They demonstrate the valid modern principle of fluid space and resist the tyranny of the rectangular room. There is nothing sacred about a right angle as the Chapultepec cases show by curving their backgrounds to make the small coins more visible and offering a welcome relief from flat planes. The cases are set in a long horizontal line along which the eye travels more easily than if forced to jagged vertical movement. The master label and fin wall vary a too-insistent horizontal stress.

The Print Section of Amsterdam's Rijksmuseum (see Plate 50) breaks the long horizontal line of subtly designed cases by acknowledging the neo-Gothic architecture of the hall whose compound piers break the sweep into manageable bays. The cases also vary the vertical stress by leaning away from the plane of the wall. The backs of the cases take an opposite incline holding the prints for the observer at the angle at which a hand would hold them for close inspection. Interior light can be controlled, in this instance, with filters over fluorescent tubes for the protection of the prints. Absence of general light under the gloomy vaults concentrates attention on the small objects. It is an admirable solution of a difficult and all too common problem, that of adapting conventional architecture to particular museum use.

Plate 51 illustrates the solution of a similar print exhibition problem; fabric-covered wood panels applied to plaster walls and a long horizontal cove built above the exhibition strip to hold and conceal fluorescent tubes. Venetian blinds diffuse and screen out an excess of general light from high windows. Two-thirds of a large rectangular gallery were walled off for storage, work and study space to reduce the

scale of the remaining corridor appropriately for showing prints. The heavy cornice of the original room contained ventilation and heat ducts so that it could not be closed off, although its interrupted architecture needed to be concealed, and scale required that the ceiling be lowered at least 3 feet. This was inexpensively done by building a horizontal louver with foot-wide redwood boards of a pleasant colour. Automatically this suggested a general scheme of warm brown values accented by off-white, lending an extra brilliance to the black-and-white or colour prints to be shown in the room. On one side the cove runs continuously through three galleries, thus avoiding the impression of 'chopped-up' space.

Another way of modifying a large room so that small objects will not be overpowered by its sheer size is shown in Plate 52. Here 44 miniatures and some text pages from an eleventh-century Persian manuscript are exhibited. Miniatures are literally miniature, paper-thin book illustrations meant to be seen at no more than arms' length. Hung on the 17-foot wall of the original gallery they would have been completely lost, like a postage stamp on a very large envelope. Since high-set windows reaching the cornice prevented lowering the ceiling without major alterations, 2×12-inch beams were thrown across the gallery at a height of 9 feet. These hold boxes with fluorescent tubes behind frosted glass to light a long plywood strip on which single folios are shown at a slight angle from the vertical, the strip acting as an elongated unified mat for the series. Framing and matting can increase the size of a small object if properly done, but matting poses its own problems. Near-Eastern artists considered the mounting of miniatures hardly less important than the painting itself, and since they were seen singly as pages of a book there was no danger of monotony in prolonged repetition of the same size. Museum exhibition of miniature paintings is a direct opposite of all the circumstances of their original environment, which should be compensated for in some way. The manuscript had been cut apart by previous owners so that all the pages in this group could be shown without ruthless dismemberment. But several folios were double, with paintings on both sides, which presents an even more complicated exhibition problem. Plexiglass sheets were cut out with the aperture being slightly smaller than the page so that it is held firmly at the edges. Between the sheets label translations of the text are inserted below the pages and the two sheets are sealed on the outer edges to stop air movement with its destructive changes of humidity. Glass cover-sheets are placed over the plexiglass and the whole is held together by a grooved frame. The frames are then supported on wooden poles in the 'pogostick' (spring-supported poles) fashion, nailed to the floor and socketed in soffits set between the beams. Thus the double folios seem lightly held as their own fragile nature dictated. The soffits house incandescent spotlights behind frosted glass throwing light equally on both sides of the folio so that one painting will not be visible through the other. Venetian blinds over the two big windows diffuse a soft general light through the lower part of the room. The tawny tone of old paper and the vivid colour of these oldest of Persian miniatures suggested a simple scheme of warm grey for walls and off-white woodwork. A further change which seemed desirable was to break the stiff rectangular gallery into a more informal space. As the sketch plan shows (see Fig. 2) the strip walls and row of lights above form an 'L' at a slight angle to the lines of the wall and the double folio mounts follow a free 'S' curve. If the whole effect should hint of a garden pavilion to some romantic visitor no harm would be done.

By building angled temporary walls to house special cases for an exhibition of *Pre-Columbian Art of Western Mexico* the Colorado Spings Fine Arts Center (see Plate 53) successfully defied the despotism of the right angle and achieved the graceful effect of a curved wall at far less cost than an actual curved wall would have entailed. Angled walls can control the visitor's attention to some extent as does here the horizontal line of cases with their small objects which points to a climax of large tarracotta figures. The free-shaped group pedestal in the centre of the room plays curves against straight lines and large cut-out

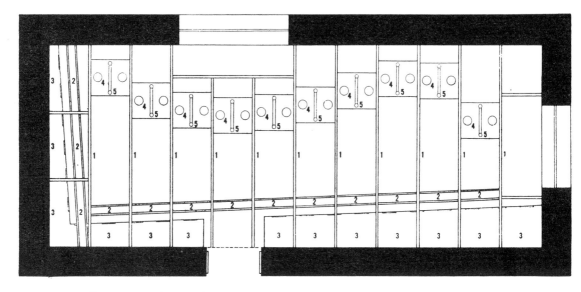

Fig. 2. 1—Gridwork of 2 by 12-inch beams. 2—Boxes holding fluorescent tubes above frosted glass. 3—Sloping wall of plywood with apertures cut for miniatures protected by glass. 4—Soffits holding 75-Watt incandescent spots over frosted glass. 5—Two-inch dowels holding mounts for double folios.

letters are used to label the room. An awning ceiling diffuses light and conceals the permanent architecture of the building.

Since the museum experience is primarily visual rather than verbal, maps are often the best kind of label and have great decorative possibilities. The Niederösterreichisches Landesmuseum in Vienna being a museum of both art and nature uses maps effectively throughout the baroque palace that houses its ecological collections. In Plate 54 the map acts as a mural frieze placed well above the group of objects from the iron Hallstatt culture, and locates the culture itself, showing its dissemination through the north Mediterranean world. A built-in wall case shows a key monument, a reproduction of the Kuffarn situla, mounted on a rotating plexiglass stand and nearby on a modest brick pedestal a stone relief. This is a sensitive use of materials; the plastic base for the situla emphasizes the light, portable character of the vessel, the simple brick pedestal is appropriate to the prehistoric theme and is architecturally justified since it supports an archi-

tectural fragment. Lettering on map and objects is consistent and carefully designed; the colour of the wall is used for land masses, making the map an organic part of the room.

In the mesolithic gallery of Stockholm's Statens Historiska Museet a series of table maps carries the principal story of the Scandinavian glacier's slow retreat (see Plate 55), and the resulting changes in flora, fauna and human cultures. They are cut out of an opaque material and set on glass table-tops which are in turn set in a table frame of simple massive design. A mural of graphic symbols on one of the end walls announces the theme of the room. Screens are set at right angles between the windows of a side wall to hold objects. The opposite long wall is broken with an accordion line of panels supported on wooden legs similar to those of the table maps. They hold photographs and small sloping table cases of objects. It is a most effective exposition of a complex subject which manages to be unusually attractive.

The Museu do Indio, in Rio de Janeiro,

combines similar elements more compactly (see Plate 56). A grid of vertical poles holds a cut-out map showing the distribution of Indian population, a screen carries photographs and two simply designed low horizontal cases house Indian objects. The floor covering, if only owing to its size, an important element in the composition of any room, works well as part of a modern decorative scheme.

The mural map in Plate 57 locates the cities of origin of the pottery, textiles and miniatures of a late-Islamic gallery. It also serves the aesthetic purpose of offering large simple shapes as a relief to the intimate scale and the repetition of small decorative elements characteristic of later Near-Eastern art. Its colours are those of the room, deep blue, pale lavender and off-white suggested by the Damascus plate in the two-way window case to the right. At the axis of the gallery is a Koran from sixteenth-century Mecca and it is actually the graphic symbol of the room's theme. It is shown on a plexi-glass lectern so that its eighteenth-century binding can be seen and its pedestal case is attached to a platform against which a Persian vase carpet is held at a slight angle from the floor. This inclined rug platform has two uses, aesthetic and practical; it shows the rug, which is after all a floor covering, in physical relation to a floor and detaches it enough to keep it from being absorbed by the floor, holding it up to the observer for special emphasis. The practical purpose served is that the angle keeps people from being tempted to walk on it and does away with the need for such security devices as ropes or railings. Security measures are necessary to protect museum objects from human curiosity, but they should not be too insistent, too constantly forbid touch, say 'no' too often. Many museum visitors are not quite sure why they came in the first place, they tend to be timid in the presence of things they are seeing for the first time. If they feel they are being regimented they will exercise their privilege of leaving and will not come back.

The labels in this gallery have printed headings and typewritten texts which have been photostated. The middle-toned grey photostat negatives are mounted on card-board. For the labels inside the cases which are lined with off-white silk, positive photostats are used. The angles of the Koran, the rug platform and the Indian miniature on the wall, all help to lead the eye up to the map and lend some variety of plane to the rectangularity of the fixed architecture.

Architectural motifs can underline the theme of an exhibition and give decorative unity, especially if the exhibition is temporary and the architectural motif implicit rather than obtrusive. The M. H. De Young Memorial Museum in San Francisco (see Plate 58) adapted the space of permanent galleries with panel screens of natural mahogany set in white spruce frames to show *Art Treasures from Japan*. The pedestals are of the same material. Fin walls to hold hanging scrolls were guarded by light-wood railings and the Japanese motif throughout was asserted by materials and proportions in the Japanese spirit more than by specific Japanese designs, for instance, in the way a trough of lights was hung from the ceiling with no more than an effect of Japanese beams. Potted plants were accents especially appropriate to the theme. Plants and flowers, however, make a vigorous bid for attention, competing dangerously with inanimate objects, even masterpieces and they also add maintenance problems. Judiciously used, however, they can decorate and freshen the still atmosphere of a museum hall.

The Museo della Civiltà Romana in Rome is an excellent example of the type of theme exhibition where objects illustrate rather than dominate, where the exhibition becomes in fact an enlarged label. In Plate 59 the theme is ancient Roman family life and large letters well-placed high on the walls proclaim it, relating objects of various sizes to the subject. The large free-standing panel dividing the long gallery carries a text explaining the theme, with a niche holding a husband-and-wife funerary portrait in much the same way as in a well-designed book a page of text might be enlivened. The gallery itself is a good example of modern exhibition architecture, a bare shell asking no attention for itself beyond its patterned skylight and gracious proportions, proportions which themselves express the theme—monumental for the

137

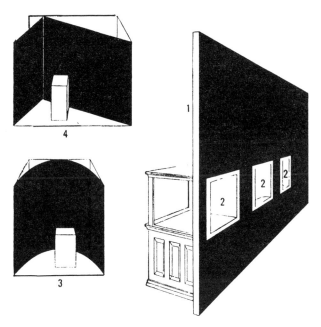

Fig. 3. Possible use of temporary or screen walls. 1—Wall of any desired construction and size. 2—Apertures of any desired size or height. 3—Modification of old case interior to escape rigid rectangularity and control case interior for new or special use. 4—Another possible control of case interior. Ceilings could be used in both instances and lighting variously supplied from sides or overhead.

institution of the family but scaled also to the individuals who compose the family.

A basic archaeological principle is effectively demonstrated by a large label to which objects are fixed in Chicago's Natural History Museum (see Plate 60). This is a pioneer example of eloquent simplification; its concrete specimens have educated several generations of school-children in what would otherwise be the wholly abstract 'sequence numbers' of scientific archaeology. The specialist can at least be amused by so telling a popularization and the average visitor of average sensibility is immensely helped. Literal reconstructions of strata have been used by many museums, and with good effect, but there is a greater graphic directness in the Chicago label. It may be that whereas such techniques are

legitimate for technical and scientific museums an art museum must consider carefully whether or not its art objects should be cast in such a minor part. In any large group of objects, however, even among paintings and prints, some are less artistically important than others. These might well be used to adorn the tale of a truly explanatory label. The artistic moral can still be pointed by accentuated showing of the finer works.

There are very few objects available to tell the *Story of the Atom*. The Palais de la Découverte in Paris (see Plate 61) consequently uses diagrams and enlarged microscopic photographs to develop a complex theme of great importance. Here a museum attempts to do on a popular scale what a textbook may often fail to do except for the technically trained. It calls on every device of aesthetic arrangement, visual emphasis and control of space and traffic to guide the visitor through a consecutive presentation. The rectangular room is first subdivided with fin walls and screen walls. Light is concentrated and concealed by soffits. Colour subdues large empty areas to the horizontal line of narrative. Some planes are inclined away from the perpendicular in the easy position of a book being read. Curves are played against straight lines to relieve monotony. Lettering and typography are consistent in style and varied in size depending on the distance at which the text is to be seen. In short, every means of holding the visitors' attention through a sustained period of time is employed without making him feel restive or too authoritatively lectured at. This is the ideal of the expository, teaching exhibition, and one which is not often so successfully realized.

In contrast there is an over-abundance of illustrative material for such a theme exhibition as the Los Angeles County Museum's *Man in Our Changing World* (see Plate 62). An exhibition of this kind usually begins with the text which carries a simplified argument, necessarily reduced to a few major points, in large letters, sometimes cut out and applied to walls and panels, at other times painted on panels of regular or free-shape, or printed and photostated. Typographical consistency is essential, not only for decor-

ation but also for effective exposition. A well-designed newspaper page with its banner headlines, sub-heads, paragraph headings and so on could serve as a guide for this type of presentation. Maps, diagrams, photographs, models and graphic symbols were all used to illustrate the text. Much of the material was shown on the permanent walls of two rectangular galleries. Soffits were introduced to reduce the height of walls and concentrate lighting in some areas, and screen walls of various kinds, sometimes open grid walls, were freely used to vary the exhibition space and guide visitors' circulation (see Fig. 3). Control of the visitors' movement is essential if an orderly argument is to be developed, but too strict regimentation may be resented. Walls set at carefully studied angles can lead by their direction without imprisoning the visitor; photographs, labels and charts can be slightly set out from the wall lending a variety of plane to what is otherwise an array of flat shapes.

LIGHTING

The exhibition's subject and the objects used to illustrate it became one and the same thing in the London Science Museum's five-month showing of *Darkness into Daylight* (see Plate 63). Ironically but logically, natural light was blanked out of the galleries to show the history and possibilities of artificial light. Existing space was effectively adapted by fin walls, strips of horizontal cases and, an enclosed ledge slightly raised from the floor and roofed with a soffit. Poles running from floor to soffit of this area held label panels, display shelves and cases. Cove lighting above it illuminated a series of photo-murals, set out from the wall to give them greater body.

The rapid development of modern lighting techniques has presented many opportunities to museums, not least among them is the chance they now have to remain open at night during the only leisure hours in which most of the members of their communities can visit them. Beginning with the Institute of Art in the highly industrial city of Detroit the lighting of many modern museum buildings has been planned pri-marily for night opening. Some museums also argue that artificial light is preferable to natural light under any circumstances, since it is more constant and more easily controlled, and possibly less costly since skylights are notoriously difficult to maintain and even windows need cleaning. Some experts contend that the destructive power of light—and all light can destroy or at least fade certain museum objects, paper and textiles being especially sensitive—varies in direct ratio to the intensity of light, and that sunlight is usually far more intense than artificial light. Hence, from the viewpoint of conservation as well as presentation, its champions argue that artificial light is preferable. But artificial light has introduced problems of its own. It is difficult, for example, to determine the degree and nature of destructive properties in artificial light. And while fluorescent tubes consume noticeably less current and have a wide range of colour—at least seven tones of white are currently available—they tend to change their colour with use, making it hard to keep a constant balance of both colour and intensity unless all the tubes of an installation are replaced at the same time.

CASE DESIGN

Sometimes the virtues of both kinds of lighting can be combined. Plate 64 shows a gallery of pre-Islamic art with four types of cases, two of which use both natural and fluorescent light. Over several years, as the Near-Eastern collection of this museum grew, a large nave-like hall lighted by clerestory windows and flanked by aisles of alcoves was divided into a series of smaller areas adjusted to the intimate size but occasionally monumental scale of Mesopotamian, early Persian and early Islamic objects in gold, silver, bronze and ivory (see Fig. 1). These walls were inexpensively built and plastered by the staff carpenter to house square inset cases in the central gallery and to hold Coptic and Seljuk sculptures in an approximation of their original architectural placement on the other sides (see Figs. 4 and 5). Fluorescent tubes over circular frosted glass

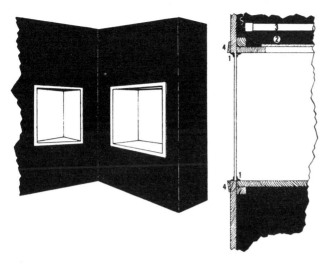

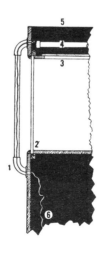

Fig. 4. Possible construction of built-in wall case. 1—Metal moulding to hold glass front. 2—Skylight with frosted glass which can be lifted and moved to replace lighting fixture. 3—Fluorescent tube. 4—Moulding which can be of any desired profile.

Fig. 5. Possible free-standing case with combination of natural and artificial light. 1—Metal conduit. 2—Groove to hold mitred glass formed by moulding and case floor. 3—Skylight with frosted glass. 4—Fluorescent tube. 5—Removable top for replacement of lighting fixture. 6—Current taken from floor socket.

openings in the ceilings of the square cases are the chief source of light, though there is some general natural light through the rooms. They are lined with beige velvet sympathetic in colour to the ancient gold objects which are suspended on plastic mountings. They are protected by half-inch bullet-proof glass set with light metal beading and Phillips-head screws. This should discourage the casual pilferer who might be tempted by the monetary value of the gold, but cannot break the glass or loosen the screws without a special tool. The professional burglar who would be interested in their far greater artistic value is another matter. Three of the more important works, an Assyrian ivory statuette of the eighth century B.C., an Achaemenid gold cup of the fifth century and a bronze statuette from the First Dynasty of Babylon are shown in single cases but tied together for architectural effect by a soffit which also holds fluorescent tubes. The soffit is high enough to allow even the tallest visitor to walk comfortably under it, and by uniting the three cases into the effect of a colonnade reduces the confusion so easily caused by a repetition of small accents in a clutter of museum furniture. Too many single cases jutting from a gallery floor or backed up to gallery walls, accidentally reflecting light from their glass, can distract a visitor's attention from the precious objects they contain. Their fragility may make for a cumulative impression of insecurity and, in fact, they may be unstable unless secured to walls or floors. Electric current to light this colonnade of cases comes from a floor pocket and is frankly carried up to the soffit in a pipe. Metal conduits so thin that they can be set in the mitred joints of a glass case have been developed, but they are apt to be complicated and to require special installation. When the wall now holding a mural map was raised to enclose a small gallery of pre-Islamic sculptures it was pierced with a two-way or window case to show Sasanian silver vessels. It, too, is lighted by both natural light from front and back, and fluorescent light from above a frosted-glass skylight. Incandescent bulbs light the small cases set into a strip wall beyond the window case. These exhibit Luristan bronzes which

are characteristically light, hence lightly held. A plexiglass column lifts the Sasanian plate; the sloping sides of the wood bases for the centre objects make the transition from the fairly large case floor to the small but powerful sculptures; and might recall the truncated-pyramid shape of a ziggurat. The colour scheme is in two tones of cool grey to complement the warmth of ancient gold and silver and the labels are middle-tone photostat negatives of typed texts with printed headings, mounted on heavy cardboard.

The Museo Archeologico in Arezzo (see Plate 65) makes good use of the built-in two-way or window case. The glass fronts slide in metal frames giving easy access to the contents, an important consideration in a technical museum where qualified students need to examine objects closely. Small labels identify individual potteries and a detailed group label is framed conveniently near. No architectural elements other than a small necessary floor moulding are allowed to compete with the pure classic shapes of the pottery, while a simple cool colour scheme enhances their warm reds and blacks.

Another type of case which does away with a bulky base or emphatic legs is well used by the Museo Internazionale delle Ceramiche in Faenza (see Plate 66). Its light metal framework is attached to the wall; metal rods support glass shelves at different levels to avoid monotony and set off with linear elegance the round or ovoid pottery shapes. These case units can be combined in various ways, extended in a horizontal line along a corridor, set at varying heights, or, if desired, incorporated in walls.

The Geodesy Section of the Deutsches Museum in Munich (see Plate 67) exhibits mathematical instruments in inset cases which, placed back to back, determine the width of the walls that divide the room into alcoves of a size suitable for the inspection of small objects. Windows give adequate daylight for the cases, which have fronts that can be operated in a variety of ways: set with screws or bolts so that they can be removed entirely, counter-weighted so that they can be lifted into the wall above like a window sash, or hinged at the top and propped open with a wooden support.

The glass front of a case this size or larger is too heavy for side hinges. Piano hinges that run the entire length of the frame are practical. The alcoves are simply and graciously designed; slight vaulting varies the repetition of straight lines and flat planes, architectural details are kept to a minimum.

The Röhsska Museet of Göteborg has designed a simple and adaptable case made of plain boards forming a honeycomb of square compartments (see Plate 68). Movable backs, solid or of frosted glass, can be set in individual squares at whatever depth may be desired, glass fronts can be applied. Such a case can be placed in front of a window if, for example, glass is to be shown; it can be combined with other units of the same kind, raised or lowered to various heights, be variously painted in modern schemes and is generally useful for the showing of almost any kind of small object.

By inserting a dividing panel in a conventional case the Rijksmuseum in Amsterdam (see Plate 69) makes the case an effective room divider and adjusts its size to the small objects shown. Here, as in many other examples, the framework of the case is kept as slight as possible, with a wood frame at the top but none for the mitred corners of the glass, which rests in grooves on the base. All objects suffer when they are closed in glass, necessary though such protection is, and the slighter the barrier is between object and observer the happier the result. Cases of this kind can subdivide a large gallery, creating a sense of architectural volume appropriate to the material shown, Delft pottery in this instance. There is probably no more important single factor in successful display than proper handling of the space that contains an exhibition, and the serene simplicity of this gallery is an admirable example.

MOUNTING OBJECTS

The mounting of individual objects offers endless possibilities for success or failure, and should always command serious preparatory thought. Here the personality of the object, its weight, colour, function and all other properties must govern absolutely. The Statens Historiska Museet in Stockholm

(see Plate 70) has fully understood the nature of a mitre, which is worn on the head, and a carved ivory detail from a bishop's staff, which is held. The silhouette of a crosier has been cut out of a sheet of plastic to hold this ivory detail and a plastic support holds the mitre at the natural relative height above the crosier. The surrounding space is in proportion to the scale of the objects which, in turn, are proportioned for human use. Musical instruments can also be held by relatively invisible wires and plastic supports in the position in which they were played, automatically giving them a vitality they must lose when laid on a shelf or hung on a wall. To the same end, natural history museums go to great lengths to give their bird and animal specimens a life-like and consequently convincing mounting.

The Brooklyn Museum's problem in mounting a group of shallow reliefs from Tell-el-Amarna (see Plate 71) was different. Many Egyptian reliefs in tombs and the inner precincts of temples were never meant to be seen, but prove to be masterpieces when properly lighted and mounted. The delicate style and small dimensions of these fragments called for an intimate human scale of presentation. Since they varied in thickness they have been inset in the plywood panel which forms the back of an exhibition case at a uniform surface plane. One result of this unified mounting is that they add to each other's size, creating a total effect greater than the sum of the parts. A general label discusses the style of Ikhnaton's reign, and individual labels identify the single pieces. The labels are simply but well designed, mounted on cardboard for effect of greater solidity, and outlined by a small border so as to distinguish them still further from the sculptures.

An exhibition of petroglyphs from the American southwest presented the opposite extreme in scale (see Plate 72). To show a series of accurate reproductions of rock drawings which had been engraved and painted on actual cliffs, the Brooklyn Museum built a temporary wall of plasterboard, cutting apertures to the size and contour of the individual specimens. The reproductions were set at about a foot behind these openings and concealed lights between the outer wall and the reproduction gave dramatic illumination. General light in the gallery was subdued to focus attention. The showing made no attempt to suggest the original physical setting which was a blaze of outdoor light, but the plasterboard wall unified the group somewhat as a cliff face might, keeping the scale large. Paperboard of various kinds, plywood, and fabric stretched on wood frames can be used to build such walls quickly and with neither great difficulty nor expense.

Many types of museums have wrestled with the problem of exhibiting costumes and perhaps none has solved it with complete success. Costumes are meaningless, except as textile specimens, unless they are mounted on some approximation of the human wearer. Both the 'habitat group' technique of natural history museums which requires carefully modeled figures, and almost abstract stylizations have been tried out. Too stylized a mounting can seem tricky or self-conscious, however, and may deflect the observer's attention from the thing shown to the manner of showing. On the other hand, too life-like a mannequin tends to make the visitor feel he is in a waxworks. Plate 73 shows the Statens Historiska Museet's solution. Stylized silhouettes of human figures have been cut from plywood and reproductions of Bronze Age arms and garments have been applied. This schematic treatment is simple and unpretentious.

The Deutsches Museum in Munich (see Plate 74) prefers a highly naturalistic solution in the hall where early weaving techniques are shown. Alcoves opening off the larger gallery are handled in the fashion of a realistic stage set, with architecture appropriate to a spinner from Lower Bavaria and a Japanese weaver. Controlled lighting enhances an illusion achieved mainly through the skill which has gone into the making of individual figures for specific settings. Stock mannequins from store windows, which many museums are forced to fall back on, are probably the poorest solution to an admittedly difficult problem.

Order saves the multiplicity of objects and labels in the education hall of São Paolo's Museu de Arte from overpowering the visitor at first glance. Since an educa-

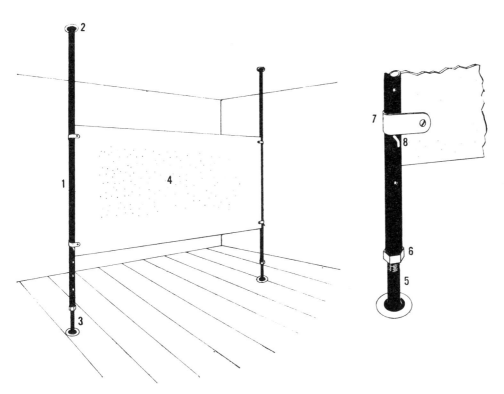

Fig. 6. Pogo-stick screens, a simple easily built example. 1—Pipes cut to approximate height of room and threaded at top. 2—Flange screwed to top thread. 3—Adjustable foot. 4—Screen of plywood or other material, fabric-covered if desired. 5. Solid foot with flange, actually a heavy bolt small enough to slip into pipe. 6—Nut adjusted to desired height. 7—Metal hasp bolted through screen. 8—Rod placed through holes in pipe to hold hasp.

tional point is to be made, the label material mounted on panels held on a pipe framework dominates the large room. Actual objects mentioned in the labels are shown in horizontal lines of cases lightly supported by tubular legs along both walls of the gallery. This is an effective demonstration of the versatility of 'pogo-stick' mounts, pipes or poles or tubes that rise from floor to ceiling and can be regrouped in an endless number of ways (see Plates 75a, 75b, and Fig. 6). Unistrut is another standard material, light steel strips in a 'U' section, that can be used in similar ways. It can be used without special tools or skills and assembled as case or table supports or as frameworks to hold panels of wallboard or plywood which can fit into its grooved section.

THE TRAVELLING EXHIBITION[1]

Through the medium of circulating exhibitions many museums extend their programmes and facilities to smaller centres, perhaps to regional centres or others in the same city. Since these smaller centres may not be equipped or experienced enough to handle exhibitions adequately, a circulating exhibition must be a self-contained installation adaptable to many kinds of setting. An exhibition of Yugoslav folk art in the Royal Scottish Museum of Edinburgh is an excellent example (see Plate 76). The wall and

1. See E. C. Osborn, *Manual of Travelling Exhibitions*, Paris, Unesco, 1953. (*Museums and Monuments* series, No. V).

case units can be combined in a variety of ways, the large map will serve as announcement and label in any circumstances. The curved walls raised on legs held in a curved plinth are especially serviceable in breaking a monotony of straight lines or in acting as a boundary wall for the showing. Such movable units have to be more sturdily constructed and consequently more expensive than similar elements in a permanent exhibition, but without them a circulating exhibition may completely lose its unity. Since any circulating exhibition is bound to suffer a certain amount of wear and tear, the materials used should be not only strong but easily cleaned and repaired. Several museums have developed a most useful but costly type of mobile unit, specially adapted trucks which are miniature travelling museums, sometimes designed with awning roofs that can unfold from the truck and be supported on poles that will also hold panels. This is a highly specialized matter however, whereas most museums need to

design and make, redesign and remake exhibition equipment for their own use which can be adapted to their varying exhibition needs. The Umelecko-Prumyslove Museum in Prague (see Plate 77) devised several exhibition units of simple construction and material for a show of modern architecture which could be used again in different combinations or serve as the prefabricated installation of a circulating exhibition. The slow curve of the table units in the centre is especially graceful as is the curved screen wall with glass louvers which sets the exhibition off from the rest of the museum.

It is said that a wise general always plans a retreat, and it is true in museums that no amount of careful forethought can provide for all the problems that even a modest exhibition will present. Resilience and adaptability are necessary virtues for anyone who designs exhibitions, in addition to the most important of them all, a fundamental sympathy with the object to be shown.

BIBLIOGRAPHY

ADAMS, Philip Rhys. 'Towards a strategy of presentation', *Museum*, vol. VII, no. 1, pp. 1-15.

ALLAN, Douglas A. 'Museums—*mutatis mutandis*', *The Museums Journal*, vol. 46, no. 5, pp. 81-7.

ALTHIN, Torsten. 'The atomarium of the Tekniska Museum, Stockholm', *Museum*, vol. VII, no. 3, pp. 167-73.

ARGAN, G. C. 'Renovation of museums in Italy', *Museum*, vol. V, no. 3, pp. 156-65.

ATKINSON, Frank. 'Colour and movement in museum display', *The Museums Journal*, vol. 49, no. 6, pp. 135-41.

BARDI, P. M. 'An educational experiment at the Museu de Arte, São Paulo', *Museum*, vol. I, no. 3-4, pp. 138-42.

BÄSSLER, Karl. 'Deutsches Museum—Museum of Science and Technology', *Museum*, vol. VII, no. 3, pp. 171-9.

BAZIN, Germain. 'New arrangements in the department of paintings, Musée de Louvre, Paris', *Museum*, vol. VIII, no. 1, pp. 11-23.

BECATTI, Giovanni. 'Recent rearrangements in Italian archaeological museums', *Museum*, vol. VI, no. 1, pp. 39-51.

BEER, Abraham. 'Recent developments in mobile units', *Museum*, vol. V, no. 3, pp. 186-95.

BLACK, Misha (ed.). *Exhibition design*, London, 1951.

BLAKELY, Dudley Moore. 'Solutions to exhibition problems caused by space limitations', *The Museum News*, vol. XIX, no. 1, pp. 11-12.

BROGLIE, Louis de. 'Scientific museology and the Palais de la Decouverte', *Museum*, vol. II, no. 3, pp. 141-9.

BURNS, Ned J. 'Modern trends in the natural history museums', *Museum*, vol. VI, no. 3, pp. 164-73.

COLEMAN, Laurence Vail. *Museum buildings*. Vol. I. Washington, 1950.

FELLOWS, Philip. 'Planning for the Festival of Britain—staging a temporary exhibition', *The Museums Journal*' vol. 50, no. 12, pp. 287-9.

FREEMAN, C. E. 'Museum methods in Norway and Sweden', *The Museums Journal*, vol. 37, no. 10, pp. 469-92.

GEBHARD, Bruno. 'Man in a science museum of the future', *Museum*, vol. II, no. 3, pp. 162-71.

GENARD, J. 'Lighting of museum objects', *Museum*, vol. V, no. 1, pp. 53-65.

GUTMANN, Robert; KOCH, Alexander. *Ausstellungsstände*. Stuttgart, 1954.

HOWARD, Richard Foster. 'Some ideas about labels', *The Museum News*, vol. XVII, no. 7, pp. 7-8.

KÄLLSTRÖM, O. 'Use of plastic mounts for the

specimens of goldsmith's art', *Museum,* vol. V, no. 2, pp. 106-9.

KINGMAN, Eugene. 'Installation of permanent exhibits in relation to education', *The Museum News,* vol. 27, no. 12, pp. 7-8.

KUH, Katherine. 'Explaining art visually', *Museum,* vol. I, no. 3-4, pp. 148-55.

LOHSE, Richard P. *New design in exhibitions.* New York, 1954.

MANO-ZISSI, Djordje. 'Reorganisation of the National Museum, Belgrade', *Museum,* vol. VIII, no. 1, pp. 50-63.

MARCENARO, Caterina. 'The museum concept and rearrangements of the Palazzo Bianco, Genoa', *Museum,* vol. VII, no. 4, pp. 250-67.

MCCABE, James A. 'Museum cases to minimize fatigue', *The Museum News,* vol. X, no. 18, p. 7.

MELTON, Arthur W. 'Studies of installation at the Pennsylvania Museum of Art', *The Museum News,* vol. X, no. 14, pp. 5-8.

MORLEY, Grace L. McCann. 'Museums and circulating exhibitions', *Museum,* vol. III, no. 4, pp. 261-75.

NORTH, F. J. 'Labelling and display in Canada and the United States', *The Museums Journal,* vol. 35, no. 3, pp. 81-6.

'Notes for students: labels, their function, preparation and use', *The Museums Journal,* vol. 49, no. 2, pp. 26-30; no. 3, pp. 55-62; no. 4, pp. 80-6.

O'DEA, W. T. 'The Science Museum, London', *Museum,* vol. VII, no. 3, pp. 154-61.

OSWALD, Adrian; LAWRENCE, G. Wilson. 'Make do and mend', *The Museums Journal,* vol. 48, no. 11, pp. 230-1.

OWEN, D. E. 'Notes for students: the temporary exhibition', *The Museums Journal,* vol. 48, no. 5, pp. 96-8.

PAYLER, Donald. 'Display and labelling', *The Museums Journal,* vol. 33, no. 2, pp. 41-4.

RAINEY, Froelich. 'The new museum', *University Museum Bulletin,* vol. 19, no. 3, pp. 3-53.

RÖELL, D. C. 'New arrangements of the Rijksmuseum, Amsterdam', *Museum,* vol. VIII, no. 1, pp. 24-35.

RUSKIN, B. F. 'The technique of gallery decoration', *The Museum News,* vol. XVII, no. 19, p. 8.

SANDBERG, W. J. H. B. 'An old museum adapted for modern art exhibition, Stedelijk Museum, Amsterdam', *Museum,* vol. IV, no. 3, pp. 155-61.

SEABY, W. A. 'The numismatic collection: display methods', *The Museums Journal,* vol. 46, no. 8, pp. 148-51.

STANSFIELD, H. 'Museums of Tomorrow', *The Museums Journal,* vol. 45, no. 10, pp. 169-75.

STERN, Philippe. 'Museography of the Musee Guimet', *Museum,* vol. I, no. 1-2, pp. 51-6.

SVEDBERG, Elias. 'Museum display', *The Museums Journal,* vol. 49, no. 4, pp. 89-92.

THOMAS, Trevor. 'Penny plain twopence coloured, the aesthetics of museum display', *The Museums Journal,* vol. 39, no. 1, pp. 1-13.

THORDEMAN, Bengt. 'Swedish museums', *Museum,* vol. II, no. 1, pp. 7-62.

WILSON, James H. 'Labels which last', *The Museums Journal,* vol. 49, no. 5, pp. 114-16.

ZAVALA, Silvio. 'The Museo Nacional de Historia, Castillo de Chapultepec, Mexico', *Museum,* vol. IV, no. 2, pp. 140-2.

MUSEUM ARCHITECTURE

by Bruno MOLAJOLI

GENERAL OBSERVATIONS

Whenever it is proposed to build a museum —whether large or small—there is usually one preliminary matter to be settled: the choice of a site. Where several possibilities are available, the drawbacks and advantages of each must be carefully weighed.

Should the site be central, or on the outskirts of the town? This appears to be the most usual dilemma. Until twenty or thirty years ago there was a preference for the centre of a town, with its better transport facilities. But as the use and speed of public and private transport have gradually increased and it has become easier to get from one point to another, it has been realized that the convenience of a central situation for a museum is outweighed by the many and substantial advantages of a less central position. These include a greater choice and easier acquisition of land (at lower cost), less fatigue from the noise of traffic—a growing and already very real problem—and an atmosphere less laden with dust and with gases which when not poisonous are, to say the least, unpleasant.

A museum should always be readily accessible from all parts of the town by public transport and, if possible, be within walking distance as well, and must be within easy reach of schools, colleges, university and libraries. As a matter of fact all these institutions have similar problems and stand equally in need of topographical co-ordination; it would be advisable to take this into account at the town-planning stage, rather than deal with each case separately as it arises, a method which may involve the sacrifice or neglect of many desiderata.

Museums tend nowadays to be regarded more and more as 'cultural centres' (the term by which they are indeed sometimes known in America). It must therefore be remembered that as such they are visited not only by students but by people with different backgrounds who, if a museum is near enough and easy to reach, may come to it, even with little time to spare, in search of instructive recreation.

Though there is still a prejudice against the building of museums in parks or gardens—on the plea that this makes them more difficult to reach and disturbs the tranquillity of such places—these are becoming very popular as the sites of new museums. They offer considerable advantages—a wider choice of detached positions, thus reducing the risk of fire; a relative degree of protection from dust, noise, vibrations, exhaust gases from motor engines or factories, smoke from the chimneys of houses and from municipal heating plants, the sulphur content of which is always harmful to works of art.

A belt of trees surrounding the museum building serves as an effective natural filter for dust and for the chemical discharges that pollute the air of a modern industrial town; it also helps to stabilize the humidity of the atmosphere, to which paintings and period furniture are often sensitive. It is said that large trees, if unduly close to the building, cut off or deflect the light and thus diminish or alter its effect on colour; but this disadvantage would appear to be unimportant, or in any case easy to overcome.

The surrounding land may offer space for an annex, built at a suitable distance from the museum itself, to house various equipment and services (heating and electricity, repair shop, garage, etc.), or the stores required for them (wood, textile materials, fuel oils, etc.), which it would be unsafe or, for some reason, inconvenient to stock in the main building.

Moreover, space will always be available —at least in theory—for future expansion, either by enlargement of the original building or by the construction of connected annexes; this is particularly important if the first project has to be restricted in scale for reasons which, though unavoidable, are likely to be transitory.

The beauty of a museum is considerably enhanced if it is surrounded by a garden which, if the local climate is propitious, can be used to advantage for the display of certain types of exhibit, such as ancient or modern sculpture, archaeological, or architectural fragments, etc.

Part of the surrounding grounds may also provide space for a car park.

The planning of a museum is an outstanding example of the need not only for preliminary and specific agreements but for close and uninterrupted collaboration between the architect and his employer.

There is no such thing as a museum planned in the abstract, suitable for all cases and circumstances. On the contrary, every case has its own conditions, requirements, characteristics, purposes and problems, the assessment of which is primarily the task of the museum director. It is for him to provide the architect with an exact description of the result to be aimed at and of the preliminary steps to be taken, and he must be prepared to share in every successive phase of the work—failing which the finished building may fall short in some respects of the many and complex technical and functional demands which a modern museum must satisfy.

Another point to be considered is whether the new building is to house an entirely new museum (whose contents have yet to be assembled) or to afford a permanent home for an existing collection. In the first case we have the advantage of a free approach to the problem and can decide on an ideal form for the museum; but with the attendant drawback of beginning our work in the abstract, on the basis of entirely vague and theoretical assumptions which future developments will probably not confirm. In the second case we must take care not to go the opposite extreme by designing a building too precisely adapted to the quality and quantity of the works or collections which form the nucleus of the museum; future needs and possibilities of development should always be foreseen and provision made for them.

All this is part of the director's responsibility.

Due regard should also be given to the special character of the new museum—the quality it already possesses and by which it is in future to be distinguished—in relation to its collections. This may, of course, be of several kinds (artistic, archaeological, technical, scientific, etc.) and respond to various needs (cultural, general or local permanence or interchangeability, uniformity of the exhibits or group display, etc.)

Naturally, every type of collection, every kind of material, every situation has its own general and individual requirements which will considerably influence the structure of the building and the form and size of the exhibition rooms and related services. It is no use attempting to present a series of archaeological or ethnographical exhibits, whose interest is chiefly documentary, in the space and surroundings that would be appropriate to a collection of works of art, paintings or sculpture of great aesthetic importance, or to apply the same standards to a museum arranged chronologically and one whose exhibits are classified in artistic or scientific categories; nor is it possible to display a collection of small works of art, such as jewellery, small bronzes, medallions, miniatures, etc., in rooms of the size needed for large objects of less meticulous workmanship, which require to be seen as a whole and from a certain distance.

Even a picture gallery cannot be designed in such a way as to serve equally well for the exhibition of old pictures and modern ones: for, apart from the fact that aesthetic considerations recommend different settings for the two groups, it is obvious that a gallery of old paintings is comparatively

'stabilized', whereas the appearance of a modern gallery is to some extent 'transitory', owing to the greater ease and frequency with which additions, changes and rearrangements can be made. In the latter case, therefore, not only the architectural features of the building but also its actual construction must be planned with a view to facilitating the rapid displacement and change-over of exhibits. The transport of heavy statues, the adaptation of space and the use of the sources of light in the way and on the scale most appropriate for particular works of art, should be taken into account as well as the possibility either of grouping or of displaying them singly, according to the importance and emphasis to be attributed to them.

A museum must be planned not only in relation to its purpose and to the quality and type of its exhibits, but also with regard to certain economic and social considerations. For instance, if it is to be the only institution in the town which is suitable for a number of cultural purposes (theatrical performances, lectures, concerts, exhibitions, meetings, courses of instruction, etc.) it may be desirable to take account in the initial calculations of the financial resources on which it will be able to rely, the nature of the local population, the trend of development of that population as revealed by statistics, and the proportion of the population which is interested in each of the museum's activities.

In fact, the word 'museum' covers a wide range of possibilities, and the architect commissioned to design one must make clear—to himself first of all—not only the specific character of the museum he is to build, but the potential subsidiary developments and related purposes which can be sensed and foreseen in addition to the dominant theme.

The future may see substantial changes in our present conception of museums. If the architect who designs one allows in his plan for easy adaptation to new fashions, new developments, new practical and aesthetic possibilities, his work will be all the sounder and more enduring. A museum is not like an exhibition, to be broken up after a short time and brought together later in an entirely different form. There should be nothing 'ephemeral' in its character or appearance, even where the possibility of changes or temporary arrangements is to be contemplated.

These considerations should be borne in mind when the architectural plans for the building are drawn up.

According to a prejudice which, though gradually dying, is still fairly common, a museum building should be imposing in appearance, solemn and monumental. The worst of it is that this effect is often sought through the adoption of an archaic style of architecture. We are all acquainted with deplorable instances of new buildings constructed in imitation of the antique; they produce a markedly anti-historical impression, just because they were inspired by a false view of history. Another outmoded prejudice is that which demands a 'classical' setting for ancient works of art, as though their venerable dignity would suffer and their aesthetic value be diminished if they were placed in modern surroundings.

But though the style of the building should be frankly contemporary and governed by the creative imagination of its designer, architectural interest must not be an end in itself, but should be subordinated to the purpose in view. In other words we must not devote our entire effort to designing rooms which will be architecturally pleasing; it is at least equally important that attention be concentrated on the works exhibited, that their *mise en valeur* be ensured and their predominance established. A museum in which the works of art were relegated to the background and used to 'complete' a pretentious architectural scheme, could not be regarded as successful; but neither could a museum which went to the other extreme, where the construction was subordinated to cold, mechanically functional considerations so that no spatial relationship could be created between the works of art and other exhibits —a museum with a completely impersonal atmosphere.

The ideal would seem to lie somewhere between these two extremes—the aim being to allow for that sense of proportion which should always be in evidence when a museum is planned, to ensure that the visitor will find there the friendly, welcom-

ing atmosphere, the attractive and convenient features that he enjoys in his own house.

It is the difficult but essential task of the architect, no less than of the director of a museum, to bring the place into conformity with the mentality and customs of every citizen of whatever rank and standard of education. Much will depend on the level of taste of both men, on their human qualities of sympathy and sensibility, which must go hand in hand with their professional abilities and which cannot be prompted or taught.

PLANS FOR SMALL MUSEUMS

The foregoing remarks apply to every new museum, whatever its size. We shall now consider more particularly the principles and characteristics on which the planning and construction of small museums should be based.

By 'small museums' we understand any institution whose programme and finances are restricted so that, at least at its inception, the premises built for it will be of limited size, in most cases only one storey high.

It is not so easy to determine precisely within what limits the idea of the 'little museum' is to be confined; for while it may, at its smallest, consist of one room, it may on the other hand be of an appreciable extent, though still too small to be properly described as a medium-sized or large museum.

For the present purpose it may be assumed that the 'small museum' will not consist of more than 10 to 12 medium-sized exhibition rooms (5×7 square metres) in addition to its other services.

A new museum, even on this small scale, cannot function efficiently unless it respects the general principles of museography and the special possibilities for applying them which are provided by the particular circumstances governing its construction.

There are certain museographical considerations which must have a decisive influence on the structure of the building, for instance, on the arrangement of the rooms or the type of roof chosen, and which

are therefore of technical importance in the construction.

Consequently, the successful planning of museum entails the well-considered choice and unerring application of these deciding principles, whose chief theoretical and practical aspects I shall now briefly describe.

Natural lighting. This is one of the subjects most keenly discussed by museum authorities, and is, indeed, of outstanding importance. It was believed at one time that electric light, being easy to switch on, adaptable and unvarying in its effects and able to give full value to architectural features, might provide not merely an alternative to the use of daylight in museums, but a substitute for it. But experience has forced us to recognize that —especially where running expenses have to be considered—daylight is still the best means of lighting a museum, despite the variations and difficulties which characterize it at different seasons and in different places. The building should therefore be so planned as to make the best use of this source of light, even if certain other structural features have to be sacrificed as a result.

Daylight may come from above or from the side. In the former case suitable skylights will be provided in the ceilings of the exhibition rooms. In the latter case, one or more walls will be pierced by windows, the height and width of which must be decided according to individual requirements (see Figs. 1a - 1j, 2 and 3a - 3d).

Lighting from above. This type of lighting, sometimes called overhead lighting (I dislike this term, which seems too restrictive, ignoring the possibility of directing the light from above at any desirable angle) has long been favoured by the designers of museums, for it presents certain obvious advantages.

1. A freer and steadier supply of light, less liable to be affected by the different aspects of the various rooms in the building and by any lateral obstacles (other buildings, trees, etc.) which might tend, by causing refraction or by casting shadows, to alter the quantity or quality of the light itself.
2. The possibility of regulating the amount of light cast on the pictures or other

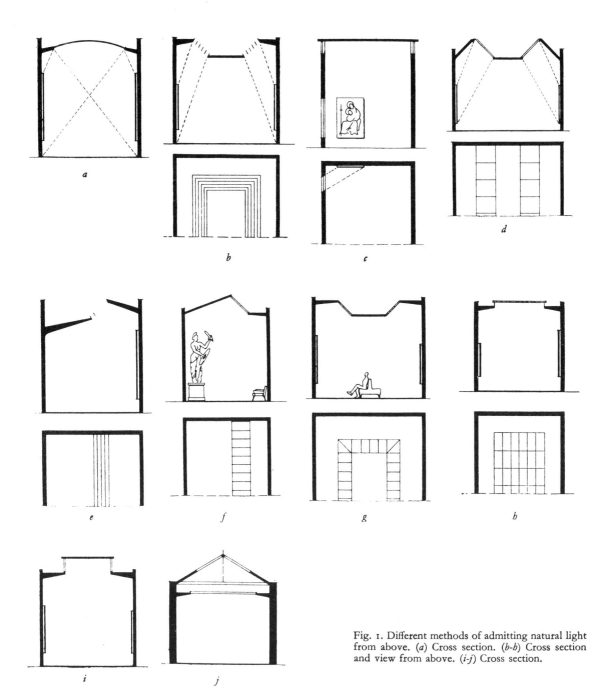

Fig. 1. Different methods of admitting natural light from above. (*a*) Cross section. (*b-b*) Cross section and view from above. (*i-j*) Cross section.

Fig. 2. The Museum of San Mateo, at Pisa, is installed in the buildings of an old Benedictine convent. The convent also includes a cloister, a secondary court and garden. The premises have been restored and the main buildings have been joined together to house the collections of the museum.

The system adopted to use light from the sky is a particularly interesting one which could be applied to advantage in other installations of exhibition halls in old buildings.

This system consists of a series of glass panels set into the ceiling to form an unbroken luminous band about sixty centimetres wide around the whole ceiling about seventy centimetres in from the walls. The panels are of frosted plate glass, and above them is placed an outer band of glass panels built into the roof.

This type of natural lighting has many advantages, particularly with regard to the intensity and the diffusion of the light which remains unchanged in quality and can be easily regulated by means of shutters, etc. installed in the space between the two sheets of glass. This space can also be used for artificial lighting and ventilation systems. 1—Outer glass panel. 2—Inner glass panel. 3—Ceiling. 4—Ventilation.

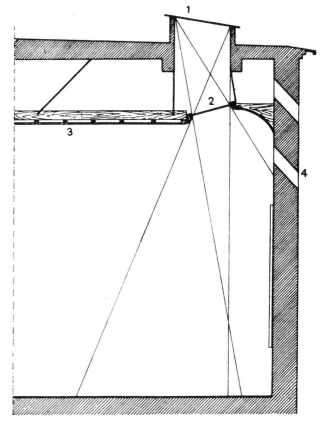

exhibits and of securing full and uniform lighting, giving good visibility with a minimum of reflection or distortion.

3. The saving of wall-space, which thus remains available for exhibits.

4. The maximum latitude in planning space inside the building, which can be divided without requiring courtyards or light shafts.

5. The facilitation of security measures, owing to fewer openings in the outside walls.

Compared with these advantages the drawbacks seem trifling, and can in any case be reduced or overcome by suitable technical and structural measures, they are:

1. The excess of radiating light, or of diffused light interspersed with irregular rays.

2. The disadvantages inseparable from any system of skylights (increased weight of the roof or ceiling supports; liability to become coated with dirt; risk of panes being broken; danger of rain-water infiltration; condensation of moisture; admission of sun-rays; irradiation and dispersion of heat, etc.).

3. The monotony of the lighting, and oppressive claustrophobic effect produced on visitors called upon to walk through a long succession of rooms lit from above.

4. The greater complexity of the architectural and technical problems to be solved in providing a roof which, while adapted to this form of lighting, will effectively serve its various purposes (problems relating to weather-proof qualities, heating, maintenance, cleaning, security, etc.).

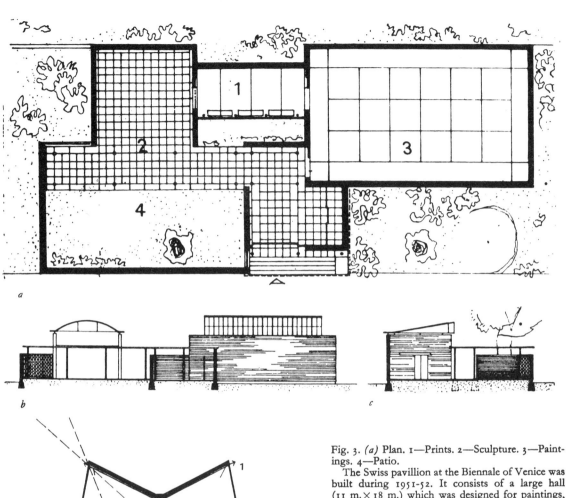

a

b

c

d

Fig. 3. *(a)* Plan. 1—Prints. 2—Sculpture. 3—Paintings. 4—Patio.

The Swiss pavillion at the Biennale of Venice was built during 1951-52. It consists of a large hall (11 m. × 18 m.) which was designed for paintings, a small gallery for prints and a court with an overhanging roof, completely open on to a patio, for sculpture. This arrangement results in a continuity of interior and exterior spaces—a particularly important consideration in a pavillion of limited dimensions.

The hall for paintings is lit from the ceiling by clerestory-type windows. An awning of white cloth forms the ceiling and covers the entire hall thus ensuring an even diffusion of light.

Lateral lighting is used in the small print gallery, the displays being so arranged as to avoid light reflections on the glass.

(b) Longitudinal section.

(c) Cross section of the sheltered court for sculpture.

(d) Cross section showing the clerestory windows. 1—Openings for ventilation. 2—Awning. 3—Air inlets. 4—Patio.

Lateral lighting. This is provided either by ordinary windows of various shapes and sizes, placed at suitable intervals in the walls, or by continuous openings; both windows and openings may be placed either at a level at which people can see out of them, or in the upper part of the wall (see Figs. 4*a* - 4*b*).

The solution adopted will be determined by the type of museum and the nature of its exhibits, as the advantages and disadvantages vary from one to another.

Windows at the usual level, whether separate or continuous, have one serious drawback, in that the wall in which they are placed is rendered useless and the opposite wall practically useless, because showcases, paintings and any other object with a smooth reflecting surface, if placed against the wall facing the source of light, will inevitably cause an interplay of reflections which impedes visibility. These windows will, however, shed full and agreeable light on exhibits placed against the other walls and in the centre of the room at a correct angle to the source of light.

Advocates of lateral lighting point out that this is particularly successful in bringing out the plastic and luminous qualities of paintings and sculpture created in past centuries, when artists usually worked by such light.

All this must be considered in conjunction with the proper use of the floor-space, the shape, arrangement and sequence of the different rooms, their size and depth in relation to the outer walls—the aim being to make the most of the sources of light and to obtain the greatest possible uniformity of lighting throughout each room.

A definite practical advantage is, however, that of rendering possible the utmost simplicity and economy in the style of building, permitting the adoption of the ordinary, non-transparent roofing (flat or sloped) customary in the district, and providing, thanks to the side windows, a convenient and simple method of regulating ventilation and temperature in museums which cannot afford expensive air-conditioning apparatus.

Another advantage of windows placed at the ordinary level is that some of them can be fitted with transparent glass, allow-

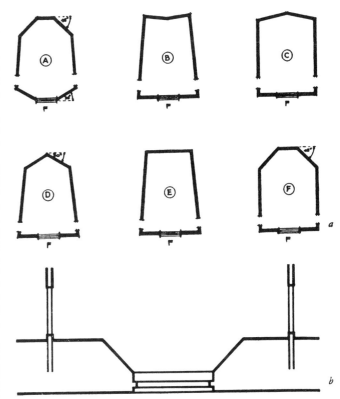

Fig. 4. Boston Fine Arts Museum. (*a*) Polygonal halls showing different arrangements of wall space for displays in relation to the windows. (*b*) Recessed window and position of doors.

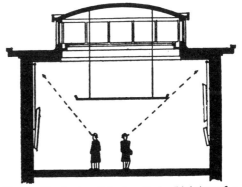

Fig. 5. Musée des Colonies, Paris. Lighting of a gallery with blind walls, by a series of skylights with vertical windows; awnings are placed beneath each skylight.

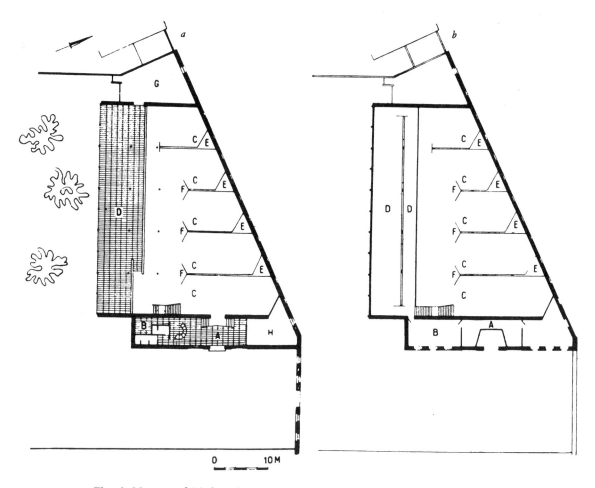

Fig. 6. Museum of Modern Art, Milan. (*a*) Ground floor plan. A—Entrance. B—Cloakroom. C—Exhibition hall. D—Sculpture gallery. E—Storage cabinets. F—Movable partitions. (*b*) First floor plan. A—Upper Gallery. B—Storage of prints and drawings. C—Exhibition hall. D—Exhibition of prints and drawings. E—Storage cabinets. F—Movable partitions.

ing pleasant views of the countryside, gardens or architecturally interesting court-yards. This provides a diversion, resting the visitor's eyes and refreshing his mind.

For this purpose it may be wise, even where overhead lighting is adopted, to arrange a few lateral openings for the passing visitor.

High-placed windows, especially if they occupy more than one wall, provide more light, more closely resembling that supplied by skylights, and leave all four walls free for exhibits: but as they must be placed at a considerable height, if visitors are not to be dazzled, the rooms must be comparatively large and the ceilings lofty. This means that considerable stretches of wall will be left blank, and building expenses will increase owing to the larger size of the rooms (see Fig. 5).

The tendency nowadays is to abandon uniform lighting in favour of light con-

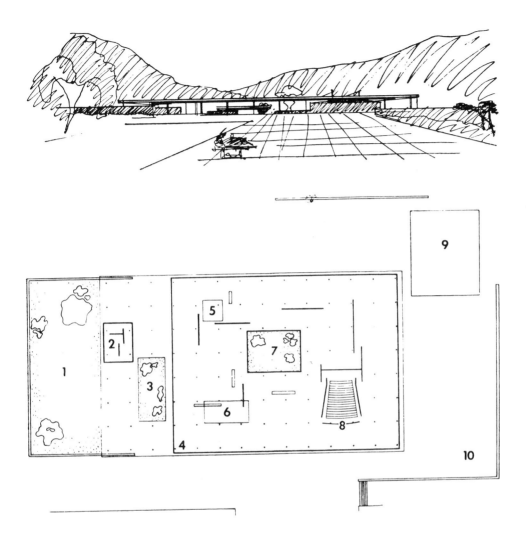

Fig. 7. In 1942, Mies van der Rohe devoted a great deal of attention to the theoretical design of a museum for a small city to provide a setting for Picasso's painting *Guernica*. The building is designed to be as flexible as possible, consisting simply of a floor slab, columns, roof plate, free-standing partitions and exterior walls of glass.

The relative 'absence of architecture' intensifies the individuality of each work of art and at the same time incorporates it into the entire design.

One of the museum's original features is the auditorium which consists of free-standing partitions and an acoustical dropped ceiling.

'Two openings in the roof plate (3 and 7) admit light into an inner court (7) and into an open passage (3). Outer walls (4) and those of the inner court are of glass. On the exterior, free-standing walls of stone would define outer courts (1) and terraces (10). Offices (2) and wardrobes would be free-standing. A shallow recessed area (5) is provided, around the edge of which small groups could sit for informal discussions. The auditorium (8) is defined by free-standing walls providing facilities for lectures, concerts and intimate formal discussions. The form of these walls and the shell hung above the stage would be dictated by the acoustics. The floor of the auditorium is recessed in steps of seat height, using each step as a continuous bench. Number (6) is the print department and a space for special exhibits. Number (9) is a pool.' (From *Mies van der Rohe*, by P. C. Johnson, Museum of Modern Art, New York, 1947.)

centrated on the walls and on individual exhibits or groups of exhibits, which are thus rendered more conspicuous and more likely to attract the visitor's attention. Consequently, instead of lighting the whole room it is found preferable to light the showcases from within, either by artificial lighting or by backing them with frosted glass which admits daylight from outside.

This is a possibility which the architect of a small museum can bear in mind, making use of it in special cases and for objects (glass, ceramics, enamels, etc.) whose effect can be heightened by such lighting. But it entails special structural features which may complicate the general budget.

Moreover, if the lighting system is too rigid, too definitely planned to suit a particular setting and to establish certain relationships between that setting and the exhibits, it will form an impediment by imposing a certain stability, tending to reduce the museum to the static condition from which modern institutions are striving to emerge—the present-day idea being that a museum should make a lively, dynamic impression.

It therefore seems preferable, especially in small museums, to choose an intermediate system which can be adapted to varying needs and necessary changes, even if it thus becomes more difficult to achieve ideal results.

Utilization and division of space. In designing a museum the architect will also be decisively influenced by the way in which it is intended to utilize and divide the space to be devoted to the displays. This, too, is of course closely connected with the question of lighting, which we have already discussed.

The modern tendency is to create large unbroken spaces, which can then be divided up by movable partitions or light-weight structures, to be grouped or displaced as required (see Figs. *6a - 6b* and 7).

The traditional system is the contrary one of dividing the space, by means of permanent walls, into rooms of various sizes, which may be either communicating or independent (connected, in the latter case, by passages or side galleries) (see Figs. *8a - 8e*).

A small museum may do well to adopt an intermediate system with a succession of average-sized rooms (for the display of permanent collections whose contents will not change, such as those received through bequests, donations, etc.) and one or more large rooms which can be variously divided up when required by movable partitions or light structures.

The structure of the building, and with it, the interior and exterior technical features, will vary according to the purpose for which it is intended. Requirements and costs will be different in each separate case, for it is evident that the larger the surface to be roofed in one span without intermediate supports, the greater the technical problem and the cost of the roof. Furthermore, the architect's calculations for the various features of a co-ordinated project (plan, circulation, lighting, etc.) will not be the same if the project relates to rigid construction subdivided by permanent walls, or to flexible construction, adjusted to the changes periodically effected in the museum.

Museum services. Before considering the planning of the museum it is essential to determine the size and location of the various services. In other words, we must decide how much space can and should be allocated for subsidiary activities, or for those necessary to the functioning of the museum in its relationship with the public (offices, rooms for meetings and lectures, library, documentation service) on the same floor as the exhibition rooms, and which services and technical plant (heating and electrical apparatus, storerooms, workshops, garage, etc.) can be housed in the basement or, if possible, in special out-lying buildings to be built as annexes, at a convenient distance from the main building.

It should be remembered that the usual custom is to set aside for these purposes an area which may be as much as 50 per cent of the total space available. In small museums this proportion may be reduced. But the fact remains that two conflicting needs have to be reconciled: on the one hand there must be easy communication between the public rooms and the museum services, since this makes for smooth relations between visitors and staff; on the other

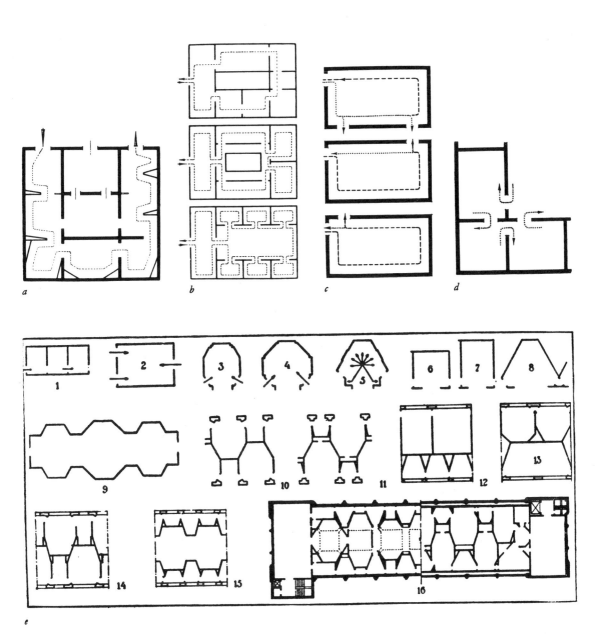

Fig. 8 (*a, b, c, d*). Floor plans for the location of doors in relation to the use of space. (*e*) 1—Traditional location of doors. 2-8—Secondary doors. 9-15—Polygonal enclosures. 16—Floor plan of the Princeton University Museum (left—ground floor; right—first floor).

hand it must be possible to separate these two sections, so that they can function independently at any time. This is necessary chiefly to safeguard the collections at times when the building is closed to the public while the curators or office staff are still at work and the library and lecture hall in use.

Planning

It is hardly necessary to explain, before embarking upon a discussion of the different questions that may arise when a small museum is being planned and built, that my aim is merely to put forward certain suggestions to serve as practical pointers, based on experience of the subject, with no intention of trespassing upon the domains of the various technical authorities who must inevitably be consulted.

The exterior. A museum which is to be built in an isolated spot or reserved space (park, garden, etc.) needs to be surrounded by an enclosure, especially if the site forms part of an extensive area. For the visitor, this enclosure will provide a foretaste of the museum's architecture, and thus must not constitute a 'psychological barrier', though the fundamental aim of security, which it has to serve, must not be sacrificed.

If, on the contrary, the museum is to overlook a public street, it will always be advisable: (a) to separate it from the stream of traffic by a belt of trees or even by flowerbeds; (b) to set back the entrance in a quiet corner: (c) to allow space for a public car park.

The architect should think of the building he has been asked to design as an organism capable of growing, and therefore provide from the outset for suitable possibilities of expansion, so that when the time comes for this it will not require far-reaching and costly alterations. He should regard the portion to be built as the nucleus of a cell, capable of multiplying itself or at least of joining up, according to plan, with future enlargements.

Where space permits, it is best to allow for horizontal expansion, as this, though more expensive, has the twofold advantage of enabling all the display rooms to be kept on one level and of leaving the roof free for overhead lighting.

Renouncing all pretensions to a monumental style, the outward appearance of the building—especially if overhead lighting is adopted, so that there are no windows to break the surface—should be distinguished by a simple balance of line and proportion and by its functional character.

Arrangement. Any general plan of construction which entails an apportionment of premises is closely bound up with the purpose of the museum and the nature, quality and principal components of its collections. Each type of museum has different requirements, which may be met by various architectural methods.

It is difficult to give any exact classification of the different types of collections, but we can offer a very brief one, if only to indicate the wide range of demands the designer of a museum may be called upon to meet:

1. Museums of art and archaeology. The size of the rooms and height of the ceilings will be determined by the nature and dimensions of the works to be exhibited. It is not difficult to calculate a practical minimum capable either of accommodating old paintings, which are usually large, or medium-sized modern canvases; a suitable room might measure about 16×23 feet, with wall accommodation to a height of about 14 feet. In the case of furniture, or of examples of decorative art (metal, glass, ceramics, textiles, etc.) to be displayed in showcases, the ceiling need not be as high. If pictures and sculpture are to be shown separately, their settings must be different from the point of view of space and lighting. For silver, jewellery or precious objects it may be better to use showcases set in the walls—which can thus be equipped with locking devices and anti-burglar safeguards—lit from within, the rooms being left in semi-darkness. Rooms lit by artificial means rather than by sunlight are best for drawings, engravings, watercolours and textiles. Such rooms may be long and narrow rather than square—rather like corridors or galleries—as the visitor

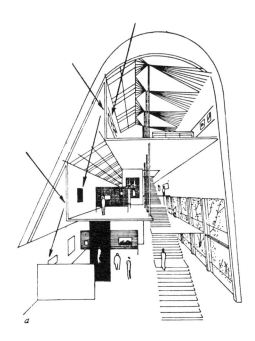

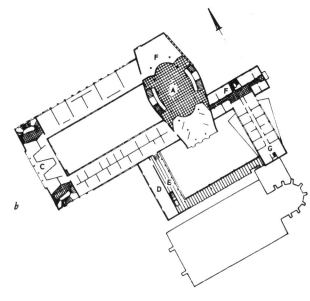

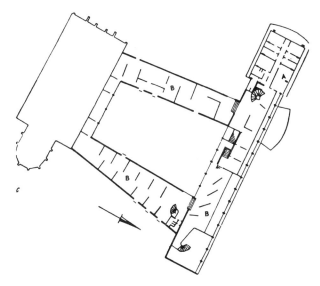

has no need to stand back in order to look at the exhibits, which will be arranged in showcases against the longest walls (see Figs. 9a, 9b and 9c).

2. Historical or archival museums. These need less space for the showcases in which their exhibits are placed, and comparatively large and numerous storerooms for the documents kept in reserve. Relics and papers are best shown in rooms equipped with suitable protective devices and artificially lighted, though some use may also be made of indirect natural light.

3. Ethnographic and folk museums. The exhibits are usually displayed in showcases. They are often large and cumbersome, requiring a good deal of space. Considerable space is also needed for reproducing typical surroundings, if this is done with genuine pieces and properties or full-sized replicas. Strong artificial lighting is generally used as being more effective than daylight (see Fig. 10).

4. Museums of physical and natural sciences, technological or educational museums. Owing to the great variety of

Fig. 9. Wallraf Richartz Museum, Cologne.
(a) Cross section of the exhibition halls.
(b) Ground floor plan. A—Entrance hall. B—Exhibition hall. C—Work rooms. D—Library. E—Reading room. F—Administrative offices.
(c) First floor plan. A—Administrative offices. B—Exhibition halls.

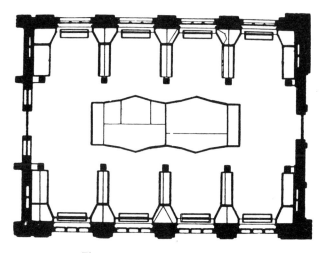

Fig. 10. Ethnographical Museum, Hamburg. Plan for the location of exhibition cases.

collections involved, their division into sections and the necessary scientific cataloguing, these museums differ in size and in architectural and functional characteristics. Where the exhibits are arranged in series (minerals, insects, fossils, dried plants, etc.), medium-sized rooms may suffice, whereas reconstructions and built-up displays of animals or plants demand considerable space and special technical features (for instance, means of keeping the special materials and preparations in good condition, unaffected by the atmosphere, or equipment for maintaining aquaria, permanent film displays, etc.). This type of museum needs laboratories for the preparation and upkeep of certain exhibits (stuffing, drying, disinfecting, etc.).

It thus rests with the architect to decide, for each of these types of museum, what arrangement will best satisfy the particular conditions, purposes and requirements involved.

There can never be any objection to adopting the modern principle of a building so constructed that its interior can be adapted, divided and altered to meet the varying demands of successive exhibitions. If this is done, the most important thing is

that the construction shall be 'flexible', that is, capable of adaptation to the different features it must simultaneously or successively contain, while preserving unchanged its general framework—entrances and exits, lighting system, general services and technical installation. This principle is particularly valuable in small museums and in any others which must allow for enlargements not always foreseeable at the outset.

The internal arrangement of the available space, the distribution and style of the galleries can then be either temporary or comparatively permanent. In the former case, use will be made of movable partitions, panels of light-weight material (plywood or thin metal frames covered with cloth, etc.) fitted into special supports or into holes or grooves suitably placed in the floor; these can either be separate or arranged in groups held together by bolts or hinges.

This system is very practical for small museums which intend to follow a definite cultural programme including successive loan exhibitions of works of art, and are therefore obliged to make frequent changes, dictated by circumstances, in the size and appearance of their galleries. It has, however, the drawbacks that all the interior structure is independent of the outer walls of the building and made of comparatively fragile materials which are expensive to keep in repair; moreover the place never looks settled, but rather mechanical and disjointed—an effect which is displeasing to the eye unless the architect designs the component parts with great taste.

Other objections to this method include the difficulty of preparing new catalogues and guides to keep pace with the changes, and of overcoming the conservatism of a great proportion of the public; and, above all, the consequent impossibility of arranging circulation within the building, and other matters affecting the division of space on a permanent basis. These things have to be left to the organizers of each successive exhibition, and therefore cannot be included in the architect's original plan.

If, on the other hand, the interior space is to be divided up in a more or less permanent manner, the question of 'flexibility' being set aside until the comparatively

distant time when the original plan of the museum comes to be radically altered, then the dividing walls can be really 'built' to last, even if light-weight materials are employed. For their role will be reduced to providing a background for works of art, for showcases, or for any exhibits hung on them, and to supporting their share of whatever type of roof or ceiling is chosen.

In this case the interior arrangement will be very similar to, if not identical with, that of a museum of the traditional type, planned as a complete building with all its sections permanently fixed and the size and shape of its rooms settled once and for all.

In this kind of structure it is more than ever necessary to plan with a view to enabling the public to circulate and to arranging the collections and services in the most rational and functional manner possible.

The question of circulation must be studied attentively, so that the arrangement and the itinerary will be clear not only to anyone looking at the ground plan of the museum, but also to anyone walking through the rooms. It should be planned to fit the logical order of the exhibition, whether that order is governed by chronology, by the nature of the material displayed, or as in a scientific museum, aims at providing a connected sequence of practical information.

Though a compulsory, one-way route may not be entirely desirable in a large museum, it is satisfactory and one might say logical in a small one, as it saves space and facilitates supervision. Visitors should not have to turn back and return through rooms they have already seen, in order to reach the exit. They should, however, be able to turn off on their way round if they wish to cut short their visit or confine it to certain things that particularly interest them.

So, even if a museum is to show a series of selected works of the first quality, we should consider the possibility of arranging them in proximity to one another in such a way that they can be seen without the necessity of traversing the entire building. For example, in a succession of rooms surrounding an inner courtyard (see Fig. 11).

Care should always be taken, however, to avoid the confusion of too many adjacent

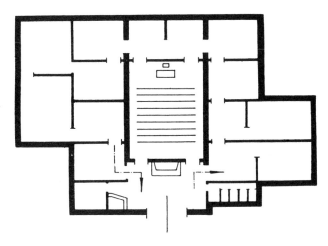

Fig. 11. Suggested floor plan for a small museum.

doors, or of rooms running parallel to one another; visitors must not be made to feel that they are in a maze where they can easily lose their way.

If the designer's preference or the demands of space result in a series of rooms all set along the same axis, it may be desirable to connect them by a corridor. But this should not be the only means of access to the rooms, for if the visitor is forced to return to it each time, his fatigue and bewilderment will be much increased.

Entrance. However many outside doors may be found necessary for the various museum services (but these should be as few as possible, to facilitate supervision and security measures), there must be only one public entrance, placed quite separately from the others. This should lead into a vestibule where certain essential services will be located—sale of tickets, information service, and sale of catalogues and postcards. In a small museum one person will of course be responsible for all this, and the necessary installation must be carefully planned to ensure the most practical form and arrangement. The official in charge should not be confined to a booth behind a window, but should be able to move

161

about freely and leave his position when circumstances require.

In a little museum it would be particularly unsuitable to design the entrance hall on a massive or pompous scale, as was customary in the past, making it unnecessarily lofty, and to decorate it in would-be monumental style, like the atrium of a classical temple, with arches and pillars. Modern architects tend increasingly to reduce overhead space and give the greatest possible width and depth, producing a balanced effect of greater intimacy and attraction. It is important for the entrance hall to seem attractive even to the casual passer-by—who is always a potential visitor to the museum. It should provide an easy introduction to the building, a point from which the individual visitor can find his way without difficulty and where large parties can be greeted and assembled. It must therefore be fairly spacious, and provided with the strict minimum of sturdily built furniture (one or two tables for the sale of tickets, catalogues, etc., a cloakroom, a few benches or chairs, a notice-board, a general plan of the museum to guide visitors, a clock, and perhaps a public telephone booth and a letter-box). It is not advisable to have only one door from here into the exhibition rooms; there should be two, an entrance and an exit, far enough apart to prevent delay should there be a crowd but placed in such a way that both can be easily watched at the same time.

In museums where arriving and departing visitors are to be mechanically counted, an automatic turnstile should be installed, serving both doors but placed at a sufficient distance from the main entrance and the ticket-office. Another possible method is that of the photoelectric cell, but the objection to this is that when visitors are crowding through the turnstile the record may not be accurate. In museums where admission is free, attendance can be computed for statistical purposes more simply by the custodian with a manual counter—which will avoid adding an unnecessary complication to the fittings of the entrance hall.

Exhibition rooms—shape and requirements.
A museum in which all the rooms are the same size becomes very monotonous. By varying their dimensions and the relation between height and width—and also by using different colours for the walls and different kinds of flooring—we provide a spontaneous and unconscious stimulus to attention (see Figs. 12a - 12f).

Monotony also results when a number of rooms follow one another in a straight line. Even where this cannot be entirely avoided, the rooms should be so constructed that the doors are not opposite one another, providing a 'telescopic' view through the building. An uninterrupted prospect of the long route ahead is usually found to have a depressing effect on visitors.

There are, however, undoubted advantages in being able to see into several rooms at the same time; it is a help, for instance, in directing visitors, and for security purposes.

On the other hand, by varying the positions of the doors we are also able to place the visitor, from the moment of his entrance, at the point chosen by the organizer of the display as the best for conveying an immediate and striking impression of its general contents, or for giving a view of the most important piece in that particular room. In principle, the door should be placed in such a way that a visitor coming through it will see the full length of the opposite wall. It is therefore not advisable for it to face a window, since the visitor will then be dazzled just as he comes in.

With regard to the shape and size of the rooms, I have already pointed out that dimensions should be varied so as to stimulate the attention of the public and should also be adapted to the size of the exhibits.

I ought perhaps to repeat here, for the sake of clarity, that the form and size of the rooms will also depend to some extent on the lighting system chosen. Overhead lighting allows greater diversity of shape (rectangular, polygonal, circular, etc.) because the lighting can always be arranged on a scale to suit the room. Oblong rooms, divided by partitions to a certain height, but with one ceiling and sky light, should however be avoided; this system has proved unsatisfactory both from the aesthetic and from the functional points of view.

The practice of rounding off the corners of rectangular rooms is also going out of

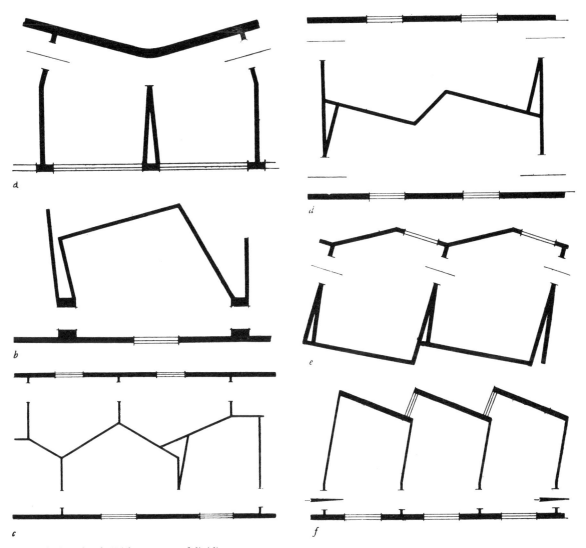

Fig.12 (a, b, c, d, e, f). Different ways of dividing up exhibition space.

fashion, as it has been found that the advantage of unbroken walls and the impression of better use of light in a more compact space are offset by the resultant monotony, and that the general effect is not pleasing to the eye.

Lateral lighting requires shallow rooms, their walls set at an oblique angle to the source of light. But the larger the windows, the more difficult it becomes to prevent light from being reflected in the works placed against the opposite wall. It is undeniably difficult to give a pleasing appearance to these asymmetrical rooms; the taste of a fine architect is needed to give them character and harmony, either by

163

careful attention to spatial proportion or by the use of different colours for the walls and ceiling.

Theoretically, the door between two laterally lit rooms should be placed near the wall next to the windows, because otherwise the two walls meet in a dark corner where nothing can be exhibited. But if the daylight is admitted not through a vertical or comparatively narrow window, but through a 'ribbon' of glass running the whole length of the wall, the problem is not the same. In this case the two end walls, meeting the outside wall from the normal direction, or at a slight angle, will be well lit throughout their length; the doorways can therefore be placed at the furthest extremities, thus adding to the effective depth of the room.

One important fact should be remembered when the shape of the rooms is being decided. A square room, when it exceeds a certain size (about 23 feet square), has no advantage over an oblong one, either from the point of view of cost (roof span) or from that of the use of space in the satisfactory display of the exhibits, especially if they are paintings.

It is sometimes found advisable to place a work of art of outstanding interest and exceptional value in a room by itself, to attract and concentrate the greatest possible attention. Such a room need be only large enough to accommodate a single work; but there must always be enough space for the public to circulate freely. Galleries intended for permanent exhibitions may, on the contrary, be of considerable size, though it is never advisable for them to be more than about 22 feet wide, 12 to 18 feet, high and 65 to 80 feet long.

Construction and equipment

On the basis of the above considerations it should be possible to prepare a general plan or broad outline of the museum and proceed to carry it out, with the constructional details I shall now describe.

The building, especially if it is being erected in the middle of a town, must be protected from vibration, damp rising from the ground, and the danger of fire spreading from neighbouring premises. Special care must be given to laying firm foundations, using materials which are waterproof and do not transmit vibrations, and insulating them, by a supporting wall if need be, from the subsoil of the surrounding streets.

An essential precaution is to make a very accurate prior examination of the geological structure of the site, especially where the water table is encountered close to the surface.

Reinforced concrete, now employed in an ever-increasing number of ways and in all parts of the world, offers excellent results in museum-building, and not only in countries which, like Greece, Japan and Sicily, are subject to earthquakes. It provides a simple means of insulating the museum from external vibrations, its greater strength enables the roof to be constructed in one piece with the rest of the building, and its use permits of large interior spaces which can be divided up by partitions of light-weight material.

It is not possible to recommend one method of construction or one material rather than another; every country has its own traditions and possibilities.

In the exhibition rooms and in all public parts of the building (passages, stairways, etc.), floors and their supporting walls should be designed to carry a weight of at least half a ton per square yard, with a very wide margin of safety. Allowance must be made for the weight of the largest possible throng of visitors and for the assembly of a number of heavy objects in the individual rooms.

As the museum adds to its contents, the director must be able to place statues, even heavy ones, in the middle of the rooms without fear of damage to the floor.

In selecting his materials the architect must aim at reducing noise to a minimum, whether it comes from outside or from other parts of the building. Reinforced concrete has been criticized as a transmitter of sound, but there are various ways of overcoming this, and full use should be made of them in the construction of a museum. The choice is wide; the walls can be lined in the traditional manner with cork or coated with asbestos, mica or wood-pulp; a more up-to-date method is to use

plastics and synthetic resins together with glass fibre ('glass wool') compressed in layers to a thickness at which sound waves are deadened and the conduction of heat prevented—chiefly by the air trapped in the kinks of the fibre.

The rooms of a museum must be protected not merely from noise, but from extremes of temperature and humidity. The building must be insulated as completely as possible. It is advisable not only to isolate the outer walls adequately by the use of inert or cellular materials or by leaving spaces, but also to investigate the capacity of absorption of the structural materials and wall surfaces used inside the rooms immediately behind the exhibits; these must be chosen with a view to ensuring that the temperature and humidity of the atmosphere surrounding the objects exhibited are kept as constant as possible, since those objects often consist of particularly delicate materials, sensitive to external conditions. In special instances certain new building materials may be used; but the architect should remember that the museum has to last a long time and should therefore give preference to what has already been well tested.

Ceilings and roof. Rooms with lateral lighting may have ordinary ceilings (flat, vaulted, smooth or with mouldings), all that is required being a suitable refraction of diffused, colourless light; matters are much more complicated, however, when a room is lit from above.

The light may penetrate into such a room either *directly* from outside, or *indirectly*, through a glass-panelled ceiling with skylights above it.

Light falling directly from above, through skylights or windows which form a permanent feature of the room, is in my opinion to be avoided; it is not possible, by this system, to control the angle of the light, which will change according to the time of day and the weather.

Moreover, direct contact with the exterior has an immediate influence on the temperature, rendering it difficult to avoid extremes of heat and cold. These drawbacks are inherent in every system, even the best, which employs the 'shed' type of roof, and

in all those where the 'monitor' system is used (this consists of a group of vertical windows in a central, raised, section of the ceiling); the greater facility of upkeep does not compensate for the entirely unsatisfactory practical and aesthetic effect.

Another system to be avoided is that of the 'cement glass' skylight, where the glass plates are so thick that the light coming through is too cold.

The best method is a compromise in which the ceiling of the room consists completely or partly of glass while the roof above it is of a type which shelters the building from atmospheric influences but allows the quantity and quality of light best suited to the museum to pass through suitable glazed openings (skylights).

For the construction of this outer roof we should turn to the ordinary technical methods, which offer a wide choice of suitable frames, usually made of iron or reinforced concrete.

There can be no hard-and-fast rule concerning the ratio between the transparent and the solid surface, for it varies from country to country, according to the average duration of daylight and the course of the seasons. Where the days are more often long and the sky clear, the skylights will naturally be comparatively small, whereas in regions where clouds, rain and fog prevail they must be as large as possible. The need to prevent loss of heat from the rooms below must also be considered. By way of indication, however, one may suggest that the transparent surface should be about a third of the roof area.

A recently tested method of securing a constant amount of light, whatever the weather, consists in having a larger transparent surface than this, and placing beneath the skylight some form of apparatus (venetian blinds or metal shutters operated either electrically or by hand) which can be drawn right back or moved slowly forward until the light is almost entirely shut out. This is also extremely useful in hot countries to prevent the galleries from becoming over-heated.

For the construction of the outer skylights it is now possible to buy, and easy to fit, special metal frames which hold and surround the panes of glass while allowing for

the necessary expansion, and ensure that whatever the weather there will be no infiltration of damp.

Considerable use is made, for roofs of this kind, of a type of glass into which wire-netting is incorporated at the liquid stage, so that, should the glass be broken, the fragments are prevented from falling and possibly causing damage.

Owing to its particular structure, however, this 'netted' glass has to be fairly thick, which sometimes has the unfortunate effect of giving the light a greenish tinge that undoubtedly detracts from the visual effect produced by works of art—especially paintings—and also imparts an unpleasantly cold and glaucous appearance to their surroundings.

These drawbacks are overcome if, instead of the netted glass, 'tempered plate glass' is used; for this, while it gives equally good if not better protection from the inclemencies of the weather, is as transparent and colourless as can be desired.

All glass roofs, particularly those of a museum, have to be kept in regular and careful repair, along the outside, and especially round the skylights, so there should be permanent, suitably protected gangways for the convenience and safety of the workmen.

The space inside, between the roof and the transparent ceiling, should be equally accessible, to facilitate security measures, maintenance and cleaning of this area, all of which are so essential to the smooth running of a museum.

Since, as I have already mentioned so often, one of the chief needs of a properly organized museum is good lighting, the form and construction of the ceilings through which light is to penetrate must receive the most careful consideration.

The glass ceiling (frosted or opal glass) through which the light is diffused from the skylights above it, must be far enough below the latter for the light to spread regularly. A distance of from 1 to 10 feet will be enough; if it is greater, the light which filters through the panes tends to lose some of its infra-red rays and sheds an unpleasant greenish tint on the works exhibited—which should be prevented.

The degree to which the daylight loses its intensity on its way in from outside must of course be calculated, and the size of the outer skylights suitably proportioned to that of the transparent part of the ceiling.

This transparent portion may be either flat or sloping. If flat, it will be in one piece and, in a small room, placed in the middle of the ceiling. In larger rooms, to prevent the rays of light shining in all directions with a dazzling effect, it will take the form of two 'ribbons' or bands, parallel to the walls and thus running between non-transparent strips of ceiling, one in the centre and one along either wall. The strips of solid ceiling along the sides cut out the excess of light which would otherwise give undue relief to the rough surfaces of the paintings and their actual texture instead of enhancing their effect as works of art. The solid portion in the centre serves to break the surface through which light penetrates and, by intensifying the effect of the band of light nearer to each wall, reduces the distortion resulting from any reflections thrown on that wall by light from the strip on the opposite side of the ceiling.

This effect is strengthened if the strip of glass is tilted at a suitable angle towards the wall it is to light. This requires a slightly more elaborate supporting structure, but gives better results—which are even more satisfactory if a row of parallel slatted shutters is fixed below the sloping window and tilted towards the middle of the wall that is to be lit. The purpose of these reflectors, or shutters, is to guide and concentrate the flow of light on the walls where the exhibits are arranged, preventing its dispersion and diffusion in the rest of the room, where it arrives only by reflection, so that this will be left more or less in shadow. Consequently, by direct and indirect means, the walls will receive a maximum of light and visitors, instead of being dazzled or flooded with light from overhead, as happens with ordinary skylights, will feel the psychological influence of a pleasant, restful atmosphere.

The objection to these large expanses of glass, whether laid horizontally or at an angle in the ceilings for the diffusion of light, is that it is difficult to keep them clean and that they may easily be broken —with a possible risk of injury to visitors.

This can now be avoided by using, instead of glass, the modern plastics ('plexiglass', 'perspex', etc., with a thickness of 2 to 3 millimetres); these materials are now being manufactured in every country, and are highly transparent and hard wearing. Most of these plastics are lighter than glass which simplifies the problem of the supporting framework; it will, however, be wiser for this to be of metal of a standard type, or of some light alloy, it will then last longer and not become warped.

In ceilings of this type the main weight is constituted by the glass (or other transparent material) and its supporting framework, which should therefore rest on the side walls or be suspended from the roof structure (by adjustable metal rods). The solid, opaque portions can be built of lightweight materials, except in places where the workmen responsible for maintenance have to walk. At such points the ceiling should be of stucco or hard plaster, in whatever shape the architect finds most pleasing to the eye or best suited to reflect back the light—for we are not concerned with the question of acoustics.

The ceiling must also carry the apparatus required for the artificial lighting of the room and its exhibits; it is preferable for this to duplicate the effect of the daylight, by means of tubular fittings running parallel to the strips of glass.

If it is desired to concentrate light on some particular work of art, it will always be best to place the necessary projectors above the ceiling so that only their lenses are on the level of the ceiling itself.

For hanging the pictures, too, it is advisable to make provision, during the construction of the building, for a special metal groove which should be fitted firmly into the wall just below the level of the ceiling. Fitted into the wall in this way, the groove will be almost invisible; it should be of steel, shaped like a 'T' or 'L' in section, so as to present a flange in which to place the hooks bearing the cords or wires holding the pictures, thus enabling them to be moved along the groove.

Windows and doors. The windows, at whatever height they may be placed, must be

(a) of suitable size for lighting the room;
(b) strong and able to be securely closed;
(c) non-conductive of heat from outside.

Metal frames are preferable, for they are more durable, easier to handle, and can be bought ready-made in standard styles among which the appropriate type can easily be found.

The glass should be chosen for its brightness, colourlessness and capacity to diffuse light to the best advantage. Ground glass usually gives a better light than opal glass —i.e., that made from non-transparent white paste. Another frequently used variety is 'thermolux' (two sheets of glass with a thin layer of 'glass wool' between them); this is only about half as translucent as ground glass, but on the other hand it diffuses the light well, looks pleasant, and guarantees the necessary non-conduction, because the rays of the sun cannot penetrate it and the air trapped in the convolutions of the fibre considerably reduces the transmission of heat.

Another type now obtainable is the double glass 'thermopane', put together in such a way that a thin layer of air is left in the middle. This gives remarkable results from the point of view of non-conduction, but is somewhat costly.

Venetian blinds made of wood, or better still of aluminium, are being increasingly employed to screen the light from entirely transparent windows where there are no special panes to diffuse it. These are easy to fit (the metal type can even be placed between two sheets of glass mounted in one frame), very simple to work, and can be used to moderate, direct or diffuse the light at will, with a wide range of effects most useful in a museum.

Outside doors should be as few as possible (a small museum need only have, in addition to its main public entrance, a service door for use by the staff, a safety exit on the side farthest from the main entrance, and a separate entrance to the workrooms, garage, etc.). All outside doors should be strong, reinforced on the inner side by metal cross-bars or supplemented by a separate metal door or grating to give further protection when needed. The locks should be of the strongest possible make and of a type which can be opened only

with a key, even from the inside, to prevent illicit or unsupervised departures from the building.

There should be no doors inside the museum except where a part of the building requires to be permanently cut off for functional reasons (doors leading into and out of the general entrance hall, management offices, storerooms and services, etc.).

The exhibition rooms should be connected only by doorways, for doors would seldom or never be used, and would merely waste space at the narrowest points through which visitors have to pass; it is better simply to face the sides of the doorways with marble, stone or wood, either throughout their height or in the part most liable to wear and tear—approximately from the hip to the shoulder of a person of average height.

At most there should be doors only at the beginning and end of each group of rooms, to enable them to be cut off while the museum is closed to the public, or for any other reasons, such as repair work, rearrangement, etc.

Whenever it is desired it should be possible to cut off one or two rooms without closing the entire section to the public; this can be done temporarily by means of a screen or a curtain.

The doorways should be of uniform height throughout the museum and that height should be such that the largest-sized exhibits can be moved as easily as possible from room to room.

In picture galleries, where some of the pictures may be of considerable size (it will be enough to measure the shortest side, provided there is sufficient space to tilt the picture and slide it through at an angle) doorways should be high, or may even be left open right up to the full height of the ceiling.

Walls. The treatment of the walls can do much to make the rooms pleasant, varied and serviceable and to set off the exhibits, especially in art galleries, where appearance is obviously of particular importance.

Materials and colours play the chief part, and it is difficult to make any suggestions on the subject, as their choice must be decided by the taste and judgement of the designer.

In theory, and always allowing for the nature of exhibits and the general aspect, it may be said that the larger the room and the greater the wall space, the lighter should be the colours used on the walls. To avoid monotony, large surfaces may be treated with stucco—stippled or slightly pitted—or they can be shaded off in successive gradations, the colours being delicately overlaid so as to soften them, or applied, much diluted, with a sponge.

Dead white or neutral tinted walls are going out of fashion. Their popularity was based on the presupposition that white was equivalent to the absence of colour and consequently allowed paintings, whether ancient or modern, to reveal their tonal qualities entirely untrammelled. In actual fact, any colour darkens when seen against the background of a white wall; and the colours, patina and lowered tonal contrasts of old paintings are particularly liable to be affected in this way.

It should be remembered that, whereas in a private house the ideal wall colour is usually one which refracts the light, a museum, on the contrary, must use colours that absorb light, if good visibility of the exhibits is to be assured.

A judicious use of colour in the background can go far to bring the general atmosphere of the room into harmony with the works displayed, provided the walls do not compete with them in tone or intensity. Furthermore, even a slight variation of the colours used in successive rooms helps to compensate for uniformity of size and shape or for any inevitable inequality in the distribution of light, the effect of which can be offset by the use of lighter shades near the windows, where the walls are in shadow, and darker tones on walls directly facing the light.

Where the walls are excessively high in relation to the size of the objects displayed, they may be colour-washed only up to a certain height, leaving the rest white, like the ceiling. It should however be remembered in this connexion that for some time now there has been a tendency to place all exhibits at a lower level than was formerly chosen, since it has been found that it is less tiring for visitors to look slightly downwards than to raise their eyes. This

fact should also influence the height of showcases, which ought not to exceed six feet. But this is not a hard-and-fast rule; and old pictures, in particular, nearly all of which were painted with a view to their being hung comparatively high, may with advantage be hung in museums at a similar level, or at any rate at a medium height convenient to the visitor's eye, and always with due regard to the perspective shown in the painting itself.

Floors. The choice of flooring for a museum is a matter of considerable importance, since the chief physical effort demanded of an attentive visitor will consist in much walking to and fro and standing about. The nature of the floor may have its influence both on the fatigue of visitors and on their degree of concentration.

Furthermore, the colour and texture of the floor must be such as to set off the exhibits. Generally speaking, the floor should be darker than the walls, with a reflecting capacity of less than 30 per cent. This is because a white marble floor, for instance, which has a reflecting capacity of about 50 per cent, will refract light on to the pictures, especially those in dark colours, and thus impair visibility. The same applies to the glass fronts of showcases.

Two other points to bear in mind—for reasons which it is superfluous to discuss— when selecting a type of flooring, are durability (i.e., resistance to the wear and tear to which the floor of the average museum is exposed, with the resultant danger of creating dust which is harmful to the exhibits), and maintenance requirements (ease, efficiency, and cost of cleaning, and the time required for it).

By way of guidance, I shall now indicate briefly the principal characteristics of the various types of flooring and their uses in a museum.

Concrete floors—unbroken surface, in squares, tessellated, etc. These are among the most economical, but also among the most common and undistinguished; they are easy to keep in condition if polished by rubbing over with carborundum; they do not absorb damp; they are hard, noisy, and unattractive in appearance owing to the concrete, especially if light-coloured cement is used; they are not very suitable for exhibition rooms, but may be used in parts of the museum not open to the public.

Stone and marble. These are always appropriate, though they must of course be chosen to suit the individual case. Where supplies are easily obtained, the expense, usually considerable, may be reduced to reasonable proportions, especially when we allow for the compensating factor of durability as compared with other materials. They are shiny and resonant, but these drawbacks are balanced by their beauty and decorative value—though these qualities make it preferable to reserve certain strongly marked marbles for stairs and corridors and to use others, quieter and more uniform in colour, for the withdrawn atmosphere of the exhibition galleries.

Tiles (terracotta). These are made, though not everywhere, in different shapes and sizes, for a variety of patterns (in squares, herring-bone, parquet style, etc.); well-baked, they have a fine colour of their own, or the reddish-brown tint that they have will absorb any colour which may be applied to them, being thus well suited to the requirements of a museum; they are economical; demand careful but not difficult attention; if waxed or treated with a synthetic varnish they collect no dust and are long lasting.

Wood. This may be of various qualities and cuts, according to position; if well bedded in a concrete base it is not resonant, though fairly hard; maintenance is difficult since wax polishes may make it too shiny and slippery, although synthetic varnishes are easier to use and keep in good condition; certain of its characteristics make it very agreeable for exhibition rooms, as its colour is pleasing and tones in well with the works of art, and it is warm and comfortable to walk on! In countries where timber is scarce or imports are chiefly confined to valuable woods, this type of flooring is more costly than the average.

Cork. This is the most silent, softest and most elastic of all types of flooring; it requires considerable care and attention; it is delicate, easily stained, and wears away quickly even if polished; it is best suited to places such as libraries, where circulation is limited and silence a necessity.

Rubber. Except for the elasticity and softness that make it appropriate for exhibition rooms, rubber flooring has no advantages to compensate for its high cost; it is difficult to keep in condition, easily becomes shiny, and is slippery when wet; for a long time after being laid down it has an unpleasant smell; but above all it is harmful to silver, illuminated manuscripts and, in general, all materials (including unvarnished pictures) and metals, which become tarnished owing to the sulphurous vapours (hydrogen sulphide) which all rubber emits, however slowly.

Linoleum. Frequently used and easy and economical to lay; linoleum's pleasant appearance, yielding surface, silence and easy upkeep render it useful even in a fairly busy museum.

Asphalt tile. Relatively resilient, easy to maintain, and obtainable in various colours. It can also be used, in basements for example, under humid conditions. It is fireproof and resistant to corrosion and staining.

Plastic varnishes. Several kinds of varnish made of synthetic resins have recently appeared on the market; they are applied in several layers on a suitable, smooth concrete base, with a result strongly resembling linoleum in appearance, but cheaper and even easier to apply and keep in condition (wax polish). They are hard wearing and can be obtained in any colour.

N.B. Wood, cork, rubber, linoleum and plastic varnishes cannot be used in museums which are heated through grids in the floor.

Museums housed in old buildings

A practice which is already widespread and usually proves most satisfactory is that of housing a museum in some ancient building whose architectural and historical characteristics give it a certain value.

In many cases the choice is determined by considerations of economy and utility, as it is thought better to use an existing building than to put up a new one.

In some cases the motive is the opposite one of finding a practical and cultural purpose for an old building and thus saving it from the risk of becoming derelict or suffering undesirable alteration.

In any case these advantages have to compensate for the unfortunate fact that modern methods of museum organization can be applied only within strict limits in an historical building or even in a merely old one. Those methods can, however, be drawn upon for certain adaptations, possible even in an ancient building; for instance, some of its features may serve to provide a more original and typical setting for works of art.

In such cases one of the advantages is undoubtedly the special interest attaching to a museum housed in a building of artistic and historical importance—all the more so if it is connected with the memory of some historical event, some important figure or even some legend calculated to stir the visitor's imagination and feeling for romance.

Almost every European country possesses some ancient buildings which have been turned into museums, and these are of the most varied types—Roman baths and mediaeval castles, churches and monasteries, private houses and public buildings, prisons and palaces.

These relics of the past—many of which, however, have recently been modernized or restored by up-to-date methods—can be classified in various groups, each of which, in the light of circumstances, is seen to be subject to restrictions so far as its use and adaptation as a museum are concerned.

The first strict principle, from which there must be no departure, is that of preserving all the original features of the architecture and decoration of such a building. When necessary, therefore, scrupulous restoration and repair work should be carried out before the museum is established; and this requirement must always be kept to the fore in any project.

While present-day taste rejects as false and artificial any imitation of ancient styles made under the pretext of restoring a work of art in the manner of its period, our feeling for history makes us unwilling to reject or alter the genuine historical flavour of any period which, where by good fortune it has survived, illustrates the taste that

prevailed in that day, even if it is at variance with ours.

The cases likely to arise can, it seems to me, be classified as follows:

1. The building of historical and artistic interest which still contains the furnishings and art collections assembled there in former centuries. Such a building is itself a museum, and little change can be made in adapting it for public use, except the most faithful restoration and a little cautious retouching of a strictly functional nature.
2. The building of historical and artistic interest whose original contents have disappeared but whose decoration has survived intact or can be refurbished. This is suitable for the exhibition of historical and artistic or decorative pieces in keeping with the setting, so as to reconstruct a harmony of style, period and taste between the objects and their surroundings.
3. The building which has preserved only its outer aspect, together perhaps with a few of its internal features (such as courtyards and staircases), its rooms having been completely altered. This should be adapted to house a museum of an independent, modern type.
4. The building which, though old, has no particularly interesting features either outside or inside. It should be adapted like the preceding one, but more freely.

As regards buildings in the first of these groups, it is hardly necessary to point out that any changes made to convert them into museums should be as slight as possible. They are genuine historical monuments in their own right, and the organizer should confine himself to measures essential to preserve the structure and make the most of it, without impairing its harmony.

The building may, in a few exceptional cases, be an historical one which has retained its original furnishings, works of art and decoration. It may be one with the historical interest of an old house whose characteristic, traditional features illustrate the craftsmanship of its day. Or it may have been the home of some celebrated figure whose possessions and relics must be kept in place simply to preserve the surroundings in which he lived and worked. In all these cases care must be taken not to destroy the historical atmosphere, which must be restored if it has been impaired in any respect.

Even a building of this type cannot, of course be opened as a public museum unless certain requirements are met. So some part of the premises should be found, suitably situated and not in itself remarkable (such as always exist, even in an ancient building) and adapted to house the essential services (offices, records and storerooms, laboratories, etc.).

Obviously it will also be possible and necessary to modernize all the technical equipment (electricity, heating, security, cleaning, etc.), make sure that it is efficient and safe, and place all pipes and other fittings in positions where they will not detract from the period atmosphere of the surroundings.

If the building still has its original stairs and floors and there is any reason to fear that these might be worn out by the coming and going of visitors, they should be protected by carpets—but only in the places actually exposed to wear and tear, for they ought not to be entirely concealed, especially if they are decorated and typical of their period.

The present-day organizer can do little more than this; his own good taste and respect for history will prompt him to the right solutions of the many individual problems which it is hardly possible to anticipate.

In the case of a building in the second category, where the architecture and interior decoration have survived more or less intact, but which has lost all its original furnishings, the organizer will be faced with the difficult but stimulating task of bringing the contents of the museum into harmony with surroundings which cannot be altered.

There are two possible solutions to this problem: (a) the exhibits or collections may be so arranged as to suggest a connexion with the style, period and taste of their setting; (b) the ancient setting may be to a great extent preserved, but the exhibits arranged without regard to it, according to the dictates of present-day taste and museum techniques.

In the former case the organizer will

171

here and there introduce elements which bring the setting and the exhibits into a mutual relationship; but he is bound to experience difficulty in establishing a systematic classification, and will not be able to settle matters merely by lining up a number of fine pieces—for the effect will be arbitrary, artificial, and only vaguely suggestive of some unconvincing historical arrangement.

The better preserved and more genuine the architectural style of a building, the more complex the problems that will arise; and their solution will vary according to circumstances.

The main problem will, however, always be that of bringing the requirements of systematic classification and of the actual structure of the collection into line with the importance and architectural features of the rooms in which it is to be displayed.

Sometimes the building—especially if it dates from the eighteenth or nineteenth century—may even have been planned and constructed to house certain art collections in the manner of its day. In such cases it is an absorbing task to restore it to its original purpose and thus confirm the historical interest of its past.

The problem, in each individual case, is to decide:

1. Whether it is possible to preserve or re-establish the former relationship between the collection and the architecture or decoration of its setting.
2. Whether—if their characteristics are too dissimilar and a majority of the exhibits are unsuitable for this architectural framework, so that there is no basis for such a relationship—it is desirable to plan an harmonious but largely unrelated collection guided by present-day principles and the canons of historical criticism.

The latter solution is naturally the most frequent, for there are comparatively few cases in which a sufficiently precise record of the original arrangement of an old building is available, and fewer still in which artistic material is forthcoming for a faithful or historically adequate reconstruction.

In most cases the best plan is to arrange collections in an historical building freely, but without completely ignoring their surroundings—to preserve all the original, architectural and decorative features and arrange the exhibition rooms independently, in a style entirely unrelated to the surroundings, but connected with them by the influence of a taste which succeeds in harmonizing the most modern forms with an ancient setting.

In any event, the relationship between the building and its contents must never degenerate into sham aestheticism of the 'antique shop' type, an indiscriminate assemblage of heterogeneous items.

Neither should the organizer be tempted into the bad taste of introducing into the old building architectural or decorative elements (staircases, windows, ceilings, State beds, etc.) taken from other houses or purchased with the intention of reconstructing an 'atmosphere'.

The result will be completely false, even if—in fact because—the individual items are genuine, but disconnected and alien to one another.

This is a subject more appropriate to a treatise on the restoration of old buildings. Here I need do no more than point out that this tendency should be avoided, even if one of the purposes for which the museum was founded was to assemble and preserve architectural relics from buildings pulled down in old districts, which happens when ancient towns are cleaned up. In such cases the architectural and decorative fragments should of course be selected, arranged and exhibited for their historical, artistic and educational interest—but never re-employed for spurious architectural purposes.

The cases mentioned in the third and fourth groups will provide the organizer with wider scope for initiative and occasion for tasteful innovations and unusual adjustments to the conditions he finds in the building. This may have retained only a few traces of its original decoration, or its proportions and the shape of its rooms may be all that is left to bear witness to its former dignity.

In such instances, where reconstruction is hardly possible and the building is not of equal architectural or decorative merit throughout, the really interesting rooms or vestiges should be scrupulously preserved and restored, but everything else should be

modernized as completely as possible, with all appropriate innovations and alterations.

In many cases the interest of a museum of a particular type, such as one devoted to local history or to applied art, will be advantageously heightened by housing it in an old building: this is especially helpful in fostering an awareness of the value of tradition and of the connexion between the life of former periods and the greater or lesser works of art they produced.

The plan which brings out the harmony and affinity between the folklore or handicrafts of a particular district and an old building possessing local and traditional features—even if the latter are not of a high artistic level—will facilitate their union and suggest imaginative and original methods of arousing the interest and curiosity of the public.

When an old building is to be adapted for use as a museum, the first step towards the rational arrangement of its collections is to solve the problem of where they are to be placed and what itinerary visitors are to follow—just as when a new museum is being designed.

An old building, originally intended for other purposes, is not easily transformed into a museum without altering and adapting the system of communication between its various parts in order to establish a clear and logical progress through it and to make the best use of available space.

The search for a suitable route must be guided by these considerations.

Certain characteristic features of the building may even be sacrificed without hesitation—though not without caution and discernment—in order to achieve the best results in this respect, for the sake of which a comparatively large sum may be spent on knocking out walls, changing the position of doors or windows and opening new ones, even if these differ in size and design from the uniform style of the building.

Particular attention will also be devoted to the problem of access to the rooms. *Staircases*, if not numerous or not strong enough for the intensive and concentrated demands sometimes made on those of a museum, must be suitably strengthened or widened, new ones even being constructed at points where they will be most useful.

At least one supplementary or 'service' staircase should be brought back into use if it already exists, or constructed if it does not; this will be used for all supervisory and other functional work, and in the event of fire or any other danger. It must therefore provide an unbroken link between all the floors of the building and go right up to the attics to facilitate the inspection and repair of the roof.

The *roof* of an old building to be turned into a museum provides the organizer with one of his chief problems.

If it is a wooden one and financial considerations make it inadvisable to replace the beams by something safer (e.g., steel), it must at least be strengthened in a rational manner, all wooden parts must be fireproofed and it must periodically be thoroughly sprayed to prevent damage, or the risk of damage, by termites, borers, etc.

The attics should be cleared of any unnecessary superstructure and of everything that is inflammable or liable to rot; and their floors, above the exhibition rooms, should be made watertight by one of the usual and now widespread technical methods, to avert the risk of rain-water seeping through the roof and ceilings and damaging the exhibits.

The roof (whether a tiled or a flat stone or metal one) should always be accessible both from inside and outside, with gangways and protective parapets to facilitate upkeep and inspection by the museum staff.

A menace to which old buildings in all parts of the world are particularly vulnerable is moisture, which creeps up from the ground into the walls. Strong and rational measures must be adopted to parry this, for it can do untold harm to works of art and to the other contents of a museum. The foundations of the building must be isolated from the soil, which absorbs water and humidity by capillary attraction or by dispersion. This may be done by inserting horizontal layers of impervious material (lead, concrete, asphalt sheeting, etc.) into walls where damp is found to have risen vertically through capillary attraction, by building new walls side by side with those into which saltpetre or water has penetrated, leaving a space between the two surfaces

for insulation and ventilation, or by introducing some method of absorption and evaporation such as the Knapen system.

To coat the walls with so-called damp-proof material is useless and harmful, for this not only fails to remove the cause of the damp, but by preventing it from evaporating at once, forces the water into other directions, so that it spreads all over the wall.

Even in the rooms of an old building it is possible to arrange the contents of a museum so that they are seen to advantage.

The chief necessity will be to improve the lighting by suitable adjustment of the existing installations. Windows and skylights can be fitted with lighter frames and with glass which is more transparent or more suitable for diffusing and directing the light, etc.; and where overhead lighting is supplied by antiquated skylights, these may be adapted by fitting them with lanterns with ground-glass panes, specially designed to meet each individual case by screening the light, diffusing it more widely, and directing it on to the walls where the exhibits are placed.

The old rooms can be improved by choosing for the walls such colours as will set off the exhibits to the best advantage; and their height, if excessive, can be reduced by using a different material or colour up to a level proportionate to the size of the objects displayed; while rooms which are too large or too narrow can be divided by movable or separate partitions (of a size which will not interfere with the style of the place) into more manageable sections.

The outward appearance of the rooms— their doors, window-frames, wainscoting— can be altered or improved to suit their new purpose. Door-panels, for instance, may be changed, leaving the frames as they were or replacing them by simpler ones: as I have already pointed out there is no need to close all the doors leading from room to room in a museum and it is therefore preferable to make the doors themselves as unobtrusive as possible, to ensure that visitors, especially on crowded occasions, can pass through easily and safely, and also that the doors will be simple and elegant in appearance.

If the floors need repair they should if possible be kept in their original style, or in one which, while suited to the character of the building, is also appropriate in appearance (colour) and practical qualities (cost, durability, upkeep) to the new use to which the building is to be put.

Another situation, not unlike that in which an old building is to be adapted, arises when a museum built and equipped by old-fashioned standards is to be modernized. Other occasions for changing the arrangement of an old museum may arise if one or two departments are added to it to house new acquisitions, legacies or gifts; or they may result simply from a change of standards, preferences and cultural programmes on the part of the management, brought about by changes in staff or by the natural evolution of taste. It may thus happen that the previous normal increase in the collections devoted to a particular period of history, school of painting or category of objects ceases altogether or is reduced to make way for new interests which are thenceforth to take precedence in the museum and therefore condition its renovation.

In this event we need only apply the theories and follow the practical advice already given with regard to newly built museums and those to be housed in old buildings. Here too the joint objective of organizer and architect will be to retain as much as possible of the existing structure, for obvious reasons of economy, while adapting it to the new aesthetic and functional requirements.

If all ingenious expedients adopted to increase the capacity of the building and save space should prove insufficient, it may become necessary to enlarge it.

This may be done either horizontally (by taking in neighbouring premises or building on a new wing) or by adding a storey to part or all of the museum. Without sacrificing the advantages offered by this new building, its proportions and architectural features should be such as will not disturb or distort the practical and aesthetic qualities of the existing display rooms. Even if the architectural styles are different, it should be possible to design the addition so as to bring it into harmony with the old.

As to the general considerations and appropriate divisions to be borne in mind when planning the part of a museum—less in evidence, but no less essential to its existence and functions—known by the general title of 'services', I will refer the reader to the suggestions already made (Chapter II, page 28). All that is necessary here is to stress the advisability of making a distinction between what might be called 'external' and 'internal' services. By 'external' I mean all those which, in addition to the exhibition rooms, serve to integrate the cultural activities of the museum, and are therefore permanently or periodically open to the public (rooms for temporary exhibitions, for lectures and concerts; library and records; rooms for study, etc.); whereas the 'internal' services are all those directly connected with the actual running of the museum (laboratories for restoration and cleaning, heating system, electrical installation, etc.; storerooms, workshop, garage, etc.).

*Hall for temporary exhibitions
and lectures; bar*

A small museum, where space is restricted, must be able to use one room for various purposes, especially if these are temporary. This applies to rooms for temporary or educational exhibitions, etc., which should also be suitable for lectures, concerts, meetings, etc., as required by the museum's programme of activities.

Such a room should therefore be provided in the plan of a new building, or set aside when an existing building is being adapted. It should be in the position best suited to its multiple uses—i.e (a) apart from the itinerary normally followed by visitors to the museum; (b) close to the main entrance hall or, better still, leading directly off it; (c) it should be fully equipped with safety devices (side doors, independent electric system, isolated from the rest of the building as regards heating and acoustics, etc.).

It should be as large as possible while remaining in the right proportion to the building as a whole and to the estimated average attendance, and in any case not less than about 26 to 32 feet wide, 40 to 50 feet long and 13 to 16 feet high.

It is useful, where this can be done without raising architectural problems, to have some arrangement whereby this hall can be divided into two or more parts, differing in size and appearance, by means of hangings or easily movable partitions. This is a great help in adapting the hall to its various uses—for instance for individual or group exhibitions, for an exhibition and a meeting held simultaneously, or for the exhibition of single pieces, recently acquired by the museum. In this way the hall will be satisfactory both for exhibitions and for lectures or concerts.

With regard to the first of these purposes I can only repeat what I said before about the considerations which should govern the construction and fitting out of rooms in a museum; for here there is the same need to display the works of art and bring out their full quality with the help of the architectural setting, the lighting and the decorative features of the hall. I should perhaps add that in this case it is more than ever necessary to make the architectural scheme as 'flexible' as possible, equipping the room with all practical devices helpful to the easy introduction and removal of objects which may be shown, of such movable panels and cases as may be erected from time to time. This should be done in such a way that it is not necessary to waste money on structural alterations or touch up and change the colour of the walls before or after each exhibition—unless this is done deliberately, to give an effect of novelty.

Arrangements can also be made to increase the surface available for exhibits beyond that of the actual walls, when necessary, by dividing up the centre of the hall with movable panels, of various types, either equipped with their own supports or fitted into special sockets provided in the floor of the room (see figure on page 143).

It will also be necessary, with a view to the requirements of different exhibitions, to provide for the possibility of combining the usual and rational sources of natural and artificial light with special effects obtained by electric lighting, whether

diffused or reflected, or concentrated and projected in a particular pattern by projectors, of which various types are on the market. To facilitate the placing of these projectors and to enable them to be moved to any point required, electric plugs and supports for projectors or reflectors may be fitted to the ceiling in a regular and perhaps geometrical pattern with a decorative effect.

When the same hall is to be used for meetings, lectures and concerts, its structural features must be combined with the means provided by modern technique for securing good acoustics with or without amplifiers. Any technician will be able to solve this problem, which has to be dealt with individually.

Apparatus must be available for the showing of films, slides, etc. It should be possible to conceal the screen, in order to use the wall for exhibition purposes; this can be done by means of a double, revolving partition, by hoisting the rigid screen and its cover into a space provided above the ceiling, by simply drawing a curtain across it or using roller-type screens.

If 35 mm. type films are to be shown, a projection cabin must be built outside the hall, with an entrance from the exterior, and it must conform to the security regulations enforced in all cinemas.

A complete outfit should include a projector for 16 mm. sound films; an epidiascope for projecting slides of different sizes (6 × 6 cm. and 24 × 32 mm.) and opaque illustrations (photographs, pages from books, etc.); a microphone connected with the cinema's amplifier; a dual sound-and-light connexion between the lecturer's table and the projection cabin (if there is one); a tape-recorder; a full set of electric controls, alarm signals, fire extinguishers and automatic connexion with the independent emergency lighting system.

The furniture in this hall (table or platform for the lecturer, chairs for the audience) cannot, of course, be fixed and should therefore be of the lightest type, easy to carry and with as little bulk as possible, so that it can be removed without too much trouble to a special storeroom when the hall is in use for exhibitions. It is highly desirable that the storeroom should

be adjacent to the hall, and fairly large; in addition to the chairs, it can take the piano with which the hall will be equipped, and which would be in the way during non-musical functions. It is desirable to have cloakrooms and toilets attached to this conference room which can be closed off from the rest of the museum.

A café-bar is nowadays attached to any hall intended for public meetings, and also to the most up-to-date museums. It should be included in the plans, to satisfy public demand. Only large museums, of course, and in fact only such as can rely on a considerable flow of visitors, will find it desirable or possible to set aside the space and undertake the organization necessary for a full-scale restaurant service (the 'public dining room' or 'cafeteria' of American museums), as this requires at least one very large room for visitors and further space for the kitchen, storeroom and other essential services.

But a small or medium-sized museum can easily provide a snack bar at a central point, serving only drinks, sandwiches, etc.

This room, which should if possible open on to a garden or exterior gallery, by a door which would be closed in winter, or have one or more windows with a pleasant view, must be separate from the rest of the museum, both to avoid disturbance because of noise and to permit smoking. It should also be possible, when necessary, to close it off so that visitors will not go through it.

The refreshment room should have small tables; there should be a public cloakroom nearby; toilets; a public telephone booth; and next to it should be a small room to hold stores, cooking apparatus and the equipment for the bar. There should be all suitable safety devices.

Storerooms and reserves[1]

Even in a small museum it is neither possible nor desirable to put the entire collection on public exhibition: on the other hand, specialists in a particular subject must always have access even to what is not displayed. Every museum, therefore,

1. See Chapter VIII, page 119.

whether large or small, must set aside one or more rooms for its reserves.

These storerooms need not be on the same level as the exhibition rooms; they may be in the basement, in premises set aside for them in the general plan of the building, in separate rooms, or—in old buildings—adjacent to or on the floor above the museum offices. The essential thing is that they should be dry, safe, easy to inspect and adequately lit—in fact that their external features should be as carefully considered as those of the display rooms.

They will be permanently equipped for their purpose, which will be determined by the type of museum. Scientific collections need a great number of capacious wooden or metal cupboards, and the space in these must be put to the best possible use by dividing them in accordance with a systematic classification. Certain objects, which need to be kept behind glass and to be visible on both sides without being touched (e.g., old fabrics, embroideries, coins and medallions, engraved glass, etc.) should be placed in panels faced with glass on both sides and turning on hinges or sliding into a specially provided space, so that without being shifted they can be protected from the light.

For storing paintings the most up-to-date museums now use a kind of vertical framework consisting of metal panels sliding horizontally along rails, with pictures hung on both sides of them, one beside the other. Arranged in series, these panels, even if close together, can be brought forward singly or in groups by drawing them along their rails, and kept out until inspection of the pictures is concluded.[1]

Library, photographic collections, prints and phonograph records

In every museum, but especially in the smaller ones, the purpose to be served by the library must be carefully determined in order to provide it with the right amount of space and with suitable furnishings. A library which is to be open to the public has very different requirements from one used only by the curators of the museum.

The latter case, however, though it appears simpler to deal with, is usually only temporary; for as the library grows, and particularly if it is the only one in the town, it will be impossible to refuse admittance to students from outside. We shall therefore consider the requirements of the library in terms of its use, actual or anticipated, by a larger public.

Here, too, much depends on the character as well as on the size of the museum. In a history or science museum the library will tend to grow proportionately more rapidly, than in a museum of art or archaeology, where the number of specialized publications to be assembled is more limited and in many cases only a brief reference to the museum's own collections is needed.

One or more rooms may be set aside for the library, according to possibilities. If there is only one it should be fairly large, with bookshelves—metal ones perhaps—lining the walls, and tables for students in the centre. The best form of lighting is by lateral windows, under which may be more tables and the general card indexes of the library.

If several rooms are available the largest should be kept for the books and smaller ones set aside for the librarian's office, for the use of the students and for the display of current periodicals and recently acquired books.

In selecting or designing the premises, the architect should take all the normal structural precautions for library buildings, not only because walls and floor will from the first be required to carry a considerable weight, but also in anticipation of the growth of the library, which may end by filling the entire room with bookshelves. The walls must thus rest directly on specially designed foundations, and should perhaps be separate from the walls of the museum itself.

The walls, doors and floors should be lined with some substance which gives adequate protection against fire and as far as possible keeps out sounds coming from the rest of the museum.

It is naturally preferable for the library to be close to the administrative offices. It it is to be used by visitors and students if

1. See Chapter VIII, page 124 and Plate 34.

must be readily accessible from the entrance hall of the museum, but have facilities for controlling the different entrances.

The museum's collections of prints and photographs can also be kept in the library, in filing cabinets, in bound volumes or in boxes. Photographs should preferably be mounted separately and placed vertically in drawers which slide easily in metal cupboards—arranged according to whatever filing system may facilitate reference to them and suit the type and contents of the museum (under place, photographer, material, subject, etc.).

When the museum has its own photographic laboratory, the catalogue of its negatives, whether or not it is kept apart from the general photographic collection, should form an 'illustrated record', i.e., it should consist of mounted copies of each subject, clearly indicating the negative and its number in the catalogue, to facilitate identification by students applying for prints.

Ethnographic museums are obliged to keep a collection of recordings of folk songs or music, which they can make available to students. But even history, art and similar types of museums now feel called upon to include a music section. The records or tapes should be catalogued and may be kept in the library itself, but a listeners' room will have to be set aside, with sound-proofed walls and doors. Or if this particular section expands considerably, one room can be fitted with several cubicles each sound-proofed by the methods used in ordinary telephone booths and broadcasting studios.

Offices, laboratories and workrooms

The space set aside for the offices of the management and administration will vary according to the size of the museum, the extent of its cultural activities and the size of the staff. The minimum would be an office for the director, another for the secretary, a third for the administrative services, and such extra premises as they may require.

Larger museums which have an independent administration or are controlled by a board of governors or trustees, will need a room for board meetings, a small waiting room and an office for the chairman.

The office section should be connected with the museum, preferably through the main entrance hall so that there is a single channel of communication with the public; but it should also have a separate entrance of its own, so that the working hours of the officials can be independent of those at which the museum is open.

The laboratories, too, must be proportioned to the size of the museum.[1] In every case there must be a room for restoration work and for all the various technical operations required for the 'conservation' of the museum's possessions, whether these be chiefly works of art or objects of many different types. The premises set aside for this purpose must be reasonably spacious, well lit and well ventilated, equipped with every possible precaution against theft and fire, easily accessible from within the museum and from outside, so that any exhibit brought in for restoration (which may be of considerable size and weight) will not have to be transported by a complicated route, so that any new acquisitions can be deposited there when they arrive and undergo any protective treatment, restoration, cleaning or disinfection, before being taken into the museum and displayed.

Adjacent to the restoration room there should if possible be a small laboratory for physical and chemical research equipped at least for the most ordinary scientific investigations which form part of all restoration work. This minimum equipment should include a Wood lamp for examining objects by filtered ultra-violet rays, a laboratory microscope and a low-powered binocular microscope for surface examinations, and the requirements for the simplest chemical analyses. This equipment can of course be increased according to the museum's needs and resources, and may ultimately include a radiographic installation for direct X-ray examination and for the ordinary radiography of paintings; a gas chamber with metal-lined walls (hermetically sealed and fitted with an electrical system for gas extraction and ventilation, communicating

1. See Chapter VII, page 101.

with the outside of the building), for the disinfection of the various objects, particularly wooden ones, by the use of methyl bromide; and any other apparatus employed in modern technical methods of examination and scientific treatment, which present no danger and give lasting results in the delicate task of preserving the historical, artistic and documentary material assembled in the museum.

It is extremely useful for even a small museum to have a photographic laboratory for records and studies which are a daily necessity. This may be situated either among the offices or in the 'services' section. Photographic apparatus has now reached a remarkable degree of perfection, especially in the use of colour.

Where it is not possible to allocate separate premises for each type of work, a dark-room should be provided, large enough to deal with each task singly. Sinks should be ranged along the walls, alternating with slabs of marble, enamel, stainless steel or some other, more modern, synthetic, waterproof, substance which is impervious to acids. Special care must be taken in fitting up the electrical apparatus for lighting and for working the automatic equipment, and in installing the water pipes.

The air in the dark-room should be kept in circulation either by mechanical means—blind ventilators with exhaust fans communicating with the exterior—or naturally, by the arrangement of a 'labyrinth' type of entrance, where the staggered walls, painted in non-glossy black, overlap in such a way that a door is unnecessary, yet not the faintest ray of light can enter.

One room may be set aside for photographing works of art; it should be long enough to give the necessary distance for photographing large canvases, and wide enough to ensure that the floodlights will not cause reflections on the surface of paintings.

To facilitate the photographing of series of objects of similar size and shape, such as vases, coins or drawings, the room should have movable shelves in a fixed framework, on which the objects can be arranged at a given distance from the camera.

Microfilming equipment, the use of which is now widespread, can be very valuable to a museum. As well as providing the reproductions of prints and manuscripts which are in frequent request by students for their work, microfilming permits the establishment, at very small cost, of a complete record of the artistic, historical, ethnographical and scientific contents of the museum. It provides an extremely useful and practical 'visual' inventory. Microfilming may be carried out either with a special camera, which uses 8 mm. or 16 mm. film, or with a camera, such as a Leica, fitted with a lens and copying attachment, suitable for taking close-ups and using 24×36 mm. film; this latter format permits enlargements large enough for study purposes in cases where no special projector is available.

Very important, more especially for the documentary value accruing to it as time goes by, is a collection of negatives, which need occupy little space provided it is carefully classified and arranged in drawers —possibly metal ones—in such a way that the negatives are perfectly protected against damp, kept at a constant temperature and inaccessible to noxious emanations or dust.

A properly equipped workshop, or at least an adequate supply of tools kept in a suitable place, for carpentry and small mechanical or electrical repairs, etc. (an electric saw and planing machine, a lathe, drills, a carpenter's bench, etc.) is most useful, not only in dealing promptly with urgent repairs and matters connected with the normal upkeep and satisfactory functioning of the museum building and its equipment, but also as an adjunct to the work of the restoration and photographic laboratories. It should therefore not be too far from these. However, it is equally important that the sounds of the work done there, and of the machines employed, shall not penetrate to the exhibition rooms. Both these conditions can be secured by a careful choice of position, and cellar or basement rooms may consequently be preferred. In any case there should be a separate entrance, reserved for supplies and staff, placed at a distance from the public entrance to the museum even if within sight of it, and giving access to the storerooms, reserves, heating, main switches of the electric system plant, and the various controls. This will

facilitate the co-ordination of general supervision, which can be entrusted to one member of the staff who will have a small office (or even a mere glass-panelled box) just inside the entrance and who can supervise everything that goes on there, such as deliveries of supplies, dispatches, etc.

In addition to the space set aside for the permanent storage of materials and supplies needed for the normal functioning of the museum, it is advisable to include and allocate sufficient space for the necessary packing and temporary storage of packing cases when temporary exhibitions are held with works lent by other museums.

This part of the building might also house the 'guard room' and the arrangements for the daily and nightly supervision of the museum. In that case one or more rooms—according to the staff employed for this purpose—may be set aside as cloakrooms, with individual lockers for clothes and uniforms, a refreshment room, a shower and toilet facilities separate from the public ones.

When the museum is large enough to make such a measure possible and justifiable, this service section may also include living quarters for a custodian, to which the telephone and electric connexions and all burglar alarms, etc. can be switched at hours when the building is closed to the public.

Technical and security installations

Even where money is scarce it is never wise to begrudge the cost of the best technical equipment for a museum. The satisfactory functioning of such equipment leads to a definite saving in management and maintenance—and also in wages, if the work is simplified in some respects by the use of machines.

Heating and ventilation. Only a few large museums can afford the considerable cost of installing a complicated air conditioning plant, let alone that of running it continuously. I shall therefore disregard this possibility and confine myself to a description of the usual systems of central heating. In choosing one of these the particular requirements of the museum must be carefully borne in mind, for the most important thing is to avoid any risk of damage to the contents. The chief dangers are (a) excessive heat or variations of temperature; (b) fluctuation in the degree of humidity in the atmosphere; (c) draughts of hot or cold air constantly blowing on pictures hung near radiators or air vents.

The wrong heating system, or the injudicious use of even the most suitable system, may cause incalculable damage to museum pieces, most of which are not only valuable but irreplaceable. To go no further than paintings on wood, numerous instances can be cited of wooden panels that have warped or split and of surfaces that have peeled away or blistered beyond the possibility of repairs as a result of improper heating conditions.

The choice and arrangement of a central heating plant, as of any other technical equipment, is a problem for engineers, and should not be based on empirical advice or proposals. At the same time it is essential that the problem should be solved in a manner compatible with the particular results desired and risks to be avoided.

The steam heating system, with radiators against the walls or under the windows, is now superseded; it is preferable to use convectors placed in spaces between the exhibition rooms or high up on the walls (though this does not look attractive), so that heat radiates from places at a distance from the exhibits.

It is easier to adopt this solution when the apparatus is one which ventilates by forcing out warm air and by controlling humidity—a method which to some extent resembles that of air conditioning. In this case the warm air may be brought into the exhibition rooms through vents concealed by metal gratings which can be regulated and which are placed in the positions best calculated to avoid affecting the works of art either directly or by causing draughts.

This system heats the whole interior of the museum, to a degree sufficient to ensure the comfort of visitors throughout their tour of the building; it must therefore be started several hours before the museum is opened to the public, and the cost will increase accordingly.

The system of heat radiating from under the floor may be found more economical, because apart from its direct effect, it more rapidly creates a zone of adequately heated air which makes an immediate impression of comfort on visitors. It has the further advantage of being inconspicuous, since it consists of a network of pipes and panels in which hot air circulates below the floor. While very suitable for picture galleries, where works of art are usually hung on the walls, it may have certain drawbacks in museums where materials naturally sensitive to heat (wood, textiles, paper, etc.) have to be placed in the middle of the rooms, on the floor, in direct contact with the source of radiation.

As for the type of boiler fuel to be used, coal and coke are no longer employed because they give rise to penetrating and harmful dust and smoke. It is better to use electricity or, as funds permit, gas, kerosene or fuel oil. The last, in particular, has considerable advantages owing to its low cost, cleanliness, safety and ease of supply, for it can be stored in underground tanks outside the museum.

While it is indispensable to heat the museum in the winter months, which vary in length and harshness, it is no less essential to ensure a proper supply of air, which is required in all seasons.

Every care must therefore be taken, while the building is being designed and erected, to allow for the maximum of natural ventilation and for a constant and automatic flow of air, especially when there is no reason to fear that this may bring in dust and smoke from outside. The best method is that of openings in the lower parts of the outer walls, protected on the inside by a metal grid which can be regulated or even completely closed. Corresponding openings should be made at the top of the walls, or better still in the ceilings, to allow the air to escape thanks to the slight draught which will be set up by the natural heating of the premises.

The air in the space between the ceiling and the roof must, of course, find similar outlets and possibilities of absorption and change.

It is also advisable to make horizontal openings in the walls between the different rooms, so as to stabilize the temperature in the upper part of the rooms and thus facilitate the movement of the air.

If more funds are available, ventilators and exhaust fans may be installed, working either together or separately, the former forcing in air and the latter drawing it out through the roof—a system which in summer has a certain cooling effect inside the building. Additional cooling can be effected by the automatic watering of the skylights from a pipe on the roof.

The ventilators may be fitted with suitable filters to keep out dust and also linked with refrigerating and humidifying machines, various simple types of which are now on the market.

Electric exhaust fans are particularly suitable for use in lecture halls, cloakrooms and storerooms.

Cleaning equipment. The daily cleaning of a museum is greatly facilitated by the use of vacuum cleaners, which can serve not only for cleaning and polishing the floors but for dusting the rest of the premises.

The choice of these machines and the extent to which they can be used will depend partly upon the nature of the exhibits, reserves and collections. The usual portable type is certainly adequate for the needs of a small museum. In the case of larger institutions, however, it should be pointed out that portable machines have the drawback of trailing considerable lengths of electric wiring after them round the room; this is an encumbrance and may lead to trouble (short-circuits, danger of fire, etc.). When possible during the period of general installation, it is preferable to make this service safer and more efficient by providing a fixed network of steel suction tubes, connected with a central apparatus (electric turbine vacuum) situated in the part of the building intended for the general services.

All that is necessary is to insert commercially made tubes fitted with brushes into one or more of these openings, and the dust is sucked up and conveyed directly to a central container. The openings are placed at appropriate intervals in the rooms and passages so that the whole building can be cleaned from floor to

ceiling. The same apparatus can be installed above the glass ceilings.

Electricity. All the electrical equipment required in a museum, whether for lighting or for power, must be planned and installed not only according to immediate requirements, but also with a view to its possible increased use or further extension in the future.

All wires, controls and fittings, in whatever part of the building, should be connected, by a number of independent circuits, to a main switch box, which will be placed in the quarters set aside for the technical supervision of the museum, and, if necessary, linked by a relay system to the nightwatchman's room or the custodian's quarters.

At this central control point there should be charts and clearly worded explanations and instructions, which can be followed and applied by anyone in the event of an emergency. The charts will plot the course of the individual lines, and show (by means of indicator bulbs of various colours) the points where the current passes and is used, and the precise course of every circuit. All members of the staff should be able to operate the switches which cut off part or all of the system, so that they can deal either with everyday circumstances or with emergencies. There must not, however, be complete freedom of access to these controls, which should not be accessible to ill-disposed persons who might be planning damage or robbery. The system should therefore combine simplicity with the fullest security.

It is extremely useful to have a second emergency network in addition to the general system; this should have a low voltage, produced either by storage batteries or by an independent generator. If the main current should unexpectedly fail, it is essential to be able to provide emergency lighting, even if this is weak, in the public rooms and especially at points of possible congestion (lecture rooms, corridors, staircases, emergency exists); this is for the sake of visitors' security as well as for that of the museum.

The switch-over should be immediate and automatic. It is therefore preferable for the emergency system to be fed by storage batteries kept permanently charged and able to run for at least three hours. The system should be used customarily for lighting the museum while the night watchmen go on their rounds. This method has several advantages—it keeps the emergency equipment in working order and under constant supervision; it does away with the need to use the ordinary current at night and thus incur possible risks on the premises; it acts as a substitute for the hand lamp, with its limited range, and this is of psychological as well as practical advantage to the nightwatchmen; and, without drawing on outside current, it feeds the museum's burglar alarms, automatic signals and security appliances.

Signals, controls, protection against theft. A modern museum needs luminous and acoustic signals for the public, and others reserved for the staff.

Among the first group are the charts indicating the way through the museum or the whereabouts of the various services, and it is sometimes advisable to make these particularly bright. Most important of all, however, are the signals that announce the closing of the museum, usually by the sound of a bell. The present very sensible tendency is to avoid the use of loudspeakers in a museum, since the disturbance they cause is greater than their usefulness warrants.

The signals reserved for the staff may be of two types—for purposes of communication, and for giving the alarm. A small museum will provide the former by means of ordinary telephones; internal lines will connect up all parts of the building and be linked with the switchboard which carries the outside lines. Larger museums will appreciate the automatic individual indicator, which repeats a pleasant sound for a given number of times for each member of the staff, who can thus be called to the telephone.

Alarm signals are a more complicated problem; but they are an essential part of the general equipment for supervision and protection against theft.

The best of all safeguards against the danger of theft is the complete isolation of the museum and its outbuildings from any

other premises; the architect should bear this in mind and make his design from that point of view.

Further protection can be attained by the methods of exhibiting a number of objects —paintings, sculpture, etc.—and of fastening them to the walls. Care should be taken that those exhibits which, owing to their material or their artistic rarity, are the most valuable and most liable to arouse the cupidity of thieves, are protected by strong showcases the glass of which is either unbreakable or so thick that it is difficult to break; and in any case for such exhibits special metal cupboards should be installed with shutters or bolts that slide back into the wall and are hidden while the museum is open to the public, but which can be closed at night.

Even the most perfect equipment cannot be regarded as efficient and adequate unless the human factor also plays its part, i.e., unless the guards who supervise the museum by day and by night are well organized, alert and unremitting in their vigilance. Every room or other part of the building must be equipped, for their use, with an electric flash signal which in case of emergency (theft, fire, disturbances) will transmit the alarm to the guardroom or to a neighbouring police station. A siren may also be used to give the alarm throughout the museum and in the surrounding area. To enable help to arrive quickly, however, the guardroom must simultaneously receive an indication showing from which gallery or at least which part of the building the alarm originated. This can be done by connecting the flash signals with separate circuits, each of which operates a lamp on the general plan in the guardroom.

In small museums, with a limited number of guards, the alarm signal should cause the immediate and automatic closing of all outside doors, so that the guilty or suspected person is unable to escape from the building before the police arrive.

Supervision and security are, of course, greatly facilitated by the architecture of the modern museum, which reduces or does away with ground floor windows and includes the fewest possible outside doors.

Nocturnal alarm signals may be provided by the same apparatus, made available to the watchmen during their tours of inspection. But this is not enough; there must also be an automatic signalling system, in case a burglar should try to force a door or window and enter the museum during the night, or to get out of it after successfully hiding there during the day.

The photoelectric cell ('electric eye'), a system in which an infra-red ray permanently connects two points situated at some distance from one another, so that any solid body passing between them interrupts the circuit and brings the alarm into action, has not given the hoped for results, chiefly because it is difficult to make the ray completely invisible in the darkness—and once its direction is apparent it can easily be avoided—and also because of the considerable expense of using this system on the large scale which is essential even in a small building if every part of it is to be effectively supervised.

A simpler system consists in installing one or more electric circuits which are completely closed only when every door and window is tightly shut, or in inserting an electric cable, so arranged that the shutter cannot be opened without displacing the wire and thus interrupting the general circuit and consequently giving the alarm. In this case, too, if the building is divided into several sections, each with its own circuit, the precise location of the alarm can be immediately indicated on the corresponding plan.

A similar arrangement of electric circuits, linked with a series of electric flash signals placed at points where every general inspection of the museum must necessarily pass, can transmit to the guardroom and automatically register (indicating the place and hour of the inspection) the passage of the nightwatchmen, and thus keep a record of the regularity of their successive rounds of inspection.

Precautions against fire. Obviously, the first measures of protection against fire must be provided by the site, the method of building, the safeguards available in the immediate vicinity, the choice of building materials, and the precautions taken in the introduction of any equipment which may cause fire or itself be easily inflammable.

Wood should not be used for roofs, partition walls, staircases or ceilings; it is advisable to avoid using any inflammable materials, to use as little wood as possible for decorative purposes, and not to line the walls with hangings. When this is unavoidable, such materials should be fireproofed by the most up-to-date methods. Even stricter precautions should be taken when an old building is being adapted as a museum, as a certain amount of the fabric is sure to consist of wood.

Every care should be taken to avoid the danger of short circuits in the electric system; all wiring will, of course, be installed according to the highest standards of safety, and completely insulated.

The precautionary measures adopted on ships as protection against fire should all be extended to museums, or at least be taken into account during building and equipment. Every country has rules and regulations on this subject, to which reference must be made.

The usual fire alarms with which ships are fitted, and which are manufactured nowadays on a large scale, should be provided more particularly in the exhibition rooms where the carelessness of visitors may cause fire, and above all in the storerooms which contain a wide variety of materials and in laboratories where use is made of volatile liquids and inflammable resins or where heating apparatus functions. Such places will be supplied with sandboxes and their accompanying equipment and with an adequate number of manual fire extinguishers—preferably those which discharge carbonic anhydrides and thus, saturating the air with neutral gas, leave the flames nothing to feed on and does not damage the exhibits, as jets of chemical foam or liquids may do. Where heating consists in the circulation of hot air through pipes, it is wise to install a device which seals these automatically in the event of fire, to avoid the flames being carried through the pipes to other parts of the building.

All openings communicating with staircases or lift shafts, and especially those leading into the storerooms, where fire is most likely to spread, should be fitted with insulating doors (asbestos) which close automatically the moment the temperature in their immediate surroundings rises above a certain level; this is ensured by an automatic release system in which the door slides shut when the wire holding it open melts.

The museum should be supplied with tanks equipped with electrical pumps to ensure a sufficient water supply in an emergency if the water in the ordinary pipes should be cut off or if pressure should be inadequate for immediate requirements. And, to meet emergencies, the museum should have some permanent means of direct communication with the local fire station as well as with the police station.

BIBLIOGRAPHY

BASSI-BERLANDO-BOSCHETTI. 'Musei', Documenti-Architetture, no. 26. Editore Antonio Vallardi, 1956.

BORDIER, R; SEUPHOR, M. 'Musées d'art moderne', Aujourd'hui, no. 2, March-April 1955, pp. 58-72. Paris, 1955.

COLEMAN, Laurence Vail. The museum in America. 3 vols. Washington, D.C., American Association of Museums, 1939.

EGGEN, J. B. 'La Galerie nationale d'art de Washington', Mouseion, vol. 57-58. Paris, Office international des musées, 1946.

GILMAN, Benjamin Ives. Museum ideals of purpose and method. Cambridge, Mass., Harvard University Press, 1923.

——. The museum news. Washington, D.C., American Association of Museums, 1924.

HOMBURGER, O. Museumskunde, with an extensive bibliography. Breslau, 1924.

ITALY. Ministerio della Pubblica Istruzione. Musei e gallerie d'arte in Italia, 1945-1953. Rome, La Librerio dello Stato, 1953.

JACKSON, Margaret Talbot. The museum. New York, Longmans, Green, 1917.

KIMBALL, Fiske. 'Modern museum of art', The Architectural Record, December 1929, pp. 559-90.

KREIS, W. 'Museumsbauten', in G. Wasmuth (ed.), Lexikon der Baukunst, vol. III, pp. 658-62. Berlin, 1931.

LABÓ, Mario. 'Il Museo del Tesoro di S. Lorenzo in Genova', *Casabella,* no. 213. Milan, 1956.

MOLAJOLI, Bruno. *Musei e opere d'arte di Napoli attraverso la guerra.* Naples, Soprintendenza alle Gallerie, 1948.

——. *Notizie di Capodimonte.* Naples, Edizione L'Arte Tipografica, 1957.

Mouseion. Bulletin of the International Office of Museums, Paris, 1928 *et seq.*

MURRAY, D. *Museums: their history and their use.* 3 vols, with an extensive bibliography. Glasgow, 1904.

Muséographie: architecture et aménagement des musées d'art. 2 vols. Paris, International Office of Museums, 1934.

Museum. Quarterly review published by Unesco, Paris, 1948 *et seq.*

SMITH, R. *Bibliography of museums and museum work.* Washington, D.C., 1928.

STEIN, Clarence S. 'The art museum of tomorrow', *The architectural record,* January 1930, pp. 5-12.

WHEELER, Joseph L.; GITHENS, Alfred Morton. *The American public library building.* Chicago, Ill., American Library Association, 1941.

YOUTZ, Philip N. 'Museum architecture', *The museum news,* December 1937, pp. 10-12. Washington, D.C., 1937.

CONCLUSION

Museums are faced with problems familiar to many other institutions, but these problems which the various institutions share in common must nevertheless be handled by each of them in its own way. For this reason we have studied some of these problems in detail, together with the solutions which have been arrived at by museums in different parts of the world. The purpose of this booklet is not to present final conclusions, but merely—as its title suggests—to serve as a guide. Museology, so far as it can be called a science, is, like all other branches of science, constantly changing to meet new needs; what may be considered as standard practice today will be modified tomorrow. Yet the general principles remain much the same over the years, and our readers may well find the present booklet of considerable help to them for some time to come.

It has been my privilege to take part in one of Unesco's international seminars, and I also had the honour of acting as director of the third seminar, held at Rio de Janeiro in September 1958, which dealt with the educational role of museums. One thing accomplished by these seminars was that the members from the different countries, each a specialist in some particular field, were led to discover that they all had to cope with a number of similar problems and that many of them had a great deal to learn from the experience acquired by others. The building up of collections, cataloguing of items and their preservation and display are tasks common to museums in all countries. All museums are confronted with the problems of scientific research and the presentation of its results to visitors, just as all museums must work out an efficient administrative system so as to co-ordinate their different activities.

It was not really until this century that the part museums play in the life of the community and the use of their collections for educational purposes took on their real importance. Emphasis on this aspect of museum work in many countries has been one of the outstanding developments in the museum world over the past fifteen years and has, beyond doubt, been the chief spur to the replanning of all forms of museum work. The new line of development is reflected in logical and attractive exhibitions, new hours for the opening of museums to the public, and a steadily increasing number of visitors of all ages and walks of life, who have come to regard their visits to museums as an important experience. Friendly rivalry has sprung up between museums, in their pursuit of a policy which enables the public to view and study their collections, to observe and understand natural phenomena, and to appreciate man's cultural and technical achievements—from the primitive vestiges of the Pleistocene or glacial epoch to the carving on a canoe paddle from the South Seas, a Japanese scroll painting or a painting by Rembrandt.

And what of the future? One thing is clear—that in many countries, museums which once had no active teaching programme now take a very keen interest in this kind of work. What other impulses are actuating museums today? There is, for example, the development of the specialized regional museum. In France one museum traces the history of the 'wine civilization'

in Burgundy, from Roman times to the present, and displays, for purposes of comparison, material assembled from lands near and far. In this field of museum work, we may well see the start of rational planning (in the past the specialized museum was often a matter of chance), whereby each region will have a museum to record the historical background of its basic local industry, its effect on folklore and the traditional culture of the region and its links with regions of a similar character.

Museums are suited by the very nature of their functions to perform this kind of work. In this industrial age with its standardized products and fashions, carried so quickly from one part of the world to another, it is well to remember that universality would have no meaning but for the traditions peculiar to each region. Museums can serve as one way of helping to preserve and maintain these original features, which bring a welcome variety into our lives.

Georges-Henri RIVIÈRE
Director
International Council of Museums

ILLUSTRATIONS

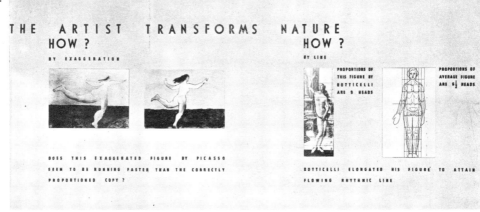

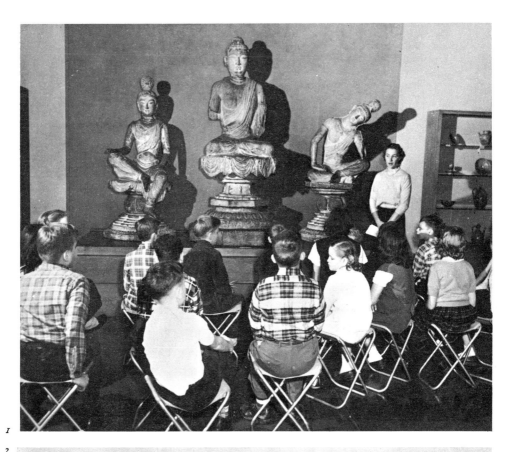

1. Art Institute of Chicago. A class from a Chicago suburban school looks at Chinese sculpture.

2. Art Institute of Chicago. The artist transforms nature. Gallery of Art Interpretation.

3

4

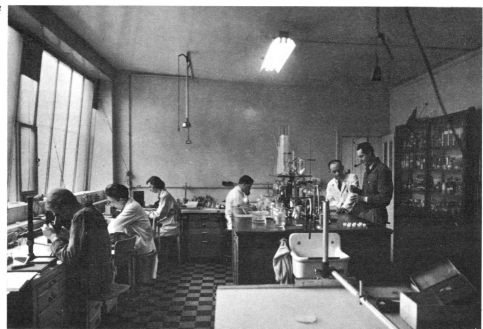

3. Institut Royal du Patrimoine Artistique, Brussels.
Insecticide chamber for use with hydrocyanic acid.

4. Part of the Laboratory of Micro-chemistry,
Brussels.

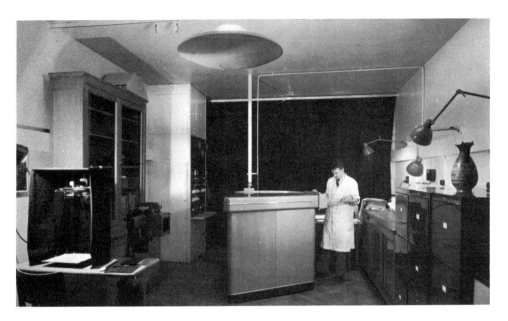

5

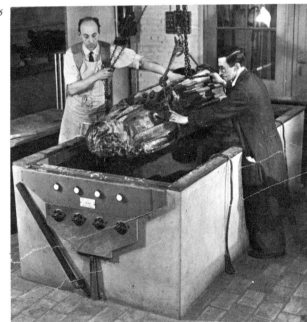

6

5. Part of the Physics Laboratory, Brussels. Physics is becoming more and more important in the study of ancient materials.

6. Conservation workshop, Brussels. Paraffin treatment: consolidation of a wooden statue attacked by worms, in an electrically heated vat containing paraffin with a 10 per cent addition of beeswax.

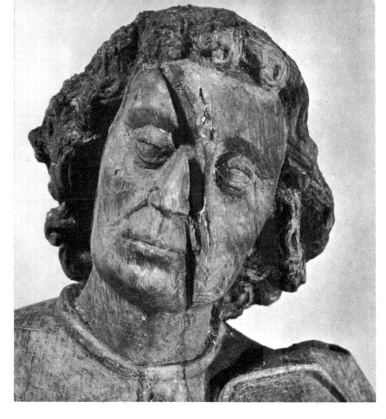

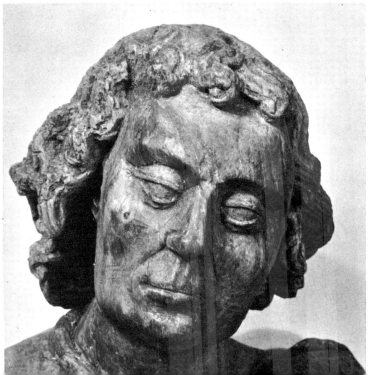

7a, 7b. St. John, oak, fifteenth century, Bierghes-lez-Hal (Belgium): (*a*) before restoration, (*b*) after restoration.

4

8. St. Anne, Virgin and Child (detail), wood, sixteenth century, Berg-lez-Tongres (Belgium). Removal of layers of paint often exposes a badly worm-eaten surface.

9. Christ on the Cross (detail), wood, Romanesque style. Worm holes artificially dug out by some instrument (a nail)?.

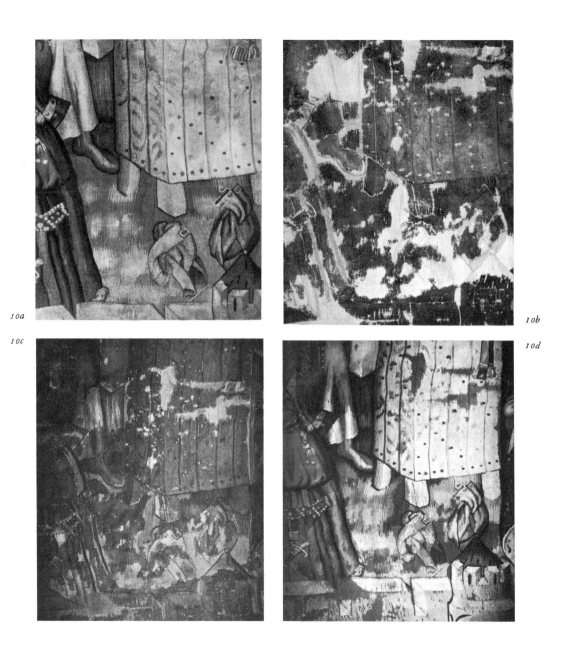

10a

10b

10c

10d

10a, 10b, 10c, 10d. Arras tapestry, fifteenth century, Tournai Cathedral (Belgium). Shows modern restoration by physical methods: (*a*) ordinary photography, (*b*) infra-red photography, (*c*) ultra-violet photography, (*d*) fluorescent photography.

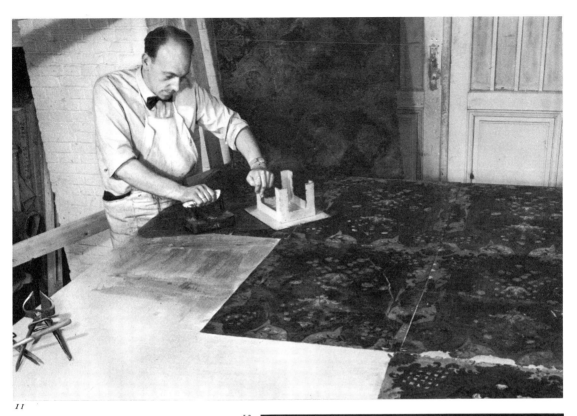

11

11. Mural covering in Malines leather, eighteenth century, Hôtel de Ville, Brussels. Operation of lining on canvas with resin-wax.

12. Romanesque sculpture, oak, *circa* 1200, Louvain (Belgium). Tangential view (enlarged 82 times): 1—ligneous rays, 2—vessels, 3—woody fibres, 4—internal deterioration. At the surface: calcination (fire).

13a

13b

13a, 13b. Sheet of parchment with Hebrew text, undated. Private collection, Brussels. The text, invisible in ordinary light (*a*), becomes perfectly legible under fluorescent lighting (*b*).

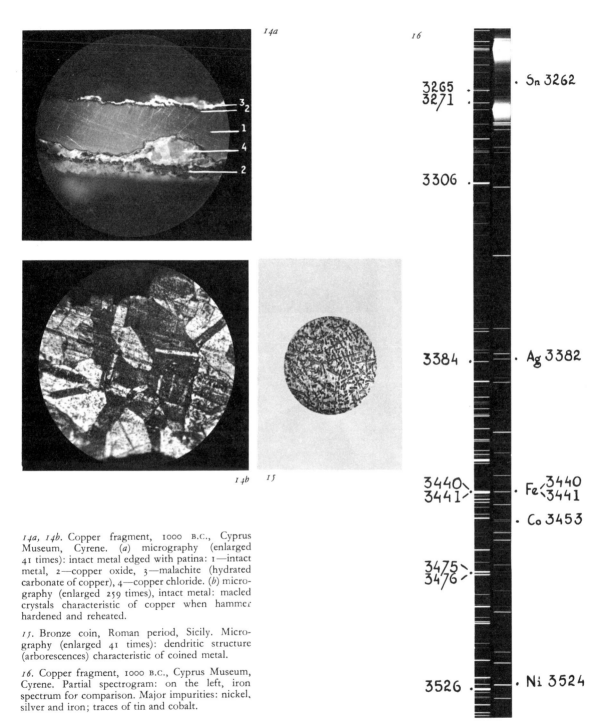

14a, 14b. Copper fragment, 1000 B.C., Cyprus Museum, Cyrene. (*a*) micrography (enlarged 41 times): intact metal edged with patina: 1—intact metal, 2—copper oxide, 3—malachite (hydrated carbonate of copper), 4—copper chloride. (*b*) micrography (enlarged 259 times), intact metal: macled crystals characteristic of copper when hammer hardened and reheated.

15. Bronze coin, Roman period, Sicily. Micrography (enlarged 41 times): dendritic structure (arborescences) characteristic of coined metal.

16. Copper fragment, 1000 B.C., Cyprus Museum, Cyrene. Partial spectrogram: on the left, iron spectrum for comparison. Major impurities: nickel, silver and iron; traces of tin and cobalt.

17

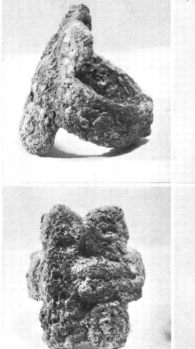
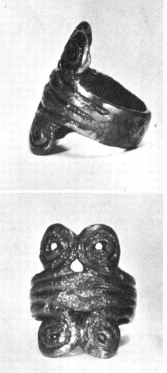

18

10

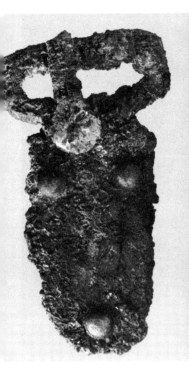

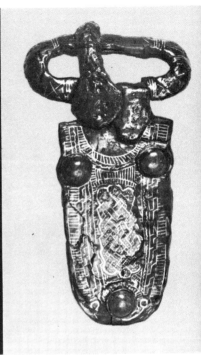

19

17. Damascened iron sword, seventh century A.D., from Spontin (Belgium), Musée Archéologique, Namur. Macrographs (enlarged 2 times) before (left) and after treatment (right); in the centre, X-ray photograph: note the superposition of the damascening on both sides of the blade.

18. Bronze ring, circa 1400 B.C., excavated at Talli Teimuran (Iran). Before and after electro-chemical treatment.

19. Merovingian damascened buckle, silver on iron, seventh century A.D., Namèche (Belgium). Condition before and after treatment. Middle: X-ray photograph revealing silver incrustations concealed by a thick layer of rust.

20. Calcareous sandstone (Baeleghem stone), St. Bavon Cathedral, Ghent (Belgium). Traces of sulphation. This is a common disease in calcareous monuments exposed to the sulphur fumes of coal.

21. Calcareous sandstone (Baeleghem stone), Gothic façade, Town Hall of Ghent (Belgium). Micrograph (cross-section enlarged 40 timcs) illustrating damage by sulphation: 1—intact calcareous sandstone: quartz crystals in a calcium-carbonate cement; 2—fine (0.02 mm.) gypsum border: beginning of transformation of calcium carbonate into calcium sulphate; 3—thick (0.5 mm.) black outer layer of soot and gypsum.

In this way the laboratory detects sulphation, measures its importance and estimates its effect.

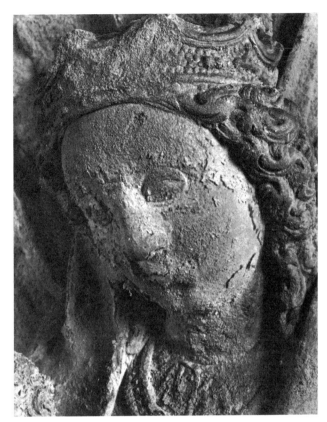

22

23

22. Sandstone, Church of St. Nicholas, Enghien (Belgium). Deterioration by freezing: shattering of the stone by the increase in volume of frozen water. This happens in rainy countries where the temperature falls below 0°C.

23. Virgin and Child (detail), limestone, beginning of sixteenth century, Musées Royaux d'Art et d'Histoire, Brussels. A coating of cellulose material has been shattered by pressure from the salts (chlorides) which have crystallized in the limestone. Stone must breathe. Salts must never be confined.

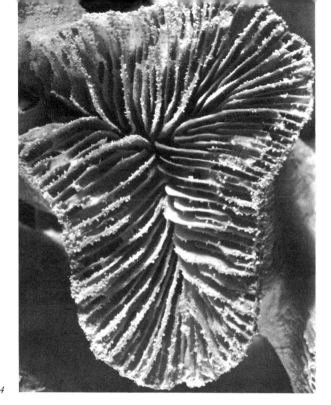

24

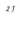
25

26

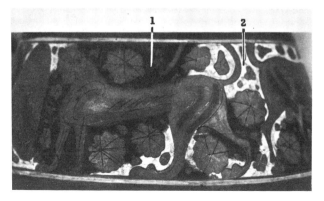

24. Shells, from the Indian Ocean, Institut Royal des Sciences Naturelles, Brussels. Macrograph (enlarged 4.3 times): the acetic acid in the oak casing has reacted on the calcium in the shell of the specimen and formed saline efflorescences. They are easy to remove by washing.

25. Lid of a Roman sarcophagus in white marble, second century A.D. Photograph in fluorescent light. To the right of the break: old fragment; to the left: the modern addition.

26. Corinthian terra cotta pitcher (detail), end seventh-beginning sixth centuries B.C. Fluorescent light shows that the vase is composed of original fragments (1—dark zones) and modern fragments (2—lighter tone).

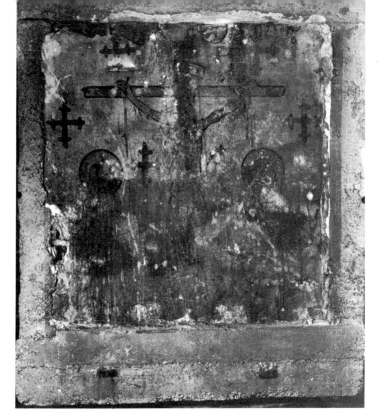

27a

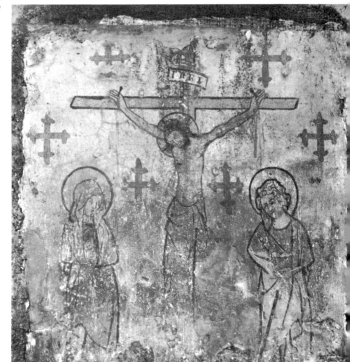
27b

27a, 27b. Tomb painting, *circa* 1300, ancient Abbey of St.Pierre, Ghent (Belgium). (*a*) Condition before treatment and (*b*) after treatment: ground water containing carbonic acid had caused incrustations of calcium carbonate. It has been necessary to combine the use of abrasives and chemical reagents.

28. Stained glass window, fourteenth century, Musées Royaux d'Art et d'Histoire, Brussels. Punctures in the glass caused by an excess of alkali transformed into carbonates. Modern glass is more resistant.

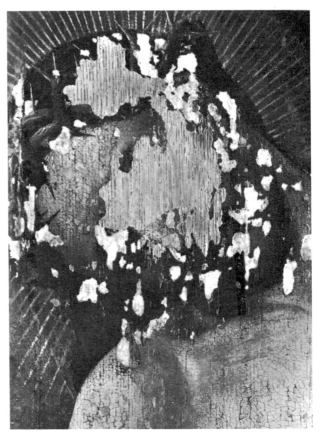

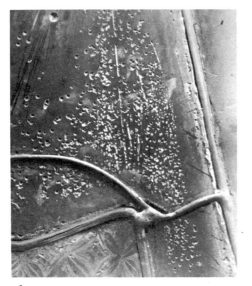

28

29a

29a, 29b, 29c. R. van der Weyden, Trinity (detail), oil painting on oak, Musée Communal, Louvain (Belgium). Reconstitution of the original (middle: X-ray photograph).

30a, 30b. R. van der Weyden, Trinity. Micrographs (enlarged 168 times) in infra-red (*a*) and fluorescent light (*b*). Dark red of a garment: 1—ground: chalk and animal glue; 2—layer of waterproofing, with an oil base; 3—sizing: white lead, a little ochre and animal black with an oil medium; 4—layer with an oil base, purpose unknown; 5—layer of paint: white lead, a little animal black, oil medium; 6—layer of paint: fixed madder-red, less white lead, oil medium.

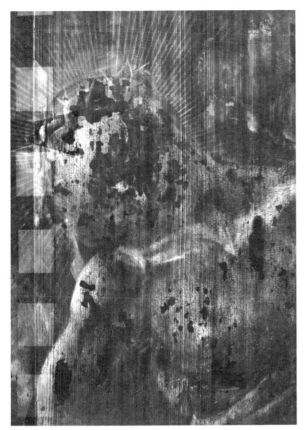

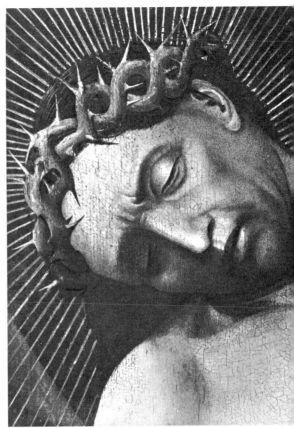

29b

30a 30b

31a, 31b. Flemish master, end of fifteenth century,
Triptych of the Trinity, oil painting on oak, church
at Berg (Belgium). Photographs before and after
restoration. Partial reconstitution of the original
only by the incorporation of geometric elements.

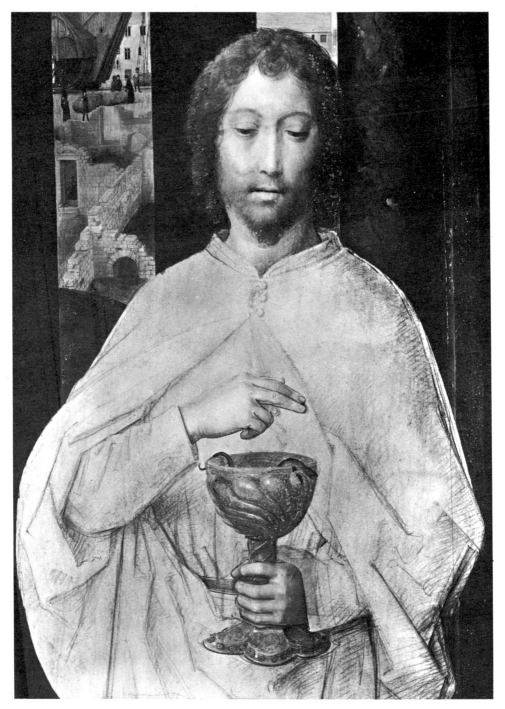

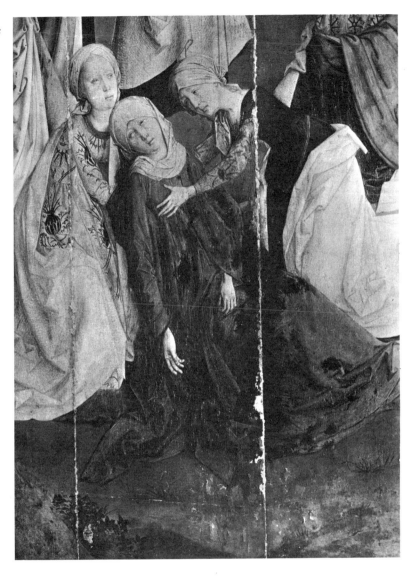

32. Mystic Marriage of St. Catherine (detail) (1479), Memling, oil painting on oak, Musée de l'Hôpital St. Jean, Bruges (Belgium). Infra-red photograph: drawing and changes in the composition are revealed, especially on the two hands and the face.

33. Triptych of the Calvary (detail) (*circa* 1466-68), Juste de Gand, oil painting on oak, St. Bavon Cathedral, Ghent (Belgium). Infra-red photograph: identification of restorations, especially in the Virgin's blue mantle.

34

35

22

37

34. Fogg Art Museum, Harvard University, Cambridge, Mass. Sliding screen panels for storing oil or easel paintings. Double rail overhead suspension type.

35. The study storage collection of the Costume Institute, Metropolitan Museum of Art, New York. The costumes are filed according to period and serve as a designers' reference library, where designers can pick a gown from a rack or take a garment from a drawer much as one takes a book from a shelf.

36. Museo Textil Biosca, Tarassa, Spain. One method of mounting textiles for a study collection; they are readily accessible and protected from light and insects.

37. Loan and study collection of the Metropolitan Museum of Art, New York. Prints, mounted and protected.

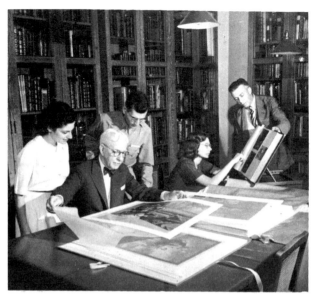

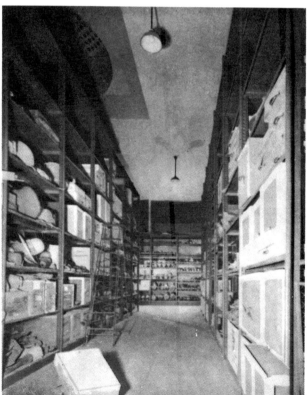

38

39

38. The print study room of the Metropolitan Museum of Art, New York.

39. Musée de l'Homme, Paris. Metal shelving: on the right, dust-proof trays in which feathers and textiles are kept.

40. Musée de l'Homme, Paris. Racked sliding trays and portable cabinets.

41. Musée du Louvre, Paris. Presentation of a fragment of the frieze of the Parthenon (Athens, fifth century), in a setting which recalls an ancient palace.

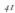

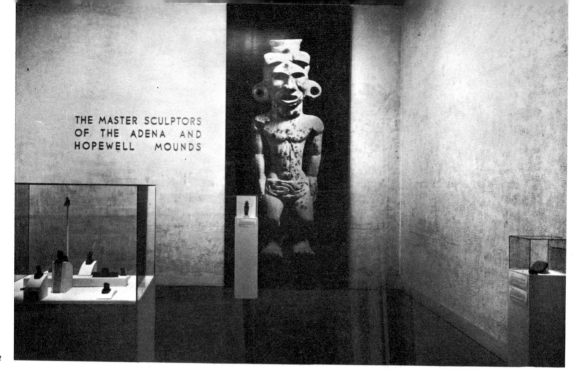

42

43

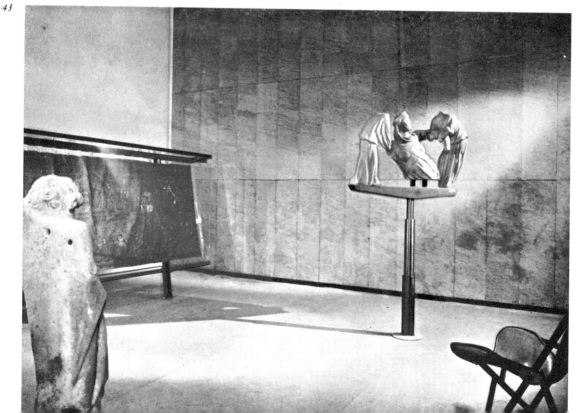

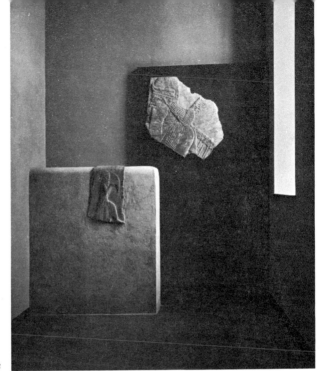

44

45

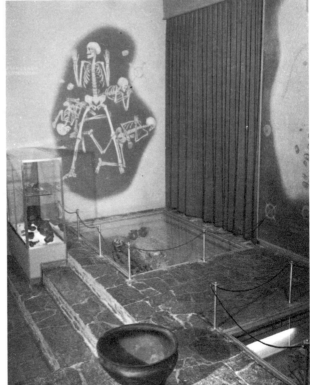

42. Museum of Modern Art, New York. Presentation of a miniature object (an Adena pipe) to show its monumental scale.

43. Palazzo Bianco, Genoa. Exhibition of an early Renaissance sculpture in the modernized setting of a sixteenth-eighteenth century palace.

44. Cincinnati Art Museum. Reliefs mounted to use natural side lighting so as to accentuate the details of the carving.

45. Niederöstereichisches Landesmuseum, Vienna. Exhibition of two graves from prehistoric Schleinbach. The exhibition includes a map of the site, a case containing artifacts, and a mural of the skeletons in burial position.

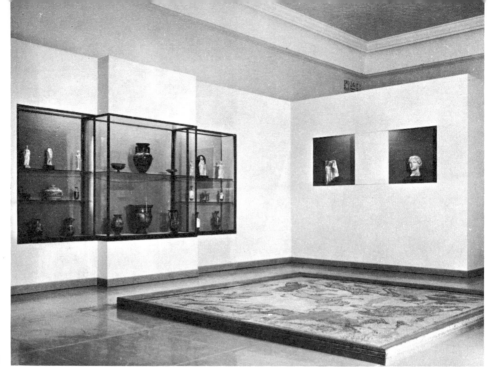

46

47

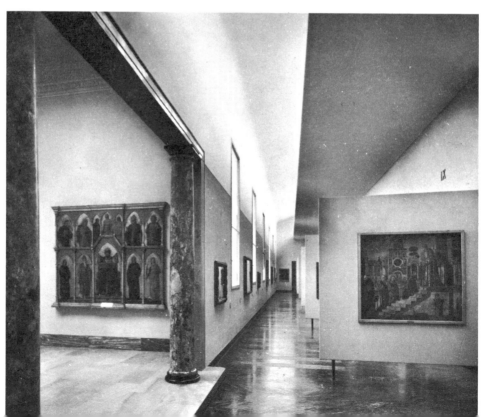

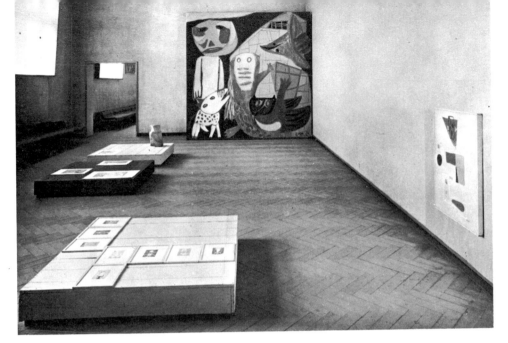

48

49

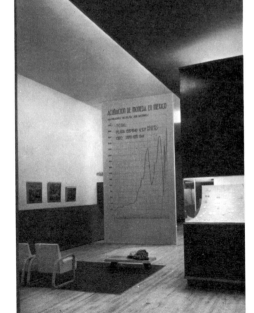

46. Honolulu Academy of Arts. Partial view of a gallery adapted to show Greek and Roman art.

47. Pinacoteca di Brera, Milan. A long narrow hall with high ceilings adapted to show small paintings, by using a suspended ceiling and screens.

48. Stedelijk Museum, Amsterdam. Translucent screens set over windows soften the light admitted. Platforms help to break up a large floor area and offer a fresh way of looking at paintings.

49. Museo Nacional de Historia, Castillo de Chapultepec, Mexico D.F. The Hall of Numismatics. The ceiling has been lowered, and a fin wall with a two-way case bounds the exhibition area. The fin wall and master label give a welcome relief to the horizontal presentation of the objects on exhibition.

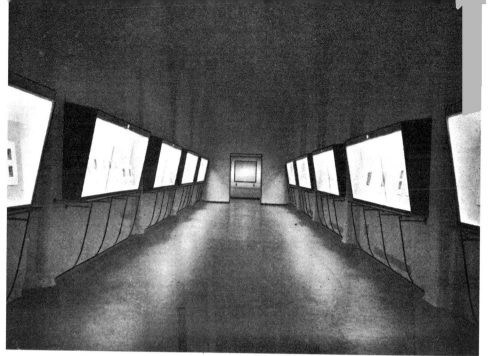

50

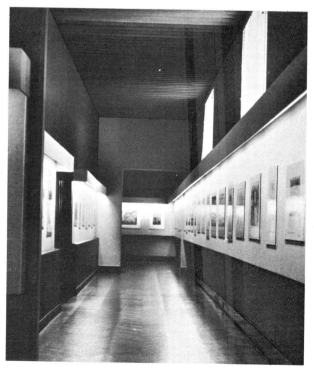

51

50. Rijksmuseum, Amsterdam. Print section—the prints are mounted at the angle at which a hand would hold them for inspection. The cases lean away from the wall to vary the vertical stress and reduce annoying reflections from the glass.

51. Cincinnati Art Museum. An exhibition of prints which were mounted on fabric covered wood panels applied to plaster walls. The horizontal cove built above the exhibition strip conceals fluorescent tubes.

52. Cincinnati Art Museum. Beams (2 by 12 inches) set at a height of 9 feet modify the room (which has walls 17 feet high) for an exhibition of miniatures and pages of an eleventh-century Persian manuscript.

53. Colorado Springs Fine Arts Centre. Angled temporary walls achieve the effects of a curved wall at less cost. The free shape group pedestal in the centre of the room plays curves against straight lines.

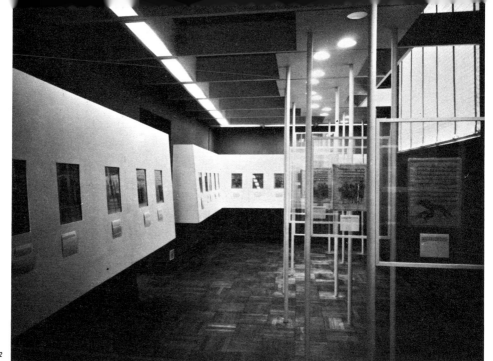

52

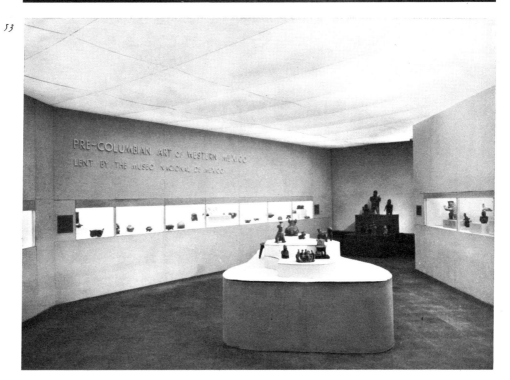

53

54

54. Niederösterreichisches Landesmuseum, Vienna. An illustration of the use of maps as part of the decorative scheme. The built-in wall case shows a reproduction of a Kuffarn situla (Hallstatt civilization) on a rotating plexiglass stand.

55. Statens Historiska Museet, Stockholm. The retreat of the glaciers and resultant changes in flora, fauna and human cultures are illustrated with the aid of table maps. Screens are set at right angles for display of objects and photographs, and small sloping table cases hold objects.

55

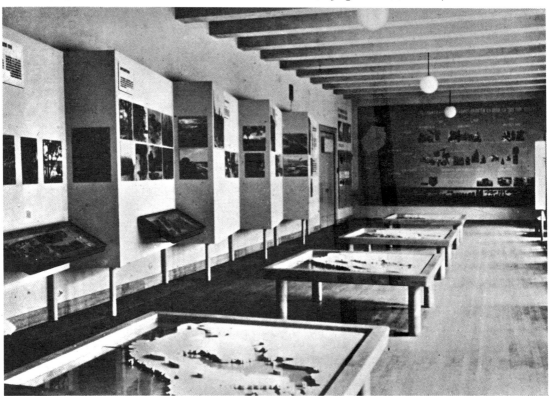

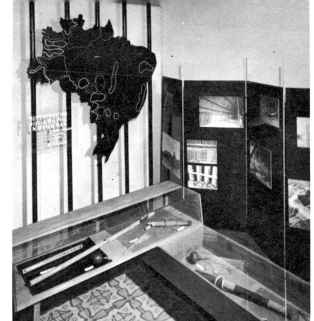

56. Muséo de Indio, Rio de Janeiro. A grid of large poles supports a cut-out map. A simply made screen carries photographs and two low horizontal cases house Indian objects.

57. Cincinnati Art Museum. A mural map locating the cities of origin of the objects on exhibition. In the axis of the gallery is a sixteenth-century Koran from Mecca, shown on a plexiglass lectern.

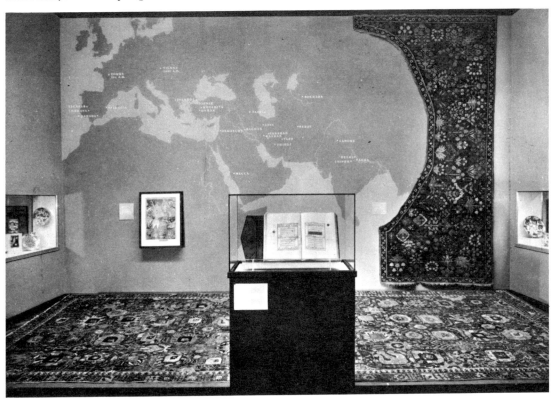

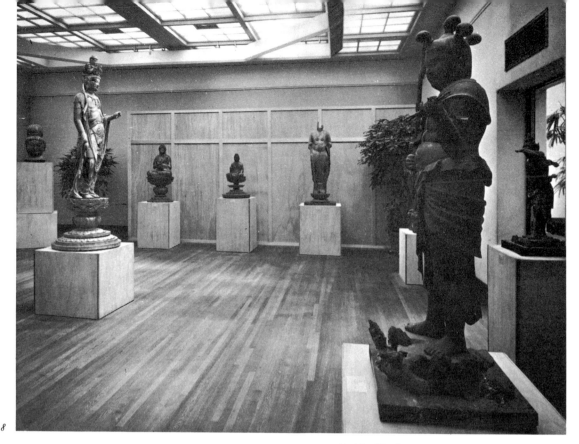

58

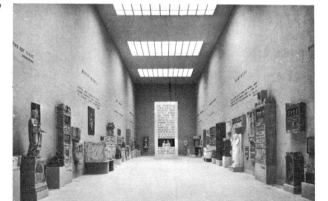

59

58. M. H. de Young Memorial Museum, San Francisco, Calif. Panel screens of light natural Philippine mahogany set in with spruce frames adapt the space of permanent galleries to show a temporary exhibition, *Art Treasures from Japan,* 1951. The pedestals were made of the same material.

59. Museo della Civiltá, Rome. Ancient Roman family life. The free standing panel carries the text of the theme of the exhibition and has a niche holding a husband-and-wife funerary portrait.

60. Chicago Museum of Natural History. Stratification in archaeology, clearly and graphically explained utilizing objects in an explanatory lable.

61. Palais de la Découverte, Paris. Diagrams and enlarged microscopic photographs used to explain on a popular level principles which would otherwise be difficult for visitors lacking technical background.

DATING LAYERS BY POSITION
IN AN ANCIENT INDIAN TRASH HEAP
IN ARIZONA

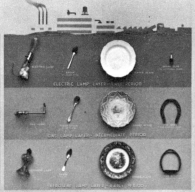

DATING LAYERS BY POSITION
IN A MODERN CITY TRASH HEAP
IN THE MIDDLE WEST

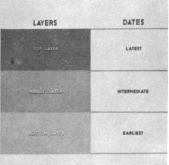

LAYERS	DATES
TOP LAYER	LATEST
MIDDLE LAYER	INTERMEDIATE
BOTTOM LAYER	EARLIEST

DATING LAYERS BY POSITION
TOP LAYER IS LATEST
BOTTOM LAYER IS EARLIEST

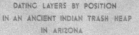

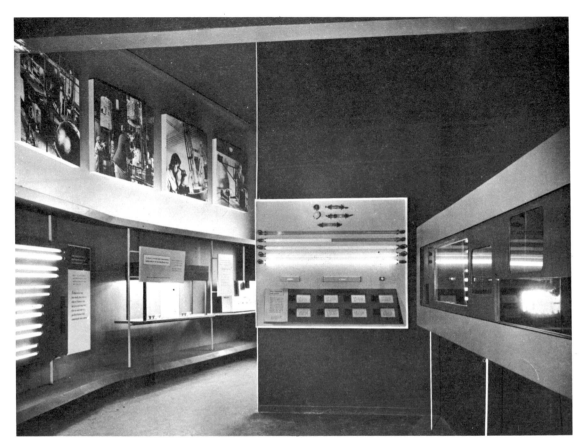

63

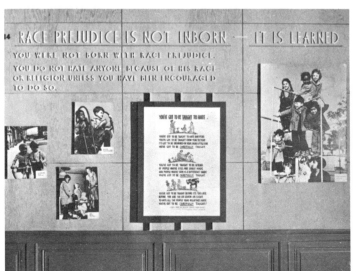

62

36

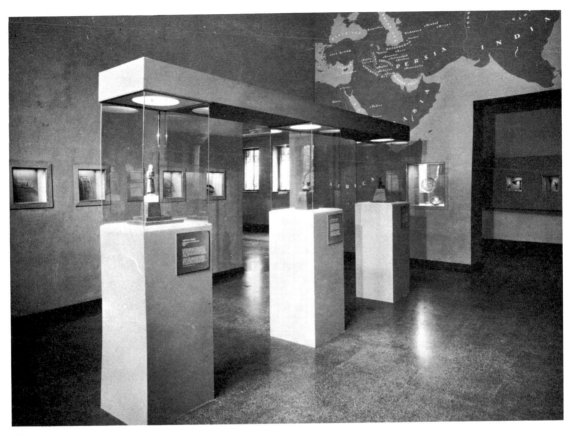

64

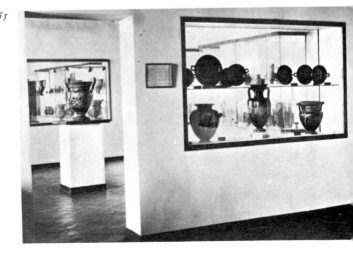

65

62. Los Angeles County Museum. *Man in our changing world,* an exhibition on race prejudice using a few major points to illustrate the theme.

63. Science Museum, London. *Darkness into Daylight,* an exhibition on fluorescent lighting principles.

64. Cincinnati Art Museum. An exhibition of Pre-Islamic art using inset cases and free standing cases which are united by a soffit.

65. Museo Archeologico, Arezzo. An exhibition using a built-in two-way window case.

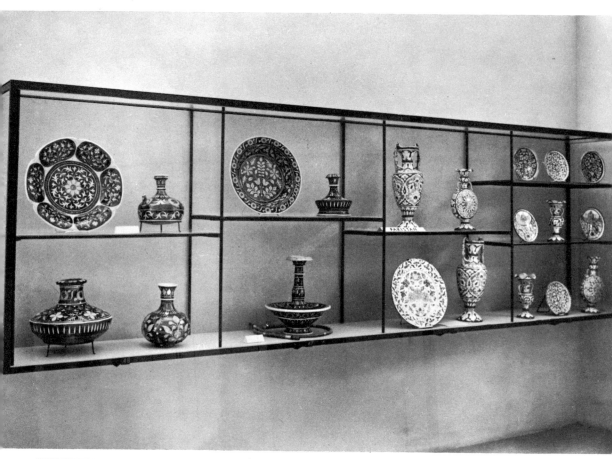

66. Museo Internazionale delle Ceramiche, Faenza. A suspended wall case with shelving set at different levels.

67. Deutsches Museum, Munich. Geodesy section. Inset cases used to display instruments used in the measurement of the earth.

68. Röhsska Museet, Göteborg. An "egg-crate" or honeycomb type of case. Movable backs vary presentation.

69. Rijksmuseum, Amsterdam. The insertion of a dividing panel in a conventional case makes it an effective space divider and adjusts the size of the case to the objects shown.

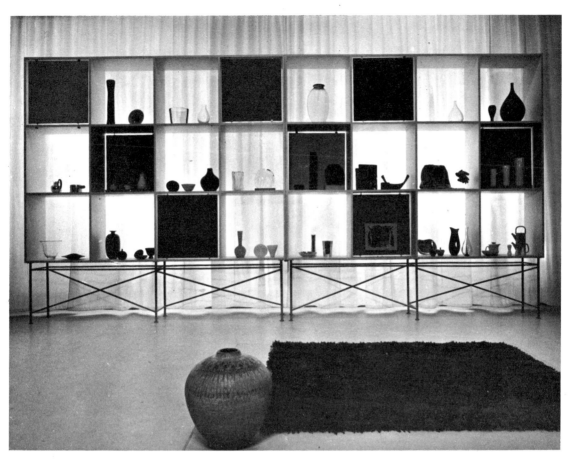

68

69

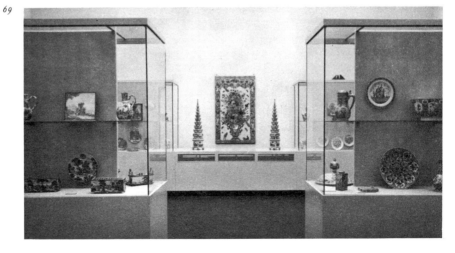

70

70. Statens Historiska Museet, Stockholm. Use of perspex to mount a mitre and a carved ivory crozier.

71. Brooklyn Museum. Fragments of bas-reliefs from Egypt mounted in a plywood panel at a uniform surface plane.

71

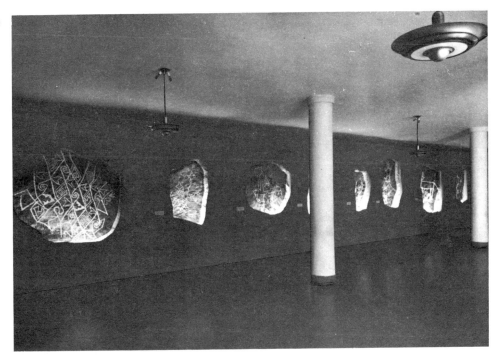

73

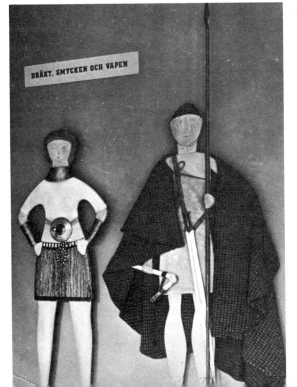

72. Brooklyn Museum. Reproductions of petro-glyphs from the Southwestern United States mounted about a foot behind a temporary wall of plasterboard.

73. Statens Historiska Museet, Stockholm. Stylised silhouettes used to mount reproductions of Bronze Age arms and garments.

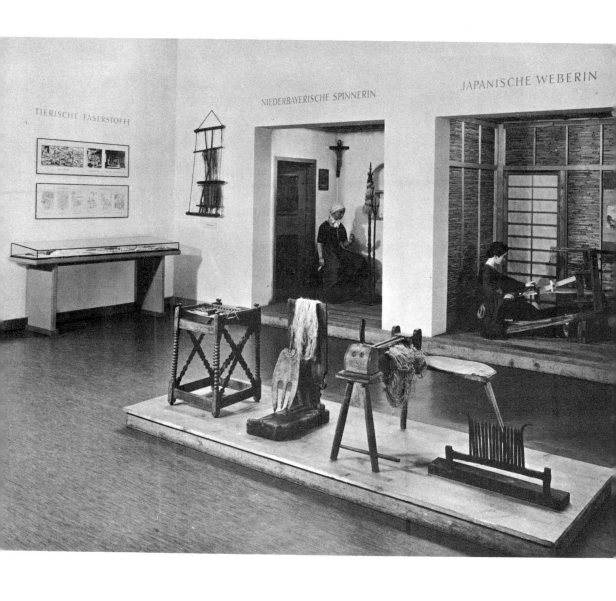

74. Deutsches Museum, Munich. A naturalistic
solution to show early weaving techniques.

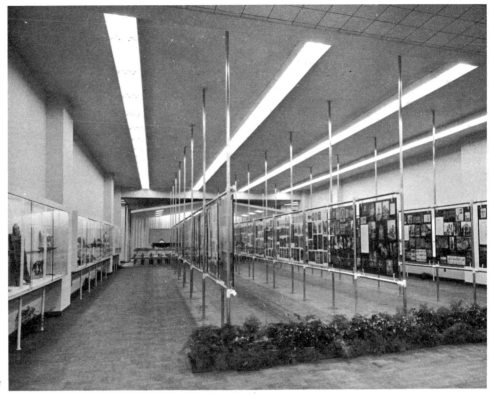

75a

75b

75. Museu de Arte, São Paulo. Use of tubular
framework to mount panels for a didactic exhibi-
tion : (a) over-all view; (b) detail.

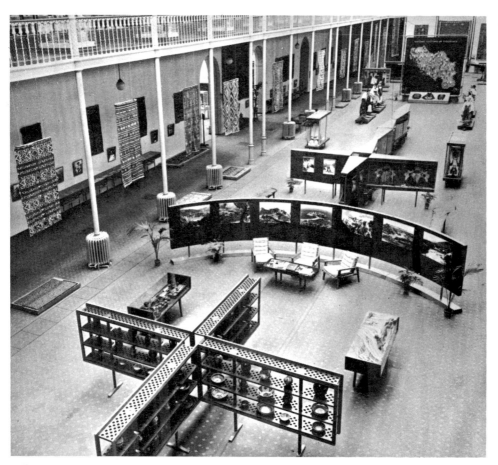

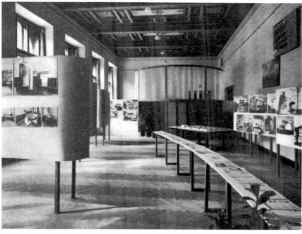

76. Royal Scottish Museum, Edinburgh. Travelling exhibition of Yugoslav folk art.

77. Umelecko-Prumyslove Museum, Prague. Exhibition units of simple construction which can be used again or serve for travelling exhibitions.